GHASTLY TERROR!

THE HORRIBLE STORY OF THE HORROR COMICS

by Stephen Sennitt

CRITICAL VISION
an imprint of **HEADPRESS**

A Critical Vision Book
Published in 1999
by Headpress

Critical Vision
PO Box 26
Manchester
M26 1PQ
email: david.headpress@zen.co.uk
visit: http://www.headpress.com/

Ghastly Terror! The Horrible Story of the Horror Comics
Text copyright © Stephen Sennitt
This volume copyright © 1999 Headpress
Layout & design: Walt Meaties
Front & back cover art: Rik Rawling, based on panels deemed objectionable during the
 crackdown on comic books in the 1950s.
Proofing: Stefan Jaworzyn
World Rights Reserved

No part of this book may be reproduced or utilised in any form, by any means, including electronic, mechanical and photocopying, or in any information storage or retrieval system, without prior permission in writing from the publishers.

British Library Cataloguing in Publication Data
A catalogue record for this book is available from the British Library.

ISBN 1 900486 07 5

If you would like a current catalogue of all Headpress/Critical Vision publications, please send a first class stamp or IRC to the address above.

CONTENTS

Acknowledgements ... 4
Introduction ... 7

Precode Horrors: 1946–1959
Into The Abyss...! ... 11
Top 20 Most Gratuitous Precode
 Horror Comics Covers! 52
Scapegoats .. 54

B&W Horrors: 1964–1975
Comics To Give You The Creeps! 64
Warren: The Covers ... 114
Shoddy Duplicates .. 116
The Horror-Mood ... 129

New Wave Horrors: 1969–Present
Bronze Age Silver Bullets! 169
The 10 Best Non-Series' Bronze-Age
 'Monster Mag' Tales .. 181
Underground Currents .. 182
Afterword .. 197

Appendix I
 An A-Z of Precode Horror Comic Publishers 199
Appendix II
 Comics Magazine Association of
 America Comics Code, 1954 213
Appendix III
 The Top 10 Greatest Horror Comics Ever! 215

Selected Mail Order Sources 216
Selected Bibliography .. 216
Picture Credits ... 217

ACKNOWLEDGEMENTS

FIRST AND FOREMOST, I'd like to express grateful thanks to David Kerekes, who has helped me see this project through with infinite patience and kindness.

Many thanks also to John Beal, for translating my messy, hand-written MS so efficiently into a legible typeset format, and for his patient and indispensable assistance in preparing material for illustrations. Additional thanks to David Slater and Dave Huxley for their loan of illustrative material.

My thanks, for friendship and kindness, go to Dave Chesters, DM Mitchell — and George Suarez, whose brilliant publication TALES TOO TERRIBLE TO TELL has been an essential source of inspiration and information for me.

Finally, I'd like to thank my wife, Louise Sennitt, who, as always, has given me her encouragement and understanding through some difficult moments.

—*Stephen Sennitt*

GHASTLY TERROR!

THE HORRIBLE STORY OF THE HORROR COMICS

INTRODUCTION

I BECAME FOREVER TRAPPED in the nether world of horror comics at the tender age of eight! One particular Saturday morning's begrudging trip to the barber's for the usual horrendous short-back-and-sides (so uncool in the days of Marc Bolan and Alice Cooper) turned into the beginning of a lifelong obsession. As I peered into the window of Jones' newsagents, wiping the prickly remains of yet another aborted attempt at a long hairstyle from the back of my neck, I saw some copies of an American magazine which absolutely riveted my attention — the title was CREEPY. I was immediately drawn into the parallel existence that the covers depicted; a supernatural realm where ghastly apparitions beckoned from crumbling archways — where snarling werewolves wrestled with leathery-skinned vampires — where sickly, greenish monsters strangled their victims over decaying gravestones... And then my heart sank as I saw the price stamped on the covers: 2/6! Astronomical! I'd only got a shilling! That was that!

After weeks of sleepless nights and via the process of nagging and wearing-down (what we in the North of England call 'whittling') my mum eventually gave in and made up the extra money I needed. On a cold Monday morning, on the way to school, and after much deliberation, I selected a copy of CREEPY #10. That was it. I was hooked. I've never looked back since!

Of course, my mum thought the idea of CREEPY was just ghastly. The thought of it — a 'kid's comic' — depicting such disturbing scenes of horror was a bit beyond the pale, really. In fact, I suspect she only agreed to buy me a copy because she thought it would scare me so much I wouldn't want another. Or like other childish interests, it would soon be superseded by something else I'd 'get

Love at first sight!
Cover: CREEPY #10.

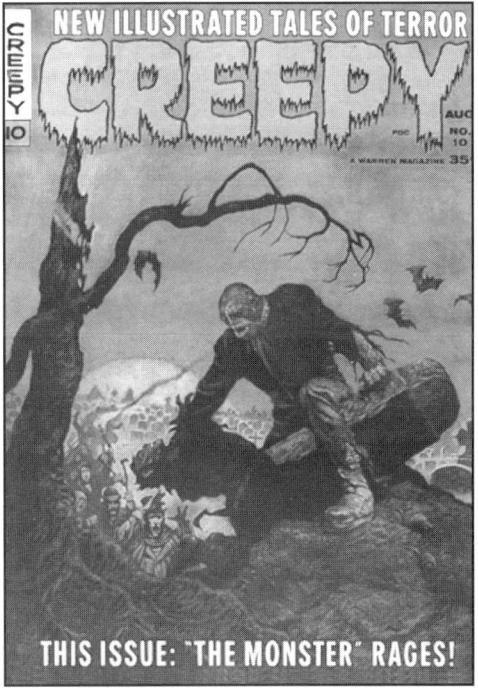

THIS ISSUE: "THE MONSTER" RAGES!

GHASTLY TERROR!

this page and next
A sampling of 'weird menace' pulps — 'highbrow' forerunners of the horror comics.

into'. Neither of these things proved to be true. Certainly CREEPY was scary. But not *too* scary! It was the type of 'scary' that was exciting. So exciting, in fact, that there was no chance of it being superseded by other interests. Everything else I 'got into' was merely a substitute! I expect my obsession sometimes worried my parents, who deemed comics (and later films and paperbacks) like CREEPY 'morbid' and a touch unhealthy. But what could I do about it? As other horror comic fans know: once you're hooked, you're hooked for the duration.

Still, you can understand the point-of-view of the uninitiated who scratch their heads and sometimes wonder how comics got from stories about zany animal antics and 'funny pages'-type jokes to depicting beheadings, blood-drinking and other perverse, feral lusts! (And much more so in small-town provincial England where exposure to such outrageous concepts was viewed with even more distaste.) Briefly, it happened like this:

Ironically, the father of the most famous of all horror comic publishers, William M. Gaines of EC fame!

Although the first American comic books appearing under the aegis of one Max Gaines* were collections of jokey stuff like FUNNIES ON PARADE and FAMOUS FUNNIES (gathered together from the 'funny pages' of the Sunday papers) there had already been a long tradition of more seri-

INTRODUCTION

ous adventure-style 'funny pages' influenced by the pulp magazines, such as the famous Flash Gordon, Buck Rogers and Dick Tracy; before long, these types of stories were also being collected together and published as bona fide comicbooks. In short order, the full potential of this new medium was realised by a whole host of publishers wanting to jump on the bandwagon. A plethora of pulp, movie and radio serial-influenced comics began to appear, and almost immediately elements from some of the more gruesome examples of these entertainments were utilised by publishers wanting to make their mark in a competitive business. This was first evidenced in the superhero-type comics of the time, some of the earliest of which came out during WWII and featured nefarious Nazi villains, such as Captain America's arch-nemesis, The Red Skull. Even more directly horror-related was a character who had appeared earlier still via the hands of pioneer creative duo, Jerry Siegel and Joe Shuster in DC's MORE FUN: the ghost detective, Dr Occult. Similar characters such as the famous Spectre, followed in Dr Occult's wake, along with monster characters like Frankenstein (see PRIZE COMICS, Dec 1940) and The Heap (see chapter: *The Horror-Mood*).

However, these were only forerunners to the *true* horror comics that followed a few years later. These were also inspired by memories of the Golden Age of Pulps which had produced such dark gems as *Weird Tales* and *Strange Tales* — though more likely, the horror comics of the late Forties and Fifties were influenced by the gleefully sordid pulps of the 'Weird Menace' variety from a decade or two earlier, such as *Terror Tales*, *Horror Stories* and *Dime Mystery*... a trio of titles that epitomised the lurid and sensationalistic subject matter of the precode* horror comic, with only the more famous EC

*This term will be explained in the chapter to follow.

GHASTLY TERROR!

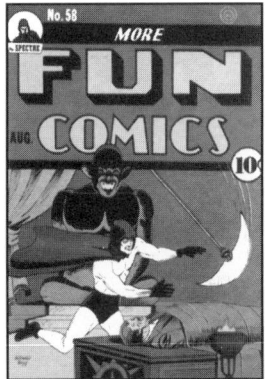

The Spectre in DC's MORE FUN COMICS, and AIRBOY COMICS featuring The Heap.

drawing on literary talents such as Ray Bradbury.

Another influence (along with the Pulps and the horror films of Boris Karloff and Bela Lugosi, *et al*) was radio, with shows like *Lights Out*, *Suspense*, *The Whistler* and *The Witch's Tale* (probably the main influence on the horror comics conception of having a witch-like 'host' to tell the tales) in which atmospheric terror tales were told with dramatic music and chilling sound effects.

All these disparate ingredients went into the creation of the horror comicbooks which went on to take America by storm. Deemed morbid and unhealthy at the outset, horror comics soon went on to be viewed as Public Enemy Number One by the pressure groups which opposed them...

This book is, in fact, less about such historical matters and much more an unbridled appreciation of the horror comics *themselves*; their gruesome stories, their lurid artwork and their striking covers! These are the things that matter much more to me than the weighty issues of censorship and moral outrage (although these matters cannot, and will not, be ignored) and these are the things I've concentrated on the most. The fact is, I still feel as excited about horror comics as I did when, at such a tender age, I discovered my first issue of CREEPY! Therefore, this book has primarily been written as an *enthused appreciation* of horror comics. It is arranged chronologically like a history of the subject, but it is not *the* history of the subject. I doubt any such feat of objectivity could be mastered by any real, true enthusiast such as myself — one who has been trapped in the horror comics' dark nether world, a parallel existence, since the age of eight!

INTO THE ABYSS...!

AFTER THE FIRST tentative forays into horror, the trickle which led to the establishment of the EC's as genre-leaders soon swelled into a flood. In 1950 several more publishers made the leap to horror titles, including major players like Atlas and DC (for listings of all precode horror publishers see Appendix I). By 1952, a further 16 publishers had jumped in with both feet, wallowing in the blood and gore. This meant that by 1953, the news-stands were swamped with literally *hundreds* of horror comics per month, all pandering to the increasing demand of their readership for greater and greater excesses. There is no doubt that a spirit of healthy competition developed between the publishers as they headed for greater and greater gross-outs. In retrospect it seems inevitable that there would be a 'public outcry', the result being the formation of a censoring body in 1954 known as the Comics Code Authority (whose regulatory guidelines can be found in Appendix II). Under the Code, comics were required to undertake a prepublication review to ascertain whether they met with 'approval'.

'The Choir-Master' on song in Harvey's CHAMBER OF CHILLS #21.

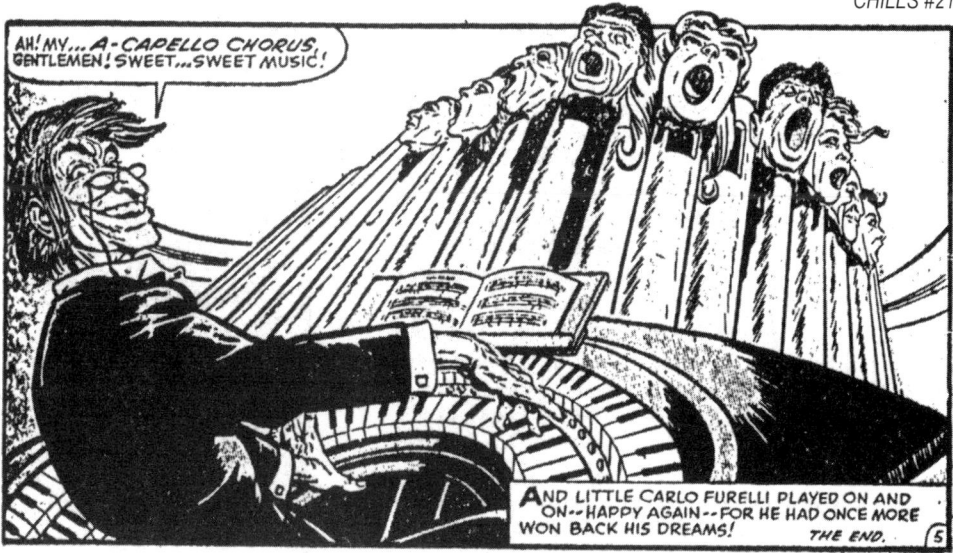

GHASTLY TERROR!

Better to have holes in your head than no head at all! 'Hollow Horror', FANTASTIC FEARS #6.

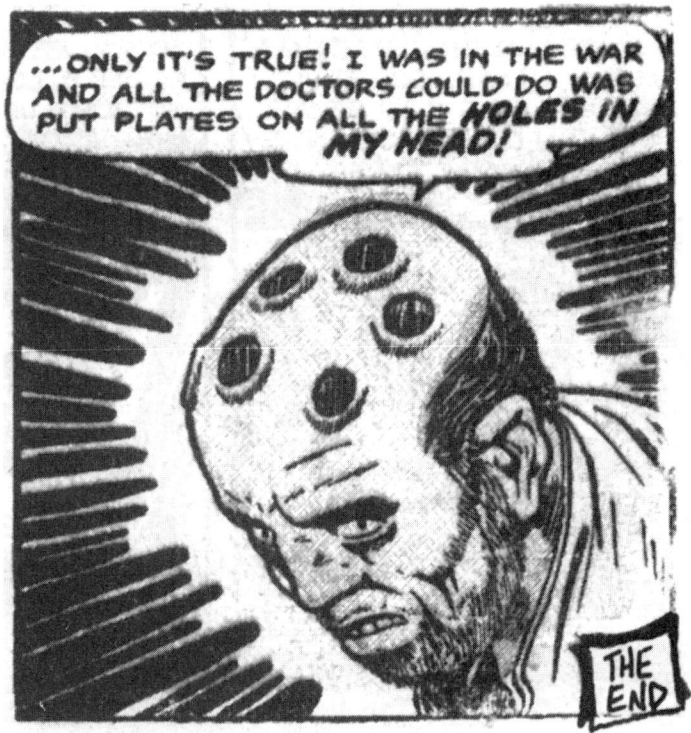

What the furore was all about will be detailed in this chapter, together with a fairly exhaustive trawl through the precode horror comics themselves, detailing their major themes and their bizarre, often perverse, obsessions. What we will find is nothing less than an incredible array of primal fears; a plunge into the abyss of social and cultural insecurity, and a deep mistrust of one's fellow-man — but more than this, a ghoulish fixation on vengeance, guilt and punishment. The punishment of vanity, greed, gluttony and arrogance, all in the pages of comics aimed ostensibly at children and youths!

Major themes of the precode horror comic are decapitation, or dismemberment, or disfigurement of some kind, such as the destruction of the face by acid, or the poking out of eyes. Horror comics really had a field day with these subjects, and some examples of the gory fun and games I'll furnish really are *'not for the squeamish'*... You have been warned!

'**The Choir-Master**' in Harvey's CHAMBER OF CHILLS #21 (Jan 54), tells the tale of a frustrated musician, whose continual disappointments in his chosen field lead to a par-

INTO THE ABYSS...!

ticularly unhealthy idea... One night he decides to lop the heads off all his decryers, fitting them to the top of his pipe-organ! At the end of the story, we find this now very happy individual playing his organ in rapturous self-absorption, the severed heads arranged to play 'a-capello' [sic] in the bizarre imitation of a choir... Illustrated by regular Harvey contributor Bob Powell, this is an effective black comedy with a satisfying shock ending.

Much stranger is '**Hollow Horror**' which appears in Ajax-Farrell's FANTASTIC FEARS #6 (Mar 54) — a queasy little tale in which a slow-witted factory worker named Swilbur decapitates a pretty office secretary with the office guillotine after being continually teased that he has 'holes in his head'. Amazingly, this turns out to be the literal truth! As his cap is lifted we see several large holes in his skull covered by metal plates: 'It was all the doctors could do for me after the war!' explains Swilbur...

Capitalising on the fear of, and animosity towards, the mentally ill — and the punishment of vain, flirty women — this little opus hides a seething pit of repressed sexual sadism under its cap...

Another story which details the shocking revenge of the down-trodden is EC's famous '**Blind Alleys**', in TALES FROM THE CRYPT #46 (Mar 55). Here we witness the elaborate punishment of the sadistic governor of a home for the blind, who starves and freezes his hapless charges in a reign of terror, while pampering himself and his dog. Finally, the blind men can take no more. They capture the dog and let it starve for days. Then they create a maze lined with razor blades through which the governor is forced to run, chased by his starved, and now ferocious dog. When they turn off the lights, we hear terrible yells of pain and the sound of shredding flesh as the governor blunders terrified into the razor-lined walls... This is a particularly uncomfortable story, cruel in the extreme. The reader still has to feel sorry for the governor as he gets sliced to pieces, despite his despicable indulgences.

In the same issue of CRYPT we also see the Joe Orlando–illustrated

Three sadder, wiser monkeys in 'Henpecked', MISTER MYSTERY #17.

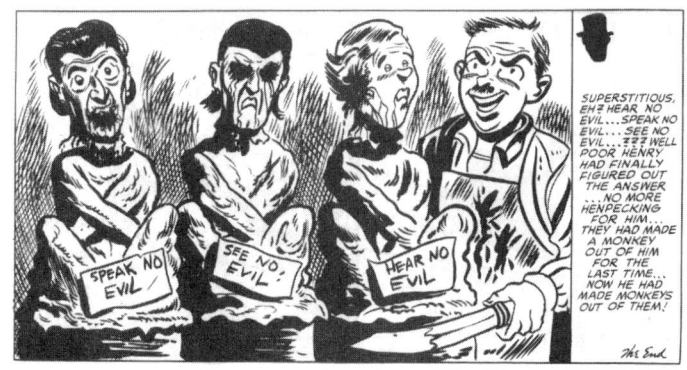

GHASTLY TERROR!

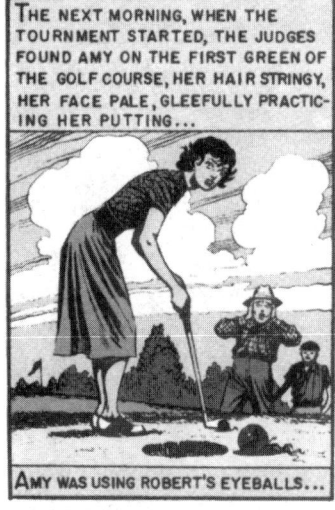
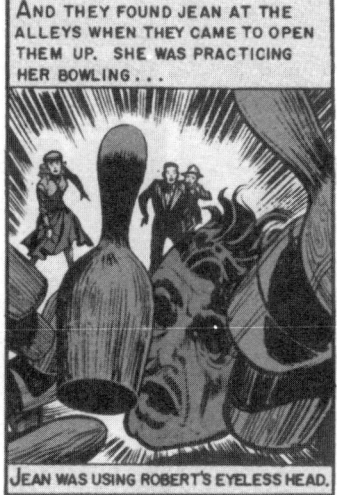

above Bad luck old sport! Bigomist Bob Smith gets what's coming to him in 'How Green Was My Valley', TALES FROM THE CRYPT #36.

below Drunk and dismemberly! The wife can take no more in 'Bottoms Up', MYSTERIOUS ADVENTURES #18.

'**Success Story**', in which a downtrodden youth is badgered by everyone around him to 'get ahead'. He responds in typical precode horror fashion by decapitating his nagging relatives, therefore 'getting three-heads'! No, it's not a great pun, is it? But the final panel, in which the three severed heads appear on a silver platter on the family dining table, is grisly enough to make up for it...

Nagging relatives are also the subject of familial vengeance in '**Henpecked**', which appears in Gillmor's MISTER MYSTERY #17 (Jun 54). An irate husband, constantly harangued by his domineering wife, her interfering sister and their overbearing mother, finally — like Popeye — can 'stands no more!' and makes a suitably dramatic statement in the mutilation and dismemberment which follows: the women are made to resemble the famous 'three wise monkeys' — See No Evil (one corpse has no eyes), Hear No Evil (one has no ears), and Speak No Evil (one has no tongue). A theme repeated in horror comics, this states a few impolite home truths about that great American institution, the family, and domesticity in general — home truths which incensed the sort of stuffy females who comprised the membership of many of the 'pressure groups' which were against comics... Incidentally, the cover of MISTER MYSTERY #17 has a great decapitation scene where a young woman is about to receive the chop and have her bonce added to those making up a totem pole of severed heads!

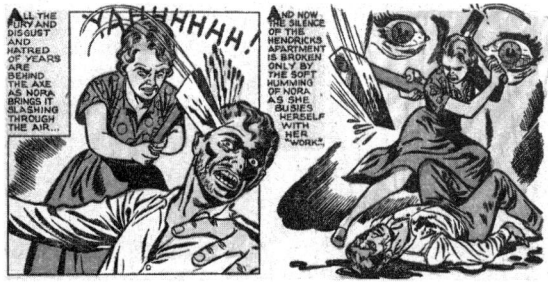

In EC's THE HAUNT OF FEAR #17 (Jan 53), the roles of the protagonists are reversed in '**The Garden Party**': a slobbish and insensitive husband destroys the pride and joy of his wife's life — her garden, to which she's completely

14

devoted, and which becomes utterly ruined when her husband invites the neighbours round for a barbecue party. Flowers are trodden down, plants squashed, bushes flattened — the garden is completely totalled. When all the guests have departed, the slob self-satisfactorily comments, 'Gardens are for barbecues!', whereupon the now hopelessly deranged wife turns on him. In the final scene we see that she's butchered him and that choice items are now being barbecued, while she vacantly intones, 'Heh… Heh… Gardens are for barbecues…!'

Tales with very similar themes abound in the precode horrors, where domestic violence turns to the extremes of cannibalism and dismemberment. In **'Chef's Delight'** (Story's MYSTERIOUS ADVENTURES #20, Oct 53), a wife butchers and cooks her picky husband — chef-supreme Francois — when she can take no more of his irritating perfectionism. The last panel shows the results of her macabre recipes sizzling away on hot plates: 'Francois' Famous Stuffed Heart… Francois' Famous Baked Kidneys… Francois' Famous Fried Brains.' Here the theme of dismemberment and the horror comics' obsession with food, gluttony and butchery are combined to nauseating effect. More on this particular brand of home cookery story-telling later…

'How Green was my Alley' in TALES FROM THE CRYPT #36 (Jun 53), tells the story of travelling

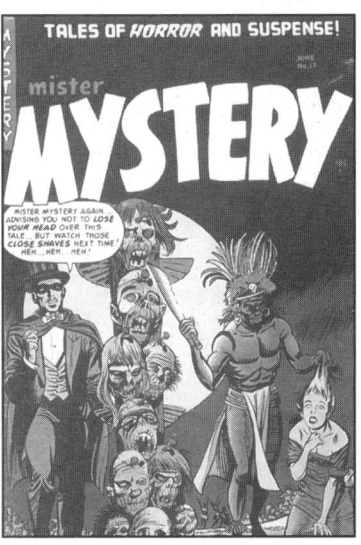

below Heh… heh… heh! indeed. Cover MISTER MYSTERY #17.

bottom left Not quite brain-dead. 'The Trophy', TALES FROM THE CRYPT #25.

bottom right Spelling it all out. Cover: WEIRD TERROR #6.

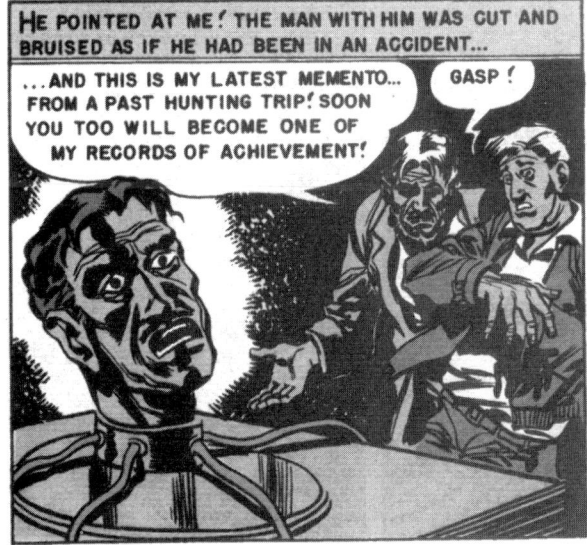

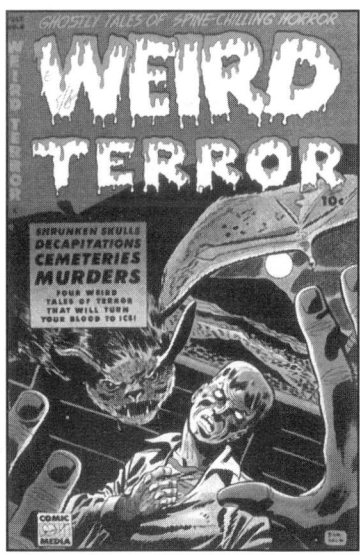

GHASTLY TERROR!

AN EXCRUCIATING PAIN WHIPPED THROUGH JOHNSTONE'S RIGHT ARM! THE HAND... THE DEAD HAND...

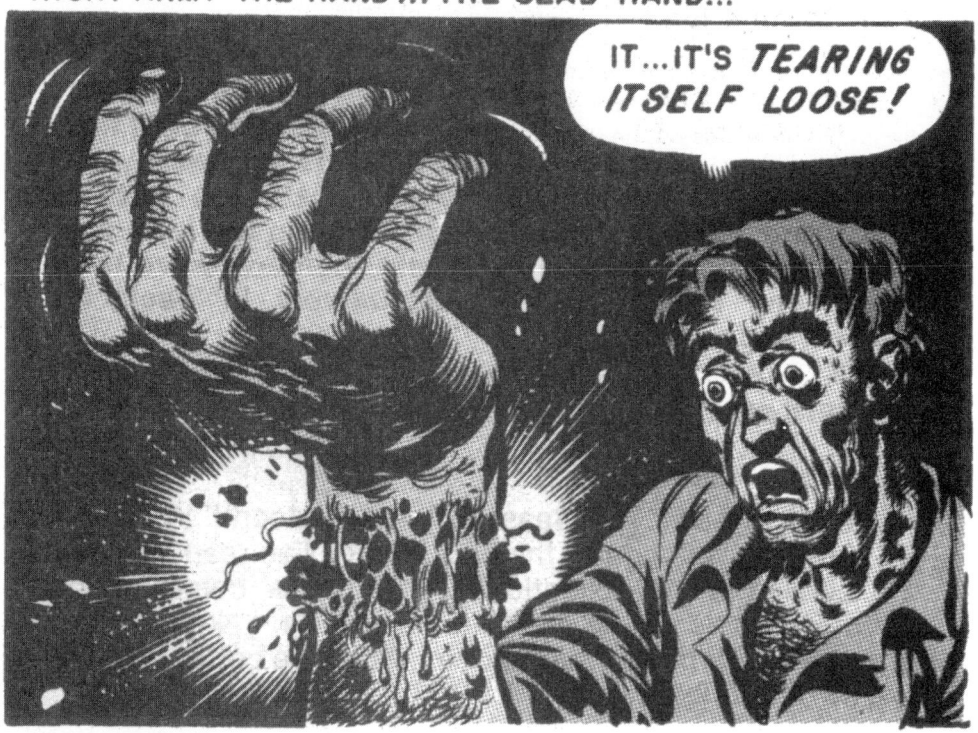

IT...IT'S *TEARING ITSELF LOOSE!*

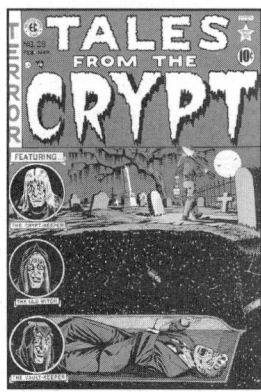

top EC nearly keeps us in stitches in 'Lend Me a Hand', VAULT OF HORROR #18.

above Cover: TALES FROM THE CRYPT #28.

salesman Robert; a bigamist, whose two sporty wives — one a golfer and one a bowler — finally get to meet each other when they are forced to share a room in a hotel catering for the sports tournaments in which they're involved (both are registered under the name of Mrs Robert Smith, you see...). When they begin to exchange stories and finally photographs of Bob, the evidence is irrefutable — they're married to the same man! (These chicks catch on quick, eh?...) So —

The next morning, when the tournament started, the judges found Amy on the first green of the golf course... practising her putting... using Robert's eyeballs... And they found Jean at the alleys... using Robert's eyeless head.

This is a genuinely amusing black comedy; it's difficult to understand how material like this — presented in such a jaunty, tongue-in-cheek fashion — could be deemed offensive.

INTO THE ABYSS...!

A far more disturbing example appears in EC's THE VAULT OF HORROR #30 (Apr 53): '**Split Personality**' is Johnny Craig's story of self-centred cad Ed King who becomes involved with Amy and Susan, two reclusive, inseparable identical twins, who are loaded with money (of course!). Ed pretends to be twins himself in order to marry both of them and get his hands on the loot. But (as usual) this sort of demanding role proves to be too much for him, and the twins find out his secret... 'The Shame! The Shame! It's so horrible... Sob! ... He took such foul advantage of us! He must pay! ...Heh, hee, hee!' The deranged Amy and Susan take an axe and split Ed right down the middle, taking half each.

Yet more nifty axe-work takes place in '**Bottoms Up**', appearing in MYSTERIOUS ADVENTURES #18 (Feb 54). This disturbing tale, set in prohibition days, tells the story of Lou, the drunken barman of a speakeasy, who, after losing the only job he's fit for, turns to alcoholism; and Amy, his long-suffering wife, who works at two jobs to support her drunken husband and their little son, Bobby. Suffering in silence as Lou spends the rent money on booze, Amy finally snaps when little Bobby gets knocked down and killed by a car on the way to his first day at school. 'Why didn't you take Bobby to school, Lou?' Amy mutters quietly... 'Aw, he's okay honey! He didn't need me! The kid's old enough to go to school by himself! My bootlegger phoned! He just got in a shipment of...' But Amy isn't listening anymore. She takes an axe, and in a scene which spares no graphic

Head of the Nazi scientists! 'The Brain', ADVENTURES INTO TERROR #4.

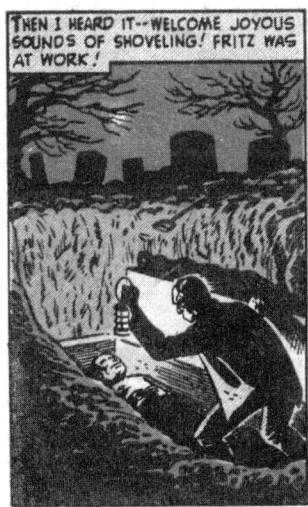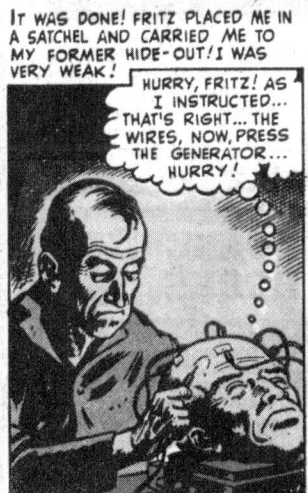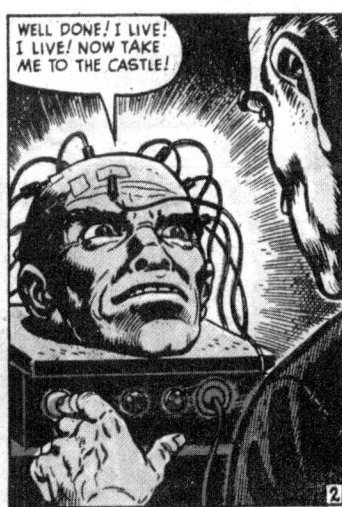

17

GHASTLY TERROR!

detail, hacks Lou to pieces, returning the case of rye to the bootlegger, each bottle now containing a piece of Lou... an ear, an eye... a finger or two... '**Bedtime Gory**' (HAUNT OF FEAR #18, Mar 53) features another downtrodden wife, Lorna, who 'takes it and takes it' until she finally snaps (why *do* these horror comic women put up with things for so long?). Having suffered cruelty at the hands of her ambitious husband, Milton, the snapping point finally comes when she discovers that the low-down schemer only married her because she was the boss' daughter — not only that, in order to become the 'big man', he bumped her father off too. So, Lorna buys Milton a new four-poster bed! Eh? But, there's a method in her madness, as the bed (unsurprisingly) turns out to be something much more useful — a torture rack! 'Milton felt his arms pulled... his legs drawn... And then Milton felt the tendons tearing, the muscles snapping, the veins and arteries bursting... as Lorna turned the crank...' Meanwhile Lorna is gleefully tittering: 'You're going to be a *big man*, Milton! Big man... eh... eh..!'

On an even more obviously satirical note is '**Decapitation**', appearing in Comic Media's WEIRD TERROR #6 (Jul 53), the bizarre story of one Homer Bobble, a hard-working, mousy little man whose fat, slobbish wife, Roberta, does nothing but watch game shows and stuff chocolates into her mouth all day (there's that thing about gluttony again). Right on cue, Homer snaps and kills fat Roberta, burying her body in the back garden during a lightning storm. Some days after, a letter is delivered saying how Mrs. Bobble has won a ticket to go on one of her beloved TV game shows. Homer decides to take her place and finds himself doing surprisingly well: 'You're right sir!'

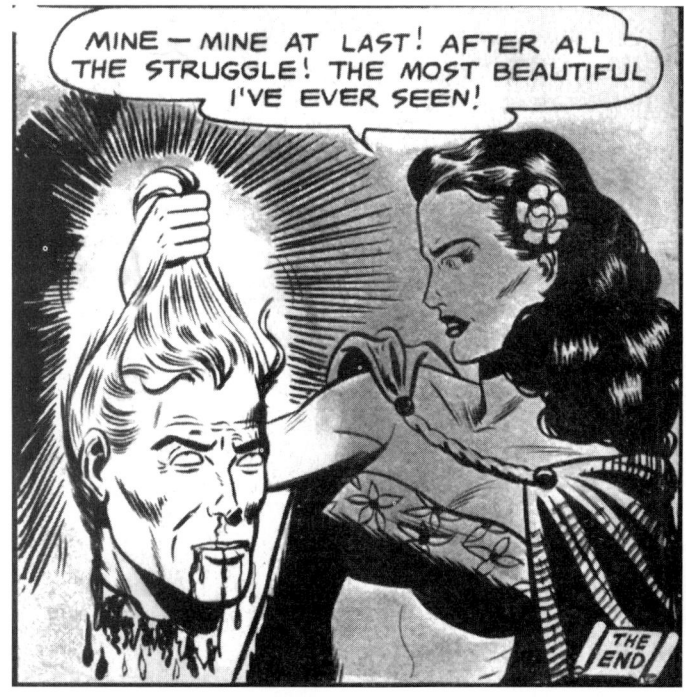

Jungle gal gets some head in 'Killer Lady', VOODOO #6.

INTO THE ABYSS...!

Out of his tiny head. 'The Tiny Heads', THE CLUTCHING HAND #1.

barks the compere as Homer answers another question correctly, 'give that man a box of crunchy-munchies and — now your jackpot question!' Hooray! Homer answers that one too, but everything goes to pot when the jackpot prize is revealed: 'The beautiful bloody head of your charming wife! Isn't she pretty?' 'S-say! What is this?' enquires Homer... Yes this is Hell and the compere is Satan himself — Homer is really dead, having been struck by lightning during the storm way back on the night he buried his wife... An unusual story, to say the least, but this is actually nowhere near the strangest decapitation/dismemberment story the precode horrors had to offer. That dubious accolade probably falls on **'The Hunter and the Hunted'** in MYSTERIOUS ADVENTURES #15 (Aug 53), in which a ruthless hunter, Roger Cranby, who has every single animal head under the sun in his trophy room, learns of the existence of surviving dinosaurs in the 'deepest jungles of the Amazon'. Determined to complete his collection, how can he be prepared for the fact that these dinosaurs walk and talk like humans...? In fact, they even have their own bowling alley (!): 'Yes, Roger Cranby....' (How do they know his name?) 'We monsters must sustain our way of life too... Hunting is your favourite sport... But we also have a favourite sport! We call it bowling!' And what do they use for bowls? Yes, human heads! The last panel shows Cranby's severed head knocking down the ten-pins to the cry of 'STRIKE!' This utterly, staggeringly weird story is illustrated by the redoubtable Doug Wildey.

Ghastly Terror!

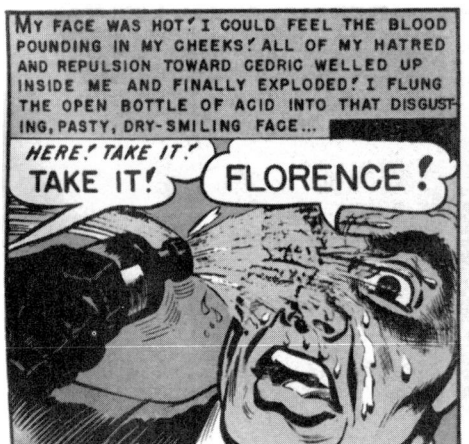
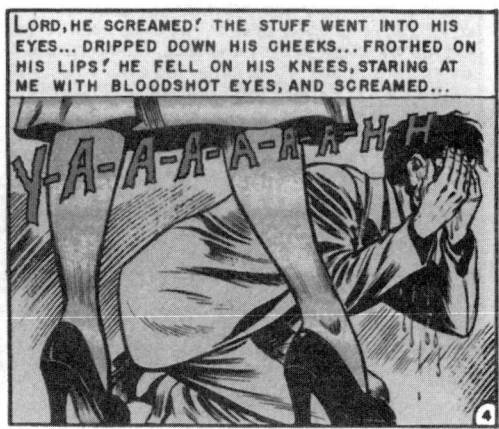

*Right in your face. EC's 'The Acid Test' (**above**) and 'Well-Cooked Hams' (**next page**).*

The 'sport' of hunting takes another drubbing in TALES FROM THE CRYPT #25 (Aug 51): '**The Trophy.**' This time the ruthless hunter is trapped by a maniac who hunts humans, and — in an added twist — keeps their severed heads alive by some scientific process involving a lot of metal boxes and tubes! Artist Jack Davis renders this creepy, back woods setting in his usual inimitable style.

Mad scientists abound in precode dismemberment stories, keeping heads, hands, and various other body parts alive in their home-made laboratories. Two perfect examples of this sub-genre appear in VAULT OF HORROR #18 (Apr 51), '**Lend Me a Hand**', and HAUNT OF FEAR #16 (Nov 52), '**Nobody There.**' The first of these concerns a brilliant surgeon, Dr Harold Johnstone, who loses his right hand in a car crash. Is he bitter and does he become unhinged? You bet! Killing a drunken tramp, he grafts on the amputated hand, but the hand has a life of its own, dragging Johnstone to the tramp's grave, where it finally tears itself away from his arm (illustrated in stitch-shredding close-up by Jack Davis) and launches itself at his throat! '**Nobody There**' tells the story of a man whose head is kept alive until a new body can be found for it — a process which must occur every 10 years. The sickened and understandably agitated Dr Mondrum, who is blackmailed into performing this little-known miracle of science by long-time 'pal' Alan, finally feels enough is enough... He punctures the 'tubing' keeping the head alive, 'and the head of Alan... whose body had died 33 years before... finally joined it...'

These scientifically dubious stories of sickly fun are only outdone by '**The Brain**' which appears in Atlas' ADVEN-

INTO THE ABYSS...!

TURES INTO TERROR #4 (Jun 51). Nazi scientist and condemned war criminal Otto von Schmittsder instructs his servant Fritz on how to preserve his life after he has been hung. Severing the dead Nazi's head from the corpse, Fritz takes it to a machine and brings it back to life in the good doctor's gloomy castle, which is later visited by sight-seeing American GIs. One of these, Larry, falls under von Schmittsder's spell, performing nefarious deeds under his instructions until a concerned pal arrives to find out what Larry's up to... 'Don't tell him!' demands The Brain, 'conquest! World conquest! Remember that! Kill him!' The strain on Larry takes its toll, and to save his buddy from certain death he hurls himself down the castle steps. At the end of the story, the evil head of von Schmittsder addresses the reader: 'I'll find another body! Who knows? My next choice may be you!' A chilling prophecy which came true in a sequel (ADVENTURES INTO TERROR #6, Oct 51) in which The Brain finally got his just desserts.

The more exotic setting of the jungle paid host to many horror stories on the theme of decapitation and headhunting. One such story, '**Killer Lady**', appears in Ajax-Farrell's VOODOO #6 (Feb 53). With its suggestion that 'the vain die young', this is the tale of handsome, golden-haired newshound Tim Mackay who is assigned to interview the reclusive, beautiful Princess Oona. Upon first sight Oona favours Tim over all the other newsmen clamouring to meet her: 'such lovely hair you have,' she croons, 'I like that in men!' 'I knew it! The locks get them every time!', smirks the self-satisfied Mackay. Finally, it's decided: 'You must come back to my country with me! Be my king!' 'Sounds swell, baby! I might make a good king!' After the sea voyage, there's a long trek through the jungle towards Oona's kingdom, during which the brave and protective Princess saves Tim from various assaults by wild creatures. When a huge

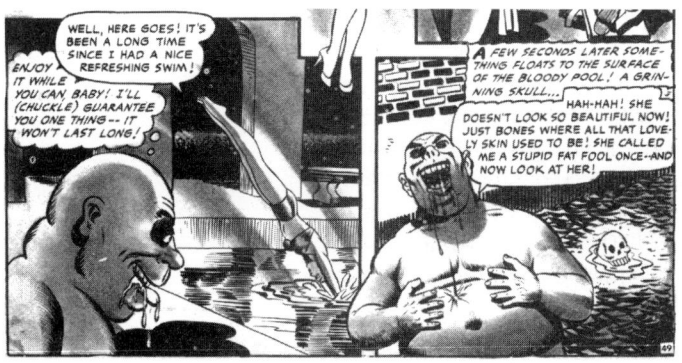

above What a dive! 'The Murder Pool' and its charming attendant, from STRANGE FANTASY #13.

below Mother knows best in 'The Way To a Man's Heart', WEIRD MYSTERIES #7.

bat gets tangled up in Tim's hair, Oona attacks frenziedly... 'Oona! All of a sudden you look so fierce — that b-bloody knife!' — 'Why Darling, I only did it for you!... Now come and let me stroke your beautiful hair!' When they arrive at Oona's royal village, Tim is dressed in ceremonial robes by attendants and then told: 'You must come with us!' Brought before the Princess on her throne, Tim begins to whine: 'Oona! Make them leave me alone!... You promised not to let anything happen to me — w-why are you looking at me that way — so f-funny!' Wielding a huge knife Oona leaps at Tim: 'Of course I cherished you, fool! I did everything for that lovely head of yours! My tribe are headsmen!' The final scene depicts the gorgeous princess holding Tim's gory, severed head aloft: 'mine at last! After all the struggle! The most beautiful I've ever seen!' The undercurrent of sexual fetishism and the portrayal of Oona as a strong, protective woman, capable and sexually aggressive, was just the sort of story ingredient that particularly shocked the sensibilities of conservative Fifties America, and something about which Dr Fredric Wertham specifically complained in his vituperative essays (see next chapter). The incidental severed head only made matters that much worse.

A story on a similar theme, but bereft of the latter's sexual subtext, is '**Dead Wait**', which appears in THE VAULT OF HORROR #23 (Feb 52)... Murderer and thief, Buckley,

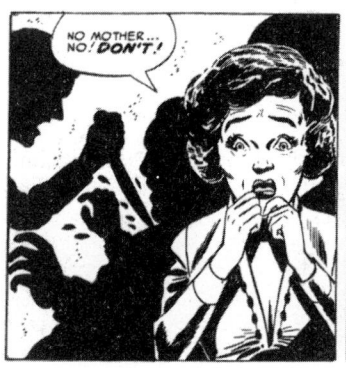 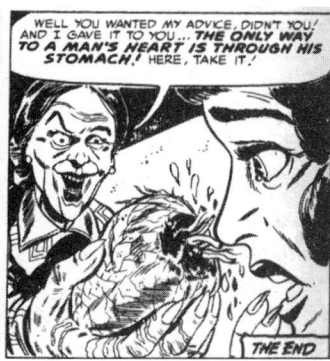

wants to get his hands on plantation owner Duval's invaluable black pearl. The red-headed scoundrel does all in his power, spending years trying to wheedle his way into Duval's confidence, but to no avail! Finally he realises he must kill Duval and then leave the plantation un-

dercover of darkness. He enlists the help of friendly and protective native Kulu, who offers to ferry the unsuspecting Buckley away in his canoe. The native drums begin to beat, getting louder and louder as the canoe gets nearer to them. At last Buckley cottons on: 'Kulu? Where are you taking me?' The gleaming, steel blade is Buckley's answer. When the canoe lands: *'The grinning natives gathered around... the head with the red hair...'* 'Three years I wait and now, it is mine!' triumphs Kulu. 'There is no head in all the Soelas like this one!'

Shrunken heads were something of a pop obsession in the Fifties, plastic replicas dangling by the side of fuzzy dice from many a car's rear-view mirror. Despite more than a dozen books having been written detailing how the Jivaro Indians of the Amazon make these gruesome trophies (five of which were published from 1952–1954), the general public still seemed to be in the dark as to how they were made — and the precode horrors did nothing to add to their education. The following three stories are progressively loopy testaments to this fact:

'Diminishing Returns', which features in THE HAUNT OF FEAR #8 (Jul 51), illustrated by artist 'unknown',* it tells the story of 'world famous explorer' and all-round professional scoundrel, Vincent Beardsley, who has a deal with the Jivaros that in exchange for their lovely diamonds he will supply them with heads to shrink! This is how various financiers of Beardsley's expedition have met their fate, and it is also the fate in store for wealthy man-about-town, Clark Hagen: 'why you dirty double-crossing... I'll get you for this, Beardsley! I'll get you!' Chop! Back in New York, the smug explorer is slobbering over his diamonds when a parcel is delivered containing — 'oh, my God! It's a Shrunken Head! Hagen's head!' Not amused by this 'morbid joke', Beardsley is totally amazed when the head opens its eyes, gnashes its teeth and begins to roll after him! Later... 'His neck has been torn and slashed as if he'd been attacked by a small ferocious animal!... Look at this!... A Shrunken Head... Look at the mouth! There's blood all over it... Fresh blood!'

'The Tiny Heads' (imaginative title, that!) appears in ACG's surprisingly gruesome one-shot THE CLUTCHING HAND (Jul 54). McGuire, another charm school graduate, trades in 'Jovali' shrunken heads, but when Maloka, the Jovali witch doctor refuses to trade anymore, the entrepreneur kills him and steals the latest batch instead. However Maloka's ghost brings the heads to life, and they begin to

*A rare occurrence in the case of the ECs, where artists' work was recognised and duly credited 99% of the time. Such was not the case in the majority of other precode publishers, however.

GHASTLY TERROR!

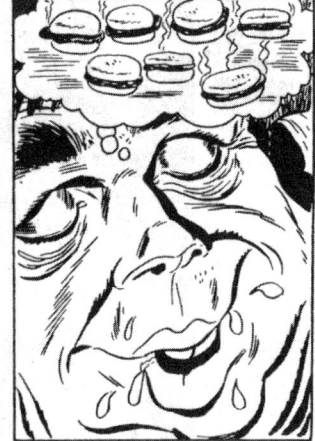
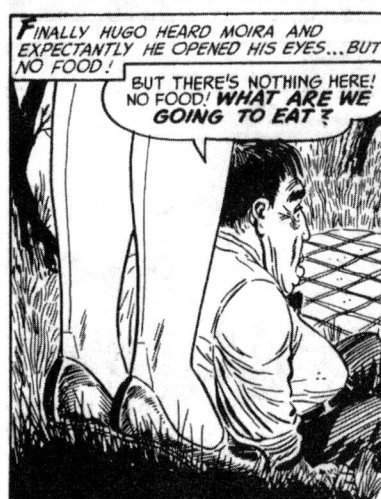
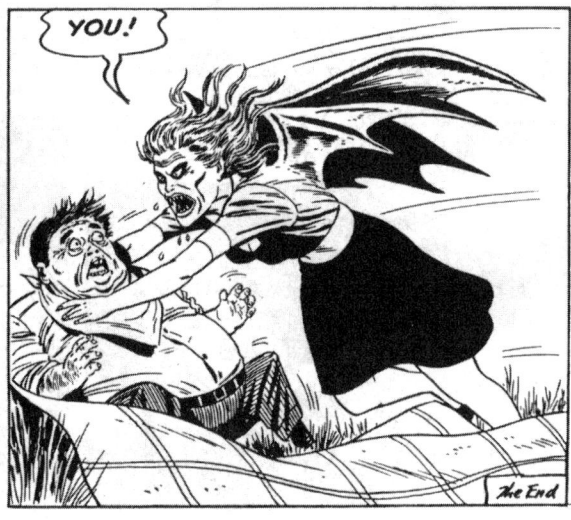

Life is no picnic for Hugo. 'The Picnic', MISTER MYSTERY #13.

bounce like tennis balls onto McGuire's bed while he's sleeping! Pursuing him in this fashion, and then growing ghostly little bodies to chase him down, the tiny heads herd McGuire to Maloka's waiting machete... Swish! AAGH! The next morning McGuire's assistant finds a bag outside the door of his state-of-the-art hut containing the tiny heads... 'Say, that last head... it's sorta... it looks like... Oh my heavens, n-no!' Yes! It's McGuire's head, shrunken, stitched and decorated in the authentic style...

Charlton's THE THING! #6 (Dec 52) tells the ludicrous tale '**Jibaro Madness**' [sic] in which the 'true process' of head-shrinking is revealed to one gin-swilling Prof Wayne

INTO THE ABYSS...!

by native turn-coat Maximo, who proceeds to poison Wayne's party with the 'shrinking drug', due to which they all end up being nine inches tall! Yep, that's how it's done according to THE THING! — the whole body is shrunken before the head is lopped-off. Before it gets to this unhappy stage Prof Wayne's diminutive party takes off, only to be eventually devoured by hungry tarantulas! Now you know what I meant when I said these shrunken-head stories get progressively loopier.

Back to the theme of dismemberment and disfigurement in general, another particular disturbing precode horror sub-genre investigates the effects of sulphuric acid on the human face! The results of this worthy field of research are demonstrated in numerous horror comic stories, a few examples of which go as follows...

In '**The Acid Test**' (HAUNT OF FEAR #11, Jan 52), Florence Blair is sick and tired of her doting, spineless husband, Cedric, who mollycoddles her and doesn't let her lift a finger around the house. One day when old Cedric gets in from work to find her cleaning the bathroom, Florence sees red and throws the acid she's using into Cedric's face. Even after her arrest for the deed, Florence finds the bandaged and suffering Cedric ready to forgive her. In court he pleads, 'I love this woman and she loves me! Let her go!' Despite the crocodile tears Florence shows for the court, she's less than pleased to go back to Cedric. However, he seems to have changed his demeanour to suit his looks. Revealing his hideous, corpse-like face, Cedric also reveals his true plan:

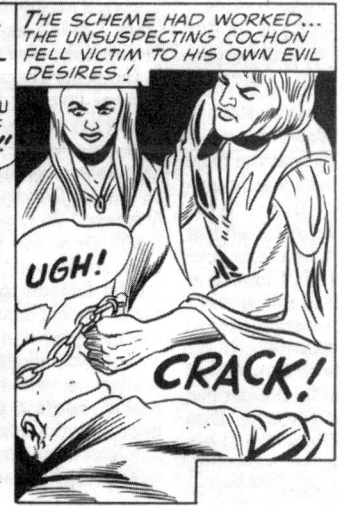

left Fat pig becomes long pig in 'Hunger', MISTER MYSTERY #16.

right Growing up in the depression gave you plenty to bellyache about! Cover: DARK MYSTERIES #18.

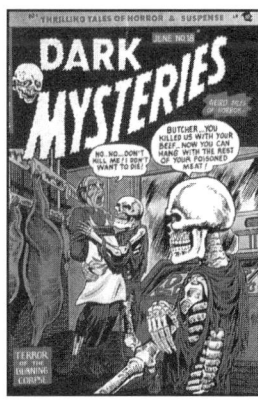

'Do you know why I pleaded for you...? I didn't want them to put you in jail! Then I couldn't have my revenge! It'll be nice here, Florence! Just the two of us together! Just like it was before...' He throws acid into her face as Florence narrates

> Searing pokers knifed into my eyes! Cedric's face came at me... his sightless eyes smiling! His blistered lips closed on mine as I passed out screaming...

This is probably the most brutally horrible story of all the precode horror comics, revelling gleefully in all the terrible shock and nauseating pain of such a dire experience. Strong stuff indeed, and not much fun either, to be truthful — despite EC's claim that all this was meant to be tongue-in-cheek...

Another story with the same title — **'Acid Test'** — appeared around the same time, in Atlas' MENACE #4 (Jun 53). Here a man's face is stripped down to the skull by acid, and only when he is finally convinced that all this is the product of a nightmare does he collapse dead!

'Well Cooked Hams' (TALES FROM THE CRYPT #27, Dec 51) is a tale about the horrific *Grand Guignol* theatre, a real-life horror/special-effects show from turn-of-the-century Paris, in which 'boiling' water and fake acid were thrown, and actors engaged in mock dismemberments and other mutilations. Of course, at the end of this tale, all the fake props are replaced by genuine counterparts, and the shocked audience witnesses real faces being burned away by real acid; I bet they never went back after that!

A variation on the acid theme occurs in Ajax-Farrell's STRANGE FANTASY #13 (Aug 54). In the story entitled **'The Murder Pool'**, deranged film producer James Gorse — an obese, bald dude who doesn't seem to be able to stop slavering and drooling — has a new pool built which he fills full of 'Acid solvent! Very powerful acid, indeed!' Phoning the sultry Gwen to come over for a swim on the promise of of a screen test, Gorse chortles ghoulishly as she dives in, only to be immediately reduced to a gleaming, white skeleton! Next in line to get bumped off is Fred, who cheated Gorse on the stock market (these Hollywood types!). Finally, the ex-wife gets a call, but this time the tables are turned. Having only three months to live she's decided to kill Gorse, consequences be damned... She shoots Gorse, who falls into the murder pool, the sight of which brings on

INTO THE ABYSS...!

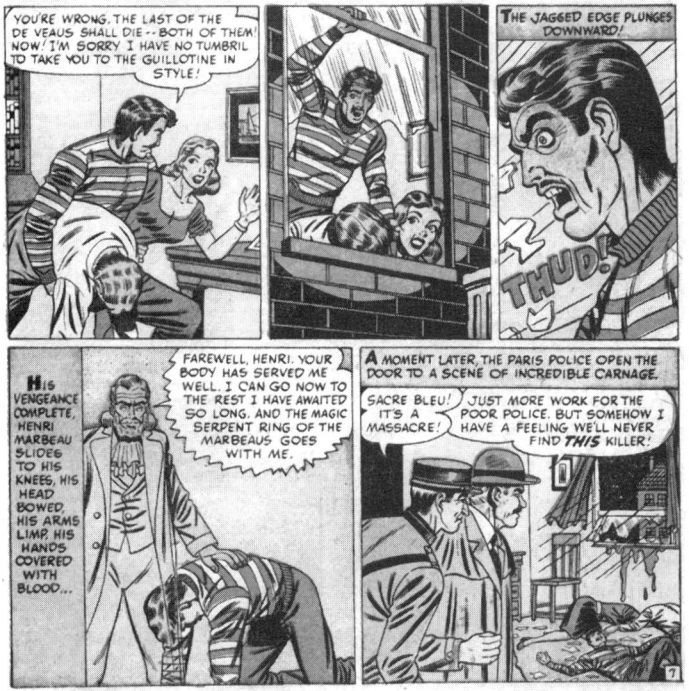

left *How to make a home-made guillotine, courtesy 'Blood Revenge' in* WEIRD ADVENTURES *#3.*

right *No escape from the cover of* ADVENTURES INTO TERROR *#10.*

his spouse's illness prematurely and she promptly falls in too! *'The Skulls, moved by the gentle urging of the wavelets, move closer together until they come to rest in each others arms! Lovers in death as, once they were in life!'* This is an excellent tale, imaginative and atmospheric — and the sleazy, perpetually slavering Gorse makes for a suitably repulsive villain...

Another offbeat story which incorporates the 'acid theme' is '**Devil Flower**' in VOODOO #7 (Mar 53). Shipwrecked Winston Creig discovers a gigantic Venus Flytrap-like plant on an uncharted tropical island. When he gets back to civilisation he keeps a specimen in his apartment, to which he feeds human beings (of course, what a great idea!). When enough people go missing to put the careless Creig under suspicion, he falls victim to the voracious plant himself.* As the police cut the plant open they discover 'a human graveyard' of partially digested bones which the devil-plant's acid was in the process of digesting. 'This is going to be one report that won't be easy to write up!' concludes a very much on-the-ball investigating officer.

The exotic theme of the above story, with its tropical setting, is common to most precode horror comics, and it's

*Could Roger Corman have read this, one wonders, prior to making *The Little Shop of Horrors*?

GHASTLY TERROR!

a theme we'll be returning to later for a closer examination.

In the meantime, let's progress with the grisly theme of dismemberment, rounding up a few stories dealing with food and gluttony, as promised earlier...

Gillmor's WEIRD MYSTERIES #7 (Oct 53) offers us '**The Way to a Man's Heart**' — one of the stories lambasted in Wertham's book, *Seduction of the Innocent* — which tells the sad tale of Diane, an attractive young housewife 'with plenty to offer' ('Indeed!' quoth a disgusted Wertham of the panel which shows her in just her bikini!), but whose husband, Frank, is only interested in food. When they go to a restaurant and a man 'makes a pass' at Diane in front of the disinterested Frank, she decides it's time to phone mother up. The advice is that if Diane wants to keep her man, she'll have to learn to cook herself. Mother and daughter prepare

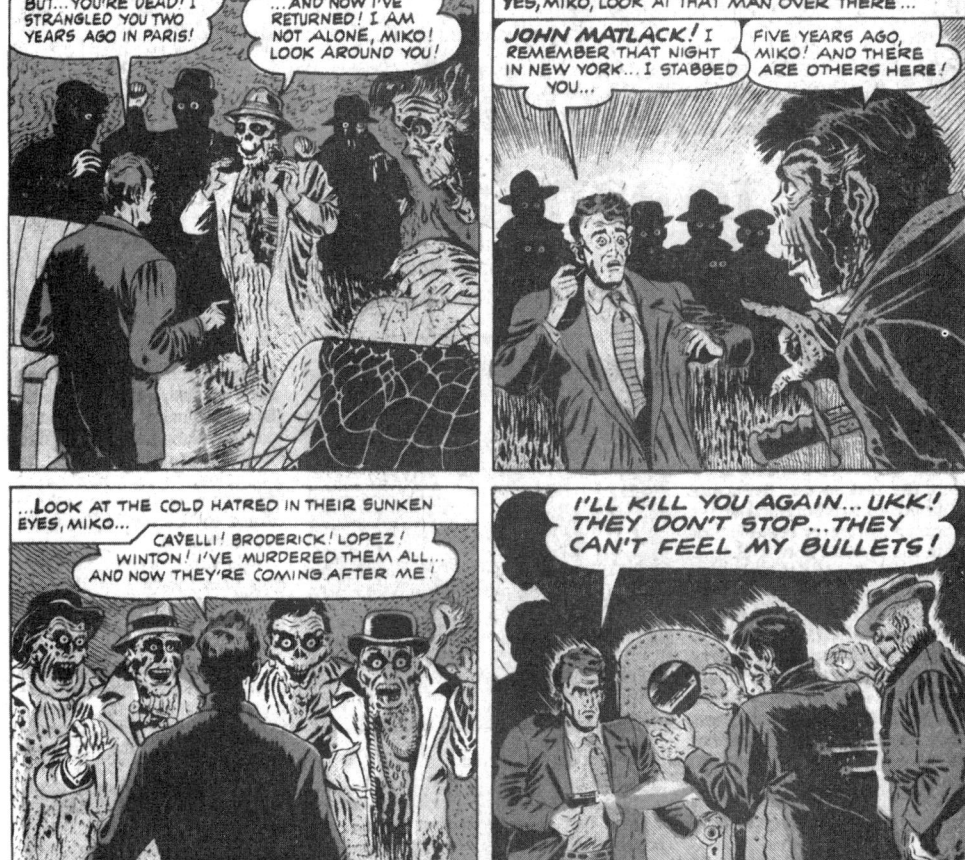

The dead make it Hell for killer Miko, in 'The Storm', STRANGE TALES #8.

INTO THE ABYSS...!

a sumptuous meal for the delighted Frank, but on finishing it he declares, 'I've tasted better, but it was alright!' This faint praise proves to be too much for the house-proud mother who reaches for a long, shiny carving knife... 'No, mother! No! Don't!' Brandishing Frank's still pulsating heart towards Diane, the deranged old woman cackles, 'Well you wanted my advice didn't you?... and I gave it to you! The only way to a man's heart is through his stomach! Here, take it!'

'**Fed up!**' in HAUNT OF FEAR #13 (May 52) offers similar fare, but here the wife is professional sword-swallower Sandra, and the husband is the forever gorging and belching Alec, who spends all their money on food... food... food! Sandra's snapping-point comes when the cash she's put away for a rainy day goes missing. With a wicked gleam in her eye, she informs hubby that seeing as all the money has gone, he'll have to start earning some himself... 'I'm going to teach you to be a sword-swallower too!' When the sword is down in his gullet, Sandra quickly ties Alec's hands behind his back and announces: 'I'm leaving you! Be careful Alec! The least movement might send the sword blade through your chest! Don't even breathe hard. And above all... hah... try not to belch!'

The punishment of gluttons is a theme with which Fifties horror comics are obsessed. '**An Ample Sample**' in VAULT OF HORROR #32 (Aug 53) results in another horrific murder when Irwin throttles his selfish, chocolate-guzzling wife and chops her into little pieces to make his own special selection box: 'Lady Fingers... Tootsies... Neck-O-Lozenge... Forearm Fudge... Sour Bowels'... (Yuk! And double Yuk!)

Another fatty who gets what's coming to him is the fittingly named 'Cochon', a cruel dungeon-master who taunts his starving prisoners by eating sumptuous feasts in front of them. However, one day he gets too flashy and they grab him and — yes, I'm afraid so — eat him. Even so, Cochon has his final revenge, as the next morning the guards find all the prisoners dead... 'Poison, it would seem! Look at their bloated bellies...' but... 'Cochon! Where is Cochon?' It would appear he must have been too vile to stomach! This charming tale, aptly entitled '**Hunger**', appears in MISTER MYSTERY #16 (Apr 54). A few issues earlier (#13, Sept 53) the same title featured '**The Picnic**', in which another chronic overeater named Hugo gets what's coming to him in the guise of a pretty young girl who pampers him and courts him, all to his neighbour's astonishment. When she sug-

GHASTLY TERROR!

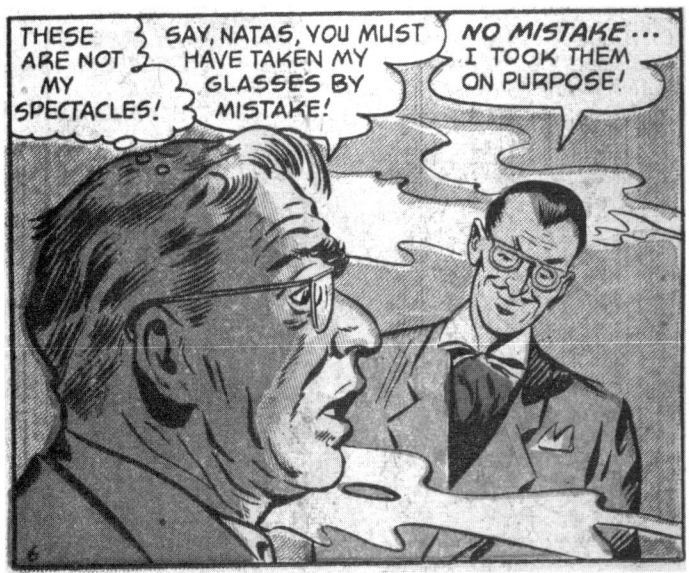

The devil is no optical illusion in the wonderfully titled 'Satan's Spectacles', WEB OF EVIL #4.

gests they go on a picnic, Hugo's delight turns to outrage at the sight of an empty chequered cloth... 'But there's nothing here! No food! What are we going to eat?' — 'You!' Yes, the pretty girl has sprouted leathery wings and sharp fangs and she launches herself at Hugo who she's been 'feeding up' for her own ghoulish feast.

'**The Garcon**' is a splendidly ludicrous tale which appears in WEIRD MYSTERIES #9 (Mar 54): A glamorous young couple-on-the-town enter a top-class restaurant and order their food, but as is the case with these jumped-up joints, the 'Garcon' cannot be rushed and the increasingly ravenous pair must wait... and wait... and wait... At last the waiter returns to their table to bring the first course, but — too late! The smiling couple are now completely satiated, having devoured parts of one another! Flesh is stripped away and ribs are exposed, but at least their stomachs are full! Ghoulish self-sacrifice is also the theme of VAULT OF HORROR #26's '**Two of a Kind**' (Aug 52) in which a loving couple who become stranded in a mountain shack make the ultimate sacrifice for one another... Neither suspects the other, but one is a vampire, who drinks her own blood in order to save her lover, and one is a ghoul, who amputates and devours his own limbs!

Children of the depression and WWII, the creators of these stories which peered deeply into the abyss of collective anxieties, showed that a conditioned, deep-seated concern about food was never very far from the surface — even in the midst of unprecedented economic stability which meant that starvation rations were a thing of the past. The insecurities the horror comics openly expressed suggested that these mean times could return soon enough — like a bad meal repeating itself...

This is evidenced no more succinctly than in the many stories about butchers selling tainted meat and poisoning

the local community. The cover of Story's DARK MYSTERIES #18 (Jun 54) even depicts a scene in which the dead have returned to hang a dishonest butcher on his own meat hook: 'Butcher... you killed us with your tainted beef... now you can hang with the rest of your poisoned meat!' This is also the refrain of **'T'aint the meat, it's the Humanity'** — another one of EC's awful punning titles — which appears in TALES FROM THE CRYPT #32 (Oct 52), where yet again a wife hacks up her butcher-husband in revenge for his selling spoiled meat, which kills members of the local community, and finally their own son. The following morning, when the butcher's shop opens, we see the wife stood over the display counter, where parts of the dismembered body of her husband are placed for sale... 'Tainted meat...? Tainted meat... anyone?' is the pathetic cry from the now insane woman.

And on it goes. The themes of dismemberment, decapitation and mutilation appear endlessly in precode horror comics. From Jack Davis' **'What's Cookin'?'** (HAUNT OF FEAR #12, Apr 52), in which various individuals are roasted, broiled, and even Southern-Fried, to **'The Maggots'** (ADVENTURES INTO TERROR #19, May 53) in which a lab accident infests a researcher with maggots that set about eating him alive — the examples are almost endless. There are even sports-dismemberment stories! Not just the infamous **'Foul Play'** (HAUNT OF FEAR #19, Jun 53), wherein the head, eyes and intestines of a baseball player are used in a macabre midnight game, but also in **'Skin 'em Alive'** (MYSTERIOUS ADVENTURES #18, Feb 54) where a game of football is played with a ball made of human skin, and **'Cutting Cards'** (TALES FROM THE CRYPT #32, Oct 52) in which card players amputate limbs as the stakes get higher and higher...

Severed heads and limbs also appear in more 'traditional' supernatural stories of headless ghosts and crawling hands. A few interesting examples...

'The Ghostly Guillotine' (VOODOO #8, Apr 53): the severed head of a medieval executioner stays alive in a castle vault until it completes its revenge against the family who own the castle...

'Headless Horror' (CHAMBER OF CHILLS #8, May 52): A live broadcast from a haunted house has a sceptical radio man encountering the ghost of a woman who can lift off her own head! Proof of ghosts at last...

'Head of Horror' (Superior's STRANGE MYSTERIES #6,

GHASTLY TERROR!

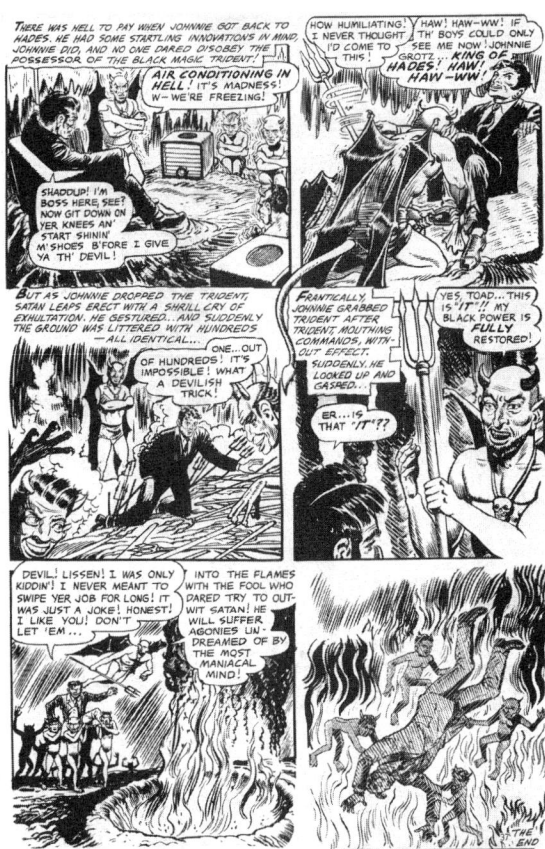

The devil is not mocked. 'King of Hades', VOODOO #11.

Jul 52): Another headless ghost which haunts the old familiar family plot...

'**Trophies of Doom**' (Standard's ADVENTURES INTO DARKNESS #11, Aug 53): Headless ghosts torment and finally behead a gloating executioner who collects the heads he chops off as souvenirs — no wonder they didn't like him!

'**Blood Vengeance**' (PL's WEIRD ADVENTURES #3, Oct 51): The spirit of a man guillotined in the French revolution possesses the mind of Henri, who beheads his pal Pierre and his girl Jeanette using the jagged edge of a broken window and its ledge as a home-made guillotine.

The subtext of these grisly tales is the vengeance and judgement of the Dead on the Living. Supernatural revenge and punishment (often pseudo-Biblical in tone) makes for a whole genre within the horror comics field, running the entire gamut of ghostly assemblies: courtrooms full of skeletal judges and bony witnesses; walking corpses returning to accuse the guilty from the grave; and, most popular of all, terrible judgement by the Great Accuser Himself — Satan. With the exception of the ECs (see next chapter) the Devil, Hell and the torments of the Damned were depicted regularly in horror comics, where — contrary to the claims of immorality by their detractors — fire and brimstone sermons issued graphic warnings against the sins of greed, vice, avarice and vanity!

The devil gets his due in the following tales:

'**Satan's Spectacles**' in Quality's WEB OF EVIL #4 (May 53), tells the story of aptly-named optician, Harry Lenz, who gets a strange request for a prescription made from some rather strange 'hot' glass. The tall, distinguished client pays Harry well, but when he discovers that the glasses will enable him to read minds and thus discover all sorts of lucrative secrets, Harry decides to keep them for himself. In a short time he gets rich, and, of course, popular. Changing

his name to Herman Greid (subtle, that) his globetrotting new life-style introduces him to society's upper crust, including one ex-patriot monarch, Prince Natas (oh oh!) and his beautiful daughter. 'Even royalty looks up to me!' thinks the triumphant ex-optician. He's even more flattered when Natas requests him to finance a revolution in exchange for his daughter's hand in marriage — 'only you, fabulous Herman Greid, can... restore us to power!' Dear, oh dear... not only does the revolution fail, but it absorbs all Herman's vast wealth. Then the walls really come tumbling down when Natas takes back the glasses (yes, it was Old Nick all along) and points out, 'I am reclaiming what is rightfully mine!' As punishment for falling into temptation, Harry Lenz (no more the rich 'Herman Greid') is made blind... A fitting punishment for an optician who nicks his client's specs, I suppose.

'**The Storm**' appears in Atlas' STRANGE TALES #8 (Jul 52). This is the story of Miko, a strangler for the mob who sincerely enjoys his work. However, one stormy night the cops see him busying away at garrotting somebody and chase him until he hides out in a dingy old airport where several people are waiting to board a plane. Not missing any opportunity, Miko garrottes one of them and nabs his ticket, but when the plane takes off he finds it's occupied by the walking corpses of all his many victims. 'Get away! I want to live! Don't touch me!' screams Miko who bolts into the cockpit and draws a gun. 'Land at once, Pilot, or I'll blast your head off!' — 'We're landing now, Miko! We are at our destination!... I made a special trip, just for you, Miko... come!' — 'You!' Shouts Miko at the red, horned figure who's come to collect his soul.

This story, probably written by Stan Lee, is just one of a hundred with an identical basic plot. Something a little different is '**The Door**', WEIRD MYSTERIES #11 (Jul 54), in which married couple Betsy and Jim Keegan enter a funhouse with dozens of doors. Passing through one of them, they find themselves in a dark tunnel leading into labyrinthine caverns,

Grave judgement! The summing-up in 'Jury of the Dead', JOURNEY INTO FEAR #14.

GHASTLY TERROR!

in which they get completely lost. Finding a pathetic, mad old man who sustains his existence by eating the mould off the tunnel walls, Betsy and Jim ask him to help them find the door to the surface world. But the door to which the exhausted and now half-mad couple are led opens into Hades, with Satan beckoning them in: 'Welcome, welcome... I see you found the way! Always room for a few more! Heh... Heh... Heh...' (What had the Keegans done to deserve their fate? Who knows? That's probably why the comic was entitled 'Weird Mysteries'.)

Two more takes on this theme appear in VOODOO #11 (Sept 53): **'The King of Hades'** has small-time hoodlum Johnnie Grotz getting rubbed out and sent to Hell, only to take over down there when he grabs Satan's trident. But he doesn't have Satan in his power for long, as the Evil One cunningly tricks him into returning the trident by having it placed among hundreds of identical ones — only the true ruler of Hell knows a kosher trident when he sees one! And in **'No Place To Go'** (STRANGE FANTASY #8, Oct 53), henpecked Wilbur Cummings snuffs it, only to find there's no place for him in Heaven — and that Hell doesn't want him either. Finally Death himself appears: 'Not doing so well, Wilbur?' — 'N-no! Nobody will have me!' Death feels sorry for him and gives Wilbur another chance, as long as he does something with his life this time — good or bad, just *something*! In the precode horrors anything except blandness is accepted.

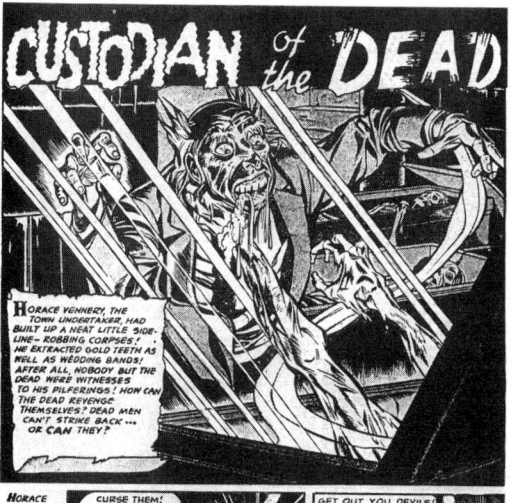

Slithering in the slime — graverobbing Horace Venery in 'Custodian of the Dead', WEB OF EVIL #1.

A final twist on this popular topic is **'Susan and the Devil'**, in Ribage's borderline crime/horror title CRIME MYSTERIES #9 (Sept 53), the story of an immoral, voluptuous girl who uses men and throws them away, leaving a string of murders and suicides in her uncaring wake. Even when she shoots a love rival dead, Susan has the all-male judge and jury twisted round her little finger. When an ex-lover kills her in a rage, super-cool Susan is sent to Hell where she's still confident that all will be well... 'For she felt she could even charm the

INTO THE ABYSS...!

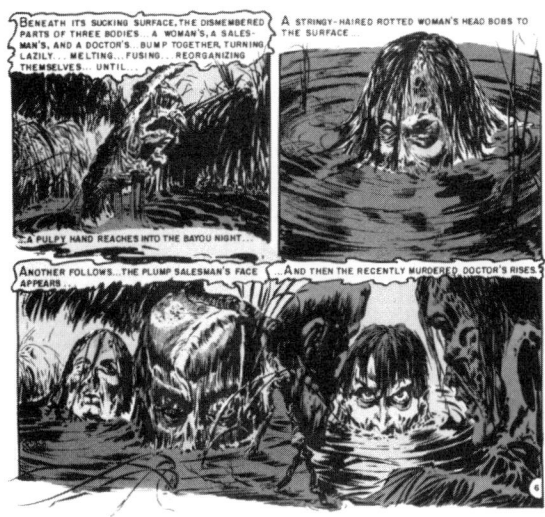

devil!' But: 'No! No! It can't be!' Yes, Susan never suspected the truth... 'The Devil is a woman!'

Hell is sometimes depicted in the precode horrors as a misty country of restless spirits. Often these stories are about the judgement and punishment of evil mortals — like the wicked judge who is tried by a spectral court comprised of his innocent victims, in '**Jury of the Dead**' (Superior's JOURNEY INTO FEAR #14, Jul 53). More often than not though, the other-worldly accuser is an ambulatory corpse, as in another courtroom story, '**Verdict of Terror**' (DARK MYSTERIES #17, Apr 54), and numerous EC tales such as '**The Thing from the Grave**' (CRYPT #22, Feb 51), '**Scared to Death**' (CRYPT #24, Jun 51), both of which have walking corpses burying somebody alive...

'**Ants In Her Trance**' (CRYPT #28, Feb 52): a variation on Poe's *M. Valdemar* mesmerism theme... '**Sink-Hole**' (VAULT #18, May 51): dead husband comes out of the well into which his murdering wife threw him... '**The Death Wagon**' (VAULT #24, Apr 52): crash victims get revenge on dodgy car dealers!... '**We Ain't Got Nobody!**' (VAULT #28, Jan 53): a dismembered corpse pieces itself back together to kill its three murderers... '**Horror We? How's Bayou?**' (HAUNT #17, Feb 53): three dismembered corpses piece themselves back together to kill their murderer...

A more 'ethereal' doom awaits the prisoner who escapes from jail down a dark tunnel, only to find it leads to the land of the dead ('**The Dark Passage**' in ADVENTURES INTO TER-

left Typical EC grue in 'Horror We? How's Bayou?', THE HAUNT OF FEAR #17.

right Love from beyond the grave. Cover: MYSTERIOUS ADVENTURES #18.

35

GHASTLY TERROR!

ROR #10, Jun 52), and the tragic wanderer who is forever denied the peace of death for violating a spectral citadel in a vulture-haunted desert ('**The City of the Dead**' in Fawcett's THIS MAGAZINE IS HAUNTED #10, Apr 53). Running from the formulaic (such as the ECs) to the genuinely eerie (such as the Fawcetts), these types of precode horror comic stories proliferate almost as much as those solely concerned with more 'common', earthly affairs, like the decapitation and dismemberment of unfortunates by legions of psychos, or the dozens of anxious people who just 'snap' one day. However, there is a particular sub-genre of these 'vengeance from the grave'-type stories which concerns the plight of corrupt undertakers and evil graverobbers... Often it's difficult to distinguish between the two professions in these comics!

For example, in VAULT OF HORROR #14 (Aug 50) we have '**Rats Have Sharp Teeth**', the story of conniving 'historian' Abner Tucker who knows which graves will prove lucrative, having traced the ancestry of every man and woman in town for 'blue-bloods'. Finding a tunnel and excavating below the graveyard at night, Abner becomes increasingly nervous about the multitude of rats — and with good reason! Acting as a vehicle of vengeance from beyond, the rats gnaw away the tunnel-supports and Abner is buried alive.

A more eerie version of the same story appears in WEB OF EVIL #1 (Nov 52). This time the graverobber is the sinister, toothy undertaker Horace Venery, whose ghoulish antics in the muddy, rain-drenched local cemetery raises the ire of re-animated corpses as well as rats... Trapped in a vault by a corpse which has hold of his legs (as in Lovecraft's tale, *In the Vault*), Venery finally crawls his way out and hides in a graveyard tunnel. But — there's a landslide and he's trapped in with the hordes of rats, and they're hungry rats at that! The last panel shows Horace's shrieking face as the menacing rodents press in for the kill.

THE HAUNT OF FEAR #6 (Mar 51) features '**A Strange Undertaking**', the story of the cruel and bitter undertaker Ezra Deepley, who mutilates the

Betsy and Jim go beyond 'The Door' in WEIRD MYSTERIES #11.

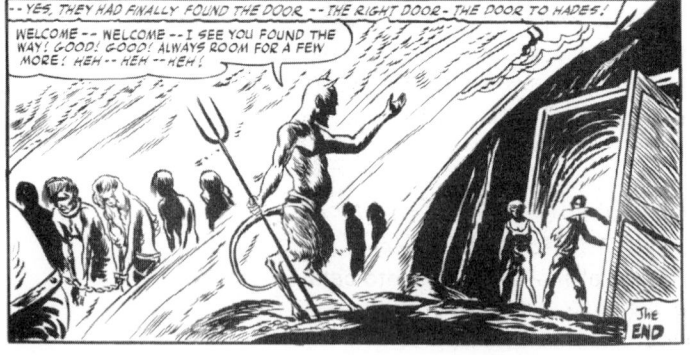

INTO THE ABYSS...!

I CRAWL THROUGH GRAVES

*Listen! That faint, scraping sound from the depth of the freshly made grave! The stir of the earth surrounding the coffin, the groaning of the reluctant wood as the tightly closed coffin door yawns open! No! It is **NOT** a death-imprisoned spirit trying to get out! It is Mr. Arcularos — **TRYING TO GET IN!***

Nice work if you can get it...
'I Crawl Through Graves',
ADVENTURES INTO
WEIRD WORLDS #5.

corpses of people who did him wrong in life. When a hard winter means that corpses must wait in the mausoleum before a thaw allows burial, Ezra cops it as four of his recent 'victims' return to life to exact their revenge. What exactly they do to Ezra is unclear, as for once the usually gratuitous EC are content to show the disgusted faces of the men who find the body... 'Good Lord!... Ough-h!... Gulp!'...

There's another cheating undertaker named Ezra in '**Grave Business**' (HAUNT OF FEAR #10, Nov 51) who gets his comeuppance when he's buried alive after falling into cataleptic shock due to a car accident... *'Staring up into the blackness that surrounds him... unable to move... unable to*

GHASTLY TERROR!

cry out... helpless...' It's a hard profession, that's for sure. This assertion can be extended to the strange little graverobber, Mr Arcularos (well at least it's not 'Ezra' again!) in '**I Crawl Through Graves**' (Atlas' ADVENTURES INTO WEIRD WORLDS #5, Apr 52). He's a man who steals a necklace from a dead woman, putting it up for sale — along with the many other items he's grave-robbed — in his pawn shop. One evening, a strange, veiled woman enters the establishment to reclaim the necklace and take it back to her grave... 'You will make one more trip to the graveyard, Mr Arcularos...', says the spectral voice, 'but this time you will not return!'

Sometimes the penalty for robbing the dead is even worse! Witness the fate of Lars Swenson, gravedigger, in '**Beneath the Graves**' (Comic Media's HORRIFIC #10, Mar 54), who decides to rob the coffin of a recently buried girl, only to find her body has disappeared. Following a trail down into strange tunnels beneath the graveyard (hmm, I wonder if there are any of these tunnels under my local cemetery...), Lars discovers a weird race of rat-like creatures — 'What fiends of Hell are these?... Horrid lumps of the very earth itself... and... alive!' And when Lars is discovered by them, he finds out they can talk too! 'Ha ha! Notify the Dark Ones below. We will soon have a customer for them!' The panic-stricken Swenson crawls away in desperation, only to find his way to the surface blocked by a coffin. 'No! I'm not dead yet!... Satan hasn't come to collect my soul!' But as he is dragged away, a sinister voice booms out: 'NO? Just who do you think I am Lars Swenson??!!'

White-zombie wife in 'Till Death', VAULT OF HORROR #28.

ADVENTURES INTO TERROR #24 (Oct 53) features the story '**The Body Snatchers**' in which surgeon Dr Knopf, a procurer of grave-robbed bodies, meets a fitting end at the bony hands of the corpses he's violated in the vault of an isolated old graveyard. *'And the sharp scalpels gleaming in their putrescent hands, the corpses keep coming toward you!'* — 'We have our experiment too, you know!' shriek the enigmatic rotters.

Perhaps the strangest grave-

robber tale is in STRANGE FANTASY #6 (Jun 53): '**Skull Scavenger**' features a 900-year-old alchemist who must search for the remains of his beloved Anne in order to retrieve the magic locket that will allow him to die. Scavenging through the vaults and graveyards of the world, the wizened figure eventually finds the locket in the ruins of an old French monastery, where the two lovers are at last reunited in death. (Brilliant stuff, genuinely atmospheric and spooky.)

These are only a brief sample of the many precode horror comic tales of corrupt undertakers and doomed graverobbers. Another type of story which features the vengeance of the dead and unearthly curses is the Zombie, or Voodoo, story, of which — again — there are many. Some of the earliest of these appear in the ECs. One in particular, the succinctly titled '**Zombie!**' features in the third issue of TALES FROM THE CRYPT from 1950. This is the simple tale of 'white zombie' Marie Morgan who is brought back to life to wreak vengeance on her cruel and murdering husband by the voodoo-worshipping natives of the Morgan plantation. The Zombie Marie pursues the terrified Jason through the jungle swamp until he falls into quicksand... *'And she blindly followed him into extinction!'* The all-important ingredient which lifts this basic plot to greater heights is its exciting setting: the exotic, comic book jungle — much more dangerous and threatening than any real jungle!

Author and illustrator Johnny Craig followed this one up with '**Voodoo Death**', from TALES FROM THE CRYPT #23 (Apr 51). With its title filched from a famous 1944 *American Anthropologist* article by WB Cannon, '**Voodoo Death**' tells the story of Jay and Bill, travellers in Haiti who witness a voodoo ceremony in which a little doll holding a sharp pin is animated. The natives capture Jay, while Bill naturally legs it; but Jay turns up later, a little worse for wear, muttering 'Voodoo doll... Zombie'. Sensibly deciding to go home at this point, the pair are pursued wherever they go by the little doll with the pin. Jay gets progressively stranger and one day the doll jumps out on Bill and attacks him, while

The paternal instincts of a zombie. 'Zombie', MENACE #5.

GHASTLY TERROR!

Jay stands on laughing: 'I have nothing to worry about, Bill! I'm already dead'. As Bill desperately tears the doll to shreds, this proves to be true... 'Good Lord! It's a heart! A human heart!' — 'Yes, Bill! That's how they gave it life! They gave the doll... my heart!' Yipes! — I wonder what Professor Cannon thought to all this?

'**Till Death**' in VAULT OF HORROR #28, again by Johnny Craig, is very similar to his first effort ('**Zombie!**') except this time the grieving husband welcomes the white zombie of his dead wife back from the grave, only to become increasingly testy as, day by day, the silent, doting wife rots slowly away.

An even creepier rendition of this story appears in JOURNEY INTO FEAR #13 (May 53) in which, to escape his zombie wife's unwelcome attentions, the husband eventually hangs himself...

'**Zombie!**' in MENACE #5 (Jul 53) features the walking deadman (who would become Marvel's 'Simon Garth — the Living Zombie!' in the 1970s) controlled by a 'devil doll' of his likeness by the nameless 'master', who sends him out on errands of robbery and murder. However, a distant glimmer in the zombie's brain does not allow him to murder one intended victim, and he turns on the master and kills him instead. Why couldn't the dead man do the dastardly deed? The intended victim was his own daughter! Sometimes even voodoo can't overcome the power of love... So sayeth writer Stan Lee, and immaculate artist Bill Everett.

WEIRD MYSTERIES #11 (Jul 54) features '**Voodoo Dolls**', a deranged story in which a voodoo practitioner becomes a real-life voodoo-doll when his vengeful sister hangs him and runs him through with swords... '**Death Drum**' in ADVENTURES INTO DARKNESS #7 (Jan 53) tells the story of hip bongo player, Chip Conway, who acquires the cursed voodoo drum of 'an ugly old witch-doctor' and ends up in the electric chair when no one will believe that the murders he commits are done under the influence of a voodoo curse.

You are right to think that horror comics were not overly concerned with presenting anthropologically accurate portrayals of voodoo. In fact, a whole range of bizarre stories featuring 'voodoo' rites

below Chip Conway about to embark on a bongo fury murder spree in 'Death Drum', ADVENTURES INTO DARKNESS #7.

bottom Haitian nightlife, precode horror style! 'The Drums of Cajou', OUT OF THE SHADOWS #8.

INTO THE ABYSS...!

and primitive idols can be swept together under the same awning, headed 'exotic'. Here are a few examples of other 'exotic' types:

'**Love Story**' by Stan Lee and the talented Joe Maneely, appearing in Atlas' SPELLBOUND #14 (Apr 53), is the amusing tale of the bitchy wife of a jungle guide stationed in Kenya who falls for the local doctor, getting him to administer poison to her husband. However, the husband is aware of what's been going on behind his back, and in the event of his death has arranged to have his native friends kill the medical man, and inform the head of the tribe that his wife wants to be his bride!... 'NO, NO!! What happened to my doctor? What have you done to him?' — '...You no worry... Bwana tell us you want to marry doctor... so you marry biggest witchdoctor in Kenya!' Yes, these obliging natives will do anything to please. Up steps the grotesque, file-toothed witchdoctor leering at his bride-to-be: 'Stand still so me can put ring thru your nose!' (Minus eight out of ten for political correctness!) In Standard's OUT OF THE SHADOWS #8 (Dec 52), '**The Drums of Cajou**' tells another 'witchdoctor' story in which an attractive plane crash victim is turned into a giant bat-like vampire creature after the Haitian witchdoctor, Cajou, performs a voodoo ritual where a cup of blood is drunk and zombies gather in the congregation... This is wild stuff, like some sort of psychotic's hallucination during a particularly severe bout of jungle fever...

'**The Weird Dead**', appearing in VOODOO #6 (Feb 53), concerns another zombie cult, this time in the service of the Aztecan feathered serpent 'Zabo' (eh?), the gigantic denizen of a mouldering crypt beneath ancient temple ruins. Also in an issue of VOODOO* is '**Torture Travelogue**', the sobering tale of one Patti Loring, a vain, sexually aggressive young woman, who strings along naïve jungle-boy Joe Owani, only to use him and then drop him when she loses interest — but the 'voodoo-spirit' of Joe haunts her thereafter, never leaving her alone. When Patti finally succumbs to the compulsion to return to him, Joe reveals an ulterior motive: a feast in her honour... But: 'Here we follow our own customs and do not heed the white man's law! Now I will have my true revenge!... There is one thing I have not told you woman! In the old days my people were — CANNIBALS!'... Oh, it's going to be *that* sort of feast! '**Torture Travelogue**' is a very interesting story with the same undercurrent of sexual ten-

Not a copy of American Anthropologist, *but DARK MYSTERIES #9.*

*Specific number and date not known. The strip was found reprinted in an issue of Eerie Publications' TALES OF VOODOO. See chapter: *Shoddy Duplicates*.

GHASTLY TERROR!

left That sinking feeling. 'Swamped', THE HAUNT OF FEAR #27.

right No weirder mystery exists! Wolverton's 'Swamp Monster', WEIRD MYSTERIES #5.

sion that made the aforementioned '**Killer Lady**' (also in an issue of VOODOO) particularly uncomfortable reading to the Werthamites. And like that other story, this one is also well suited to the suggestion 'the vain die young'.

Less 'exotic', but equally hot and sticky, is the swamp setting of many more strange voodoo-like precode horror comic stories. Such as '**Swamp Haunt**' in Ajax-Farrell's HAUNTED THRILLS #5 (Jan 53): flirty Lucybelle has eloped with boring old Tom and now regrets it. Telling Tom to hide out in the swamp until she informs her folks about the marriage, Lucybelle instead goes to swamp witch 'old memmy' asking her to cast a hex to make sure Tom 'never leaves the swamp'. But the senile, evil old witch uses the zombie of Tom to hunt Lucybelle down: 'No use! You got to die like I did!' says Tom, now a vision of evil with the snake that killed him coiled around his neck! Lucybelle panics and blunders into 'Quicksand! Help!' — 'Reckon we can be together always now, Lucybelle!' As the lovers sink into the swamp, *'From the witch's shack comes the sound of maniacal laughter...'*

'**Swamped**' (HAUNT OF FEAR #27, Oct 54) features a maniac in the swamps whose murder victims are revived by the primal ooze in which they're buried. At the end of the

tale, the homicidal half-wit is consumed by a tidal wave of slime and corpses!

A swamp belle appears in Atlas' MYSTIC #19 (Apr 53), '**Swamp Girl**', a siren-like apparition who first appears as a cat and then transforms into a beautiful girl who lures a deserting revolutionary soldier to his doom. (Very odd indeed, this one.) Even more bizarre is the legendary Basil Wolverton's '**Swamp Monster**' (WEIRD MYSTERIES #5, Jun 53), in which escaped convict, Cabot, encounters a weird old man in the swamps who jumps on him and bites him! When he recovers, Cabot is transformed into a slavering, fanged monster... 'My face! My body!... What did you do to me?' — 'I simply inoculated your body with the capacity to conform with the level of your mind... and you have the mind of a fiend!' This is another whacked-out psychotic opus, unlike anything else you'll ever read.

Yet another swamp-weirdie is the old witch-woman Ouanga who can transform folks into 'gators in '**Beast of the Bayous**', appearing in Ace's THE HAND OF FATE #24 (Aug 54). And speaking of alligators, there is a whole sub-genre of precode horror comic tales which deal with the menace caused by creatures such as: *Spiders* ('**A Sucker for a Spider**', CRYPT #29; '**The Red Spider**', Avon's WITCHCRAFT #3)... *Ants* ('**Black Death**', FANTASTIC FEARS #4; '**The Little Monsters**', Atlas' MARVEL TALES #114)... *Rats* ('**Cycle of Horror**', CHAMBER OF CHILLS #16; '**Rat-Trap**', MISTER MYSTERY #8; '**The Phantom Ship**', OUT OF THE SHADOWS #6)... *Fish* ('**The One That Got Away**', WEIRD MYSTERIES #8)... *Crabs* ('**They Crawl by Night**', Atlas' JOURNEY INTO UNKNOWN WORLDS #15 — as this is another weird Wolverton tale, they're not *exactly* crabs, if you see what I mean...). Not forgetting, of course, hapless humans who transform into spiders or insects, notably '**Deadlier than the Male**' (WEIRD MYSTERIES #7), the excellent '**Lair of the Black Widow**' (Ace's THE BEYOND #24), and '**A Death for a Death**' (Fawcett's WORLDS OF FEAR #6), in which a psycho insect collector transforms into a bug, gets attacked by spiders, and finally gets accidentally stamped on by his landlady!

'*Out from the dank, foul sewer's depths come the ghost-like creatures...*' Another sticky (or should that be 'stinky'?) setting. Slimy things that crawl around in the sewer systems — particularly of Paris, for some reason — are the subjects of not a few precode horror stories. The above quote comes from '**Terror in the Streets**' in Trojan's BE-

GHASTLY TERROR!

WARE! #8 (Mar 54). Here the creatures are diminutive albino ghouls which inhabit the sewers, stealing corpses from the horse-drawn hearses in the turn-of-the-century Parisian streets. Investigating officer, the corrupt Inspector Vidac, gets trapped in the tunnels and eaten alive for his troubles! A very similar tale, though a little less gruesome, entitled **'Fiends from the Crypt'** had appeared a year or so previous in the second issue of FANTASTIC FEARS (#8, Jul 53). Here, another corrupt Parisian copper is devoured (along with his innocent wife and daughter) by a race of scaly, sewer dwellers; this time with their own language: 'ERS-DA-ESTT-EN-BOR-TA!' which means 'He was a fool and a knave, and was doomed from the start!' we are thoughtfully informed...

'**The Last of Mr Mordeaux**' in Atlas' ASTONISHING #11 (Apr 52) is another French-sounding sewer story, where the Mr Mordeaux in question traces his aristocratic lineage back to a race of scaly 'horrors from the bowels of the Earth!' Vaguely reminiscent of Lovecraft's *The Rats in the Walls*, this is another excellent short tale from Atlas, nicely illustrated by Joe Sinnott, later of FANTASTIC FOUR fame. Even more (!) French sewer monsters are found in Harvey's WITCHES TALES #4 (Jul 51): '**Sewer Monsters**' — illustrated by stalwart Bob Powell — tells the story of subterranean beings enlisted to overthrow the aristocracy in pre-Revolutionary Paris... But perhaps the whackiest of the lot is '**The Rat-men of Paris**', in which sewer-dwelling rat-dudes (looking for all the world like a continental Roland Rat, with their berets and striped T-shirts) attempt to overthrow the surface world at the behest of their anatomically normal queen. Weird. This one appears in STRANGE MYSTERIES #4 (Mar 52).

If you thought all the precode freaks and deformities were relegated to an underground existence, you would be very much mistaken. The 'freak' and/or 'ugly' sub-genre in precode comic publishing is far-reaching. In fact, vast! The following run-down, as exhaustive as it might seem, is just a small sampling:

'**The Ventriloquist's Dummy**', TALES FROM THE CRYPT #28 (Feb 52): the dummy in question is discovered to be a

Revolting precode creepy-crawlies!

top 'Lair of the Black Widow', THE BEYOND #24.

above 'They Crawl by Night', JOURNEY INTO UNKNOWN WORLDS #15...

INTO THE ABYSS...!

grossly deformed, diminutive Siamese twin, which eventually turns on its normal, 'ventriloquist' brother and tries to kill him, thereby destroying them both.

'**The Hunchback**', THE HAUNT OF FEAR #4 (Nov 50), is another Siamese twin story in which the 'hump' on Peter Golgo's back turns out to be a monstrously deformed 'little brother'. HAUNT #7 (May 51) features '**The Basket**'. Q: Why does Mr Cabez carry a basket on his shoulder when he makes his infrequent visits into town? A: It conceals the nasty fact that he has a shrivelled, second head on his broad shoulders! Similar is '**People in Brass Hearses**' in VAULT #27 (Oct 52), about a Siamese twin who has been dead for years, but is still being humped around by his living brother.

'**About Face**' in HAUNT #27 (Oct 54) tells the tale of twin sisters, one terribly beautiful and the other just terrible. Why do they never appear in each other's company? Because they're the same person! The wretched Olga is a parasitic twin-face on the back of lovely Peggy's head...

'**Lower Berth**', CRYPT #33 (Jan 53), tells the comical story of two-headed Enoch's love for a 3,000-year-old pickled mummy! (Their blissful union spawns CRYPT host, The Crypt-Keeper!)

Plus!...
top 'A Death for a Death', WORLDS OF FEAR #6.
above 'Rat-Trap', MISTER MYSTERY #8.

45

GHASTLY TERROR!

In '**Only Skin Deep**' (CRYPT #38, Oct 53), Herbert meets the voluptuous Suzanne every year at a masked party during New Orleans' Mardi Gras week, but Suzanne asks Herbert never to remove her wizened witch's mask. They spend the night together as usual, but Herbert can no longer stand the suspense — he takes a hold and pulls, pulls, pulls! Finally the mask tears off, accompanied by Suzanne's awful shriek. There she lies on the bed, a raw visage of blood and tissue... 'I... gurgle... never... wore... a mask...!' This is a theme also covered in '**The Mask of Horror**' (THE VAULT OF HORROR #18) and in '**Kiss and Kill**' WITCHES TALES #20, Aug 53), where both unsuspecting parties turn out to be horrendously ugly. Similar is '**About Face**' (not the same as the one in HAUNT #27) in which a mauled lady-liontamer somehow exchanges her disfigured face so that her cheating lover, Steve, gets ugly while she is restored to beauty.

Prize's BLACK MAGIC #29 (Nov 53) offered few stories as visceral as '**The Greatest Horror of Them All**', where the apparently beautiful Elena, who lives in a home for circus freaks (!), turns out to be the most horrible of them all when the body-suit and make-up she wears is removed to reveal that she's a burnt, multi-armed, caterpillar-thing. Along with another BLACK MAGIC freak story, '**The Head of the Family**' — in which a horrible, over-sized head literally acts as the brain and nerve-centre for its deformed, symbiotic family — this tale was created by the famous team of Joe Simon and Jack Kirby.

'**The Madman**' (MENACE #4, Jun 54) features a 'mad doctor' who conceals the existence of a race of subterranean beings with four arms, but is foiled by his sympathetic new nurse — who has got four arms herself!

Another race of subterranean uglies transforms a handsome movie star into '**The Ugliest Man in the World**' (OUT OF THE SHADOWS #7, Oct 52)... The theme of ugliness as a punishment of the vain also appears in '**Mirror of Madness**' (HAUNTED THRILLS #17, Sep 54), where a beautiful girl is driven insane by a trick mirror which gives her the appearance of an old hag. (This plot is repeated in '**The Sunken Grave**' in JOURNEY INTO FEAR #5, Jan 52.) And of another HAUNTED THRILLS tale, '**Horribly Beautiful**', you might reasonably imagine the title speaks for itself — but who could be prepared for a beautiful face which does not grow in ugliness, *but in size*? (Another 'What was the author on?' type story...)

'Freak' and 'ugly' stories played on everyday fears and

INTO THE ABYSS...!

Up from the fetid stench of Rome's ancient catacombs swarmed the horrible army — strange and sinister beyond belief, sworn to destroy humanity in their terrible bone crunching jaws, slavering after the smell of human blood! And to this fearful scourge was added the greed and lust for power of one man who in turn was to meet **THE GREEN HORDE**...

FIENDS from the CRYPT

"ERS-DA-ESTT-GN-BOR-TA!"*

*MEANING: HE WAS A FOOL AND A KNAVE, AND WAS DOOMED FROM THE START!

left and right Beware the Paris sewers... 'Fiends from the Crypt', FANTASTIC FEARS #8.

insecurities about self-image, sexuality, and bodily functions. Appearing as they did in magazines which advertised corsets (for men and women), pimple-removers, wigs, cosmetics, diets (to put weight *on*, as well as lose it), bodybuilding courses, books on courting and social etiquette, and so on, these horror comic stories about deformity and the revulsion and loathing it inspires, scored cheaply but tellingly.

More 'traditional' horror fare was offered in the many, many stories featuring vampires, werewolves and other creatures of the night from occult lore and folk-tales. Haunted houses, replete with ghosts of the headless, and other varieties, abounded. So too, tales of walking mummies, ancient curses (a particularly good one being '**The Withered Hand**' about a mummified hand from Tibet, in ADVENTURES INTO TERROR #19, May 53) and all sorts of monsters; either created in a mad scientist's lab ('**The Thing That Grew**': ADVENTURES INTO TERROR #7, Dec 51) or in the depths of the ocean ('**Monster of the Mist**': WEB OF EVIL #4, May 53) or in the lonely swamps ('**The Thing in the 'Glades'**': TALES FROM THE CRYPT #31, Aug 52). Some monsters are stranger still, such as the tiny 'Wudgies' who terrorise a family and abduct their children (like the fairies of old) in

47

GHASTLY TERROR!

The Wudgies terrorise a nice ordinary family in 'Terror Unlimited', VOODOO #16.

VOODOO #16's '**Terror Unlimited**' (Jul 54) — or the evil little toy which appears in '**Satan's Plaything**' in VOODOO #8 (Apr 53)…

Stories of mad or possessed artists and sculptors also make regular appearances — the classic plotline being where the artist paints a portrait of 'Death himself', or whose self-portrait causes his own death by the mechanism of sympathetic magic. '**Drawn and Quartered**' (TALES FROM THE CRYPT #26, Oct 51), '**Mardu's Masterpiece**' (THE THING! #9, Jun 53), '**The Fat Man**' (THIS MAGAZINE IS HAUNTED #10, Apr 53), '**The Locked Door**' (WORLDS OF FEAR #6, Sep 52) — are just a few stories which utilise this classic plot.

Other classic themes about witches ('**The Witch's Curse**', WEIRD MYSTERIES #8, Jan 54), the Sabbat ('**When Witches Summon**', THE BEYOND #8, Jan 53), and the Dance of the Dead ('**The Dancer from Beyond**', ADVENTURES INTO DARKNESS #7, Mar 53, and '**Dance of Death**', WEB OF EVIL #4, May 53), appear regularly in horror comics, but even more overt references to classic plots and stories appear in the many tales which are based on — or are unaccredited 'swipes' of — established classics of horror literature. As you will see from the following survey, the most popular author to be 'swiped' is Edgar Allan Poe…

'**The Living Death**' (TALES FROM THE CRYPT #24, Jun 51) is a fairly straight version of *The Facts in the Case of M. Valdemar*. '**The Wall**' (HAUNT OF FEAR #1, May 50) is a modernised version of *The Black Cat*. '**Demon in the Dungeon**' (STRANGE FANTASY #4, Feb 53) is another updated version of *The Cask of Amontillado*.

'**The Thing from the Sea**' (TALES FROM THE CRYPT #20, Oct 50) is a straight rip-off of F. Marion Crawford's ghost story, *The Upper Berth*. And in the same issue '**RX Death**' brought us an accurate adaptation of Arthur Machen's *The Novel of the White Powder*.

'**Revolt of the Beast**' (HORRIFIC #10, Mar 54) is another Machen-influenced tale, this one being a pretty poor version

of his short novel *The Terror*.

'**Island of Death**' (VAULT OF HORROR #13, Jun 50) is one of many comic stories with variations on the theme of *The Most Dangerous Game* by Richard Connell.

'**Baby, It's Cold Inside**' (VAULT OF HORROR #17, Feb 51) is Lovecraft's *Cool Air* — a classic of sorts. '**Voodoo Horror**' (in the same issue) would no doubt have had Oscar Wilde chortling away, as it's a bizarre variation on his classic novel *The Picture of Dorian Gray*.

'**A Grim Fairy Tale**' (VAULT OF HORROR #27, Oct 52) is one of many of EC's grotesque takes on old fairy stories and fables, a formula which proved very successful, and was therefore much copied by their competitors. However, this 'fairy tale' — despite its setting — seems to be more inspired by George Fielding Eliot's gory opus *The Copper Bowl*.

'**I'll String Along**' (WITCHES TALES #20, Aug 53) is a South of the Border rendition of Ambrose Bierce's *An Occurrence at Owl Creek Bridge*.

'**Mirror Image**' (WEIRD TERROR #8, Nov 53) is Rudy Palais' version of Bierce's *The Man and the Snake* (and a pretty atmosphere-less version it is too).

'**The Face of Death**' (ADVENTURES INTO WEIRD WORLDS #4, Mar 52) is Bill Everett's beautifully illustrated version of Poe's *The Masque of the Red Death* in a futuristic setting.

'**The Brain-Bats of Venus**' (MISTER MYSTERY #7, Sep 52) is Basil Wolverton's loony-tunes version of Clark Ashton Smith's interplanetary pulp opus, *The Vaults of Yoh-Vombis*; which, along with more original Wolverton tales like '**Where Monsters Dwell**' (ADVENTURES INTO TERROR #7, Dec 51) and '**The Devil Birds**' (MYSTIC #4, Sep 51) is

Art becomes realer than life in 'The Locked Door', WORLDS OF FEAR #6.

GHASTLY TERROR!

Faces of fear — some horror comic hosts:

The Mummy from WORLDS OF FEAR (left), and Dr Death from THIS MAGAZINE IS HAUNTED (right).

testament to the heights of total, utter weirdness to which the precode horror comic could sometimes climb.

On the subject of 'swipes', apart from borrowing from classic sources, horror comics often borrowed from each other — again without crediting the source. The ECs were most often ripped-off in this way, but it must be remembered that they were not entirely guiltless themselves... When **'What the Dog Dragged In'** appeared in VAULT OF HORROR #22 (Jan 52), the editors received a very courteous letter from one Ray Bradbury, who pointed out in quiet, but by no means uncertain, tones, that the story in question had a lot in common with his short tale *The Emissary*. It ended up being a good deal for EC, as they began to produce nice adaptations of Bradbury's works, which the author himself endorsed. However, it indicates that the EC editors were not the saints the Fan establishment have made them out to be, and though they were most often on the 'receiving end' of swipes, they did their fair share themselves.

That said, some of the other horror comic publishers were less subtle in their 'admiration' (shall we say) for EC's winning formula. In particular, Story, who blatantly ripped off a number of popular EC tales in the latter issues of their DARK MYSTERIES and MYSTERIOUS ADVENTURES — for example **'Ghost Town'**, which appears in MYSTERIOUS ADVENTURES #18 (Feb 54), is a direct lift from the famous vampire tale **'Midnight Mess'** in TALES FROM THE CRYPT #35

INTO THE ABYSS...!

(Apr 53). And certainly the aforementioned 'grim fairytales' — which became a staple ingredient of the ECs — were much copied; again by Story ('**Mother Ghoul's Fairy Tales**'), but also by Harvey ('**Mother Mongoose's Nursery Crimes**'), Ajax-Farrell ('**Little Red Riding Hood and the Werewolf**', FANTASTIC FEARS #2, Jul 53) and Charlton ('**Rumplestiltskin**', THE THING! #15, Jul 54).

But by far the most obvious 'swipery' came via the copying of EC's 'horror hosts'; the dreadfully punning, but somehow endearing characters who hosted the magazines and introduced the stories: The Crypt-Keeper, The Vault-Keeper and The Old Witch. There were numerous 'homages', and again Story were the most prominent with their The Grave-Keeper, The Corpse and The Grave-Digger. But there was also Trojan, with The Nameless One; Gillmor, with The Ghoul-Teacher; Charlton, with The Thing!; and, slightly more original, Fawcett with the grim Dr Death, the host of THIS MAGAZINE IS HAUNTED, and The Mummy, who introduced BEWARE! TERROR TALES.

These were the visible faces who compered and introduced an avid (and huge) readership each month to the terrifying, often deranged, world of precode horror comics — comics featuring stories of torture, death, hunger, pain, murder, decapitation, vampirism, voodoo, black magic, cannibalism, and things even worse... much worse! Things that lurked in the cobwebbed shadows... in dark alleyways... in ancient ruins... in graveyards and dungeons and cold, damp cellars...

The Horror-Hosts were the *visible*, four-colour faces of the horror comics. But who were the *real* publishing companies behind this lowly branch of the entertainment industry, deemed to be so vile and corrupting by its detractors? Indeed, so vile and corrupting that congressional hearings were called for, and a rigid Comics Code was endorsed, which nearly ruined the whole industry...

In the following chapter, we'll take a look at the horror comic publishers and how they fared during this period of book burning madness.

EC's horror hosts:
top to bottom *The Vault-Keeper, The Crypt-Keeper and The Old Witch.*

GHASTLY TERROR!

TOP 20 MOST GRATUITOUS PRECODE HORROR COMIC COVERS!

1 MISTER MYSTERY #12 (Gillmor) — *Red hot poker in the eye.*
2 FIGHT AGAINST CRIME: HORROR AND TERROR #20 (Story) — *Bloody severed head.*
3 WEIRD MYSTERIES #5 (Gillmor) — *Exposure of brain removed from severed head.*
4 TOMB OF TERROR #15 (Harvey) — *Exploding gory face.*
5 THE THING! #7 (Charlton) — *Eyes poked out.*
6 LAWBREAKERS SUSPENSE STORIES #11 (Charlton) — *Severed tongues.*
7 LAWBREAKERS SUSPENSE

Note: As Joe Signorelli and Erich Medenbach point out in their article on precode horrors in *Comicbook Marketplace* #46 — all the above comics are very pricey and very scarce now, no doubt due to the fact that when parents originally saw such images back in the early Fifties, these issues were thrown away fast!

52

INTO THE ABYSS...!

STORIES #15 (Charlton) — *Acid in the face.*

8 VAULT OF HORROR #30 (EC) — *Severed forearm in subway car.*

9 BLACK CAT MYSTERY #50 (Harvey) — *Radium face-rot.*

10 CRIME SUSPENSTORIES #22 (EC) — *Severed woman's head/bloody axe.*

11 WITCHES TALES #25 (Harvey) — *Severed head rung to a pulp inside church bell.*

12 VAULT OF HORROR #31 (EC) — *Face beaten to bloody pulp.*

13 MISTER MYSTERY #13 (Gillmor) — *Head forced down into boiling liquid.*

14 WEIRD TALES OF THE FUTURE #8 (Gillmor) — *Exposed heart dripping gore.*

15 DARK MYSTERIES #13 (Story) — *Severed leg.*

16 MISTER MYSTERY #11 (Gillmor) — *Buried up to the neck and left to be devoured by ants.*

17 DARK MYSTERIES #10 (Story) — *Burning witches alive.*

18 WEIRD MYSTERIES #6 (Gillmor) — *Gory shrunken head.*

19 WORLDS OF FEAR #9 (Fawcett) — *Close-up of a drowning face.*

20 HORRIFIC #3 (Comic Media) — *Bullet in the forehead.*

This last cover is regarded by pundits as a real classic — and it is good, but I wonder how many people realise the image has been lifted from the cover of Comic Media's WAR FURY #1 (Sept 52)?

GHASTLY TERROR!

SCAPEGOATS

THE NAME WHICH will be forever associated with the most notorious and extreme Fifties horror comics is, of course, EC. With their world-renowned titles, TALES FROM THE CRYPT, THE VAULT OF HORROR and THE HAUNT OF FEAR, EC has become synonymous with bloodcurdling graphic horror and has influenced several generations of comic creators the world over, as well as inspiring dozens of movies and an amazingly successful TV series — with a plethora of merchandising paraphernalia to boot! There is no doubt that EC deserves its solid reputation in comic history. Its talented creators — publisher William Gaines, editor Al Feldstein, artists Graham Ingels, Jack Davis, Johnny Craig, Jack Kamen, *et al* — are rightly regarded as leading exponents in the field; pioneers of the putrid, if you will! However, such has been the prevalence of EC in the pages of comics criticism since the creation of the Comics Code Authority, that many long-lasting errors and discrepancies have crept into the general understanding of EC's place in comicbook history. Here follows some of the major *myths* about EC that have taken root, juxtaposed with the *real* facts which refute much of what has become known as the 'EC legend' over the years:

this page and next *Sample of covers for EC's three groundbreaking horror comic titles.*

The EC horror comics were the *only* horror comics to appear in the Fifties, and when people talk of Fifties horror comics, it is the ECs to which they are referring...

It's amazing how many comics enthusiasts — not just fans, but full-time dealers and professionals in the industry — believe this to be true! This is one of the main reasons for the appearance of the book you're now reading! Even a cursory glance will prove that nothing could be further from the truth — the ECs made up only a small portion of the vast amount of horror comics which were published in the USA between 1948–1955.

SCAPEGOATS

The EC's were the *first* horror comics...
Not true, either. This is a myth which many believe even today — a situation perpetrated by dilettante 'researcher' Digby Diehl in his 'Complete History of EC Comics', *Tales From the Crypt: The Official Archives*. Here a contrived piece of wrangling manages to side-step the tricky point that EC *didn't* publish the first horror comics by attacking every other publisher with the suggestion they ripped EC off with vastly inferior products.*

It's a subjective issue as to whether EC or their competitors produced the best horror comics of their day, but it's a different matter regarding the cold facts that follow:

The first genuine horror feature in comics appeared in Levy's YELLOWJACKET #7 and #8 (early 1946; no specific cover-dates) which showcased '**Tales of Terror**', complete with an *old witch* 'host'-type character stirring a boiling cauldron and tittering away to herself insanely... sound familiar?

The first horror comic book proper, which featured the soon-to-be-familiar anthology format of illustrated terror tales throughout, was Avon's EERIE COMICS #1, appearing in late 1946 (cover-dated Jan 1947).

Then followed ACG's ADVENTURES INTO THE UNKNOWN #1 (mid-1948; no specific cover-date), the first continuing horror comic which had amassed a run of *10 issues* before EC got in on the act, suddenly changing the title of their own CRIME PATROL to THE CRYPT OF TERROR (later TALES FROM THE CRYPT) after a couple of successful horror 'try-outs'.

However, before this happened, Atlas' AMAZING MYSTERIES #32 came along (May 1949) and the long-running Golden Age title, MARVEL MYSTERY converted to horror from #93 (Aug 49) onwards and was renamed MARVEL TALES (*'The Ghoul Strikes!'* shrieked the garish cover!). Even CAPTAIN AMERICA got the horror makeover, becoming CAPTAIN AMERICA'S WEIRD TALES! (#74 and #75, Aug and Dec 1949). Then came another Atlas title, SUSPENSE #1 (Dec 49). Finally, in April 1950 came EC's CRYPT

*In a short chapter entitled 'The Copycat Brigade'.

GHASTLY TERROR!

left YELLOWJACKET's Old Witch, pre-EC style!

right A portrait of Bill Gaines surrounded by his horror-hosts — Al Feldstein's wonderful commemorative plaque, personally signed by several of the original EC artists, as it appeared in the limited edition hardback of Digby Diehl's EC tribute Tales From the Crypt.

OF TERROR #17 — not the *first* horror comic title ever, but the *eighth*... Not even the *first continuing* horror comicbook, but the *fifth*. Whichever way you look at it, these are the facts.

Er, well, OK — but despite all this EC was the highest profile publisher of horror comics with the biggest output...

Not true, either! Between 1948–1955 (after which the Code spoiled all the fun) EC published 88 horror comics in three titles — no mean feat. Still, Atlas published 399 horror comics in 18 titles, ACG published 123 horror comics in five titles, Ace published 98 horror comics in five titles and Harvey published 96 horror comics in five titles... By far and away the most prolific, it goes without saying, was Atlas — or, as they were to become known later, Marvel. And who can argue with this company's high profile? Similarly in their day, all of the above-mentioned companies were bigger, or at least as big, as EC, and were regarded as some of the top publishers in the industry.

OK! Enough facts and figures. What remains is that EC

produced the best talent of the era...

Undoubtedly. But not *all* the best talent of the era worked for EC. Let's look closer and we might find that other companies had at least an equal share of top talents.

Whereas EC had legendary names like Graham Ingels, Jack Davis, Johnny Craig, Jack Kamen, Wally Wood, *et al*, Atlas had Bill Everett, Joe Maneely, Gene Colan, Stan Lee, Sol Brodsky, Joe Sinnott, Tony DiPritta, *et al*... Prize had Jack Kirby and Steve Ditko... Harvey had Bob Powell, Rudy Palais and Howard Nostrand... Ajax-Farrell had Jerry Iger, Will Eisner and Matt Baker... Gillmor had Basil Wolverton and Bernard Bailey (who would go on to execute the designs for the world famous *Mars Attacks* bubble gum cards). Standard had Alex Toth and Jack Katz... Should I go on?

No, no! Anyone who knows anything about the history of comics would know that these writers and artists are all equally legendary figures in the field. But EC produced the best plots and stories — that's the most important thing...

A lot of people adore the EC plots due to their instant recognisability — their 'formula'. But sometimes their very standardisation can be too repetitive and unadventurous. Gaines and Feldstein had a strict policy regarding what type of plot-lines they would use, which created the famous EC 'house style', but which also effectively censured variety. Under the heading, 'Help Wanted', the following telling ad was placed by EC in an early Fifties issue of *Writer's Digest*:

> You should know this about our horror books. We have *no* ghosts, devils, goblins or the like. We *tolerate* vampires and werewolves if they follow tradition... We'll accept an occasional zombie or mummy. We love walking corpse stories and we relish... tales of sadism...

This makes it clear that EC's editorial policy was strict and formula-based, unlike the bizarre tales churned out by the more 'whacked-out' publishers, in which absolutely *anything* goes. For a lot of people's money, these incredibly strange horror comics are more fun, or alternatively, more disturbing and effective than the relatively sophisticated ECs, which by compari-

below Wertham's <u>Malleus Maleficarum</u> for modern-day witch-hunters.

bottom The first horror comic book proper — cover for Avon's *EERIE #1*.

GHASTLY TERROR!

THE SURGEON MAKES A ROUGH SKETCH OF THE HUMAN FACE...

THIS AREA IS KNOWN AS THE INFRA-ORBITAL REGION...

*Following the Comics Code, EC launched their 'New Direction' comics, a strange array of short-lived and largely uninspired titles such as EXTRA (cover, **above**), PSYCHOANALYSIS and MD (panel from 'New Outlook', MD #4, **top**).*

son seem too 'logical' and 'civilised'. Another thing which goes against EC in this context is their verbosity. Sometimes their huge and frequently unnecessary narration blocks (they explain what's going on instead of letting the pictures tell that aspect of the story) make the tales seem laboured and long-winded... In the same sense that a long, circuitous telling of a joke can ruin the punch-line...

In conclusion, it's all down to personal taste, but it's not a Sacred Truth that EC produced the 'best' horror stories in comic form. If you like spooky tales of ghosts, demons, black magic and the devil, they certainly *did not*!

Fair enough, but EC carved out a niche because they *cared* about the fans. They could be bothered enough to create feedback. Gaines' and Feldstein's hospitality towards awe-struck kids who visited their offices is refreshing in an era of quick exploitation...

This is a good point. Larry Ivie (in *Scary Monsters* #25) makes the comparison between visiting the EC headquarters, where he was made welcome, and the offices of Atlas Publishing, where everyone was too busy to deal with a young kid, and he couldn't even get to lay eyes on the czar himself, Stan Lee. But all this hits the nail on the head: when the Comics Code Authority effectively banned the horror comics, the ECs were remembered primarily *not for their outstanding quality*, but for the feeling they'd given to their young fans of belonging to a special social group — the EC Fan-Addict Club, for instance. It was out of this background that the first comic conventions emerged and serious collecting began. EC effectively created the comicbook 'nerd'!

You're not going to win many friends with this section of the book, are you? But to press on, what about William Gaines' lonely stand against the Code and its governmental representatives during the senate hearings into the possible causes of juvenile delinquency? Here, EC showed its uncompromising mettle and its integrity.

Gaines was brave indeed — or in professional terms,

SCAPEGOATS

foolish. This book purposefully intends *not* to go too deeply into the proceedings of the senate hearings and the creation of the Comics Code Authority because it is covered at length in almost every other book on the subject of comic history (the interested reader is referred to the Bibliography at the back of the present volume). However, stated briefly, the hearings were under the jurisdiction of Senator Estes Kefauver, whose committee investigating juvenile crime and related matters met amongst much media hype in the New York courthouse in Foley Square on 12 April, 1954. The star witness lambasting comics as *the* premier bad influence on the youth of the day was Dr Fredric Wertham, author of the famous *Seduction of the Innocent*, a paranoid tract which revealed much more about its author than his actual subject.

When Gaines took the chair (giving his famous answers to questions about good and bad taste, and the depiction on comic book covers of severed heads), it was obvious that despite generations of EC supporters' claims, he was badly out of his depth. I think he felt he'd been set up by journalist Lyle Stuart, who had persuaded him to testify without the support of any of his colleagues in the comic book publishing field. Whilst they had intelligently declined to be made scapegoats, Gaines had sacrificed himself at the behest of his own vanity, naïvely believing he could make an appeal to the better judgement of this gang of rabid witch-finders. In the midst of the proceedings, deranged and paranoid himself on amphetamine-based slimming pills, Gaines lost his composure and left Foley Square a defeated and humiliated man. Shortly afterwards, he lost all interest in continuing to co-plot the horror books (hence the *Writer's Digest* ad quoted above) and began to feel the newly created Code administrators were out to get him personally. Part of his belief was founded in the subsequent banning of any comics with the words HORROR and TERROR (see Appendix II) in the title, ludicrously claiming these words had been chosen specifically as a way of victimising EC. Even a cursory glance at the A–Z listing of other publishers' output (Appendix I) shows this to be nothing more than a paranoid delusion. Gaines presented himself henceforth as a martyr to the comic book cause who had gone out on a limb where others feared to follow — and yet, unlike the majority of his contemporaries, Gaines had in fact given up. Unwilling to ride the punches and change tactics like many of their contemporaries — who had altered their titles and toned things down to suit the

below The 1954 Comics Code seal of approval.

bottom Samples of Code-approved mayhem from Marvel: TALES TO ASTONISH and TALES OF SUSPENSE.

Ghastly Terror!

The Code at work, before and after. Doctored panels for the strip 'No Place To Go', which originally appeared in HAUNTED THRILLS #18.

Authority's requirements — EC threw the towel in. Gaines disguised the fact that he'd lost the stomach to continue publishing the type of comics he wanted by claiming he could no longer have his artistic integrity challenged.

But this is strange, because a few years earlier he seemed to have no real problem with censorship, having subscribed to an earlier incarnation of the Code along with 11 other publishers (out of a total of 35 at that time) who formed the Association of Comics Magazine Publishers (ACMP) which dictated standards prohibiting obscene language, scenes of torture, and so on. The ACMP had also prohibited the use of the word TERROR in comic book titles. Gaines seemed to have no sense of martyrdom when, in complying to ACMP rules, he toned down the title of THE CRYPT OF TERROR to TALES FROM THE CRYPT… Similarly, Marie Severin, the

SCAPEGOATS

colourist at EC, was given carte blanche by Gaines to splash a disguising wash of deep blue or green over any 'offending' image to tone down its impact, a ploy which rendered some illustrations more than obscure once the comic had been printed. Gaines went on to found the MAD magazine empire, and after a brief fling with unwieldy 'picto-fiction' magazines, abandoned comicbooks altogether. Since then, and up to his death in 1992, he has been the victim of his own PR, emphasising the old adage that if the same story is repeated often enough it will eventually be believed.

What I hope to have done here is killed a few sacred cows and raised some doubts. It hasn't been my intention to 'trash' Gaines, or EC. Despite all I've said I still think EC produced some of the best comics ever published. I just think it's about time those who profess to be interested in comics — and in their wider cultural ramifications — dug a little deeper and stopped regurgitating information without thinking. If I have dared to knock EC, perhaps someone else with more inside information will also dare... There's more to horror comics than EC.

See for yourself in Appendix I, an A–Z of precode horror comic publishers.

The real horror comic boom between 1951–1954 produced an average of over *fifty* horror comic titles on the newsstands, each and every month. One can understand the real

top Safeguarding the nation. Kefauver's hearing pinpoints the culprits.

above The precode Code of approval from the ACMP — Gaines' secret code.

GHASTLY TERROR!

this page The Code took umbrage at walking skeletons, as can be seen in 'The Fleshless Ones' above (origin unknown). Skulls and bones became men in cloaks and cowls when the strip was reprinted post-Code.

next page More censorship in 'The Fleshless Ones'... Panels with skulls are subjected to some rather obvious cut-and-pasting.

power of the Comics Code Authority in noting that this amazingly high figure had been decimated to two or three lukewarm, Code-approved titles by the Spring of 1955 — taking out industry forerunners EC and many other smaller fry in its wake. It would take almost 10 years before horror comics returned with a vengeance. In the meantime, there was an unspoken sense of shared guilt surrounding the comics' industry scapegoats who had been made to take the blame for all society's ills. Kefauver, Wertham and co. had struck an unprecedented victory against freedom of speech and expression in a popular printed medium, their subsequent reputations based on entirely bogus psychological and sociological claims made by Wertham's specious thesis in *Seduction of the Innocent*. The few horror related projects which turned up over the intervening years were, as previously stated, either very mild and inoffensive, or failed ideas such as EC's risible b&w 'picto-fiction' magazines, which, being neither fish nor fowl, proved totally uninteresting to both comic fans and fiction magazine fans alike. Other companies (such as Hastings with EERIE TALES, 1959) came up with similar formats, meeting with equal disinterest, these efforts folding after a single issue.

Still, with EC's understandable popularity, and the late Fifties–early Sixties 'Monster Movie' craze — out of which came James Warren's seminal FAMOUS MONSTERS OF

SCAPEGOATS

FILMLAND — things couldn't stay like this forever... Just as Warren began printing comic strip versions of classic horror films, such as '**The Mummy**' by former EC-er Joe Orlando in FAMOUS MONSTERS, publishers like Ballantine were issuing b&w paperback collections of EC horror tales, and Russ Jones was producing comic-strip versions of classic horrors, such as *Dracula*... Even Marvel were creating some haunting Jack Kirby and Steve Ditko tales in exciting new comics like AMAZING FANTASY, and their famous 'giant monster' tales began to appear in the likes of TALES OF SUSPENSE and STRANGE TALES — bizarre, demonic monsters with names like Zzutak, Moomba, Gorgilla, Goom, Groot; gigantic alien beings on a Lovecraftian scale! And Dell had begun publishing spooky 'one-shots' based on classic horror and ghost stories...*

It appeared the world was ready once more for unadulterated graphic horror. James Warren would be only too happy to oblige...

*Like Charlton, DC, Gold Key, etc., Dell's output is too 'mild' to be covered in any detail in the present book, and much of it seems more like 'stories with pictures' than proper comics, but with titles like TALES FROM THE TOMB, Dell produced a handful of interesting, if slight, horror comics.

GHASTLY TERROR!

COMICS TO GIVE YOU THE CREEPS!

Comics to give you the creeps! Jack Davis' cover for CREEPY #1.

THE FIRST, SUCCESSFUL b&w horror comic magazine was CREEPY, which emerged sometime in late 1964 (the first few issues are undated), coming out of the melting-pot of talent which had produced the illustrated stories for Warren's FAMOUS MONSTERS and MONSTER WORLD, Russ Jones' paperbacks, and the EC horror comics of the Fifties.

Although, as we have seen, the horror comics had continued in watered down fashion in dribs and drabs over the years, CREEPY made publishing history as the first full-blooded on-going horror comic since the days of the Kefauver hearings and the Comics Code. It was also the first magazine-style title to achieve any success in bucking the Code and surmounting the distribution difficulties previous publishers had encountered with the b&w magazine format.

Publisher James Warren had paved the way with his monster film mags, and the 'monster boom' which arrived with TV screenings of old horror films in the early Sixties* meant the time was right to resurrect the old horror comics in a format outside the jurisdiction of the Code.

In on all this from the outset was Oklahoma-born comic enthusiast, Archie Goodwin, and his New York art school pal, Larry Ivie. Ivie was a good friend of comic art genius, Al Williamson, who in turn knew Russ Jones, and it was out of this close circle of associates that a staff of top-class artists was assembled for the first issue of James Warren's pet project, CREEPY:

*Presentations like Shock Theatre came complete with punning, gurning hosts, Zacherly, Ghoulardi, *et al.*

64

COMICS TO GIVE YOU THE CREEPS!

Reed Crandall, Jack Davis (cover), Frank Frazetta, Gray Morrow, Joe Orlando, Angelo Torres, Al Williamson... Names to conjure images of fear and terror from the Fifties' Dark Age of comics!

Credited as #1 editor, Russ Jones was little more than a 'name'; the real work of script-writing and story creation being divided between Goodwin, Ivie, and artist Joe Orlando.

Orlando had been a rising star in the EC days with a real 'feel' for horror. The first issue of CREEPY kicks off with a nice piece of jungle exotica (set in 'comicbookland' Haiti). Illustrated by Orlando and entitled '**Voodoo!**', it has all the old staple ingredients of a classic precode tale: squalid, overheated setting, an arguing vindictive couple, primitive rituals, and a shrunken head. What more could you ask for! The inaugural issue continues in fine style with Goodwin's '**Vampires Fly at Dusk**', illustrated by the ever-on-form Reed Crandall. This one tells the tale of Count Orsini, who is suspected of being a vampire by his young bride, Elena, because of the strange hours he insists they keep — sleep all day, live at night. Little does Elena realise this strange routine is actually for *her* benefit. Count Orsini is not the vampire — it is the amnesiac Elena herself. When she throws aside the heavy curtains to expose the count to the light of dawn she unwittingly destroys herself.

Next, Larry Ivie gives us '**Werewolf**', another jungle tale illustrated by the legendary Frank Frazetta. This story is unique on two fronts: Its the only full-length story to appear in a Warren magazine by Frazetta, and it's the only story to be narrated by a host named Julius (a skeletal dude with a cowl) rather than by the tittering, gnarled old codger Uncle Creepy... Obviously modelled on the old EC hosts, Uncle Creepy strikes the reader as a fixture of the magazine immediately; a character who just 'clicks' and 'seems right' from the inception. When his ugly mug went missing from some of the later issues things never seemed the same...

The best story of the first issue is Goodwin's '**The Success Story**', rendered beautifully by his old pal Al Williamson. By all accounts based on a true incident,* it tells the tale of talentless and unscrupulous comic strip creator, Baldo Smudge, who makes a success of himself and his daily newspaper strip by hiring a team of top talents — a writer, an artist and an inker — telling each of them that he is performing the others' tasks; to the writer he says he is the penciller and inker, to the penciller he says he is the writer and inker... You get the idea. Inevitably, the trio of duped talents get

Hello boys and girls... Uncle Creepy.

* According to George Evans (*The Comics Journal* #177): "That was based on the guy who 'drew' *Dan Flagg*, Don Sherwood... The first parts of it were art swipes from Alex Raymond's *RIP Kirby*, and as the schedule hit him, producing strips seven days a week plus the story, he began to hire other people to do it. These included Al Williamson... myself and ... Wally Wood... He hired a whole slew of people and it turned out, as we talked to each other, that that's what was happening. He was buying the story, buying the art and everything else, but his name was signed large and clear on all these strips... The guy was a real pain in the ass."

Ghastly Terror!

Goodwin and Williamson make the big time in 'The Success Story', CREEPY #1.

**See Larry Ivie's article, 'EERIE: The Beginnings' in Monster Memories Yearbook 1998.*

their heads together one night in a bar and work the situation out. Confronting Baldo later that night, they announce: 'We're on to you, Smudge! Without us your strip is nothing! We want what's coming to us!' Baldo happily complies by shooting the three of them and dumping their bodies in the docks... 'I've been expecting this might happen for some time', he muses, 'Why do you think I had you getting so much advance work done?' But some nights later, the ghastly trio emerge from their watery grave to exact their revenge... All that's left at the end of the story is a curious picture depicting a terror-stricken Baldo being attacked by three rotting corpses! 'I've never seen him use coloured inks before...' comments Baldo's wife. 'This isn't drawn with coloured ink', says the head of the comic strip syndicate, '...it's blood!'

Flushed with success, Warren was so pleased with this First Collector's Edition of CREEPY (subtitled 'comics to give you the creeps') that he held a celebratory steak dinner at the Cattleman restaurant in New York for everyone concerned — a rare gesture of magnanimity from a man who was still to owe Larry Ivie his first issue's scripting fees over 30 years later.*

The classic CREEPY style, with its gloomy atmosphere and other-worldliness, continued into the second issue with the first of many excellent Frank Frazetta covers. Here he depicts a scene from Goodwin's shape-shifter story '**Spawn of the Cat People**', illustrated by Reed Crandall. Also good this issue is old-time pulpster Otto Binder with his tale '**Wardrobe of Monsters**', illustrated by Gray Morrow, in which a student of the Black Arts wears the astral forms of various ancient monstrosities to bump off his adversaries. A novel idea, the last page of the tale is completed by an uncredited Angelo Torres, who also turns out some fine work on Goodwin's excellent fantasy, '**Ogre's Castle**', in which a knight

66

in shining armour comes to the aid of a fair damsel in distress, only to be transformed into a grotesque, hunchbacked familiar, as the damsel is really a sorceress. Life just isn't fair, is it? All this gothic moodiness is broken only by the first instalment of Binder's lo-fi, sci-fi series '**Adam Link: Robot**', which seems entirely out of keeping with the CREEPY atmosphere, despite the appealing artwork of Joe Orlando.

Issue #3 has another superb (and scary) Frazetta cover, depicting a rotting spectral form beckoning from beneath a crumbling archway. This issue includes the first of Goodwin's Poe adaptations, '**The Tell-Tale Heart**', once more illustrated by Crandall. Goodwin turns out five of the six stories this issue, so it's no surprise to see him promoted to Story Editor. However, it's ironic that the best tale is Arthur Porges and Joe Orlando's '**Return Trip**', a real slice of EC style grue about a husband who returns from the grave to exact revenge on his cheating wife and ex-business partner. In the horrific finale, the ex-partner gets strangled to death by the rotting corpse, while the wife faces the veritable fate *worse than death*: 'I'm not going to kill you, my sweet wife! We're going to live together like any normal couple should! Forever and ever! Now give your husband a great big kiss!!!' Yuck!

With a vampire tale set in the swamps ('**Swamped**', artwork by Torres) and an amusing werewolf tale in a domestic setting ('**Howling Success**', also rendered by Torres) CREEPY #3 is a fully rounded-out effort by all concerned.

Now that the CREEPY 'formula' had been established and proven to be successful, all that remained was to give the readers more! The first step in this direction meant a page increase for #4, from 52 to 60 pages (though some of this extra space was wasted on Warren's always gratuitous amount of advertising...). Featuring Frazetta's best cover so far, CREEPY #4 is the first Warren mag to be fully edited by Archie Goodwin, who with this issue makes the final step to the creative command post. Not that there would have been much bickering anyway, as once more Goodwin turns out five of the stories, excluding only the second episode of Binder's incongruous '**Adam Link**'.

All Goodwin's stories are entertaining and well-written; the birth-of-Uncle Creepy tale

Frazetta's art defines the world of the CREEPY! Cover for issue #3.

GHASTLY TERROR!

The old codger as a young codger in 'Monster Rally', CREEPY #4.

'**Monster Rally**' harks back to EC's '**Lower Berth**' — in which a similar blasphemous union results in the creation of The Crypt-Keeper! — and '**Curse of the Full Moon**' is an exemplary werewolf tale. But perhaps the best of the bunch is a Morrow-illustrated version of Ambrose Bierce's '**The Damned Thing**' — a truly outstanding effort which ranks as one of the very best 'classic' adaptations to appear in a horror comic.

With an expanding page-count comes an expanding line of artists (if not writers). CREEPY #5, Oct 65 (the first issue to be dated) features the début of that great comics innovator, Alex Toth, illustrating Goodwin's '**Grave Undertaking**', a story of corrupt undertakers and vengeful vampires (hmmm, why does all this sound so familiar...?). The issue's other highlight is '**Revenge of the Beast**'. Immaculately drawn by Gray Morrow, it's an Old West tale in which a gang of varmints do away with an old injun, who curses them as he dies with the *Kwi-uktena* — the 'devil-beast-that-walks-like-man'. This is no 'ordinary' spirit of vengeance, it is a spirit that can enter the bodies of evil men and bring out the Beast that is evil in man's nature, causing the gang to rip one another to pieces. Goodwin wrote all six stories this issue, including a good adaptation of Bram Stoker's '**The Judge's House**'.

For #6 (Dec 65) Frank Frazetta created one of the magazine's most powerful, effective covers: the demonic '**Gargoyle**', which illustrates Goodwin and Torres' gloomy tale of medieval alchemy and demonology. Making his first appearance this issue is the superb John Severin, who illustrates the Bill Pearson tale '**Abominable Snowman**'; but the highlight remains one of Larry Ivie's last Warren efforts, '**The Thing in the Pit**', in which the victim of a car smash is forced to spend the night in an old backwoods manse among an assortment of blind, scaly, albino freaks who keep a beau-

COMICS TO GIVE YOU THE CREEPS!

tiful young woman imprisoned in a deep pit in their cellar. But, as per usual, there's more to this than meets the eye... Really, the girl is the freakiest of all, as our hero finds when he is thrown into the pit with her... 'Gotta get out of here... but how? Wait! This feels like... a rope... No! It isn't a rope... it's... YAAAAAAH!' The girl strangles him with the long, ropy tentacles she has for arms...

Anyway, what gives, here? Archie Goodwin writes only three of the seven stories featured this issue! Can this have anything to do with an advertisement announcing the first issue of a CREEPY-companion title named EERIE? Thereby hangs a tale... As Goodwin himself explains:

> By the time the second issue of CREEPY was out, Warren was already planning two more titles. The first was a companion magazine to CREEPY, which — after much debate... — became EERIE. The second was BLAZING COMBAT*... EERIE, which would last much longer than BLAZING COMBAT, had a more troubled beginning. Once we finally settled on the title, we began promoting it in CREEPY. Then Warren discovered that another publisher who used the same distributor was bringing out an imitation of CREEPY and intending to call it EERIE.† In the late Fifties, there had been a one-issue attempt at a b&w horror comic; its title was EERIE [TALES]. With its failure, rights to the title had lapsed. Now, whoever got their version of EERIE out first would have new claim to the title. Since Warren's rival was going to be reprinting material from the Fifties there seemed little chance of beating them into print... The distributor was after Warren to give in as the other publisher had a

*A short-lived war comic with the same editorial and creative team which ran only four issues.

†In fact Warren had got the wrong end of the stick here — the company in question was called Eerie Publications, and their mag was entitled WEIRD (see chapter: *Shoddy Duplicates*).

below Another Frazetta cover masterpiece: CREEPY #6.

bottom Morrow's Wild West is beastly. 'Revenge of the Beast', CREEPY #5.

69

GHASTLY TERROR!

A devil of a time as EERIE's premiere issue has to be numbered #2.

*See Archie Goodwin's article 'The Warren Empire: A Personal View' in GORESHRIEK #5, 1988.

†Larry Ivie, 'EERIE: The Beginnings', *Monster Memories Yearbook 1998*.

‡*Eando* Binder: a pen name adopted by brothers Earl and Otto Binder when working together.

**This image, more than anything else led me into developing an early fascination with Demonology and the Occult.

larger line of magazines and was therefore considered a more valuable customer. Warren had one day before he was scheduled to meet with the distributor and the other publisher to argue his case. [So we used] some inventory material from CREEPY as well as some material already printed [and] cobbled together a pamphlet size little magazine emblazoned with the EERIE logo... By the next morning there were 200 copies of 'EERIE #1' in existence... When he went into his meeting, Warren tipped the newsstand operator outside his distributor's building so that several copies of our freshly printed 'magazine' would be displayed.*

As a result, the 'other publisher' and the distributor had to capitulate. But what was really gained by this calculated scheming? As the then-departing Larry Ivie has noted

The possible record, in publishing, set by Warren was not for re-using an already over-used title... but using it for the *seventh* time!†

In the meantime, it was more like business as usual with the seventh issue of CREEPY (Feb 66) — and what an excellent issue it is. No '**Adam Link**' and seven top-notch tales illustrated by a confident art staff in absolutely top form. '**The Duel of the Monsters**' (Goodwin/Torres) is a monster bash-up featuring a werewolf vs. a vampire; '**Image of Bluebeard**' (Pearson/Orlando) is an EC-style black comedy about a young wife mistaking her secretive husband for a murderer; '**Rude Awakening**' (Goodwin/Toth) is the story of a nightmarish premonition about enforced surgery; '**Drink Deep!**' (Binder‡/Severin) is a Jolly Roger tale of zombie pirates; '**The Body-Snatcher**' (Goodwin/Crandall) is a superb version of RL Stevenson's classic tale; '**Blood of Krylon**' (Goodwin/Morrow) is perhaps the best of the lot — about an interstellar vampire who gets caught-out by the sun on a planet where night lasts only four hours! The issue is rounded-out satisfactorily by '**Hot Spell!**' (Goodwin/Crandall) in which warlock Rapher Grundy exacts his revenge on the New England descendants of the folks who burned him at the stake.

Just about on a par with this classic issue of CREEPY is the first (official) Collector's Edition of EERIE (#2, Mar 66). Kicking off with a fantastic, demonic cover** by Frazetta,

COMICS TO GIVE YOU THE CREEPS!

EERIE #2 is perhaps the best début issue of a horror comic — ever! It also marks the Warren débuts of Gene Colan and EC legend Johnny Craig (under the pseudonym 'Jay Taycee'). Particularly good are these tales:

'**Footsteps of Frankenstein**' (Goodwin/Crandall), an enjoyable man-made monster opus in which Dr Byron King arrives in the gloomy Northern England town of Lower Kilburn to fill his new posting as assistant to monster-maker, Amos Sebastian. Byron must transplant the brain from Dr Sebastian's withering old body into an electrode-headed monstrosity he has in waiting. Upon successful tidings, the newly vitalised Dr Sebastian goes on the rampage — only to be reduced to a handful of ashes when lightning strikes his electrodes!

'**Vision of Evil**' (Goodwin/Toth) is the first of Goodwin's stories to be loosely based on Lovecraft, and is more than a little reminiscent of *Pickman's Model*.

'**One for De-money**' (E. Nelson Bridwell/Torres) is a superb Robert Bloch-style tale of a demonologist's greedy, grasping nephew who gets his just desserts in the hands (or claws) of the demon Oeillet... This story, written by pithy and talented E. Nelson Bridwell is, despite its corny punning title and second-hand premise, a subtly unnerving, atmospheric tale of greed and black magic. Bridwell went on to edit DC's line of horror-mystery titles in the early Seventies when they were at their peak.

Also of interest is the Craig story '**Eye of the Beholder**' in that it's very reminiscent of his old EC tale '**Till Death**' (see chapter: *Into the Abyss...!*). Grieving widower goes to wizened old necromancer, Lorenzo, to get Eve, his wife, back from the grave. The diabolical experiment is success-

The far-from-smooth birth of Cousin Eerie. Ad for EERIE.

GHASTLY TERROR!

> A STRANGE... INDEED SINISTER LEGEND LIES BEHIND THE DECAYING WALLS OF THIS CHATEAU...
> IT BEGAN 93 YEARS AGO ON A MOONLIT NIGHT, MUCH LIKE TONIGHT, WHEN BARON VON RENFIELD'S COACH WAS TRAVELING ON THE NARROW ROAD... COMING INTO THE SOUTHERN SLUM OF THE VILLAGE. THE HOUR WAS LATE, AND THE COACHMAN WAS DRIVING THE HORSES AT FULL GALLOP TO DELIVER HIS MASTER TO A LATE RENDEZVOUS....

Introduction to 'The Invitation', CREEPY #8.

ful — but only up to a point... Everyone else is terrified of Eve apart from Gerald (even Monty, their dog, drops dead!) and the last panel reveals why... 'Oh, no... Lord! No!' screams Gerald as he holds Eve in his arms in front of the bedroom mirror... *'The terrible realisation of just how limited Lorenzo's powers had been... working on Gerald's vision only! Nothing else... not even mirror reflections!'* Yup, Gerald sees in the mirror that in reality poor Eve is literally rotting away in his arms.

EERIE #2 is rounded off by **'Ahead of the Game'** (Goodwin/Orlando) — a story about the ghost of... a headless gorilla!

Another successful ingredient to these 'comics in the CREEPY tradition' is the inclusion of a gap-toothed, lumpy-faced host, Cousin Eerie. Now Uncle Creepy had someone to bicker and argue with over whose magazine and whose stories were best! Something else very much in the tradition of the old EC comics...

Next up was CREEPY #8 (Apr 66). With Frazetta's art duties now doubled — extending to provide additional cover art for EERIE as well — this issue of CREEPY features the first Warren cover by Frazetta-substitute Gray Morrow, a nicely coloured, atmospheric piece illustrating the first episode of Goodwin and Crandall's two-parter, **'The Coffin of Dracula'** — an enjoyable but rather hackneyed sequel to the classic tale, in which one Lord Varney inherits the king vampire's cape only to become dutifully possessed by its spirit.

EC veteran George Evans makes his long awaited CREEPY début this issue, illustrating **'Death Plane'**, a phantom pilot

COMICS TO GIVE YOU THE CREEPS!

story set in WWI. Less inspired is scripter Ron Parker's '**A Vested Interest**', which marks the début of veteran Marvel illustrator George Tuska, and concerns a werewolf who wears a bullet-proof vest to protect himself from silver bullets! Easily the best début effort this issue is '**The Invitation**', a story by the team of Englehart, Jones and Whitman, illustrated in fine detail by Manny Stallman. The tale concerns a nasty group of bloodthirsty vampires encountered one night by Baron von Renfield, who swears an oath that if they let him go free he will provide them with an endless string of surrogate victims. This is arranged via a series of elaborate, masked balls thrown by the illustrious Renfield in which the vampires secrete themselves awaiting their chosen victim! Not an original plot by any means, it just goes to show that if a story is produced with care and attention to detail, lack of originality need not be too much of a problem.

EERIE #3 (May 66) has some excellent material on offer, not least of which is the Goodwin story '**Room with a View**' — the 'view' in question being that perceived through a weird mirror in a haunted hotel room — illustrated in tremendous style by the great Steve Ditko. Goodwin commented on Dikto's Warren début thusly:

> Just leaving a comics-history making run in Marvel's SPIDER-MAN and DR STRANGE, [Ditko] surprised many people with his mastery of line and wash and his ability to give visual life to Lovecraftian-style horror.*

*Archie Goodwin, 'The Warren Empire: A Personal View', GORESHRIEK #5, 1988.

left 'Room with a View', Ditko's arrival at the EERIE hotel in issue #3.

right Frazetta's cover for CREEPY #9.

73

GHASTLY TERROR!

Ditko would go on to produce his very best work for Warren — but on the theme of 'Lovecraftian horror' you need look no further than this issue's superb '**Soul of Horror**', written by Goodwin and drawn by Angelo Torres in that night-black style of his which so epitomises Warren's classic early years. Based loosely on Lovecraft's *The Dunwich Horror*, '**Soul of Horror**' is one of Goodwin's crowning achievements in the horror comics field, and in my humble opinion (all you Lovecraftians out there: close your eyes, and cover your ears!) even manages to *improve* Lovecraft's original premise by streamlining the plot and concentrating on the character of grossly misshapen Lemuel Catlett (Goodwin's version of Wilbur Whately), as the transmigratory spirit of the warlock, Simon Hecate, forces the young boy's mind and body into hideously misshapen premature growth. It's a shuddersome tale alright, and arguably the best story *ever* to appear in an issue of EERIE.

Another débuter this issue is the artist Rocco Mastroserio who illustrates Goodwin's Frankenstein-type story '**Monsterwork**'. Frank Frazetta's effective cover illustrates '**Full Fathom Fright**' (Goodwin/Colan) — a tale about justly

left The incongruous Adam Link figures it out. Panel from 'I Robot', CREEPY #2.

right Ditko's screamingly good horror tale 'The Shrieking Man', EERIE #4.

74

COMICS TO GIVE YOU THE CREEPS!

Visions of his own death: Danforth's horror-struck eyes in Goodwin and Ditko's masterpiece 'Collector's Edition', CREEPY #10.

hydrophobic Bert Caine who transforms into a fishy monster when exposed to water!

And there is sterling work from Al Williamson, illustrating Goodwin's chilling ghost story, '**The Lighthouse**', and Joe Orlando, with '**Under the Skin**' — one of those horrible-makeup-that-won't-come-off stories. Very distressing for twisted thespian Leo Ernst, its wearer, who ends up writhing in agony screaming 'It won't come off! It won't come off!!' as he rips the skin from his blood-drenched face…

CREEPY #9 (Jun 66) has part two of the Crandall-illustrated '**The Coffin of Dracula**' and some superb work by Gray Morrow, Johnny Craig, and Alex Toth, who illustrate in fine CREEPY style these respective tales: '**The Dark Kingdom**', in which Argos the Spartan swashbuckles his way through Hades to save his soul, as his body lies between life and death on the battlefield (superbly presented by Frazetta as the issue's cover painting); '**The Castle on the Moor**', a gothic whodunit featuring a rival werewolf and ghoul; and '**Out of Time**', in which murderous gangster Joey Quinn exchanges places with 17th century warlock Isiah Curtin in order to beat the rap, only to be burnt alive at the stake by Curtin's witch-finding neighbours! Toth's stark b&w illustrations — as opposed to his usual use of shades and tones — lend the story an extra air of accomplished menace.

Another piece of comic art history is made by a young Berni Wrightson, who appears in the fan club pages with a gruesome drawing that oozes precocious talent, a certain indication that more would be heard from this mega-talent in the future! There is also some nice work by artist Wally Wood — yet another legendary name from the EC comics — and his protégé Dan Adkins, who illustrates the rather hum-drum in-joke '**Overworked**', about a horror comic artist whose mind snaps under the pressure of his work. (Cue nepotistic guffaws.) Much better is Goodwin's and Ditko's

GHASTLY TERROR!

*Gene Colan and Angelo Torres' masterful washes and tones: 'A Matter of Routine' (**above**) and 'Swamp God' (**next page, top**), both from EERIE #5.*

'The Spirit of the Thing', an excursion into hypnotism and the astral world in which the soul of unscrupulous double-dealing occultist, Professor Walden, becomes trapped in a hellish realm of demonic shadow-creatures.

The best story in EERIE #4 (Jul 66) is illustrated by Steve Ditko: 'The Shrieking Man'. This is Goodwin's tale of Dr Mandrell, a dubious character who seems to relish his 'mad scientist' role — the 'Shrieking Man' in question being one of his 'successful experiments'... New assistant Dr Colbert, is appalled by this endlessly screaming lunatic locked in his padded cell and is determined to find out the cause of his incurable madness, despite the warnings of Mandrell. Colbert's 'misplaced' concern leads to the shrieking man breaking loose... And also to the revelation that this man is in the grip of madness because in reality he has been resurrected from the *dead*... Not surprisingly, the shrieking man only finds peace when he wraps his fingers around necromantic Dr Mandrell's neck! The other highlights in this average-to-good issue are: Goodwin's '**Island at the World's End**', rendered by Morrow; complete with characters The Dread Shoggoth and Cthylla, this is another tale loosely based on Lovecraft, strongly reminiscent in parts to his famous novella *The Call of Cthulhu*... '**House of Evil**' is a gruesome tale illustrated by Orlando of a satanic family so evil that their corruption manifests as an 'oozing black slime' which grows like mould on anything it touches — truly horrible! So too is Ron Parker's

COMICS TO GIVE YOU THE CREEPS!

tale '**Gnawing Fear**' in which a new type of rat poison turns our furry friends into frenzied man-killers. Rocco Mastroserio's artwork was never better.

CREEPY #10 (Aug 66) is perhaps the best issue of any of these early, classic Warren magazines. It has a superb Frank Frazetta cover, illustrating Goodwin's and Mastroserio's '**Monster!**', a moody, man-made monster tale which cannot be spoiled even by the printer's mistake of getting the last three pages out of sequence! And there is also sterling work from Angelo Torres, illustrating '**Brain Trust**', a Goodwin tale similar to both '**Soul of Horror**' (EERIE #3) and '**The Head of the Family**' (one of those ol' BLACK MAGIC stories by Joe Shuster and Jack Kirby). Also featured are: Joe Orlando, with Goodwin's walking mummy story '**Into the Tomb**'; Johnny Craig, who scripts and draws the bewildering vampire tale '**Midnight Sail**'; Goodwin's ghostly cowboy story '**Backfire!**', illustrated by Gray Morrow in absolute top form; and the disturbing '**Thing of Darkness**' (Goodwin/Colan) which tells the tale of nervous Sid Avery, a man who fears the dark after a shocking encounter with a strange, demonic entity in the tunnels of the New York subway and forever after must surround himself by light... But what can he do when all the lights go out on Nov 9, 1965 — the night of the 'Big Blackout' which plunged the whole of New York into total darkness? Only scream...

But by far the best story in CREEPY #10 is Goodwin and

below Goodwin and Adkins open 'The Doorway' to Wolverton-esque monstrosities! CREEPY #11.

GHASTLY TERROR!

> SLOWLY, SOFTLY, THE DAWN GROWS AND EXPANDS INTO DAY...THE RAYS OF THE SUN SEEKING YOU OUT, SURROUNDING YOU, BATHING YOU WITH LIGHT...THEN, YOU FEEL THE PAIN...EATING AT YOU, BURNING YOU, **DESTROYING YOU!**

> AAAAGHHH! WHAT IS IT? **WHAT'S HAPPENING?!**

> **THE LIGHT!** WHY DOES IT HURT SO? WHAT'S IT **DOING?!**

> OH, NOOO! NOOOOOOOOOOOO!

*Neal Adams' mastery of technique on show in 'Fair Exchange', CREEPY #9 (**above**) and 'Voodoo Drum', CREEPY #10 (**next page**).*

Ditko's **'Collector's Edition'**; without a doubt in my mind, the best thing to ever appear in a Warren magazine... Book collector Colin Danforth spends all his shrewish wife's inheritance money on his collection of rare books and esoterica, much to her increasing displeasure. When he finds out that oily, taunting, bookdealer Mr Murch 'might be able' to lay his pudgy hands on a copy of arch-Satanist Marquis le Mode's ultra-rare book *Dark Visions*, his obsessive acquisitiveness goes into overdrive... 'Colin! Where have you been? You're never home... never spend your time with your own wife... Just my money!' — 'Not now, Audrey, I'm in a hurry...'

But when he gets to Murch with the bundle of cash he's breezed off with, the 'fat pig' is no longer selling... 'How I hated him!' narrates Danforth as he throttles Murch, 'hated the spittle-flecked jowls of his disgusting face turning now white, now red, now purple...' At last *Dark Visions* is in his possession. Like a man in a trance, Danforth goes to his study, ignoring his wife's shrieking protestations... 'A book?! Everything my father left me squandered on junk!' But when Danforth consults this 'junk' he finds its weird scenes shift-

ing from le Mode's hellish visions to views of his own recent past, even depicting him strangling Murch a few hours previously. Entranced, Danforth can't tear his gaze from the pages, even when the illustrations continue to depict his life in present-time, second by second... even when the book shows his wife entering the study with an axe to split his head in two!

'**Collector's Edition**' is a really superb tale, illustrated in finely detailed line-work by Ditko, who also uses the clever device of Danforth's eyes slowly closing at the foot of each page in a slow-motion premonition of his imminent death. In horror comic terms, this is the pinnacle of perfectly executed, seamless story-telling.

In the following months, the demonic duo of Uncle Creepy and Cousin Eerie turned out a roster of top-notch horror tales via the talented Warren staff — said to be locked in their dungeons! '**A Matter of Routine**' (Goodwin/Colan) in EERIE #5 (Sep 66), tells the story of one man's premature encounter with the spectral Fates who judge men in the afterworld. In the same issue we encounter '**The Swamp God**' (Goodwin/Torres) in which a surviving Tyrannosaurus Rex is worshipped by jungle natives as their god. In CREEPY #11 (Oct 66) we find Goodwin and Crandall's faithful version of Poe's '**Hop-Frog**', and '**The Doorway**' (Goodwin/Adkins) in which Black Magic is blended with science to uncover the doorway to another dimension; and best of all '**Beast Man**' (Goodwin/Ditko) which harks back to the old Monogram B-movies and concerns a boxer who turns unpleasantly feral when he receives a heart transplant from a gorilla! Another couple of superb tales by the same team

GHASTLY TERROR!

top Good Morrow, Gray werewolf! Cover: CREEPY #13.

above Warren heading for the chop. Cover: CREEPY #17.

are: **'Deep Ruby'** in which a man's soul is drawn into the demonic dimension at the heart of an enchanted stone (EERIE #6, Nov 66), and **'Blood of the Werewolf'** (CREEPY #12, Dec 66) in which a stranger is forced to have a blood transfusion by a mad doctor trying to save his lycanthropic son. **'Scream Test'** by John Benson and Bob Stewart, with Torres artwork, appearing in CREEPY #13 (Feb 67), is a tale of a latter-day Phantom of the Cinema, as opposed to the Opera. **'Demon Sword'** (EERIE #8, Mar 67) is another superb occult tale by Goodwin and Ditko about an unearthly sword excavated in the Andes by Professor Brace, which releases all his subconscious evil in the form of a demonic tulpa which wields the demon sword, destroying Brace's colleagues (or, as the evil part of his mind thinks of them, rivals) at the museum. Plunged by his assistant, Harcourt, into a deep hypnotic trance, Brace must battle the ancient evil within him, but does so only with the result of destroying himself, as 'you can't kill part of a man without destroying the whole!' This fascinating Manichean tale evokes a real sense of awe with regard to the ancient past and mankind's spiritual origins. EERIE #8 also features the superb **'Day after Doomsday'**, a post-apocalyptic tale of mutants and cannibals written, again, by Goodwin, and illustrated with stunning detail by Dan Adkins. **'Wolf Bait'**, plotted by Buddy Saunders and drawn by Mastroserio is an amusing werewolf opus in which the unfortunate lycanthrope is finished off by an injection of silver nitrate!

CREEPY #14 (Apr 67) features the Warren début of comic superstar Neal Adams, who beautifully illustrates Goodwin's gothic tale **'Curse of the Vampire!'**. In the same issue, **'The Beckoning Beyond'** is Goodwin/Adkins' take on the theme of advanced scientific machinery and Black Magic opening up a dimensional doorway to an inky void populated by weird, bat-like entities. EERIE #9 (May 67) — perhaps the best all-round issue of this particular title — offers another Goodwin/Adams vampire tale, **'Fair Exchange'**, in which a greedy old codger pays to have a young man abducted so that he can exchange bodies with him, only to get burnt to death by sunlight when the 'young man' in question turns out to be a vampire... And a walking mummy tale where the shambling guardian of the tomb turns out to be trying to protect, rather

COMICS TO GIVE YOU THE CREEPS!

> THE REVEL WENT WHIRLINGLY ON, UNTIL AT LENGTH THERE COMMENCED THE SOUNDING OF MID-NIGHT UPON THE CLOCK; AND THERE WAS AN UNEASY CESSATION OF ALL THINGS AS BEFORE. BUT NOW THERE WERE TWELVE STROKES TO BE SOUNDED, AND A MUCH LONGER TIME TO PAUSE AND THINK...

> THERE AROSE AT LENGTH FROM THE WHOLE COMPANY A MURMUR OF FIRST SURPRISE, THEN TERROR, HORROR, AND FINALLY, DISGUST...

> SIRE, THE FELLOW GOES TOO FAR! EVEN AMONG THE UTTERLY LOST TO WHOM LIFE AND DEATH ARE BOTH JOKES, THERE ARE MATTERS OF WHICH NO JEST CAN BE MADE!

> BEFORE THE LAST ECHOES OF THE LAST CHIME HAD UTTERLY SUNK INTO SILENCE, THE MOTIONLESS DANCERS BECAME AWARE OF THE PRESENCE OF A MASKED FIGURE WHICH HAD ARRESTED THE ATTENTION OF NO SINGLE INDIVIDUAL BEFORE...

Poe would have approved. 'The Masque of the Red Death', EERIE #12.

than destroy, the archaeologists — this time from an immortal ghoulish pharaoh, stalking the tomb after being interred alive. Also this issue is Goodwin and Adkins' atmospherically chilling '**The Wanderer**' — a lost soul story about a hospital patient who tells the tale of his hellish two-year stint in the beyond before crumbling away before the doctor's eyes… 'It looks like … someone who… has been dead for at least two years!'

'**The Terror Beyond Time**' is another Goodwin/Adams magnum opus which appears in CREEPY #15 (Jun 67), managing to successfully combine plot threads from Edgar Rice Burroughs' *Pellucidar* series and Bulwer-Lytton's occult Hollow Earth novel *The Coming Race* to great effect. At 16 pages in length, it's also twice as long as the average War-

GHASTLY TERROR!

ren story.

Highlights of EERIE #10 (Jul 67) are Bill Pearson and Joe Orlando's bizarre swamp story '**The Slugs**', and yet another Goodwin/Adams tour de force '**Voodoo Drum**', a really good piece of horror comic exotica with all the usual zombie trimmings, rendered by Adams in subtle soft pencils.

The quality continues with the covers too: Frank Frazetta turning out superlative work for CREEPY #11 (illustrating '**Beast-Man**'), #15 ('**Terror Beyond Time**'), #16 ('**A Curse of Claws**' — Goodwin and Adams' in the jungle with a were-panther tale), #17 ('**Heritage of Horror**' — Goodwin and Donald Norman in gothic style telling the tale of mad executioner John Daxland... Another story seemingly influenced by Goodwin's childhood memories of reading BLACK MAGIC); and EERIE #5 ('**Swamp God**'), #7 ('**Witches Tide**' — Goodwin/Colan's tale of tainted New England ancestry) and #8 ('**Demon Sword**'). There are also some surprises from Dan Adkins (EERIE #9) and Joe Orlando (EERIE #11) who exhibit equal skill as cover artists as ever they did in the comic-strip format.

But it seems that all good things must come to an end, and with the creation of CREEPY #17 (Oct 67) and EERIE #12 (Nov 67) Goodwin decided that his tenure as Editor must finish. Before he left he welcomed aboard yet more class-act contributors in the form of Jerry Grandenetti, Jeff Jones, Rick Estrada, Roger Brand and, most importantly, Tom Sutton, whose adaptation's of Poe's '**The Masque of the Red Death**' in EERIE #12 is a real gem. But as good as these additions were, they couldn't make up for the mass-exodus of artists who departed with Goodwin. The two issues already mentioned proved to showcase

Rayond Marais' brilliant story 'The Rescue of the Morning Maid', perpetrated by Rocco Mastroserio and Pat Boyette. CREEPY #18.

COMICS TO GIVE YOU THE CREEPS!

left Get with it... Uncle Creepy and Cousin Eerie's new ghoul-friend, the seductive Vampirella.

right Richard Corben shows early promise with the cover for EERIE #32.

the last original contributions from Angelo Torres, Joe Orlando and Gray Morrow — and Steve Ditko had already departed after drawing the surrealistic **'Sands that Change'** in CREEPY #16. It was a while (to the fans it seemed like an age) before Frank Frazetta, Reed Crandall, Neal Adams, Alex Toth and Al Williamson returned.

The official reason for all this, as noted in Warren's letter pages, was that everyone was suddenly 'busy... tied up elsewhere'; but the fact of it was that James Warren wanted his contributors to work for increasingly lower rates of pay as he entered into a period of 'financial difficulty'. Never one to curry favours when it came to finances, Warren's alleged mean streak was reciprocated by one creator after another when mediator Archie Goodwin left the scene (he

GHASTLY TERROR!

Tom Sutton proving that 'Spiders Are Revolting!' in EERIE #26.

went on to work for Marvel and DC before returning to Warren, on and off, in later periods). This meant that only the newcomers like Tom Sutton, and the staff of replacement contributors which Warren drew upon — more concerned with kudos than cash — could be tempted to stay in the fold.

At first this seemed to make little difference — CREEPY #18 (Jan 68) is an excellent issue! Well, OK, admittedly, a Vic Prezio, as opposed to a Frazetta, Morrow or Adkins, cover, is a bit lame, and the lead-off story ('**Footsteps of Frankenstein**') is a reprint from EERIE #2, but the rest of the issue is comprised of first-rate original material... Particularly good is '**Mountain of the Monster Gods**' by Ron White (débuting writer) and Roger Brand, in which brothers, evil Carl and saintly Sinclair, become united in death as they sink together into *'that primal matter from which oozed the monster gods'*... 'I have become part of the primal ooze!' narrates the disgusted Carl, '...and with me, part of me... is the consciousness of Sinclair! My brother... my colleague... my *self*!' And all this happens inside a tremendous vault within a hollow mountain in which untold treasures are said to exist. Is it ever worth it, I ask you?

Also good this issue is Johnny Craig (dropping the pretence of being 'Jay Taycee') with the Hollywood werewolf tale, '**Act, Three!**'... But by far the best, and one of the greatest tales to appear in a Warren mag, is Raymond Marais'

'**The Rescue of the Morning Maid**', illustrated by Rocco Mastroserio (with uncredited assistance by débuting artist Pat Boyette, later prolific contributor to Skywald and Charlton, as well as Warren). The story is set in an eerie nightworld atop abandoned ruins, where a hatchet-faced old sorceress has eternally imprisoned an old love-rival in the body of a small girl. The little girl's plight is witnessed by a hideous creature who observes the pair from the shadows, feeling sorry for her when the girl loses her doll. But in finding it, and returning it to her, the creature reveals his presence to the old bag and things come to a head. The out-of-shape old sorceress lunges at him, and smashes through the rotten floor of one of the roofs, falling to her death. Jubilant, the creature races back to the little girl, shouting in his excitement, 'Emma! Emma! You're free! The old hag... she's dead!' But she's free in more ways than one: Emma's body ages and crumbles away to dust now that the sorceress' spell has been broken... *'As for him... he lumbered off into the gloom which was his world — a strange, torn doll gently resting in his arms...!'* What a grotesque, truly *strange* tale this is, aided in no small part by the excellent artwork which depicts the decaying nightworld in all its glorious squalor. Outstanding.

I wish the same could be said for the next dozen-or-so issues of the Warren magazines, but sadly it's not the case. Whereas the exodus of first-rate talent didn't take immediate effect, only a couple of issues later things had seemingly gone to pot with reprint after reprint standing in as filler for the paucity of original material — only occasional works by Tom Sutton, Ernie Colon (not always hitting the spot, it must be said), Tony Williamsune and Pat Boyette standing amongst the re-treads... And this at a time when Warren released the first of the annual yearbooks: Best Of collections which would have had some real validity if not for the gratuitous reprint situation in the regular issues...

Despite the difficulties, throughout 1968 and 69, with only occasional highlights — such as CREEPY #21's Lovecraft adaptation, '**The Rats in the Wall**', illustrated nicely by Bob Jenney — these years under long-suffering editor Bill Parente (an ex-sailor in the US navy drafted in by Warren shortly after Archie Goodwin's departure) eventually gave way to improved new material, less re-

Another Spanish master, Luis Garcia, gives Warren a face-lift. 'The Man Who Called Him Monster', CREEPY #43.

GHASTLY TERROR!

prints and more all-round general quality. Never one to be cowed by adversity, Warren rallied to the challenges of his day-to-day existence by announcing a new horror comic magazine in the pages of CREEPY #29 (Sep 69) featuring a voluptuous femme fatale by the name of... Vampirella.

In many ways Vampirella revived the whole Warren cause, and although the 1970/71 issues of the Warren line still show signs of patchiness — and in some instances, outright shoddiness — in retrospect this can be more fairly judged as the 'interim' period, in which the magazines are seen to be slowly evolving from their early, classic days into something strangely different altogether. The third Warren title, VAMPIRELLA, can be viewed as the initial catalyst in this transition, the second factor being a quality challenge from Warren's much-hated rivals, Skywald. The third factor being the acquisition of many fine Spanish artists in the syndication deal made with José Toutain Publishing of Barcelona, a top-class studio which had peddled its wares all over Europe before striking out into the US, and towards whom Warren reacted very positively.

The character of Vampirella began as a Barbarella-influenced vampire hippie-chick created by FAMOUS MONSTERS editor, Forest J Ackerman. Her costume was created by underground cartoonist Trina Robbins (drafted in due to her 'trendyness', no doubt) but it was left to Frank Frazetta (the returning hero!) to refine all this and depict the definitive look for Vampirella, as she appeared on his cover for VAMPIRELLA #1 (Sep 69). Having said this, initially the character was almost wasted as yet another addition to Warren's roster of blackly comedic horror hosts. It wasn't until later issues that 'Vampi' (as she became affectionately known) appeared as a character in her own right in a continuing series — the real kick-off taking place after fits and starts with the triumphant return of writer Archie Goodwin, and the first appearance of the definitive artist of the series, José Gonzalez. This didn't take place until #12, in July 1971.

In the meantime, let's take a brief look at some of the highlights from Warren's interim period, focussing once more on CREEPY and EERIE...

At the turn of the 1960s the Warren magazines were featuring as many reprints as their 'shoddy' rival, Eerie Publications (see next chapter), definitely a case of bad karma for James Warren who had initially knocked his competitors for this very reason! However, with the Mar 70 issue of EERIE (#26) at last Warren was able to announce on the

COMICS TO GIVE YOU THE CREEPS!

cover, 'All New Stories'* (adding, with much less justification than in the old days, 'By the world's greatest Artists and Writers!'). Even so, EERIE #26 is a pretty good issue, with nice work from writer Ken Dixon and Jack Sparling on **'Cyked-Out'**, a story of rival vampire and werewolf motorcycle gangs; and a particularly gruesome tale by the team of Bill Warren (no relation) and Tom Sutton, **'Spiders Are Revolting!'** — certainly one of the most gratuitous tales to appear in a Warren mag, with spiders exploding out of every orifice of the hollow, human zombie bodies they have taken-over... 'Ssswee havvve comme backss... wee neeed bodiesss... bodiesss... the eggss have hatchedsss'. Oh dear! What has poor old Elliot Willis got himself into... And will our straight-jacketed hero ever be believed as he tells (from his padded cell) his tale of woe about the world-dominating spiders? 'The Web! The Web!' he screams endlessly. But Dr Shapiro and his intern do believe poor old Willis, as he discovers when they too collapse into revolting husks and spiders explode everywhere... (Boy, this is a sick one!) Also of note this issue is the writing début of one Alan Hewetson, with his rather average tale (badly illustrated by Tony Williamsune) **'In the Neck of Time'**... hmmm...

CREEPY #32 has the first Frazetta cover since #17, illustrating this issue's cover story... And a real coup it is, as it teams a returning Neal Adams with sci-fi award winner and all-round champion loud mouth, Harlan Ellison. The resulting tale, **'Rock God'**, is an excellent foray into pagan belief and primitive worship atavistically erupting into an unsuspecting modern world...

CREEPY #33 (Jun 70) has the first Warren cover by Boyette, illustrating his grotesque tale **'Royal Guest'**, a sort of supernatural take on Dumas' *The Man in the Iron Mask*. Best

*The Feb 1970 issue of CREEPY (#31) also claimed to have 'All New Stories', but it was not the case as **'A Night's Loding'** [sic, it should have read 'Lodging'] had already appeared back in #17.

José Bea's 'garbled' Warren debut: 'The Silver Thief and the Pharaoh's Daughter', VAMPIRELLA #13.

GHASTLY TERROR!

top Sexy girl vampires <u>and</u> Dracula on the cover of one magazine! VAMPIRELLA #18.

above Rotting reunion! Uncle Creepy celebrates his 50th birthday — I hope I look that good when I'm 50...

of this issue is a vastly improved Al Hewetson with his voodoo/shrunken head tale **'I'm Only In It For the Money'** in which an unscrupulous cameraman exploits the jungle natives to his everlasting regret (cue the shrunken head). It's illustrated by the talented Juan Lopez.

To counteract the low advertising page-rate of their rivals Skywald, CREEPY #35 was the first edition to feature 'cover to cover' story and art — and also the last! (See chapter: *The Horror-Mood*.) Under a mind-numbingly bizarre cover by Kenneth Smith, #35 is also notable for the débuts of Alan Weiss, Bill Stillwell, veteran artist Syd Shores (illustrating R. Michael Rosen's Third Reich zombie opus **'Army of the Walking Dead'**) and includes sterling work from Roger Brand, Tom Sutton and Pat Boyette, with his stomach-distressing tale of reassembled mangled corpses, called **'Justice'**. One more item of note is the return of Archie Goodwin under the aegis of Associate Editor, with Bill Parente's role now being reduced to Contributing Editor, where he is paired with newcomer Nicola Cuti.

CREEPY #36 (Nov 70) is notable only for the début of Kansas artist Richard Corben, a stalwart of the more horror/sci-fi orientated Undergrounds. Here he writes (as well as draws) a tale of wizardry entitled **'Frozen Beauty'**. In contrast, CREEPY #36 also features a dull story everyone seemed to rave about in this publishing period — and which spawned an equally boring sequel (in CREEPY #42): T. Casey Brennan's 'poetic' allegory **'On the Wings of a Bird'**, the first in a string of po-faced, soul-searching, but ultimately meaningless, tales from this bizarrely over-rated author — just what was the appeal of this portentous tripe one wonders...? The same month (Nov 70) saw the release of EERIE #30, showcasing a fine medieval gothic by Pat Boyette, **'The Entail'**, in which Prince Eric von Rafen is transformed by sorcerer Baron Riga Vilka into a human scarecrow endowed with eternal life. Débuts are made by artists Ken Barr (**'I, Werewolf'**) and Carlos Garzon (**'The Creation'**) — this latter scripted by Doug Moench, who would go on to become one

COMICS TO GIVE YOU THE CREEPS!

of Warren's most prolific writers before moving on to work for Marvel, where he scripted WEREWOLF BY NIGHT, FRANKENSTEIN and other titles.

EERIE #31 and #32 (Jan 71 and Mar 71) feature Richard Corben's first cover artwork for Warren, and CREEPY #38 (Mar 71) features Ken Kelly's first horror magazine cover... All three are really fine efforts, showing a marked improvement on some of the rather humdrum efforts to appear throughout the previous few years, indicating the beginning of an upsurge in all-round quality which would begin in earnest with VAMPIRELLA #12 (Jul 71). In the (brief) meantime, CREEPY and EERIE continued to feature excellent débuts from creators who would go on to make real names for themselves in the industry. Artists Frank Brunner, Dave Cockrum, Pablo Marcos; scripters Steve Skeates, Gerry Conway, Marv Wolfman — and yet more great stuff appeared from Larry Todd, Rich Corben, Tom Sutton and Pat Boyette...

EERIE #34 (Jul 71) features the Warren début of cover-artist Boris Vallejo — and July 71 also inaugurated the Warren career of another superb cover artist, Sanjulian, whose cover for the aforementioned VAMPIRELLA #12 signalled the beginning of the 'Spanish invasion' in earnest. Sanjulian caused an immediate stir as a talent to vie with the great Frank Frazetta — at last Warren had found a painter with the same confident look of practised ease who could produce dramatic, atmospheric covers to order... In comic book terms, each cover Sanjulian produced was a masterpiece. No wonder Warren was so enthusiastic about the Spanish artists — they also worked *cheap*! Masterful covers at a fraction of Frazetta's (or for that matter, Vallejo's) price. This deal paid in spades with the acquisition of another fellow-countryman, Enrich (début, EERIE #35, Sep 71) who along with home-grown talent, Ken Kelly, went on to make up the triumvirate of great cover artists in Warren's second golden period, 1973–77.

In the meantime, the quality of interior artwork (if not always the writing!) improved steadily throughout 71–72... And it was Archie Goodwin who once again set the standard with his first entry in the VAMPIRELLA series, '**Death's Dark Angel**', a story beautifully illustrated by José Gonzalez in which Vampirella for the first time encounters the Servants of Chaos ('The mad, banished God') in the form of the demon, Skaar, and his earthly acolytes. This plot development did a lot to alleviate the corny and rather lame concept

The vastly improved Al Hewetson with 'I'm Only In It For the Money', CREEPY #33.

GHASTLY TERROR!

EERIE's controversial dying horror-heroes...

*Hunter (in an episode entitled 'The Village', EERIE #55; **above**).*

*Shreck ('Worms in the Mind', EERIE #55; **below**).*

behind Vampirella's character as an alien from the planet Drakulon, where blood flows instead of water — hence Vampi's terrible blood-thirst dilemma here on Earth. To add to this banality, she becomes an assistant to drunken old stage magician, Pendragon (hence the excuse for her skimpy costume) and the descendent of the original vampire killer, Adam van Helsing, with whom she falls in love. It's a testament to Goodwin's writing/plotting skills that he managed to salvage this ridiculous nonsense and quickly turn VAMPIRELLA, against all odds, into a fairly coherent and entertaining (if still completely nutty) ongoing series. The remaining contents of VAMPIRELLA #12 are notable for the inclusion of artwork by Jeff Jones, and some stunning (and sexy) work from the returning Wally Wood, with his semi-classic, ancient Egyptian werewolf tale '**To Kill a God**' — a story he also wrote himself.

The theme of ancient Egypt recurs in Dean Latimer's garbled '**The Silver Thief and the Pharaoh's Daughter**' (VAMPIRELLA #13, Sep 71), a tale notable for the Warren début of José M. Bea, another hugely talented Spaniard with a style quite unlike any other comic artist. He would go on to become a real Warren favourite — and not surprisingly, as Bea is certainly one of the top ten artists to work for Warren in the Seventies. In the same issue, Vampirella encounters another demonic servitor of chaos, the creature-from-the-black-lagoon-lookalike Demogorgon, who unsportingly tries to infiltrate Vampi and Pendragon's magic act aboard a luxury liner.

VAMPIRELLA #14 (Nov 71) showcases another superb Sanjulian cover, beneath which lies two significant tales: '**Isle of the Huntress**', probably the best episode in the Vampi series, even though it draws too heavily on *The Most Dangerous Game* hunting-humans-for-sport theme; a well-used plot which would

Horror-hero: The Spook ('Webtread's Powercut', EERIE #58).

seem entirely threadbare if handled by any lesser a creative duo than Goodwin and Gonzalez. The other is a story by one Joe Wehrle, '**Wolf Hunt**', a rather basic werewolf tale… Except that it's exquisitely drawn by Spanish artist-supreme Esteban Maroto, without doubt one of the most talented artists to appear in Warren's pages. Maroto went on to single-handedly create the first ongoing series in EERIE (beginning in #39, Apr 72) the popular and long-running saga of '**Dax the Warrior**' — which set the artistic standards for all the subsequent EERIE series of the mid-Seventies.

Officially, 1972 kicked off well for Warren with three superb January issues of CREEPY (#43), EERIE (#37) and VAMPIRELLA (#15).

CREEPY #43 features an effective cover by Ken Kelly illustrating Fred Ott's story '**The Mark of Satan's Claw**', a chilling story of devil worshippers in a remote Scottish village, notable for the artwork of yet another Spanish import, Jaime Brocal. The Spanish theme continues with the début of fantastically talented Luis Garcia, who illustrates '**The Man Who Called Him Monster**' — a thoughtful (perhaps *too* thoughtful!) werewolf tale by wordy wordsmith Don McGregor, in which the lycanthropy theme becomes rather buried by the ruminations of McGregor's political and racial

GHASTLY TERROR!

Horror-hero: Dr Archaeus ('The Quest', EERIE #55).

ponderings, a trait that had become fashionable in comics in the early Seventies after the success of the conscience-stricken Dennis O'Neill/Neal Adams run in DC's GREEN LANTERN. After this, certain authors — notably quite a few Warren writers and in particular, Don McGregor — took it upon themselves to really let rip every so often with 'heavy' sociological observations, usually to laughable effect. McGregor's rambling, wordy and occasionally confused style led to more than a few grumblings in the 'Dear Uncle Creepy' column over the ensuing months. McGregor went on to work for Marvel, where he showed significant improvement, and his long run in the Black Panther series in JUNGLE ACTION (#7 — #23) though still wordy and occasionally schmaltzy, is a very creditable piece of work. In the meantime (EERIE #37), he continued to obfuscate the theme of EC-style walking corpses with '**The Ones Who Stole it From You**', an otherwise enjoyable tale of vengeance from the grave, beautifully illustrated by another new Spanish artist, Aureleon. This is EERIE #37's cover story, superbly illustrated with a frightening painting by Enrich which exudes menace and atmosphere.

The cover of VAMPIRELLA #15 is also notable for its classic status as one of the great Sanjulian's best efforts. It illustrates another Don 'blah blah blah' McGregor opus, '**Welcome to the Witches Coven**', a sub-feminist rant disguised as a tale of witchcraft, once more exquisitely illustrated by Luis Garcia. Also beautifully drawn by José Bea is Doug Moench's unsettling gothic '**Quavering Shadows**', in which dreamy Andrew is invited to stay at his mate's new home — a remote castle — and is forced along with the eccentric Jason to dress in a style contemporary to the castle's heyday (they both look like Jacobean poisoners). The ghostly atmosphere builds as Jason goes insane, leaping out at Andrew with an axe and showing him a supernatural shadow-play in which a woman is murdered each night at midnight... Here the plot gets even more convoluted, as it turns out Jason has a doppelgänger who has been killing *real* women in Andrew's home town while he's been staying at the castle. The whole thing reads like a bad dream, and it wouldn't be surprising if Moench had actually based the story on a nightmare he might have had. This issue's Vampi episode is notable for the guest appearance of granddaddy vampire of them all — Dracula. The theme of vampirism continues in EERIE #38 (Feb 72) in Doug Moench's extended piece '**A Stake in the Game**', illustrated by José Gual (can you guess his country of origin?) and yet more portentous philosophising from Don McGregor's stablemate, T. Casey Brennan, who this time around creates the half-decent mystical foray '**A Stranger in Hell**', more than ably illustrated by the ever-on-form Esteban Maroto. Without a doubt, Ken Kelly's cover illustrating another piece of T. Casey Brennan's mind, '**The Carrier of the Serpent**' (rendered nicely by veteran Jerry Grandenetti), is his best on a Warren magazine — and, in my view, is in the running as one of the best 20 horror comic covers ever.

Common to each of these concurrent magazines is the inclusion of in-depth coverage of the 1971 Warren Awards at that year's New York ComiCon, communicating a sense of Warren's renewed purpose and drive, though mentioning nothing of his bitter hatred of rivals Skywald, who were at this period about to go into creative overdrive under the aegis of ex-Warren writer Al Hewetson (see chapter: *The Horror-Mood*). Warren's hatred of Skywald's success was, however, a boon to the horror comic fan, as the Warren magazines began to sharpen up and try to out-compete their closest rivals. By spring 1972 this also included Marvel —

GHASTLY TERROR!

and to a lesser extent Eerie Publications and DC — who had gone into production with their own Dracula comic and had much more in the pipeline in the same vein (see chapter: *Bronze Age Silver Bullets!*).

No bolder (or more hideous!) a 'statement of intent' could be made than that of the leering, rotting corpse which reaches toward the nervous reader of CREEPY #44 (Mar 72). Painted by another young Spaniard, Segrelles — who would go on to produce equally queasy renderings for Skywald — the monstrosity in question illustrates Tom Sutton's excellent gothic **'Something to Remember Me By'**, a tale which combines a background of Salem witchcraft with the equally tried and tested theme of vengeance from the grave to great effect. Also good this issue is Jan Strnad (yes — that's spelled correctly!) and José Bea's claustrophobic coffin tale, **'Like a Phone Booth, Long and Narrow'** and the Mike Ploog-illustrated **'Sleep'**, in which two thieves dabble with the black arts to procure a 'Hand of Glory' that will allow them to ransack occupied houses in the night whilst their owners sleep entranced. So far, so good... Except that the opulent house they choose is occupied by vampires who, as we all know, sleep during the day!... Never mind, Ploog's artwork is superb. There is nothing superb about **'Dorian Gray: 2000'**, the last Warren story by Al Hewetson which shows absolutely nothing of the 'Horror-Mood style' of his brilliant later work for Skywald... **'With Silver Bells and Cockle Shells'** is another routine piece by future successful horror novelist F. Paul Wilson, author of *The Keep*.

VAMPIRELLA #16 (Apr 72) showcases Vampi's continuing contretemps with Dracula, **'...And Be a Bride of Chaos'**, where all is revealed about the vampire lord's allegiance to the Mad God in his role as 'Supreme Leader of the Companions of Chaos', an office he fulfils admirably by deciding that Vampirella should be sacrificed as the Great God's Bride. However, all's well that ends well (sort of) as by the next issue (#17, Jun 72) Vampirella is back battling more run-of-the-mill servants of Chaos in the Florida Everglades under the hand of T. Casey Brennan (a poor replacement for a writer of Goodwin's stature).

above Warren out-Skywald's Skywald with this truly foul cover for CREEPY #44.

below Horror-hero: Goblin's first appearance in self-titled strip, EERIE #71.

Much more appealing is the inaugural episode of Esteban Maroto's enigmatic series '**Tomb of the Gods**', a much less successful and shorter-running counterpoint to EERIE's '**Dax the Warrior**', which utilised the more recognisable props of generic Sword and Sorcery. Entitled '**Horus**', the first episode sets the tone of the series in flowing, dreamlike images, investing an atmosphere of romantic mysticism into the mythic setting. The readers generally hated it — philistines!

More traditional grue flowed through the pages of CREEPY and EERIE in the remaining 1972 issues. CREEPY #45 (May 72) — a superb issue — has a scary cover (painted by Enrich on top-form) illustrating the blood and thunder vampire epic '**For the Sake of Your Children**', written by another future Skywald alumnus, Ed Fedory. Expertly drawn by Jaime Brocal, this typical vampire opus is lifted by the superb atmosphere Fedory generates with his florid, Horror-Mood-esque purple prose:

Horror-hero: El Cid, from his booklength epic, EERIE #66.

> The Vienna Woods... riddled with ancient hermetic mysteries... hoary with the dust of countless ages! Fresh morning mist lies not within, for centuries ago it was ripped asunder by a pall of malevolence that choked the dryad carpet of ferns, and wrought finality to the divine nuptials of nature!! Of kindred nature, it dwells more within the cloak of night... more beneath the cerements of evil, an unholy place the Earth-mother could never suckle!!!

And so on for the remaining 10 pages of stakings, decapitations, blood-sucking and other acts of mindless violence. Excellent! Jan Strnad offers us '**What Rough Beast**',

GHASTLY TERROR!

The masterful Berni Wrightson and 'The Pepper-Lake Monster', EERIE #58.

a capably illustrated tale based on the theme of WB Yeats' famous poem, *The Second Coming*, drawn by Frank Brunner in his usual subtle pencil shadings. The best story in CREEPY #45 — in terms of story and art, both tasks executed to perfection by José Bea — is '**The Picture of Death**', a simple tale set in an 18th century Scottish village which is celebrating its feast days. A stranger to town, Herbert Wilson, requires a room for the night, cursing his luck that he should be in the vicinity at such a busy time. Finally he's offered a vacant room in a dingy tavern, where a drunken stranger warns him,

> The room you've got is empty because nobody here would take it. Four people who have rented the room have already disappeared without leaving any trace!... It began when that strange man left a horrible painting as payment for the room. Now it hangs in there.

Undeterred, Herbert takes the room, and being no slouch in art history observes that the canvas ('A confused and twisted mass of horrible monsters') '...appears to be a reproduction of one of the paintings of the Flamenco [sic] master Heironimus Bosch... But it's obviously not! It was

created by a much more feverish and tormented imagination than his.' Unsurprisingly (hey, this *is* a horror comic story), the grotesque creatures absorb poor Herbert into their world during the night, tormenting and pursuing him through a series of hallucinatory, psychotic landscapes until he reaches an empty plain where he thinks he is free of them... 'Run! Run! Keep running. You'll be the first to arrive!' They laugh maniacally. 'Arrive where?' thinks Herbert. He reaches an unpassable boundary, his face frozen in a scream, his hands held high in a gesture of helplessness as the monstrosities crowd round him.

The next morning the maid nonchalantly observes 'Every time I look at this picture it seems different...' And there's Herbert, right at the front of the composition, frozen into the hellish world within the painting.

Once again, this story shows how a second-rate, hackneyed plot can sometimes be used to great effect if due care and attention is paid to setting, characterisation and atmosphere. Certainly there is *something* about this tale — perhaps after all, merely the look of Bea's superb artwork — which stays with the reader and haunts his imagination for a long time afterwards.

CREEPY #46 (Jul 72) continues with the tradition of Warren's 1972 hard-core horrifying covers, featuring Sanjulian's excellent and disturbing painting of two of the most scabby, vile and downright nasty looking vampires you're ever likely to see! The cover in question illustrates Doug Moench and Esteban Maroto's vampiric mini-biography '**Cross of Blood**'. Another superb Sanjulian painting graces the cover of EERIE #41 (Jul 72), illustrating '**Chess**' by Maroto, a further episode in the long-running saga of Dax the Warrior. Other notable pieces are: '**The Caterpillars**' by Fred Ott and Luis Garcia — a story similar to EERIE #26's classic '**Spiders Are Revolting!**' — and '**Derelict**', illustrated by débuting artist Paul Neary, a young Englishman who would go on to make a real mark at Warren with the '**Hunter**' series in the mid-Seventies.

In the meantime, beginning with VAMPIRELLA #18 (Aug 72), Warren made a move which was to be as much a creative turning point for his magazine line as the appointment of Al Hewetson as Editor was for Skywald. This was the posting of San Franciscan Bill DuBay to Art Director in place of JR Cochran (who had been Warren's right-hand man for the last 18 months or so). DuBay, an occasional but unremarkable contributor to Warren magazines in the past,

Letter page logos.

brought a fresh new look to the line, and provided a focussed and consistent approach to the type of material Warren published over the next few years. DuBay's capability is evidenced by his promotion to Managing Editor a couple of months later, and finally to Editor (in place of Warren himself) effective from spring 1973.

As Art Director, the first thing DuBay did was spruce up the appearance of the magazines by designing dynamic new contents pages (which featured a small b&w reproduction of the cover, plus short description) and including capsule book reviews, commentary pages from Warren staffers, and more in-depth feedback in the letters pages. CREEPY #49 (Nov 72), along with some excellent work by Sanjulian (cover), Esteban Maroto (illustrating Doug Moench's vampire-pirate sea shanty, **'Buried Pleasure'**), José Bea with his demented fairy story **'The Accused Flower'**, and Jim Stenstrum and Jaime Brocal's headless horror cover story **'The Third Night of Mourning'**, also includes an editorial — 'The Story Behind the Story' — in which Rich Margopoulos gives his reasons for writing **'Behold... the Cybernite'** (CREEPY #46), while 'CREEPY's Fan Club' continues with an extended profile of Minnesota-born writer, Jim Stenstrum. EERIE #45 (Feb 73) features **'The Mask Behind the Face'**, an amusing self-parody by Doug Moench, reprinted from a *Chicago Sun-Times*' Sunday Supplement on the art of — and stigma attached to — writing horror comic stories. This revealing one-pager is illustrated by horror comic veteran Russ Heath.

This period marks the beginning of Warren's second classic age, in which CREEPY, EERIE and VAMPIRELLA underwent radical face-lifts that would see them evolve from the routine horror comics they had become after the departure of Goodwin *et al*, to develop once again into a real creative force in the comics field.

Bill DuBay made his editorial intentions known from the inception of his tenure in hand-picking a core staff of artists and writers, to whom he sent a package of East Coast's EC reprints with the following attached memo:

> These books illustrate to some degree the kind of stories we want to publish and the direction we're heading in. We're not going to copy the EC style, of course, but... their stories were imaginative, visual and very well thought out and this is basically what we want. Only better. The early EC stories are revered by fans all over the world because they never ceased to

COMICS TO GIVE YOU THE CREEPS!

strive for perfection. The same thing goes for Warren publishing... Read them, remember them from when you first read them, enjoy them again. And then get to your typewriter and make the world forget them.*

Fighting words from a real taskmaster. By all accounts DuBay was quick to encourage and stern in his criticism. As Jack Butterworth, writer for Warren at the time, writes:

I was beginning to think of Warren's editorial office as a revolving door... Dube was the third editor I worked with [after Cochran and the swift and acrimonious departure of Marv Wolfman] but he turned out to be the one who lasted... The best thing about Dube as editor during this period was the ownership of his own career. He had a good working relation-

*Quoted in Jack Butterworth's article, 'Warren Comics in the Seventies, Part 1' in GORESHRIEK #6, 1989.

'Nightfall' — a tale written by DuBay, influenced by Little Nemo in Slumberland, and illustrated by Wrightson. CREEPY #60.

GHASTLY TERROR!

*Jack Butterworth, 'Warren Comics in the Seventies, Part 1', GORESHRIEK #6, 1989.

ship with Jim Warren, not the easiest thing to achieve, and he gave the impression of a man making his own decisions.*

It was this confident, focussed, attitude that lifted the Warren magazines from the doldrums of just 'ticking along' into a creative hot bed over the following few years. This new-found vitality inaugurated an increase from seven issues per year (six regular issues and one 'special', replacing the old 'yearbook') to nine issues per year of each of the three titles, effective from Feb/Mar 73 onwards.

In the midst of all this, CREEPY had reached its milestone 50th issue, celebrated by the first issue tribute monster mash party cover by Sanjulian. Sadly, the rest of the issue is a rather average affair. Jim Stenstrum and Esteban Maroto offer the jungle epic '**Forgive us our Debts**', about a one-armed drug smuggler who gets transformed into a reptilian monster (sounds great, but it isn't); Ed Fedory returns with a rather stupid tale, '**Frog God**', drawn by Spaniard Adolfo Abellan; and the sorely missed Reed Crandall returns, offering some solace with Doug Moench's interesting voodoo-esque '**The Sum of its Parts**'. All in all, not the 50th issue classic one would have expected. EERIE #46 (Apr 73) is another story, with the inaugural episode of Warren's very own addition to the Dracula legend (not connected in any way to his appearances in VAMPIRELLA, much to the puzzlement of the more pedantic Warren fans) written by Bill DuBay and illustrated by Tom Sutton. In tandem with the continuing saga of Maroto's Dax, this Dracula series inaugurated a new creative phase for EERIE, which, from this point on would concentrate increasingly on powerfully themed, mostly short-running series, providing stark contrast to CREEPY's 'anthology' format. This new formula increased the validity of both mags,

Adams' gut-wrenching return with 'Thrill Kill', CREEPY #75.

100

COMICS TO GIVE YOU THE CREEPS!

whilst also highlighting the contrasting qualities of VAMPIRELLA.

Just to confuse matters further, yet another usage of Dracula appears in the first ever Warren colour sections in CREEPY #51 (Feb 73) and VAMPIRELLA #22 (Mar 73), excerpting the vibrant colour work of Warren's Spanish artists (Bea, Maroto, Enrich, *et al*) as it first appeared in the Spanish language horror comic DRACULA, in the early Seventies. No wonder Warren was excited about this 'full-spectrum colour' (as it was termed in differentiation from the regular, rather dull 'four-colour' comic book hues), as Maroto's work looks superb printed on art paper in this way. In conjunction with this, Warren advertised the 120 page English language book version from which the excerpt was taken (also entitled DRACULA) with shameless hype, through which he communicated his genuine enthusiasm for the project.* Shortly thereafter, the innovative colour sections featuring *original* work would appear regularly as an additional attraction to the growing quality of Warren's products.

Meanwhile, future Marvel writer Steve Englehart had taken over from T. Casey Brennan as writer for the Vampi series, getting into his stride with his voodoo instalment '**The Blood Queen of Bayou Parish**' in VAMPIRELLA #23 (Apr 73). Even better is all-round dab-hand Don Glut's '**Cobra Queen**', an old fashioned jungle pulp about the queen of the snakes and her zombie entourage, superbly illustrated by Maroto and depicted on the cover by a staggeringly good painting by Sanjulian. As well as nice work by Ramon Torrents and Aureleon, the artistic achievement of the issue once again goes to José Bea, who manages to turn Kevin Pagan's routine werewolf story, '**The Accursed**', into some-

Doom and gloom as Uncle Creepy gets all serious in 'Excerpts from the Year Five', CREEPY #67.

*British readers may remember the 12-issue English language run of DRACULA put out by publishers New English Library in 1972–73, all printed on large-format art stock, and very nice too!

GHASTLY TERROR!

Wrightson's award-winning 'Jenifer', CREEPY #63.

thing special.

CREEPY #53 (May 73) kicks off in fine style with Sanjulian's rotting, murky cover illustrating Tom Sutton's classic tale, 'It!'. Both written and illustrated by Sutton, 'It!' is a darkly comic vengeance-from-the-grave story with a twist. Here, the mouldering corpse of half-witted Timothy Foley returns from the dead, destroying everyone in his wake, only to collect the teddy bear he was thoughtlessly buried without! Sutton's rancid, decaying artwork complements this oddly touching story perfectly. 'It!' is without a doubt the highlight of the issue, but much more lauded at the time (it won DuBay a 1973 Warren award for the best story of the year) was '**Freedom's Just Another Word**', drawn by Adolfo Abellan, a sincerely felt meditation on racial intolerance in which the Turners, a family of black settlers, are castigated and finally violently murdered by their hypocritical neighbours — who are in turn destroyed by the one Turner they leave alive, the blind crippled old Grandmother whose knowledge of voodoo allows her to gain swift revenge. The very seriousness of the story's tone is what ultimately lets it down, as in wreaking revenge, Grandmother Turner falls into the 'voodoo nigger' stereotype DuBay spends the rest of the story trying to invalidate. When horror comics occasionally try to get this 'heavy' they invariably fail to convince, as per the political soapboxing noted earlier.

To his credit, DuBay produces better work in EERIE #48 (Jun 73), in which the series orientation gets into full swing with '**The Son of Dracula**', a tender love story about Dracula's amorous encounter with a beautiful deaf-mute girl, written and illustrated by DuBay and inked by Rich Buckler (of mid-Seventies FANTASTIC FOUR fame), and the first episode of

the werewolf series **'On a Stalking Moonlit Night'**, excellently told by a young Al Milgrom with the same art team of DuBay and Buckler. Concerning Arthur Lemming, a wolfman who kills his own daughter in a lycanthropic fury, this is a classic episode, boding well for the series' future. Another genuine classic is the first episode in the Mummy series, **'...And an End'**, by Steve Skeates and Jaime Brocal, in which unfortunate Egyptologist Michael Harding becomes trapped in the rotting form of an ancient mummy (via the power of a cursed amulet) when his plan to destroy his cheating wife and her lover goes dreadfully wrong. When the dreaded amulet falls into the hands of 'visiting American' Jerome Curry, the scene is set for many issues to come.

Along with Dax, four out of the six stories this issue belong to character-driven series. The two exceptions are both good short stories by Jack Butterworth: **'Think of Me and I'll be There!'**, illustrated nicely by Martin Salvador; a tale of a telekinetic girl whose powers draw to her whatever she desires — even, unwittingly, her dead boyfriend. **'The Resurrection Man'** is a Frankenstein gothic drawn complete with film sprockets by Paul Neary. The classic status of EERIE #48 is confirmed by Sanjulian's menacing werewolf cover, one of his most enduring images.

CREEPY #54 (Jul 73) heralds the return of Rich Corben, illustrating Doug Moench's surrealistically violent cartoon **'The Slipped Mickey Click-Flip'**, an ultra-zany spoof impossible to summarise, but which contains such enduring images as a TV set that comes to life and a bone that grows arms and buries a dog! This issue also sees the return of a regular colour section, once more featuring the artwork of Maroto who illustrates Kevin Pagan's mythological opus **'A Descent into Hell'** in vibrant washes of red and yellow. Perhaps the best tale of the issue is Don McGregor's surprisingly good **'This Graveyard is not Deserted'**, drawn in curiously elongated style by Reed Crandall. In another Western-themed cursed Indian burial ground story, McGregor rises above the tired sub-genre's conventions and produces a gripping, first-rate script, full of menacing little touches. Whilst this is my favourite story in CREEPY #54, who can argue with an authority like Stephen King? He singles out Jack Butterworth's **'Dead Man's Race'**, calling the story an example of 'how good the form can be when it's working'.* It's based on the superstition of the Ankon, the spirit of the last person buried in a graveyard who must ride out to meet the next person to die, ably illustrated by Martin Salvador.

*Stephen King writing in a 1973 issue of *Writer's Digest* on the subject of horror comics.

GHASTLY TERROR!

King's championing of the comic format also extended to praise for Skywald magazines (see chapter: *The Horror-Mood*).

Colour sections also began to appear regularly in VAMPIRELLA (beginning in #25, Jun 73) and a little later in EERIE (beginning in #54, Feb 74). Around this time, EERIE really began to push ahead with the 'finite series' format (heroes who *died* at some point, unlike most all of other comic characters) kicking off with the death of Dax in #52 (Nov 73). This novel, morbid trend continued over the ensuing months, ensuring EERIE's place as one of the most innovative and interesting horror comics of the period, certainly out-stripping its Warren stablemates in terms of originality — although a few dissenting fans felt that EERIE was pandering too much to the Marvel audience in whose character-based horror mags they saw a similarity. In fact, any similarity is purely superficial. Whilst the Marvel horror magazines are for the most part fine, entertaining comics, EERIE had a totally different *feel* to it that made it stand head and shoulders above the competition.

Here's a round up of the characters and series which appeared in EERIE's pages in this second golden period of Warren publishing...

'**Schreck**' — the *Omega Man*-style Doug Moench tribute

'In Deep', Bruce Jones and Rich Corben's twisted tale from CREEPY #83.

to Richard Matheson. Scientist Derek Schreck is the last man on Earth to survive nuclear testing on the moon, while everyone else suffers from the lycanthropic 'moon-taint'. Illustrated by Vincente Alcazar.

'**Hunter**' — another post-apocalypse nightmare which was the most popular series EERIE ran in this period. Conceived by Rich Margopoulos, but written mostly by Budd Lewis, it tells the far-future adventures of Demian Hunter, a half-breed mutant and vigilante killer of 'true' mutants, whose tarnished heritage is his driving force. Paul Neary renders a convincing landscape populated by remote castles, strange isolated monasteries, abandoned weapon silos, and savage bands of hideous mutants; the demons and goblins of legend. The popularity of this concept inspired a follow-up series '**Hunter II**', by the same creative team. Superb!

The never-ending blood drenched saga of Vampirella. Cover: VAMPIRELLA #44.

'**Dr Archaeus**' — survivor of a hanging, the evil Dr Archaeus returns from the 'dead' to expiate his vengeance on the 12 jurors who condemned him, killing each of them in a bizarre, inventive way based on the Twelve Days of Christmas. Gerry Boudreau scripts this long-winded *Dr Phibes*-style mystery-thriller which Spanish artist Isidro Mones lifts from the doldrums with his atmospheric illustrations.

'**The Spook**' — Raised from his grave by voodoo with a sacred mission to free all his enslaved brethren, the Spook patrols the eerie provinces of the Louisiana swamps, punting along in his silently gliding long-boat. Silly but great spooky stuff from Doug Moench and Esteban Maroto (who were later replaced by Budd Lewis and Leopold Sanchez).

'**The Hacker**' — Pea-souper London fogs and a Ripper-style murderer in this Victorian Penny Dreadful of dismemberment and cannibalism, excellently written by Steve Skeates and illustrated with equal panache by Tom Sutton (episode 1) and Alex Toth (episode 2 and 3).

'**Child**' — Full colour three-parter by Greg Potter and Rich Corben, which basically retells the Frankenstein story from the point of view of the monster as an overgrown, grotesque child. Better than it sounds in synopsis, Corben's colour work is as vivid and dramatic as ever, and the fantasy elements in the final instalment make for a surprising

GHASTLY TERROR!

CREEPY FAN CLUB?
WHAT'S IN IT FOR ME?

FULL COLOR PIN

MEMBERSHIP CARD

JUST WHAT ALL YOU L'LL DEMONS HAVE BEEN WAITING FOR!! An 8x10 FULL COLOR portrait of your favorite fiend, UNCLE CREEPY by that master of the monstrous, FRANK FRAZETTA, suitable for framing. The OFFICIAL CLUB PIN, full color and sturdily constructed. And the pocket-size MEMBERSHIP CARD printed on strong high quality paper stock with your own personal number on it. Once you get this fearful fun kit, you'll be the most popular kid in the graveyard!! Send away TODAY!

JUST SEND $1.25
WITH YOUR NAME
AND ADDRESS TO:

CREEPY FAN CLUB
P.O. Box 430
Murray Hill Station
New York, N.Y. 10016

this page and next
The fan clubs!

finale.

'**Night of the Jackass**' — Brilliant four-parter by the bizarrely-named Bruce Bezaire, superbly illustrated by José Ortiz. Dr Jekyll's famous potion gets onto the black market as a potent, synthesised drug which allows the poor and downtrodden dregs of Victorian society a 24-hour escape from their misery in an orgy of violence and destruction terminating in the user's death — hence, addicts are labelled 'Jackasses'. 'Jack-assing' becomes a growing trend which threatens to overturn society, as every system of popular thought and mores teeter on the brink of destruction. A truly nightmarish series, superbly conceived and realised by the creative team.

'**Exterminator**' — Another popular Paul Neary-illustrated series (similar to Marvel's DEATHLOK), the Exterminator is an experimental government assassin, part-human, part-computer.

'**The Unholy Creation**' — Yet another take on the man-made monster theme: on the eve of his wedding poor old Jason Boswell has his brain transplanted into the body of a grotesque patchwork monster. (Whew, lucky escape, eh chaps!)

'**Coffin**' — Way out West for this series about a walking dead man (hence the name), half-devoured by ants and doomed by a witch doctor's curse. Superb stuff from Budd Lewis and José Ortiz.

'**The Butcher**' — set in prohibition gangster days, The Butcher is a vigilante Catholic Priest (!) who has heard one ghastly confession too many, so becomes the nemesis of the mob. Excellently told by Bill DuBay and Rich Corben.

'**El Cid**' — the Conan-style adventures of the noble hero-lord as annunciated by Budd Lewis and Spanish stylist, Gonzalo Mayo.

'**Goblin**' — he's a grotesque demon who emerges from an old Grandfather clock (sort of like a *really* ugly Funky Phantom) to befriend a demure Victorian lady... Er, yeah, right... Oddball stuff at the fag-end of Warren's second great period (EERIE #71, Jan 76), a trend which would continue with increasingly black-comedic, zany stuff culminating in sub-superhero pap like '**The Rook**' (a time-travelling cowboy dude who eventually got his own short-lived mag) and ultimately the execrable HEAVY METAL rip-off 1984 (later banally retitled 1994). The last really good EERIE series were '**Jeremiah Cold**' — a ghostly old coot gunman who brings old-Western style justice to 1920s New Mexico via his band

COMICS TO GIVE YOU THE CREEPS!

of demons; and '**The Freaks**' — a carnival horror-show with a winged character rather reminiscent of Skywald's Human Gargoyles (see chapter: *The Horror-Mood!*).

Accompanying these excellent, and for the most part truly groundbreaking horror series, was the occasional tale from Warren new-comer Berni Wrightson. In addition to providing superb frontispiece splash-pages featuring Cousin Eerie, Wrightson also created a string of superbly executed tales beginning with '**The Pepper-Lake Monster**' in EERIE #58 (Jul 74) and continuing in fine style in EERIE #60 (Sep 74) with '**Nightfall**', a tale written by DuBay, influenced by the vintage *Little Nemo in Slumberland* strips — this one could be subtitled 'Little Nemo in Nightmareland'. Next up is Wrightson's version of HP Lovecraft's famous tale *Cool Air*, a very faithful adaptation appearing in EERIE #62 (Jan 75). Finally, the best of the lot, the beautifully coloured '**Muck Monster**', another Frankenstein-type story in EERIE #68 (Sep 75).

Wrightson also began to appear regularly in CREEPY. His frontispiece renderings of Uncle Creepy in this period were a staple part of the magazine's overall quality, doing for the ghoulish old host exactly what his similar splash pages for DC had done for mystery hosts, Cain and Abel.* After Warren had got a couple of really good issues under his belt in CREEPY's #60 and #61 (Feb and Apr 74) the creative cur-

*Cain being the evil caretaker of HOUSE OF MYSTERY, while his quivering brother Abel runs THE HOUSE OF SECRETS.

107

GHASTLY TERROR!

rent really began to flow beginning with CREEPY #62 (May 74) and Wrightson's exquisitely rendered version of Poe's **'The Black Cat'**. This superbly detailed adaptation, one of Wrightson's greatest achievements, kicks off a real quality issue which sees the return of Archie Goodwin in a brief spell as editor (Goodwin also edited concurrent issues of VAMPIRELLA, but not EERIE — DuBay's pet project). In a standout issue, two other tales of merit are: **'Buffaloed'**, written by Larry Herndon and drawn by veteran Warren artist John Severin, which tells the tale of a transmigratory medicine man's spirit which reincarnates in the form of a demonic one-eyed albino buffalo! And **'The Maze'**, a sewer story of decidedly questionable taste involving cannibalism and gory amputations beneath the New York subways, by Steve Skeates and Leo Summers. Pouring on the gore in this period, CREEPY #63 (Jul 74) offers Bruce Jones and Berni Wrightson's all-time classic **'Jenifer'** [sic], the now-famous tale of a man who takes in the hideously deformed and retarded little girl of the title, only to see his family torn apart and eventually killed, dismembered and eaten by the grotesque waif! Jones' gruesome, pathos-driven story is effective and genuinely shocking, and Wrightson's detailed use of washes and tones offers the perfect complimentary atmosphere to the tight, professional script. A real masterpiece.

It's no surprise to find the 'Dear Uncle Creepy' letters page of CREEPY #64 (Aug 74) riddled with complaints about Warren's recent gratuitous gore policy — evident in CREEPY at this time much more so than in EERIE or VAMPIRELLA. Outcries seemed to particularly concentrate on the themes of disfigurement and dismemberment, and specifically the story **'Twisted Medicine'** which appeared in CREEPY #61: Steve Skeates' and Leo Summers' tale of the psychotic hallucinations of a bed-ridden multiple amputee thought to be 'all-too-real' for comfort! One long-winded opus by outraged letter-writer Michael Oliveri even elicited a sincere, heartfelt response by a concerned Archie Goodwin, replacing the usual flippant responses of 'Uncle Creepy'. Yes, this was a serious subject, alright, said Goodwin, but it was Warren's aim to make the reader *think*, not just to gross him out. Imagine, then, the shocked Oliveri's reaction to this very same issue's flagship tale **'Mates'**, by Doug Moench and Maroto, which tells the charming story of a sex-crazy spaceman whose face ends up rotting off *toot-sweet* after his encounter with some super-syphilitic space sirens. Hmm,

Comics To Give You the Creeps!

makes you think, doesn't it...?

Perhaps the following issue (#65) — a yearbook-style edition reprinting classics from the past — had a bit of a calming influence, as CREEPY #66 (Nov 74) offers more traditional fare in the form of vampires ('**Solitude**' by Goodwin and Salvador), headless ghosts ('**Relatively Axe-idental**' by Potter and Abellan), and Mad-Artists-who-paint-Death ('**Portrait of Death**' by Lewis and Alcazar). CREEPY #67 (Dec 74) commits a real clinker by featuring Ken Kelly's cover for Strnad and Corben's '**Bowser**' — but then forgets to include the story (using instead '**The Raven**', Corben's Poe adaptation)! This error is more than made up for by Lewis and Ortiz' chilling post-apocalyptic opus '**Excerpts from the Year Five**' — a moving study of survival after the breaking of the seventh seal which won 'Best Story' in the 1974 Warren Awards.

After this much promise, it's disappointing to realise that the following half a dozen issues of CREEPY had little to offer in comparison to EERIE. CREEPY #68 is the Christmas issue (dated Jan 75); a rather schmaltzy affair far too full of sentimentality. CREEPYs #69 and #70 (Mar and Apr 75) are specials entitled EDGAR ALLAN POE'S CREEPY STORIES, featuring two issues' worth of yet more Poe adaptations. All very good, but what was the point? Also fairly drab was the experiment to feature two consecutive issues spotlighting an individual artist: CREEPY #71 (Jun 75) features Luis Bermajo, and CREEPY #72 (Jul 75) features the slightly better José Gual. Both issues have some good sto-

top No pain but he is dying... 'Facts in the Case of M. Valdemar' from CREEPY #69 (cover, **above**), an issue of Poe adaptations.

GHASTLY TERROR!

ries, but there's something remarkably unappealing about all six CREEPY tales looking the same. Experimentation continued as CREEPY #73 (Aug 75) was an 'All Science Fiction' issue. Very good it is, too, but it's just not... CREEPY!

Issue #74 (Sep 75) was another yearbook-type issue, but even this concept was spoiled by using it again to represent the work of a single artist. At least this time it was the marvellous Reed Crandall.

Despite all this, there was still a few great issues of CREEPY left in the bag before the rot really began, circa 1978. CREEPY #75 (Nov 75) is a landmark issue featuring immaculate work from Alex Toth, illustrating Boudreau's detective-pulp **'The Phantom of Pleasure Island'**; Wally Wood (with Rich Buckler) illustrating Bezaire's cannibal tale of a near-future ice age, **'Snow'**; Neal Adams illustrating Stenstrum's rooftop sniper tale **'Thrill Kill'**, one of the first stories to use the ironic device of mismatching narration blocks with the illustrations, so that the violence replays in silent past-tense, whilst the posthumous dissection of the tragedy rolls glibly on in the form of a cheap news column interview. This works to brilliantly powerful effect, and must have been a big influence on the likes of Alan Moore and Grant Morrison, two writers who continue to use this form skilfully.

Although **'Thrill Kill'** is a stone classic, CREEPY #75 also features the equally disturbing but completely overlooked **'Death Expression'** — another Stenstrum tale illustrated by John Severin — about a military coup in some backwater banana republic whose revolutionary forces turn out to be disguised aliens who really look like cockroaches! An absurd idea by any standards, it all turns out to be the deranged fantasy of a paranoid-schizophrenic interned in a military hospital... Or does it? When a hospital guard who comes to escort him from his cell seems to have the 'Death Expression' of the aliens, our boy lunges at him kamikaze-style and they both fall to their deaths as he screams '*¡Muerte para los usurpador!*' — 'Death to the usurper!'

CREEPY #76 (Jan 76) looks pale by comparison, despite the excellent Sanjulian cover and classy interior artwork by Alex Toth, John Severin and Vincente Alcazar. Issue #77 (Feb 76) can be more forthrightly written off, as it's once again the sickeningly over-sentimental Christmas issue... It's really difficult to understand what the policy was behind these increasingly mawkish holiday specials. Much better is #78 (Mar 76) which includes Goodwin's last classic Warren

TOP TEN CREEPY STORIES
(in order of appearance)

'The Success Story'
Goodwin/Williamson #1

'Revenge of the Beast'
Goodwin/Morrow #5

'The Thing in the Pit'
Ivie/Morrow #6

'The Spirit of the Thing'
Goodwin/Ditko #9

'Collector's Edition'
Goodwin/Ditko #10

'The Rescue of the Morning Maid'
Marais/Mastroserio & Boyette #18

'Jenifer'
Jones/Wrightson #63

'Excerpts from the Year Five'
Lewis/Ortiz #67

'Death Expression'
Stenstrum/Severin #75

'In Deep'
Jones/Corben #83

tale '**Creeps**', about prim and proper pipsqueak Lester Finch, who anticipates Bret Easton Ellis' Patrick Bateman by 20 years in deciding to bump off New York's low life in a bid to rid the city of 'rheumy, blood-shot eyed creeps' — drunks, pimps, drug addicts, you name it! However, this epicure of righteousness goes too far when he notices his mother's shaking palsied hands... 'her clicking dentures! The cracked, quivering lips that food escapes!' Yep, Lester decides his mom's a 'creep', too, only he's spotted knifing her to death by a low life neighbour and must flee the scene to live undercover on the streets. Finally, days later, as Lester is being pursued by cops, he finally gives up the ghost when he catches a glimpse of his wretched features in a shop window... 'Holy Christ! I don't get it! We'd lost him! Why should he stab himself?' Asks Cop No 1. 'Don't waste your time tryin' to figure it,' answers Cop No 2, 'Face it... the guy was a CREEP!'

Russ Heath returns to horror comics with '**The Shadow of the Axe**' in CREEPY #79 (May 76) a story by Cerebus-creator Dave Sim about a small depression-era town under the shadow of an axe-murderer — told from the point of view of his young son, who finally plucks up enough courage to bump the old man off himself. Heath's beautiful artwork compliments the story setting perfectly. Issue #80 (Jun 76) sees the welcome return of long-absent José Bea, illustrating DuBay's odd fable '**Bald Sheba and Mountebank the Rogue**', in which the rogue of the title attempts to steal the fabled emerald green cloak from the grave of witch Bald Sheba. Decidedly odd.

Perhaps the last great issue of CREEPY is #83 (Oct 76) — even though the rot had already begun with the audacious reprinting of a previous famous cover (Frazetta's from #15). Despite the great artwork by Severin, Heath, Ortiz and a returning Al Williamson, it was the teaming of Bruce Jones and Richard Corben on '**In Deep**' which stole the show. Beginning with a b&w prologue, the story goes into superbly vivid colours to tell the woeful tale of a shipwrecked couple who are attacked by marauding sharks, before fading back into a b&w epilogue which reveals that only the man survived, traumatised into a coma, gripping for dear life onto something which he holds to his breast. At last the muscle-relaxing injections work and the doctors discover that the object is a human heart... We are reminded of the woman's dying words: 'Feel my heart? It's beating just for you... Whatever happens, don't let anybody or anything take it

> **TOP TEN EERIE STORIES**
> (in order of appearance)
>
> '**One for De-money**'
> Bridwell/Torres #2
>
> '**Soul of Horror**'
> Goodwin/Torres #3
>
> '**The Shrieking Man**'
> Goodwin/Ditko #4
>
> '**The Wanderer**'
> Goodwin/Adkins #9
>
> '**The Masque of the Red Death**'
> Sutton #12
>
> '**Spiders Are Revolting!**'
> B. Warren/Sutton #26
>
> '**The Mummy... And an End**' Skeates/Brocal #48
>
> '**24 Hours of Hell**'
> Bezaire/Ortiz #60
>
> '**Nightfall**'
> DuBay/Wrightson #60
>
> '**The Hacker is Back!**'
> Skeates/Toth #65

GHASTLY TERROR!

away from you...'

'**In Deep**' is probably the last truly great horror story published by Warren, and an indication of future fruitful teamings between Jones and Corben — but *elsewhere*, in Jones' self-created TWISTED TALES (see chapter: *Underground Currents*).

In the meantime, VAMPIRELLA continued as ever: ironically, the least interesting of the Warren magazines despite its popularity and the fact that it had undoubtedly saved Warren's publishing empire from total stagnation in the early Seventies. Vampi's series continued to flourish under the unlikely aegis of scripter 'Flaxman Leow', who was none other than Mike Butterworth of Savoy Books, the publishers who courted much controversy with their *Lord Horror* novel and comics in recent years.*†

Other VAMPIRELLA highlights include the creation of another supernatural femme fatale, Pantha the cat-girl, and several appearances by subtle writer-artist Fernando Fernandez, with his typically Spanish romanticism, perhaps best expressed in the story '**Rendezvous**' (VAMPIRELLA #35, Aug 74) — although his best tale is without doubt the macabre '**The Man Whose Soul Was Spoiling**', appearing a few months earlier in VAMPIRELLA #32 (Apr 74), a nasty little opus about a mobster who is so *bad*, he begins to rot away from the inside as his very soul deteriorates. Ugh!

Although Warren continued to publish CREEPY, EERIE and VAMPIRELLA until 1983 — as well as various side-

*According to Jack Butterworth (no relation) in his article 'Warren Comics in the Seventies, Part 1', GORESHRIEK #6, 1989.

†For the story of Savoy see the article 'Banned, Torn & Quartered' in the book *Critical Vision*, Critical Vision 1995.

112

COMICS TO GIVE YOU THE CREEPS!

projects including a re-vamping of Will Eisner's THE SPIRIT — by 1977/78 the magazines had begun to flop and the rest of the run makes for sorry reading. Apart from the occasional appearance by Corben, Williamson or Ken Kelly — or the discovery of ultra-weird painter Terence Lindall, whose covers added some badly needed attraction to the Warren product in the Eighties — it was the same old story on the one hand, with reprint after reprint, and utter banality on the other, as 1984 magazine became Warren's zany flag-ship title, a shoddy duplicate of HEAVY METAL (from James Warren, the man who hated shoddy duplicates above all else in life). This sad decline reached its sorry finale when Warren even ran a reprint cover from a *Skywald* magazine (NIGHTMARE #9)! Principles now soundly to the wall, it was high time to pack it in.

Yet it was a sad day when Warren Publishing finally folded. In their heydays, 1964–68 and 1972–76, the Warren magazines were a ground-breaking force in the comics field, firmly putting horror comics back into the arena of public consciousness, paving the way for others: Skywald and Eerie Publications initially, and then the giants, Marvel and DC. But to most people, these 'Comics to give you the Creeps', these 'Original and Best' b&w horror comic magazines with their almost household name status, and their ghoulish hosts' fan clubs with membership in the thousands, will remain the definitive article. And the rest will still seem the 'shoddy duplicates' James Warren professed them to be.

this page and previous Terrance Lindall tries to put the *Bosch* on Warren's decline. Covers: CREEPY #116, EERIE #103 and VAMPIRELLA #86.

TOP TEN WARREN MAGS
(not counting yearbooks)

CREEPY #10

EERIE #9

CREEPY #7

EERIE #4

CREEPY #62

CREEPY #75

EERIE #48

VAMPIRELLA #12

EERIE #60

CREEPY #6

GHASTLY TERROR!

WARREN: THE COVERS

The *eerily* atmospheric and *creepily* chilling paintings of legendary cover-artist Frank Frazetta appeared on the following Warren magazines:

FRAZETTA'S CREEPY

- #2 Cat People
- #3 Living Corpse
- #4 Werewolf
- #5 Vampire
- #6 Gargoyle
- #7 Monsters Battle
- #9 Dark Kingdom
- #10 Man-made Monster
- #11 Beastman
- #15 Neanderthals
- #16 Cat Woman
- #17 Executioner
- #27 Demon King
- #32 Rock God

FRAZETTA'S EERIE

- #2 Demonic Evocation
- #3 Sea-monster
- #5 Tyrannosaurus
- #7 Sea-witch
- #23 Egyptian Queen
- #81 Kong-sized Woman

FRAZETTA'S VAMPIRELLA

- #1 Vampi!
- #5 Amazons
- #7 Cave-girl
- #11 Banshee
- #31 Beast-girl

114

COMICS TO GIVE YOU THE CREEPS!

TOP TEN WARREN COVERS BY OTHER ARISTS...

EERIE #38 — Ken Kelly: Serpent Monster
CREEPY #44 — Segrelles: Rotting Corpse
EERIE #41 — Sanjulian: Demons
EERIE #48 — Sanjulian: Wolfman
CREEPY #79 — Sanjulian: Girl-ghoul
VAMPIRELLA #15 — Sanjulian: Red Witch
CREEPY #38 — Ken Kelly: Haunted Room
CREEPY #64 — Todd/Bodé: Rotting Man
VAMPIRELLA #23 — Sanjulian: Cobra Queen
CREEPY #58 — Sanjulian: Satan

Note: Very few Warren covers are poor, though a couple of stinkers really stand out: VAMPIRELLA #6, by Bill Hughes, and CREEPY #63 by, would you believe, Ken Kelly. Others, like EERIE #21 by Vic Prezio, or CREEPY #31 by Vaughn Bodé, are just *too weird* to be called bad — though outraged readers at the time didn't agree... One reader thought the CREEPY #31 cover looked like 'a chicken climbing out of a robot'!

115

GHASTLY TERROR!

SHODDY DUPLICATES

SHODDY DUPLICATES! — designated thus by the seething James Warren, Eerie Publications, Stanley Publishing and a trickle of other lesser 'culprits' cashed in on the success of CREEPY throughout the Sixties and Seventies. For the most part, grossly ignored by comic historians and fans alike, these cheap, unbelievably garish horror comics, with their primitive, ultra-gruesome covers and their fun-fair ghost train style contents provided a quick thrill of in-your-face schlock for the thousands of readers who bought them. This was an undiscerning readership, not generally concerned about the burgeoning fan scene and the finer points of graphic storytelling — who probably couldn't care less about the comics medium and its 'serious' artistic aspirations. Ironically, it's exactly because such outfits as Eerie Publications had none of these 'serious' mainstream concerns that finally they have started to become recognised as a sort of supreme example of kitsch-esoterica by a few contemporary comic fans. What was once deemed worthless garbage is now being avidly sought at increasingly high premiums by a handful of visionary connoisseurs who are willing to trade expensive 'key' Marvels and DC's to get their hands on issues of HORROR TALES and WEIRD...

And yet, even now, very little is known about these magazines. Research is stymied at every turn. No one seems to have any 'inside' information! Mentioning these books to most professional dealers will draw nothing but blank looks.

Here's what we *do* know. It's

below This ultra-rare one-shot 'homage' from Eerie Publications was not appreciated in some quarters.

next page More of the subtle approach to comic covers as exemplified by Eerie Publishing!

116

SHODDY DUPLICATES

not much, but it's a start:

For more than a decade Eerie Publications operated out of offices at 222 Park Avenue South, New York. Its founder seems to have been one Mel Lenny, a name which has solicited blank looks from everyone I've talked to! Not so Eerie Publications' editorial staff, comprising Editor Carl Burgos — the famous veteran who created Marvel's first super-hero, the Human Torch and worked for Marvel briefly on hit Silver Age strips like Giant Man in TALES TO ASTONISH; Irving Fass, Art Director — brother of 'mad' Myron Fass, both of whom did lots of work for the precode crime and horrors; and Ezra Jackson, Art Editor — another old school artist with a pedigree from the Golden Age era.

The horror comics Eerie Publications produced are as follows:

WEIRD: Beginning with the first issue in Jan 66, dubbed Volume 1 #10 (!), Eerie Pub's output is confused by the idiosyncratic numbering and the use of 'volumes' at the beginning of each year of publication. The latter seems straight-forward enough, except that they didn't always number the volumes correctly, and certainly quite frequently made mistakes as to the actual number of a given issue, sometimes resulting in beginning a given year's Vol with #2 (instead of #1), or producing two issues numbered #5, etc. As if this isn't confusing enough, absolutely *none* of the horror comics Eerie Publications produced have any indication as to volume or number *on the cover* — only the month and year of publication! WEIRD ran from Jan 66 all the way through to Dec 74 (numbered Vol 8 #6) before it was revived for a further few years in Jun 76 with — wait for it — Vol 9 #2... I told you!

TALES OF VOODOO: Eerie Pub's second on-going series followed about two years later, beginning in Nov 68 with Volume 1 #11, containing (like its companion, WEIRD) precode horror reprints from (primarily) Ajax-Farrell, but also other sources such as Comic Media and Trojan. Often these stories were re-touched, making them much more gruesome and bloody than the originals, in a complete reversal of the Comics Code's censorship efforts in the Fifties. A case in point being the story '**Bloody Mary**' in the first TALES OF VOODOO, which had originally appeared in Ajax's STRANGE FANTASY #10 without all the blood! Later issues from

117

GHASTLY TERROR!

Eerie Pubs became even more extreme, with old stories often entirely re-drawn by a new artist to make them even more blood-drippingly gory.

TALES OF VOODOO ran from Nov 68 through to Nov 74, numbered Vol 7 #6.

HORROR TALES: This third title followed less than a year later, cover dated Jun 69, numbered Volume 1 #7. One can't be certain about these things, but I think it was at this point that Burgos *et al* began to solicit new artwork to accompany the endlessly re-shuffled precode reprints (stories originally published elsewhere, and then recycled throughout the Eerie Pub titles). HORROR TALES ran through to Dec 74 (Vol 6 #6) before being recycled yet again for a time in May 76, with Volume 7 #2...

TALES FROM THE TOMB: This was Eerie's shortest-running title, beginning in Jul 69 (Vol 1 #6) and ending in Dec 74 (Vol 6 #6).

WITCHES TALES: The final title of the bunch... Jul 69 (Vol 1 #7) to Feb 75 (Vol 7 #1).

Two more items of curiosity appeared from Eerie Publications: the one-shot TALES OF TERROR, way back in the summer of 1964, and the first issue of the quickly aborted TALES FROM THE CRYPT (dubbed Vol 1 #10 (!), Jul 68) which, not surprisingly, one William Gaines took immediate umbrage at...

One of the many puzzling facets about Eerie Publications is their staff of artists, most of whom appeared not to have worked for any other companies. Of the few *known* artists, here was the place they produced their most extreme work, untrammelled by questions of good taste and artistic finesse. Ezra Jackson,

Mindless carnage from respected veteran Dick Ayers... 'I Chopped Her Head Off!', WITCHES' TALES Vol 4 #5.

118

SHODDY DUPLICATES

the Art Editor, seems to have done little interior work, though presumably more than a few of the demented (unsigned) covers came from his hand. A nice piece by Jackson *does* appear in HORROR TALES Vol 2 #1 entitled '**The Witch and the Werewolf**', a caption-less macabre charade full of grim humour. In addition to Jackson, the two most famous artists had in common that they'd both worked with the legendary Jack Kirby at Atlas/Marvel as inker to his pencils, the pair in question being Dick Ayers and Chic Stone.

Amongst many stories by Dick Ayers (all of them stomach-churningly sickening, it must be added) some of the best are:

'**House of Monsters**' (HORROR TALES Vol 2 #1).* A Frankenstein-type opus where the unfortunate protagonist is ripped limb from limb (in crudely glorious detail) in a mad scientist's laboratory by a menagerie of evil monsters. Subtle.

'**The Devil's Zombie**' (TALES FROM THE TOMB Vol 4 #5): On a lonely swamp road, a murderer accidentally runs down a beautiful girl only to find that she is a demon who controls all the dead things in the swamp. Her father appears to be Satan himself, as our murderer finds out when he plunges beneath the swamp's filthy waters into Hell.

'**I Chopped Her Head Off!**' (WITCHES' TALES Vol 4 #5): In some of the most ghastly scenes of excessive, but 'schlocky', violence, a useless wimp chops up and disembowels lovely Mary just to prove he's got the backbone for it! When his folks dismiss the idea that anyone as wimpish as he could have killed Mary, our misunderstood hero hangs himself in a fit of despair. Yikes! This one was redrawn by

Ayers at it again...
'The Devil's Zombie', TALES FROM THE TOMB Vol 4 #5.

*Eerie Publications' stories were frequently recycled, so my citing particular issues doesn't rule out the inevitability that many of these stories will also have appeared in other issues and titles in Eerie's vast output.

119

GHASTLY TERROR!

left Slimy mummies on acid! Chic Stoned?

right The work of the prolific and talented Oscar Fraga. 'Demon's Night', TERROR TALES Vol 4 #1.

Ayers from an old script originally appearing in Gillmor's WEIRD MYSTERIES #8 as '**I Killed Mary**.'

'**Witch's Revenge**' (WEIRD Vol 4 #2): Our hero is compelled to return to his birthplace in Ireland where he is pursued by a ghastly spectre with a broken neck and both eyeballs hanging out, the victim of an ancestral witch's curse. Nice.

Two of the most amazing stories in Eerie Publications' entire output (and that's going some!) came from the neat brush-strokes of Chic Stone:

'**The Slimy Mummy**' (TALES FROM THE TOMB Vol 3 #5) tells the almost psychotically unbelievable story of a group of bearded ancients who are cursed to live with the dead (who are posted to them through a sort of huge letterbox!) in a cavernous dungeon below the streets of a medieval city. One night, having had enough of this arrangement, the doomed group reassembles several fresh corpses and resurrect the result in the shape of the slimy mummy (!?), a monstrous form which leads their revolt up to the surface world until a messianic, Christ-like figure descends from the skies to halt the bloodshed. The slimy mummy is destroyed, and the messianic figure returns the ancient men to their eternal torment beneath the city streets. I honestly can't find the words to express the sheer strangeness of this story, which is sort of like a lunatic's take on the Book of Revelation! Mind-numbing... Staggering... Sheer primi-

SHODDY DUPLICATES

tive genius… Whatever.

'**Bloodbath**' is Chic Stone's frantic anti-LSD opus, in which a group of acid-dropping groovers go on one almighty bad trip… Skulls with flashing eyes appear; there are severed heads and hands, scalpings and skinnings, and crucifixions abound! The cops burst in at the end to find a scene of total carnage — body parts and pools of blood all over the place. An absolute classic in the annals of comic book history!

Apart from the occasional tale by sometime-Warren artist Hector Castello, the worthy researcher is in for a difficult time spotting any other recognisable artist (except for 'Iger-shop'* production line reprints) and signatures are few and far between. However, one occasionally finds a small bit of scribbled handwriting here and there, the most prominent probably belonging to someone who signs himself Reynosa.

The 'Reynosa' signature appears on a number of Eerie Publication stories — and where it doesn't, this distinctive stylist is easy to trace once you get an eye for the job. Some of the artist's best work appears in the following stories: '**Zombie Vault**' (TALES OF VOODOO Vol 5 #5), '**The Head-Shrinkers**' (TERROR TALES Vol 6 #6), '**The Flesh-Eaters**' (HORROR TALES Vol 5 #1), '**The Demon is a Hangman**' (TALES OF VOODOO Vol 3 #6).

Another prolific contributor is one Oscar Fraga, an exceptionally talented artist, particularly suited to stories about demons and witches, whose dark washes and atmospheric use of tones does this subject immense justice. Two especially fine efforts can be found in '**Demon's Night**' (TERROR TALES Vol 4 #1) and '**Pit of Evil**' (TALES OF VOODOO Vol 7 #2), though there are many more…

Just as prolific is the artist who signs himself Casadei. Among a plethora of sterling efforts, some standouts are: '**Vengeance**', a particularly brutal rape story in TALES FROM THE TOMB Vol 4 #5; '**The Creatures**', gremlins from an-

The skull beginning what seems like a transition… More hallucingoenic horror from Chic and as WEIRD (Vol 8 #4) as it gets in 'Bloodbath'.

*Jerry Iger managed the 'Iger Shop' — a New York-based studio assembly line of artists, which Iger had founded with comics legend Will Eisner before they went their separate ways in 1941. The shop produced work of all genres (in the Iger house style), supplying many (lurid) strips to publishers of horror and crime comic books of the Forties and Fifties.

GHASTLY TERROR!

top Moody and malevolent panels from Reynosa. 'Zombie's Vault', TALES OF VOODOO Vol 5 #5.

above Shocking behaviour from Stanley!

other dimension in HORROR TALES Vol 6 #1, and the frightening '**Pit of Horror**' in TALES OF VOODOO Vol 5 #5, in which a hypnotist becomes trapped in the personal hell of a madman's mind.

Less prolific is Macagno, whose best work is '**Swamp Devils**' (TERROR TALES Vol 4 #1); while OA Novelle is a truly polished stylist, with '**Voodoo Doll**' (HORROR TALES Vol 5 #1) and '**A Thing of Terror**' (TALES OF VOODOO Vol 6 #2) in which a man's spirit becomes trapped inside a tree... 'OOWAAAR! MOORAW!' — 'That tree sounds like it's trying to tell us something, Harry! — Strange... I never heard a tree that made such noises!'

Equally polished is one Stepancich with '**The Body Snatchers**' — a superb *Devil Doll*-like story (TERROR TALES Vol 6 #6) and '**House of Vampires**' (WITCHES' TALES Vol 5 #6). Best of the lot is an anonymous, unsigned artist whose work would sit well aside the likes of Joe Orlando and Reed Crandall in the early CREEPYs. The work of this consummate stylist appeared in many early Seventies Eerie Pub titles, two of his greatest being: '**The Sea Monsters**', complete with a soggy monster aptly named Carpo (WEIRD Vol 7 #3), and '**Skull in a Box**', a superb shrunken head story (HORROR TALES Vol 5 #4). This artist may also be responsible for the haunting, dreamlike tale,

SHODDY DUPLICATES

'**The Witch's Pit**' in TALES OF VOODOO Vol 3 #5; an issue which also includes another of Eerie Publications' defining tales, '**Yeeech**', one of those 'greedy fat pig gets his just desserts' sort of stories in the best precode tradition!

Another question: just *who wrote* all these stories, anyway? Was it Carl Burgos? Ezra Jackson? Irving Fass? The artists themselves? (I suspect this to be the case with Chic Stone...) Who knows? Similarly, who painted all those horribly bad taste covers (or cut them up and spliced them back together to be re-used afresh...)? These are questions that cannot be answered at this time.

What *is* certain is that Eerie Publications produced some of the most consistently weird, disgustingly gory and truly horrific comics ever seen, without apparently even breaking into a sweat! Just as in the precode days (we're not talking about EC here), these things were produced almost via conveyor belt; automatically, without too much thought other than to terrify or gross out the reader. In this sense, WEIRD, HORROR TALES *et al* were not at all similar to Warren's output (despite Warren's accusations), being more like a throwback to the days before comics ever had a critical fan scene or a roster of star name artists. The Eerie Publications never showed any sign of reader feedback: no editorials, no letters pages, rarely even any ads... It was as though they

left and right Reversing the Comics Code. Eerie Publications give 'Bloody Mary' — originally printed in STRANGE FANTASY #10 — a makeover for its reprint in TALES OF VOODOO Vol 1 #11.

123

GHASTLY TERROR!

emerged out of a dark realm where the Comics Code had never existed! A dark realm where the most primitive, horrible fables were still told unselfconsciously, having no truck with the 'post-Code' world and its agendas.

Similarly orientated (though they made Eerie Pubs seem sophisticated by comparison) were the magazines produced by Gillmor veteran, Stanley P. Morse, whose Stanley Publications gave us the following:

SHOCK (Vol 1 #1, May 69–Vol 3 #4, Sep 71)
CHILLING TALES OF HORROR (Vol 1 #1, Jun 69–Vol 2 #5, Oct 71)
GHOUL TALES (#1, Nov 70–#5, Jul 71)
STARK TERROR (#1, Dec 70–#5 Aug 71).

All these worthy but unbelievably crude magazines were made up of Gillmor reprints in the early issues (including some great Basil Wolverton material, such as '**Swamp Monster**', plus Bernard Bailey *cover* reprints from Gillmor's WEIRD CHILLS and WEIRD TALES OF THE FUTURE). Later issues reprinted solid, but tamer, material from ACG's ADVENTURES INTO THE UNKNOWN and OUT OF THE NIGHT. Though short-lived and rather ephemeral, SHOCK, GHOUL TALES and STARK TERROR are now — like the Eerie Pub titles — sought-after items achieving higher and higher prices in today's comic book marketplace.

The stuff of nightmares from Stepancich. 'House of Vampires', WITCHES' TALES Vol 5 #6.

Much more similar to Warren's output is WEB OF HORROR (three issues, Dec 69–Apr 70), published by Major Magazines — aka Robert C. Sproul of CRACKED 'fame'. This short-lived project even poached some of the top talent which Warren regularly utilised: Jeff Jones (cover for #1 and #2), Otto Binder, Syd Shores, Frank Brunner, Roger Brand... Sproul even got in on the ground

SHODDY DUPLICATES

above, left to right Eerie Publications stitch two earlier covers together to make a 'brand new' third (which also borrows from TALES FROM THE CRYPT, see page 116).

below Covers were sometimes regurgitated in a more forthright fashion, as per this image for WEIRD (Sept 69) which turns up again as the cover for WITCHES' TALES (Jul 72) minus the guts and impalings.

floor by publishing some of the earliest professional work by Mike Kaluta, Bruce Jones and proto-megastar Berni Wrightson (cover: #3, and the gothic snake story '**Feed It**' in the same issue)… As well as two early, and excellent pieces by Ralph Reese, '**Man-Plant from the Tomb**' (#2) and '**Curse of the Yeti**' (#3). WEB OF HORROR even had its very own host, Webster the spider, though this rather cute little guy hardly seemed fit to challenge the gnarled old codger and his half-witted cousin over at Warren… Subtitled 'America's Nightmare Magazine', WEB OF HORROR didn't really fulfil its billing, its short three-issue run causing Warren relatively few sleepless nights in comparison to the *real* NIGHTMARE just around the corner at Skywald (next chapter).

In the meantime, a host of other publishers had jumped on the horror bandwagon, and although most of these cannot (even by Warren's strict standards) be viewed as 'shoddy duplicates' due to their regular 'four-colour' comic book format, the jealous publisher was still annoyed by their poaching of some of his top talent.

While it would be nice to go into all this in lots of detail, to be fair, most of the material about to be men-

GHASTLY TERROR!

tioned is rather tame by EC/Warren/Eerie Pub standards, and therefore falls outside the scope of this book; suffice to say that the late Sixties/early Seventies gave birth to a real horror comic renaissance in the wake of CREEPY with titles such as THE MANY GHOSTS OF DR GRAVES, HAUNTED, GHOST MANOR, GHOSTLY TALES, and GHOSTLY HAUNTS from Charlton, most of which are very whimsical, often sketchily written and poorly drawn, despite the presence of Steve Ditko and the likes of Nicola Cuti, Wayne Howard, Tom Sutton and Pat Boyette (who at least turned out some fine covers). Gold Key gave us the soporific BORIS KARLOFF'S TALES OF MYSTERY and Dell gave us 37 rather pedestrian issues of GHOST STORIES. Much better than all these put together, but still rather mild in the present context, were the DC books which frequently showed real talent and innovation. Taking the lead as the flagship 'mystery' title was the re-vamped HOUSE OF MYSTERY, closely followed by THE HOUSE OF SECRETS. Both magazines were

The unknown 'genius' of Eerie Publications with his stylish panels... 'Skull in a Box', HORROR TALES Vol 5 #4.

SHODDY DUPLICATES

Two of the best from DC. Covers: BLACK MAGIC #1 and THE HOUSE OF MYSTERY #214.

edited by Joe Orlando and featured some outstanding artwork from Neal Adams, Nestor Redondo, Alex Nino, Mike Kaluta, Luis Dominguez — and, on splash-pages and a number of superb covers, Berni Wrightson. Excellent stories by veteran scripters Jack Oleck and Carl Wessler complimented the top-notch artwork. Other DC titles of note include WEIRD MYSTERY TALES, THE WITCHING HOUR, THE UNEXPECTED and GHOSTS — this latter purporting to be based on factual accounts, occasionally coming up with some authentically hair-raising moments despite the ludicrous claim. Probably the best of these DC titles was BLACK MAGIC, a nine-issue series of reprints from the original Prize editions of the Fifties, featuring the classic team of Joe Shuster and Jack Kirby...

Kirby also added to DC's roster of 'mystery' characters (such as SWAMP THING and PHANTOM STRANGER) with his innovative THE DEMON (16 issues, Aug 72–Jan 74), the on-going adventures of demonologist Jason Blood, who periodically transforms into The Demon, Etrigan, once the Familiar of Merlin the magician... Excellent stuff. This type of 'horror-hero' echoes the slightly more focussed horror-

GHASTLY TERROR!

left Sproul must have been cracked to challenge Warren, but here's Jeff Jones' fine cover to WEB OF HORROR #2.

right Superb Boris Vallejo cover for issue #2 of Seaboard's excellent but short-lived WEIRD TALES OF THE MACABRE.

type books that Marvel were producing in such vast quantities at the same time (see chapter: *Bronze Age Silver Bullets!*).

Back on track with another direct challenger to Warren's b&w magazine territory, one late-comer was Seaboard's short-lived WEIRD TALES OF THE MACABRE (only two issues; Jan 75–Mar 75) a high quality project edited by the experienced Jeff Rovin, and featuring sound artwork from Jeff Jones (cover #1), Pat Boyette, Leo Duranona, John Severin, Boris Vallejo (cover #2), Ernie Colon, Ramon Torrents, Leo Summers, and others. Seaboard even produced another unsolicited 'Warren tribute' in DEVILINA, a short-lived, less creatively successful effort. But despite all these interesting contents and first-rate artwork, the short-lived, late-coming Seaboard offered no real threat to Warren's dominance of the field… That had come in the form of the Skywald Publishing Corp. (a few years, and some forty-odd editions, earlier in the game). Thereby hangs a tale!

THE HORROR-MOOD

SKYWALD MAGAZINES, formed in 1970 and created from an amalgamation of its founder's names — Sol Brodsky and Herschel Waldman — was a small close-knit concern operating out of offices on New York's East 41st Street throughout its short, five-year existence. Waldman, who had briefly published comics in the early Fifties, and who had continued to publish colouring books and books for children, had known Brodsky as a production manager whose pedigree also went back to the Golden Age of comic books. Brodsky had subsequently worked as a founding editor of MAD magazine-doppelgänger CRACKED, and from 1960–69 he'd toiled at the world famous Marvel Comics Group, where as produc-

Blood is thicker than water!
'Orgy of Blood',
NIGHTMARE #1.

GHASTLY TERROR!

Heaps of horror and the non-psychological dangers of horror comics!

*Covers for NIGHTMARE #1 (**this page**) and PSYCHO #2 (**next page**).*

**Hewetson was fond of creating labels like this. Another was 'Primal Spinal', the definition of which was the subject of an ongoing competition. One reader (in NIGHTMARE #17) suggested it to be 'a dread foreboding that creeps its cancerous way insidiously up the spine to lodge in the stygian recesses of the brain [where] it lurks like a fetid embryo, pulsating and nourishing its foul grossness on the essence of the soul...'*

tion manager he created the logos for THE FANTASTIC FOUR, TALES TO ASTONISH, and many other of their seminal Silver Age superhero titles.

With the advent of NIGHTMARE and PSYCHO, Brodsky and Waldman created the first large format b&w magazines to seriously challenge Warren's horror mag news-stand status — something for which Warren never forgave them. In reviving and revamping the swamp-monster The Heap, and creating the infernal cycle-superhero Hell-Rider, Brodsky also anticipated a trend for new, horror-type heroes which Marvel later exploited, with (oh, just for example) swamp monster The Man-Thing, and the infernal cycle superhero Ghost Rider... When Brodsky retired from publishing and went back to Marvel, it was left to Alan Hewetson to take over the creative reigns, a job he did with relish, taking NIGHTMARE and PSYCHO into unparalleled realms of extreme, festering (almost spiritually sickening) horror. Out of this arose a third title, SCREAM, thus completing the trilogy of the most frightening and gruesome horror comics of the 1970s.

'Horror-Mood' is the catch-all term that Hewetson would create and apply to these comics, perfectly capturing the essence and nature of Skywald's insular, unique atmosphere.*

Under a striking but uncredited cover depicting *'the coming of... the Pollution Monsters!'*, NIGHTMARE #1 kicks off to a good start with this Don Heck illustrated story of ecological disaster. Heck, an old Marvel stablemate of Brodsky's, who for years pencilled IRON MAN and THE AVENGERS, may seem a surprise choice for lead-off artist in a horror magazine which was to become (as Skywald's first, and therefore 'flagship' title) the most powerfully original and truly perverse horror comic in publishing history. But, many years before he had come to Marvel, Heck had churned out gruesome precode horrors for companies like Comic Media,

as Brodsky well knew... Apart from a couple of other original entries, notably the vampire yarn '**Orgy of Blood**' (by comic industry stalwarts Ross Andru and Mike Esposito), the nicely drawn werewolf tale '**Mark of the Beast**' (by old-timer Syd Shores and up-comer Tom Palmer), plus a couple of good illustrations by Sub-Mariner creator and another Brodsky buddy from way back, Bill Everett, the rest of NIGHTMARE #1 is made up of early Fifties precode reprints — retouched and toned by Brodsky after the manner of Carl Burgos' horror comic magazines (see previous chapter). Whilst these are typical ghastly precode fare (that's meant to be a complement), Brodsky shows his editorial talent in selecting good, solid stories, well-drawn, with decent plots; perhaps the best one being '**Master of the Dead**' with its deranged necromancer raising armies of the dead to take over the world (of course; what else would you do in his situation?) pre-shadowing The Heap's encounter with '**The Horror Master**' in PSYCHO #3. As first issues go, NIGHTMARE #1 is a pretty solid affair, but certainly nothing which should have unduly worried James Warren, who at this point had put out 35 issues of CREEPY and 30 issues of EERIE, and for whom things were looking good with the success of the first few issues of VAMPIRELLA, and whose own 're-print crisis' had passed (see chapter: *Comics To Give You The Creeps!*) — but, oh no, by all accounts Warren was seething mad. Not about the *quality* of NIGHTMARE, but the fact that it contained only *five* pages of ads to Warren's average *twenty*. Mr Warren was so incensed he ordered *all* ads to be dropped from his own publications forthwith. This radical move lasted for *one* issue before the avaricious publisher came to his senses!

Skywald followed NIGHTMARE #1 with the brilliantly titled PSYCHO, the first issue of which is cover-dated Jan 71. Despite the striking cover by one Brendan Lynch, and the appearance of the great Gray Morrow (not at his best here, it has to be said) illustrating the cover story, the delightfully ludicrous '**Skin and Bones Syndrome**', PSYCHO #1 isn't quite up to the same standard as NIGHTMARE #1; whether Brodsky's rather heavy-handed use of tones throughout the entirety of the magazine is a contributing factor is hard to say, but the whole thing certainly looks bogged down and muddy, and the choice of reprint material is average rather than good. Again, as in the case of NIGHTMARE, PSYCHO #1 has only two more original stories beside the cover story, these being '**...and then there's Cicero**', a pretty

Ghastly Terror!

Things hot-up for Dr Bradford of I.C.E. in 'Children of the Cold Gods', NIGHTMARE #2

substandard effort about an old lady's vengeful cats finishing-off her money grabbing nephew, illustrated by the experienced Paul Reinman, and **'The Gruesome Faces of Mr Cliff'**, another clinker about a dying horror movie star whose monstrous alter egos overtake his mind, causing him to go on a series of bloodthirsty killing sprees. By the time the cops catch up with him, and his vampire mask is removed, we find he has been long dead, no more than an ambulatory skeleton. 'What do you suppose animated him?' asks one baffled cop. 'Who knows?' is the answer, 'It could have been the devil himself!' Indeed. This uncredited story seems to be based on a mixture of **'Wardrobe of Monsters'** and **'Under the Skin'** (CREEPY #2 and EERIE #3, respectively).

The first thing to note about NIGHTMARE #2 (Feb 71) is its blood-drenched, atmospheric cover by Boris Vallejo, a cover artist many believe to be second only to the great Frank Frazetta. The painting illustrates the Gardner Fox-penned pot-boiler **'The Circle of Circe'**, a story typical of Fox, who had worked for years writing comic books (notably Hawkman — a character he created — in DC's MYSTERY IN SPACE and THE BRAVE AND THE BOLD) and weird pulps and paperbacks of the 'Ace Double' variety. Far better is **'Children of the Cold Gods'**, a truly chilling (sorry!) tale of cryogenic freezing, in which the denizens of another planet (or dimension?) of ice demons reanimate the smashed up, frozen body parts of the occupants of a disaster-struck spaceship returning to earth, reassembling them willy-nilly into a battalion of grotesque, crawling monsters. Dr Bradford, head of the Institute for Celestial Ecology (I.C.E., get it?), is suitably unimpressed when his fiancée, Lalla, returns from space in pieces, looking for all the world like the contents of a domestic butcher's freezer. 'Oh my God!' he laments, 'This cold chamber was to have preserved Lalla's life on a trip to the stars — but instead it's murdered her!' When his beloved later attacks him, *'sliding crabwise on the floor, fangs bared to tear, to slash, to eat!!'* he is reduced further to a choked 'Lalla — oh God! No!' The solution is to lower the temperature to '317.9 degrees Fahrenheit; air itself becomes

THE HORROR-MOOD

a blue liquid' which 'will not support life...' Writing CAUTION, DANGER, DO NOT ENTER, Dr Bradford seals the cold chamber, observing that it has become a mausoleum for his beloved Lalla. As a final gesture he places a red rose at the door of her eternal tomb.

Crudely but effectively rendered by Andru and Esposito, this is a standout tale of the early Skywalds and one of the most original. Another original tale in NIGHTMARE #2 is also notable because of its Dan Adkins artwork, his first for Skywald. Adkins had worked for Warren — and Marvel, where he drew Dr Strange in STRANGE TALES — before coming to Skywald for a brief spell, mostly inking the pencils of 'Sean Todd', a pseudonym of Tom Sutton. '**Pressed for Time**' features Adkins' trademark clean lines and neat shading with an atmospheric use of 'lighting'. The story, which is uncredited, is also above average in its depiction of a small New England community (modelled on Salem) which falls under the spell of one Ephraim Knowles, a Satanist who desires eternal life. (Don't they always?) What he gets instead is eternal aging, as he is condemned to death by 'pressing'* for his sins, forever reliving the hour of his condemnation and agonising execution. (Will horror comic characters never learn that Satan always has a few tricks like this up his sleeve?) NIGHTMARE #2 has four original stories

*The 'ghastly punishment' (Philip W. Sergeant, *Witches & Warlocks* Hutchinson 1936), in which stones are piled on the accused witch in layers, causing a lingering death.

Bruce Jones' rotten story — 'A Rottin' Deal', NIGHTMARE #3

> HA-HA! I WON, YOU BLOATED *HORROR!* I'VE *HAD* MY DRINK ALREADY...HEH-HEH... I BEAT YOU!

GHASTLY TERROR!

Spaced-out elegy for the Earth in 'Beware Small Evils', NIGHTMARE #3

and fewer reprints than the first two offerings from Skywald. In fact, on the last page of the magazine we see *'An Open Letter to Our Readers'*, which states:

> It happened faster than we expected... our next issue will feature the works of many top-quality writers and artists. The all-original stories will make you fans of NIGHTMARE magazine forever!

In the meantime there was THE CRIME MACHINE #1 (Feb 71) a short-lived project which ran only two issues featuring retouched and toned Fifties reprints of Avon crime titles. Much more interesting was PSYCHO #2 (Mar 71), the first all-original Skywald horror comic. But not only that, the introduction of *'The most exciting character in years! The mind of a man — in a body of earth-matter!'* None other than The Heap!

The Heap first appeared in AIRFIGHTERS #3 (Dec 1942) in the Skywolf strip. This walking mound of swamp ooze was previously Baron von Emmelmann, a WWI fighter pilot who was shot down over a mysterious swampland from which he emerged transformed into a green yeti-like monster. By #23 the title had changed to AIRBOY COMICS, and in #32 (Oct 1946) the Heap proved to be such a popular character that he got his own strip until the comic's demise (#111, May 53) with cover appearances from #98 onwards. Created by Harry Stein and Mort Leav, the original Heap was conceived as a sympathetic anti-hero, a trait which was continued in his Skywald incarnation as Jim Roberts, the crop-duster who flies off-course and crashes into a secret military base, straight into 'zone 19!'; 'Good Lord! That's the zone where we're storing the SHP-OP Nerve Gas!' Jim Roberts lies *'suspended in his coma-like state'*, during which,

THE HORROR-MOOD

A not too fantastic voyage after all! 'The Inner-Man', NIGHTMARE #3

'an odd commingling of nerve gas and pesticides occurred', leading to a *'strange metamorphosis'*…

> when he raised his hand to brush the drippings from before his eyes and saw the sickly sagging flesh shaking on his hand he began to understand!

The Heap is certainly a ludicrous, but disgusting, sight. Born from a marriage of such sinister forces as eco-unfriendly industrialism and the dreaded military (these were the Nam years, man), with his obscene, vagina dentata-style slobbering mouth, he is every inch the completely hideous apparition his name suggests. 'God, why me? Why me? Why was I transformed into this horrible Heap!' It's the voice of the little man suffering the ultimate fate in the hands of an uncaring world — and just to emphasise his powerlessness, The Heap can't even speak; all his anguish is internal.

The cover of PSYCHO #2, painted by Hector Varela, shows The Heap menacing a blonde, busty chick who looks none too pleased to be in his company. Other highlights of

GHASTLY TERROR!

the issue include a cautionary tale by Chuck McNaughton, ostensibly about the fracture of the hippie dream, '**To Laugh, Perchance to Live**', illustrated by precode horror veteran Jack Katz and a young Rich Buckler. This story certainly contains some odd dialogue; 'The bubble sure burst', muses burnt-out case Steve Weston as he surveys the East Greenwich Village dropouts who are his peers,

> and now these tenements house wreathes of wilted flowerchildren... Hmm... seems he took an overdose — he's crumbling! Mmm... feathers in his hair. The distress signals of a dying mind... whatever happened to simple horror?

This last question seems to forecast the future direction of the Skywald magazines as they plumbed the depths of death, perversion and lust and exhibited a multitude of psychoses. In fact, in many ways, McNaughton's story, with its emphasis on being trapped in some inner Hell of the deranged mind, anticipates the particularly insular direction the Skywalds would take under Al Hewetson's Horror-Mood. It's a taste of what was to come, and an indication that the Skywalds were horror comics with a difference.

'*68 pages of Twisted Tales of Terror!*' NIGHTMARE #3 (Apr 71) features the first horror comics appearance of Philip Roland... Better known as Bruce Jones, future editor of TWISTED TALES (see chapter: *Underground Currents*). '**A Rottin' Deal**', written and illustrated by Jones (who, along with Tom Sutton, Ernie Colon and possibly a few others, chose to work for Skywald under pseudonyms to avoid contractual difficulties) tells the disturbing story of a murderer pursued by his victim through a desert storm, only to find that his tormentor, a leper, has passed the disease on to him, and that the whole thing is a product of feverish hallucination as his body and mind decays. A truly revolting work, medical inaccuracies aside; Jones reveals his burgeoning talent for crisp dialogue and atmospheric narration, and his artwork is reminiscent of greats like Al Williamson and Gray Morrow. This much said, presumably you're thinking that this is the cover story... No! Once more a predictable outing from Gardner Fox, '**When the Dawn Gods War**', takes the honour, though Boris' striking cover painting manages to make this cave-

Third time unlucky — the non-event that was. HELL-RIDER #3.

136

man vs. spaceman opus a little more palatable. Much better than Fox's, or for that matter Jones', efforts this issue is '**The Inner Man**' written by somebody called Sinclair Rich, and illustrated by Tom Sutton (as Sean Todd) and Dan Adkins: a retake on the *Fantastic Voyage* theme, with a malicious miniaturised voyager ending up trapped inside the severed head of Dr Varga, there to be menaced by Varga's *'last line of defence... the unspeakable horrors of the subconscious mind!'* More weird medical speculations! But this fast-paced story is great fun and was deservedly chosen for reprinting in a later yearbook. So too was Frank Voltaire's brilliant '**Beware Small Evils**', illustrated by the busy Jack Katz, nicely inked and toned by Frank Giacoia. In this tale of a dystopian future (1984!) where nihilism and anarchy have run amok, 'Spacey's Spitfires, a huge multi-ethnic terrorist hoodlum gang' have taken over Southern California... 'The Spitfires were named after Spacey Jaglin, a female motorcycle tramp turned "respectable" 3-D movie queen who tragically died of an overdose of amphetamines mixed with other deadly body pollutants.' While the bikers hold their ersatz funeral for Spacey on a deserted oil-slicked Californian beach, a deadly germ-plant culture mutation, 'able to produce oxygen' with the ability to solve the pollution problem, is being shown to a congressman... 'Uh, please don't grab that slide senator'— SNAP! — 'It's not fully developed! At this stage of mutation — it's parasitic!' Of course, 'mutation 320' gets loose! Back at the funeral,

top The old hag's Haunt of Fear. 'Hag of the Blood Basket', NIGHTMARE #4.

above Boris Vallejo's fathomless talent! Cover: NIGHTMARE #5.

the pathetic carcass of the lonely, misunderstood, pop superstar tumbled with a flop before his boots... The Leader and

Ghastly Terror!

left Still the freakiest of them all: Frankenstein's Monster. Panel from 'Freaks of Fear', PSYCHO #4.

right The ultimate price of infamy. 'The Horror-Master', PSYCHO #3.

High Priest Guru with the last shreds of his drug-rotted mind, groped for appropriate words...

In true biker style, Spacey's body is burned on a pyre, where mutation 320 absorbs the heat-fused compound of formaldehyde and drugs and feeds on it, beginning to *'rise like yeast and continue to grow and multiply...'* The wake is spoiled somewhat by this turn of events and in short order mutation 320 has destroyed most of Southern California, 'an immense, creeping carpet of death!!' Those in authority decide that deadly cargoes of oils and detergents must be dropped on the marauding mutation — and then napalm... 'The spores must be all over the globe — no place will be spared the remedial conflagration... all the oxygen will be gone in about four days!..' This mordant satire ends with the scientist advising a nurse to slash the senator's stomach open, as anyone knows 'politicians are full of hot air!'

Also featured in this outstanding issue is **'Soul of the Warlock'**, written and illustrated by Chic Stone (another one who had worked for Marvel, inking Jack Kirby's pencils on 'the greatest comic magazine in the world', THE FANTASTIC FOUR). **'Soul of the Warlock'** is a tale of necromancy and Goetic magic in which one Erik Mortus attempts to resurrect the 'infamous Spanish nobleman of the 14th century,

The Horror-Mood

condemned to death for perpetrating hideous crimes of black magic and sorcery…' Esteban Delgato, no less! Needless to say, things go hideously, terribly wrong for Mortus — and with a name like that who could claim to be surprised? Equally interesting is '**Vault of a Vampire**', which has the unusual setting of Ancient Rome, 126 BC. Illustrated by Serg Moren, a stalwart of the early Skywalds, this grisly tale is significant in that it marks the first Skywald appearance of writer Al Hewetson.

A long-time comics fan (particularly of the ECs), Hewetson, whose family emigrated from Scotland to Canada in the 1950s, was first a darkroom man and then after high school graduation a fully fledged news photographer for the *Ottawa Journal*. Later he moved to Montreal to work on the *Montreal Gazette*. After a series of jobs working as feature writer for various commercial ventures, he moved to New York and spent six months in 1969 working for Marvel as Stan Lee's personal assistant. It was here, of course, that he met Brodsky, a man Hewetson described as 'always busy, always industrious, and always pleasant and emotionally uncluttered.' Although he didn't have a tremendous amount of contact with Brodsky at Marvel, it's obvious Hewetson was well remembered for his own industrious and professional attitude. When Brodsky amicably left Marvel to form

The romantic delights of Gay Paree! Splash pages from 'Slime World', NIGHTMARE #5.

GHASTLY TERROR!

Skywald with Herschel Waldman, Hewetson was one of the first people to be contacted. A letter, dated September 29, 1970, reads:

Dear Mr Hewetson, Sol Brodsky, who is now working with me on a new horror magazine venture, suggested I write to you since he has knowledge of your ability in the horror field. I would appreciate hearing from you and perhaps we can acquire the benefits of your talents. Sincerely, Herschel Waldman.*

Recently, Hewetson had been selling scripts to Warren. His byline had appeared in issues of CREEPY and EERIE throughout 1970 without any indication of his deeper feeling for horror which would emerge over the next few years. His first meeting at the Skywald offices took place on Sep 30, 1970 — the very next day after he received Waldman's let-

140

THE HORROR-MOOD

ter. He drove 500 miles from Ottawa (where he lived again, with his wife Julie) and 'hung around' New York for a couple of days to work up some 'interesting stories', all of which were typed in the noisy Skywald offices, evocatively described by Hewetson as

> many people crowded into various small spaces, one a production area where artists listened to loud radios and yelled over them, and laughed and joked constantly... I was joined during the day by Chuck McNaughton, Serg Moren, Bob Kanigher, Tom Sutton, Gary Friedrich, Ross Andru, Mike Esposito, Syd Shores, Dick Ayers, Jean Izzo and Bill Everett. Industrious lot, cheery, many familiar faces from Marvel.*

Hewetson concludes mildly, 'This might turn out to be a nice place to work.'*

No Hewetson stories in PSYCHO #3 (May 71), but despite this, it's a fine issue with even Gardner Fox turning in an interesting, bizarre tale of pirates, Spanish galleons and an ancient Peruvian named Cacique Cataquetl, transformed into a monstrous 'corpse-man' and sealed in a lead-lined coffin by alchemist Rodolphus Magnus. Illustrated by Serg Moren, '**A Coffin for Captain Cutlass**' is a cutlass above Fox's usual standard. So too is Fox's '**The Man Who Stole Eternity**', but this time largely because of the beautiful and subtly toned artwork of Bill Everett, here producing his first (and last) fully-fledged effort for Skywald. Interesting as these are, PSYCHO #3 is particularly notable for its introduction of two more series characters: Sean Todd's '**Frankenstein**', in which the creator, the creation, and some supporting characters like Dr Pretorius (from James Whale's *The Bride of Frankenstein*) are brought together for another monster mash; and the curious, short-lived '**Love Witch**', written by

above You're 'It'! 'The Asylum of Frozen Hell', PSYCHO #7.

previous page, top Towards the Horror-Mood. Cover: NIGHTMARE #7.

previous page, bottom No tape in existence could measure this worm! Splash pages from 'Tunnels of Horror', NIGHTMARE #8.

*Hewetson's diary of his Skywald years, as featured in 'My Years in Horror Comics', *The Comics Journal* #127.

GHASTLY TERROR!

Marv Wolfman at his most enigmatic (the story reads like something penned by Esteban Maroto), illustrated with tones by 'Jack Purcell' — Ernie Colon by any other name. The Heap makes his second, and probably his greatest, appearance as he faces '**The Horror-Master**', a dude of obvious genius, but questionable taste, whose necromantic rites reanimate the corpses of Lucretia Borgia, Gilles De Rais, Isle Koch, Caligula, and Adolf Hitler, among others. As usual, World Conquest is the aim, but 'plot' aside, the real horror comes across in little touches like the Heap troughing down dead rats and the contents of a dustbin, observing pathetically, 'It almost tastes good! Is it that I'm starving — or have I really become the monstrous thing I appear to be?' Written by McNaughton and illustrated by Andru and Esposito, with atypically moody, carefully executed artwork, this episode of the Heap is a real standout.

NIGHTMARE #4 (Jun 71) features a ludicrous but enjoyable effort, absolutely desperate to appear 'with it', Chuck McNaughton's '**The Phantom of the Rock Era**', a tale designed to exploit the inherent decadence of the Rock'n'Roll lifestyle. This cover story, despite its execrable dialogue, still manages to evoke a few chills due to Ralph Reese's superbly grotesque artwork, his first for Skywald. But without doubt the real highlight of this issue is Al Hewetson's epic '**The Hag of the Blood Basket**', a Sean Todd-illustrated tale which runs for an unprecedented 16 pages. The story concerns one Madam Du Sade (who looks remarkably like the Old Witch of EC fame) the eponymous Hag of the Blood

top Biting off more than he could chew! 'The Geek!', NIGHTMARE #6.

above Insect fear! 'Sting of Death', NIGHTMARE #8

Basket, who in revolutionary France stood over the 'crimson receptacle' which caught the decapitated heads of guillotine victims. One day the Hag is betrayed and stands accused of allegiance to the Royalists, whereupon she hears 'The verdict... Guilty of treason you old Toad Hag. I sentence you to death! May the lord have mercy on your wretched soul, woman!' Come the hour of execution, despite the beheading, the Hag's consciousness remains intact and she begins an agonising descent into Hell... 'Tartarus welcome you Madam!' exclaims Vogt, Satan's deformed henchman, a mirror image of the hideous, popeyed Hag herself. Trapped for agonising days in a box of spikes, the Hag waits an eternity for an audience with Satan who, when finally he deigns to see her, explains that in his kingdom, 'every resident has a private Hell! The thing one fears most... come, I'll show you...' Torture by rats and insects and other atrocities unfold before the Hag's horrified eyes, before it is decided, 'You'll rot, woman... rot in eternity till your miserable carcass smells like manure! You'll pay the supreme punishment... eternal loneliness!' Offering to help the Hag escape, feeling she has been treated unjustly all along, Satan's henchman Vogt reappears offering the hag a map of Hell. Using the henchman's detailed directions, and an incantation he has given her, the Hag attempts to escape from Hell. She fights her way into the light of the surface world demanding her life in the words of the incantation, which ends, 'Release my Soul... And give me life!' But she forgets — how can one return to an ordinary life with no head! The story ends with the illogical, grotesque image of the headless *eternally living* body of the Hag chained in Bedlam, duped by Satan into creating her 'own personal Hell' after all... More important than the rambling plot is Hewetson's use of grotesque and decaying imagery and his portentous, hyperbolic narration with its obsessive attention to squalid details. So too, the dialogue is strangely disturbing; the utterances of madmen, degenerates, psychotics, wallowing queasily in psychic filth. **'The Hag of the Blood Basket'** reveals a new dimension to Hewetson's style, indicating for the first time what the Horror-Mood was all about according to 'Archaic Al', as Hewetson now signed himself...

top Al Hewetson — the Archaic One in his editorial prime.

above Hewetson and Co prove they're certifiable — application form for Skywald's Shoggoth Threat expedition, from NIGHTMARE #20.

GHASTLY TERROR!

top and above Piling on the horror. Covers for the 1972 Annuals.

A month's hiatus occurred after the publication of NIGHTMARE #4 (and the first issues of two short-lived colour comics JUNGLE ADVENTURES and BUTCH CASSIDY) in which Herschel Waldman officially reduced his role to Associate Editor, and son, Israel Waldman, took over as Brodsky's co-publisher. This resulted in NIGHTMARE #5 appearing on schedule (Aug 71) with PSYCHO #4 (scheduled for July) following in Sep 71, both mags looking slightly revamped with their flat, book-like spines instead of centre staples. Another Skywald mag cover-dated Aug 71 is HELL-RIDER #1, subtitled 'Right On, with the Cycling Superhero!'; an individual with the Right On name of 'Brick Reese', who becomes the nefarious Hell-Rider, a daemonic anti-hero rather than clear-cut goodie-goodie... The first issue has him battling horned, red-skinned demons, and in the second he faces the 'Mr Hyde'-like Ripper. A third issue, in which Hell-Rider was to take on '**The Zodiac Killers**' sounds particularly interesting to us .44 magnum true crime fans, but it never appeared.

With supporting character-based strips '**The Wild-Bunch**' (a violent tear-up with big guns and big cars) and '**The Butterfly**' (a gossamer-winged Black super-chick) was HELL-RIDER the first non-Code new superhero comic...?*

NIGHTMARE #5 has another superb Boris Vallejo cover, illustrating '**Creatures of the Deep**', another eco-terror story in which radioactive pollution turns local marine life extremely nasty. Pollution, of a kind, also plays its part in Chuck McNaughton and Ralph Reese's '**Slime World**', very probably the best non-Hewetson story to appear in a Skywald magazine. Developed from an 'original idea' by Sol Brodsky (or rather, he had remembered some of those precode horror comics which portray the Paris sewer system as teeming with subterranean cannibal-things), '**Slime World**' begins with honeymooners Sidney and Susan taking a guided tour of the Paris sewers (oh, how romantic!), when a grotesque figure beckons to Susan from the shadows. 'Sid! I just saw another guide go that way... He said "Follow me"'... Follow him they do until 'SKREELANG!', an iron gate crashes down, sealing the tunnel... 'Then I saw them!' narrates Sidney, 'They came lumbering at us, hideous, oozing creatures of slime!' Chained in a dungeon by the slime people, the honeymooners await their fate, but Sidney gets loose, and unfastening Susan's bonds he makes the sensible suggestion, 'Let's split this slimy scene!'. Deciding they're being followed, the young couple split up and we follow Sidney

*I say 'new' superhero comic, because the famous 'drug' issues of SPIDER-MAN were non-Code approved, resulting in the relaxation of Code regulations. See chapter: *Bronze Age Silver Bullets!*

further down into the slime world where he sees 'The monster slime-men holding people in captivity!' And shortly after: 'Good lord! A kitchen!... they eat most normal people before they can turn to Slime-men!' Not surprisingly disturbed by this revelation, Sidney takes off at a pace and after a while a slime-man comes along chowing down on a human hand. Sidney brains him with a piece of drain-pipe only to discover from the engagement ring it bears that the hand is Susan's: 'Oh no! No! No! Susie... They... They caught Susie!!' A truly gruesome scene unfolds in which the incensed Sidney beheads the unconscious slime-man whose total sliminess is such that his head just pulls away... Yuk! Pursued and then trapped in the lower tunnels, when Sidney finally emerges the disease of sliminess has taken hold of him, and, degenerating swiftly, he is accepted by the slime-community where he takes a slime-wife and acquires the necessary taste for human flesh... 'Then one day, the edificial gate to the surface world was hoisted open... my day... of Test! The day... they trust me to acquire food!' Hiding in the shadows, slime-Sidney beckons to a young couple; 'Follow Me!'...

Things start to get seriously weird in PSYCHO #8. Panels from 'Filthy Little House of Voodoo'.

The choice of Ralph Reese as artist on this story is absolutely perfect; he captures the dripping, decaying atmosphere brilliantly, and his rendition of the slime-men evokes shudders of revulsion. Truly a standout effort in all respects.

NIGHTMARE #5 also contains the notable **'Whence Stalked the Werewolf'** by Len Brown and CREEPY veteran Carlos Garzon, a refreshing lycanthropy tale involving time-travel, and Al Hewetson and Serg Moren's morally dubious **'Nazi Death Rattle'**... all in all, the best issue to date.

PSYCHO #4 (Sep 71) has a good cover — Ken Kelly's first for Skywald. Kelly went on to be a regular cover artist for Warren, where his colourful paintings are featured

GHASTLY TERROR!

throughout the early to mid-Seventies, but he only ever did a few for Skywald. This one illustrates '**Comes the Stalking Monster**' written by Larry Todd (who contributed to the best of the Underground horror comics) and illustrated by one David Cook, and the veteran Syd Shores. The story concerns a scientist, one Aleister Kohner, who probes the 'Regions of Chaos' by blending scientific theory with ancient magic... *'Incantations were unnecessary; a sonic filter of white noise to keep outside sounds from interfering with the pattern was enough!'* (All you Chaos Magicians take note.) Along with another episode of The Heap's tragic biography and another instalment of Frankenstein (in which the monster is exhibited in a travelling freakshow), PSYCHO #4 also features Part One of a two-parter by Marv Wolfman and Rich Buckler, '**Out of Chaos**', an interesting, apocalyptic tale about the destruction of Hell by a group of cosmic beings named The Procreators of Eternity. All the prideful, Satanic rhetoric and the 'Storm the Gates of Heaven' stuff makes for absorbing, exciting reading. Still, the highlight of the issue is a relatively quiet affair, written and illustrated by the ever-talented Bruce Jones, '**Plague of Jewels**', in which treasure seekers become trapped in a vast subterranean Incan palace where one of them meets his fate as the consort of the ghoulish, hideously disfigured queen. This is weird stuff — unsettling, even though it doesn't make a great deal of sense.

top The slithering, slimy Horror-Mood. Cover detail from PSYCHO #9.

above "I'm not having a nightmare! I am a nightmare!" The Heap in his own short-lived full colour comic. Cover: THE HEAP #1.

Also out in Sep was issue #1 of THE HEAP, which turned out to be a one-shot 52-page colour comic featuring artwork by the prolific Tom Sutton. The book, one of the scarcest of the Skywalds, was rounded off by some precode reprints which originally appeared in Avon's STRANGE WORLDS #8 (Jun 52).

With NIGHTMARE #6 coverdated for December (instead of October) it's obvious that one or two gears were being

THE HORROR-MOOD

shifted in the Skywald offices. This resulted in the next magazine being PSYCHO #5 (Nov 71). Here, '**Out of Chaos**' part two comes to a climax with the universal enthronement of the crowned and conquering child — were some members of the Skywald staff Crypto-Thelemites, subscribers to The Book of the Law? Also in this issue The Heap enters '**The Cavern of Doom**', another one of the bizarre subterranean worlds that Skywald was so fond of depicting. Here Andru and Esposito's artwork is given uncredited assistence by Pablo Marcos, a Mexican artist who would later become one of the staple contributors to the Horror-Mood. Yet more subterranean shenanigans take place in Frankenstein chapter three, in which the creation descends into '**The Sewer-Tomb of Le Suub**', a sort of mini-Cthulhu lurking in — yes, you've guessed — the Paris sewers. Meanwhile the creator's head is being kept alive by the frenziedly deranged Dr Pretorius... Hewetson and Moren team up once again to produce '**The Unholy Satanists**' (not one of Archaic Al's best story titles!), a turn-of-the-century opus in which a

Out on a limb! The unbelievably sick doctor from the 1972 NIGHTMARE ANNUAL. 'Limb from Limb from Death'.

GHASTLY TERROR!

bereaved wife gets involved with devil worshippers in order to get her dead husband back. Of course, when he does return from the grave he looks like a right old mess. In a bizarre finale, the wife dies of shock, but remains somehow conscious because of her sworn devotion to the Demon; 'I'm not really dead!!' she screams in her grave. PSYCHO #5's cover is by Boris Vallejo — a demonic scene illustrating **'Let the Dreamer Beware'**, written by comics legend Jerry Siegel (he of SUPERMAN fame) and illustrated in the usual high fashion by Ralph Reese. It's a bizarre, hallucinatory tale about a wife-poisoner who escapes to a demonic

Archaic, alliterative awfulness in 'The Funeral Barge', NIGHTMARE #10.

THE HORROR-MOOD

The Saga of the Human Gargoyles (panels from NIGHTMARE #10)....

left *Three's company! The immaculate misconception of Mina Sartyros.*

right *Enter Satan.*

realm in his dreams, only to be reduced to a skeleton when in one of his sojourns he is thrown into 'the acid pool with the carrion.' Siegel's old-time fans were no doubt very surprised by this odd little tale.

After the excellent standards set by the previous three issues of NIGHTMARE, issue #6 (Dec 71) seems curiously flat, and even the Jeff Jones '**Love Witch**' cover is rather static. This is all the more surprising when considering the talent involved, such as Ernie Colon (who illustrated the second and never-to-be-repeated appearance of the '**Love Witch**'), Carlos Garzon, Jerry Siegal, Larry Todd (whose miniature alien tale '**Broken Sparrow**' seems familiar), Bob Kanigher and Doug Wildey (who offer us the bland '**Corpse by Computer**'), and Mike Kaluta (whose artwork seems a bit wasted on the sci-fi pot-boiler '**The Cosmos Strain**'). In fact the whole issue is probably too sci-fi-orientated with Skywald no doubt gearing up to the aborted production of SPACE ODYSSEY, a sci-fi comic title which was advertised but never materialised.

Much better is the Skywald début of Pat Boyette, a writer-artist from Texas with a unique, grotesque style and whose tales are always set in the dim dark past, featuring snow-bound log cabins in Eastern Europe, or cold, gothic cathedrals in cruel medieval cities. Boyette had taken to drawing

GHASTLY TERROR!

top left All the fun of the fair. Cover: NIGHTMARE #11.

top right Love hurts! 'The Man-Macabre', PSYCHO #10.

above The inquisitive andriod. 'The Suicide Werewolf', PSYCHO #10.

comics relatively late in life, after spending many years in broadcasting. '**The Geek!**' is his Casper Hauser-like story of one Max Schuller, a widower who finds a strange little freak which attaches itself to him. But when the local Baron hears of its existence, he is taken into 'royal custody', there to provide amusement for the Baron's court. Cruelly treated, the geek kills the Baron, and in a final act of kindness to Max Schuller (before he disappears for ever) he digs up the rotten corpse of Schuller's wife... 'He tried to repay my kindness! He didn't want me to be alone anymore...' sobs Schuller.

The next few months heralded more reshuffles behind the scenes, with Herschel Waldman vacating the Assistant Editor's post in favour of Jeff Rovin (who had interviewed Jeff Jones briefly in NIGHTMARE #6). The elder Waldman's role was now labelled Business Manager. What with all this commotion, PSYCHO #6 didn't appear until (cover-date) May 72. Under a Vicente Segrelles cover — whose work for Skywald and Warren differs immensely from the generic fantasy strips for which he became famous (HEAVY METAL's '**The Mercenary**', for example), PSYCHO #6 kicks off to a good start with another Pat Boyette grotesquerie '**The Vow**', a story drawn in part in the 'wide screen' double-page style which

150

THE HORROR-MOOD

was utilised often thereafter until Skywald were asked to stop by their syndicators because it caused so many 'production difficulties'. (The mind boggles.) More of The Heap (this time Pablo Marcos is given an art credit) — and more of the Frankenstein monster, who in this episode meets the Phantom of the Opera in those ubiquitous Paris sewers. Imagine the monster's surprise when the Phantom's pipe organ turns out to be some sort of time machine! What the hell is going on here? There was no more Frankenstein for a while after this, presumably because it seemed impossible to top this current episode… More significantly, the prolific Doug Moench makes his scripting début with a macabre take on the Rolling Stones' 'Midnight Rambler' song: '**The Midnight Slasher**'. It's passable, but indicative of Moench's sometimes infuriating stylistic idiosyncrasies which mar some of his most interesting ideas, especially in the case of his work for Warren. Also making his scripting début is Ed Fedory (later to be known as 'Emotionally-disturbed Ed'*, and good mate of Archaic Al's) with '**Sand Castle**', a story in which being lost in the desert is a symbol of one man's personal hell (bring back the Hag of the Blood Basket!). This interesting story is illustrated by a slightly under-par Pablo Marcos.

Now back on course with a regular schedule, NIGHTMARE #7 (Jun 72) appeared next. This was due mostly to the efforts of Al Hewetson, who was made Associate Editor of NIGHTMARE and PSYCHO on August 21, 1971, after the unceremonious departure of Jeff Rovin. This momentous occasion in the history of horror comics cannot be underplayed. Under Hewetson's editorship the Skywalds would develop into the most unique and disturbing horror comics of all time, generating their own particular, coherent world-view which would at last put them on a 'philosophical' par with the ECs and the early Warrens.

The subtly changing process toward the Horror-Mood is evident in the pages of PSYCHO #7 (Jul 72), the cover of which illustrates a Hewetson tale for the first time, '**The Asylum of Frozen Hell**'. This Pablo Marcos illustrated story is told from the reader's point of view, an old EC trick to really get the reader involved in the story, and a device their detractors absolutely reviled as particularly harmful to the impressionable.† Harmful, or not, it was an editorial device which Hewetson was to use time after time in an effort to make the audience feel part of the Horror-Mood, a sort of miasmic evil which drew you in (and the idea of which disturbed this 13-year-old reader far more than any other hor-

*Dying Doug Moench, Jaundiced Jane Lynch, Awkward Augustine Funnell, the Late-Departed Lurid Luis Collado… These are just some of the weird nicknames of the Horror-Mood team, a ploy which Hewetson borrowed from his Marvel days when Stan Lee created rather more upbeat monikers for his bullpenners: Gentleman Gene Colan, Jolly Jack Kirby, etc.

†One particularly pertinent example being 'You, Murderer' (panel, **above**) by Bernie Krigstein in EC's SHOCK SUSPENSTORIES #14 (Apr 54), a tale promoting autonomy in an issue also featuring parricide and an anti-KKK story… No wonder 'they' wanted the comics banned!

GHASTLY TERROR!

Ooze in the swamp? Cover: PSYCHO #11.

ror comics...). At the end of '**The Asylum of Frozen Hell**', the reader is fated to take over the role of the blind guardian of 'Hell' — in this instance the warden of a colony of other-world mutants at an interstellar gateway at the North Pole!

With this same issue, Hewetson takes over the scripting of The Heap, signalling a real degeneration into psychosis for our hapless anti-hero (you can almost feel Hewetson itching to finish The Heap off, a character he was far from fond of, by all accounts). The very talented artist Ramon Torrents makes his first appearance in a Skywald magazine with '**The Discombobulated Hand**', a whimsical little piece of negligible consequence. There are also first appearances from Domingo, a fine Spanish artist, Denis Fujitake, and Steve Englehart (as *artist*, rather than writer — the latter a role for which he's better known).

NIGHTMARE #8 (Aug 72) features a stunning, uncredited cover illustrating '**Tunnels of Horror**'. This disgusting opus from Hewetson and Marcos is prefaced on the contents page with the statement, *'You've heard of the sewers of Paris'* — Boy! Have we! — *'but have you ever heard of the sewers of New York...?'* So, a real change of pace here as yet more sewers are explored, this time in search of an enormous *tapeworm* menacing a city suburb at the turn of the century. But if it's 'only' a massive tapeworm why, as one character points out, has it got 'a head like... oh my God... Like a rotting Skull!'...? This is a very, very strange story with a *Beowulf*-like ending to boot: the giant tape-worm is only a youngster — you ought to see the size of its mother! In this issue any semblance of sanity begins to slide down the slippery slope towards the Horror-Mood. This is evidenced by 'Howie Anderson' (a Hewetson pseudonym) who writes '**The Weird and the Undead**', the mind-boggling tale of an advertising executive who makes a 'life eternal' deal with the Devil. (Will these people never learn?) This seems fine until disaster strikes the Earth and wipes everybody out. As the exec floats in nothingness he laments, 'I can't die... for me... there is only the torture of un-death'. This story marks not only the début of Howie Anderson, but also the artistic début of Ferran Sostres, an exceptionally skilled artist who also draws Hewetson's '**Hey Creep: Play the Macabre Waltz**' in the same issue. Also making his début is another Spanish artist, Dela Rosa, whose baroque style perfectly complements Ed Fedory's tale of arctic cabin fever '**Snow Bound**'. Bruce Jones returns to compose '**Hung Up**', a realistic tale of deceit and domestic violence. Held

TEN ESSENTIAL TALES BY ARCHAIC AL

'The Funeral Barge'
(NIGHTMARE #10)

'Beware It... Fear It... It Screams!'
(1973 NIGHTMARE WINTER-SPECIAL)

'The Filthy Little House of Voodoo'
(PSYCHO #8)

'The Slither-Slime Man'
(PSYCHO #9)

'1 and 1 Equals 3'
(NIGHTMARE #10)

'The Asylum of Frozen Hell'
(PSYCHO #7)

'When the Dusk Falls... So Does Death'
(SCREAM #4)

'The Roots of All Evil'
(NIGHTMARE #16)

'I am Dead: I am Buried!'
(NIGHTMARE #12)

'The 13 Dead Things'
(PSYCHO #15)

THE HORROR-MOOD

The big crybaby of 'And it Whispered, And it Wept, And it did Shudder, And it did Die', PSYCHO #11.

over since it was slated to appear in PSYCHO #3, Chic Stone's **'Sting of Death'** rounds off the highlights for this issue, although one more item of interest appears in the shape of Al Hewetson's illustrated review of the *Tales From the Crypt* movie (Amicus 1971), in which he manages to sound entirely enthusiastic, although in private he thought: 'Not much of a movie!'

PSYCHO #8 (Sep 72) is a storming issue! It's the first Skywald to be solely edited by Al Hewetson — and there for the first time, on page three (the contents page) we see the phrase HORROR-MOOD!* Hewetson tells it like this:

> Sol quit today. Sol Brodsky was a nice guy. On Friday Sol asked me if I wanted to stay over the weekend because on Monday he'd have some important news... the news was important alright! He's going to return to Marvel... and he's recommended me to take over the editorship of Skywald.†

Hewetson's enthusiasm is immediately obvious from the re-set title page and the weird, cryptic introduction it carries; something meant to define the spirit of the magazine, a device which would become Hewetson's trademark approach as Editor. The Horror-Mood was tenuous, miasmic, but it was *something*; a kind of decaying atmosphere which other horror magazines lacked... This was all down to Hewetson, carefully setting the scene with a few well-chosen (sometimes meaningless) editorial phrases. When Hewetson took

*In an introductory blurb that reads: 'This proud macabre gathering of gargoyles, crypts, black raindrops, thousands of faces, and filthy little houses; destined we hope — to rock your primal spinal, eagerly awaits you to turn the page to where the freaky fun of this issue REALLY BEGINS... TO SHRIEK AT YOUR HORROR-MOOD...'

†Hewetson's diary, *The Comics Journal* #127.

153

GHASTLY TERROR!

Archaic Al exhumes Poe. 'Premature Burial', NIGHTMARE #12.

THE TEN BEST HORROR-MOOD MAGAZINES

PSYCHO #8
THE 1973 NIGHTMARE WINTER-SPECIAL
NIGHTMARE #16
PSYCHO #11
SCREAM #4
SCREAM #1
NIGHTMARE #10
PSYCHO #10
THE NIGHTMARE ANNUAL 1972
PSYCHO #9

over something clicked into place. The contents of PSYCHO #8 are breath-taking: the first appearance of The Human Gargoyles, written by Hewetson and illustrated by Dela Rosa (although NIGHTMARE would become their regular home, where they would find their definitive illustrator in Maelo Cintron — more on these characters later); **'Have You Seen the Black Rain'** by Hewetson and artist Xirinius, making his first appearance with this tale of medieval sorcery, dungeons and castle-tombs in the 'Countess Bathory' tradition; **'City of Crypts'** by Howie Anderson and début illustrator, Villanova, a story of foul lumps of predatory slime in an ancient Egyptian Pharaoh's tomb; Marv Wolfman's and Andru/Esposito's **'Devil's Woman'**, so well illustrated on the atmospheric, but uncredited cover — and best of all, the brilliantly titled **'The Filthy Little House of Voodoo'**, by Hewetson and Ramon Torrents. This weird allegory begins with two young women, lost whilst driving in the Australian Outback, who come upon a horrible, crumbling town occupied by retarded, vacant-eyed old people playing with dolls. 'Nobody will speak to us... They just sit blankly staring into the desert... They're all senile... senile!' In disgust they drive a short distance to a ramshackled old house. On one of its walls they find a portrait of a demonic figure... 'Look at the eyes... it has the same eyes... as the people'. In the night an odd procession of figures appear, one of them mumbling, 'voodoo, sapping strength... not much... left...' then the painting comes to life, and 'It's not just the painting... The whole wall is twisting...' The filthy little house comes alive and blocks off all their exits, and finally the girls find themselves in 'a den of spongy, sopping mud 'neath the earth where creatures once upon a time known as humans mutter senseless drivel on their knees...' Trying to shake some sense out of one of these degenerates, the girls are horrified when he just crumbles away under their fingers... The demonic figure pro-

The Horror-Mood

nounces: 'I am of an old, indeed an ancient, race... of Parasites! What is the voodoo? Why, I am the voodoo!' The girls finally begin to degenerate as the life is sucked out of them... 'Soon they will be playing with the dolls!' This odd, unsettling tale certainly lives up to the title of the magazine in which it appears! It's undoubtedly one of the most curious things I've read, and it epitomises the Horror-Mood in its almost queasy portrayal of mental disorientation and the warping of subjective reality...

Hewetson followed this *tour de force* with the NIGHTMARE and PSYCHO 1972 Annuals, collections of all-original material which broke with Warren's tradition of making these special issues (sometimes called YEARBOOKS) a collection of Best Of reprints. The PSYCHO ANNUAL (on sale Jun 72) is a solid package of first-rate material including another episode of the increasingly psychotic Heap and the Hewetson/F. Dela Fuente **'The Truth Behind the Myth of Dracula'** which purports to set the record straight, but it's best not to worry about it on that score! The NIGHTMARE ANNUAL (on sale Jul 72) has two undoubted highlights in: **'Dr Jekyll and Mr Hyde'** illustrated by Xirinius, with Al Hewetson managing to adapt the classic story well, packing it all into about 10 pages without missing any salient details, and **'Limb from Limb from Death'**, Hewetson and Marcos' *really disgustingly foul* tale of a doctor driven to madness when he is forced to amputate and eat the limbs of two fellow survivors after their plane crashes in the desert. I'm not kidding, if you want to feel nauseated read this one...

Back on track with the regular issues, NIGHTMARE #9 features the first of Hewetson's 'continuation' of HP Lovecraft's Cthulhu Mythos, **'The Skull Forest of Old Earth'**,

Prison is just a state of mind in 'I am Dead: I am Buried!', NIGHTMARE #12.

GHASTLY TERROR!

illustrated by first-timer Zesar, and the cover story this issue. And a good cover it is too, painted by one Miralles, presumably another Spanish import. Hewetson builds up the goose-bumps with more scene-setting introductory words to get the reader in the Horror-Mood:

The mad-emotions within us taunt and horribly tease our sad, slithering souls... send us reeling into wild realms of essential archaic horrors thought long buried in graves unforgettably lunacy-spawned... This is the LUNATIC issue!..

As if to underline this fact, the Pablo Marcos double-spread title page features a tittering, cackling gap-toothed kid, Skywald's first small concession to the idea of having a 'horror host' in the EC (and Warren) tradition. Hewetson also re-designed the letters page as one rambling continuous column entitled (for this issue, at least) *'Lunatic letters and Noxious Nightmare News Designed to Seep into Your Shock-Wrought Weird Brain...'* All this hyperbole marks the arrival of the Horror-Mood proper; on the back page Hewetson announces coming attractions from 'The Master story-tellers... the men who live to create the mad-emotional HORROR-MOOD!'

PSYCHO #9 (Nov 72) is the first Skywald magazine cover to feature the legend: 'A Skywald HORROR-MOOD Publication'. It's a Domingo cover depicting **'The Slither-Slime Man'**, a sinister, toothy individual reminiscent of the weird little grave robber character from **'Custodian of the Dead'** in WEB OF EVIL #1 way back in Nov 1952 (see chapter: *Into the Abyss...!*).

top *The love-lives of dead things. Cover: NIGHTMARE #13.*

above *Obviously unlucky for some... Cover: PSYCHO #13.*

In fact, this unpleasant chap is also a grave robber of sorts, who, as the cover-blurb points out, *'Slithers, half-dead, half buried into graves he doesn't own... to defile bodies he doesn't know...'* A nasty 'hint' at necrophilia for all to see — and on the cover yet! Hewetson's verbose tale is drawn by the prolific Pablo Marcos, who does a good job of portraying the foul, muddy, rain-drenched graveyard in which most of the story takes place. There the slither-slime man desecrates grave after grave in the insane belief he is

THE HORROR-MOOD

helping the locals by stopping the corpses transforming into vampires and other unpleasant creatures! In his deep-southern accent he drawls, 'All done... All finished for the night... cleansed this here graveyard this night... ain't no ghouls or vampires or warlocks gonna rise from this graveyard on this night... I seen to that...' The story finishes with the slither-slime man 'cleansing' the fat, corrupt local sheriff, tearing off his head and muttering: 'Gotta cleanse the world fer mah fellah man...' There the lunatic stands in the ceaseless rain, clutching the sheriff's head. Hewetson laconically comments, *'The blood mingles with the rain, and makes more mud...'*

'**Suffer Little Children**' is Hewetson and Villanova's loose adaptation of Henry James' classic *The Turn of the Screw*. I wonder what James would have thought about the Horror-Mood version which concludes with a repellent image of animated, maggot-infested corpses and the statement: *'You want to snatch a look at the epitome of horror, dear reader? Look into the blood-black hearts of these DEAD THINGS...'* If there is any remaining doubt that this sort of morbid fare is exactly what the Horror-Mood is all about, the back cover makes it all too obvious:

> Come into this archaic living Horror-Mood where things live and die that have no names — no faces... only tales to tell... of abominations undefined, of agonies unheeded... where unnameable beasts and fiends rule, and writhing, horrid, tiny dead things serve, while senile elder things drivel and choke...

Lautréamont eat your heart out! Also of interest is the *'Seething Psycho Scribblings Scrawled to Scratch a dent in your Primal Spinal'*, that is, the letter's page. Here is featured an item on James Warren's scathing attack on Skywald in the New York comics convention booklet he produced

... LUNATIC PICNIC ...

... there are picnics ... and there are picnics ... THIS picnic kinda bends the mind a bit, for these 4 weird weekenders are having a barbecue in a GRAVEYARD ... only 4 people we know are so into the HORROR-MOOD to even think of such a thing ... Jagged Julie Hewetson, Dreadful Donna Fedory, Emotionally-disturbed Ed Fedory (doin' the cooking on the headstone there), and Archaic Al Hewetson asleep ... dreaming up a tale called LUNATIC PICNIC, (oddly enough), which'll be appearing shortly ...

XEROX AWARD
To Skywald Publishing, whose appings of Creepy & Eerie (Psycho & Nightmare) gave no new meanings whatsoever to the word "imitate."

top Editing the Horror-Mood comics was a real picnic! Photo of the 'Lunatic Picnic' that appeared in PSYCHO #11. The story of the same name appeared in the following issue.

above An unwarrented attack, as detailed in PSYCHO #9.

GHASTLY TERROR!

left Cover: SCREAM #1.

right Proof that love conquers all. 'Beware it... Fear it... It Screams!', THE 1973 NIGHTMARE WINTER SPECIAL.

SKYWALD SERIES'
–FRANKENSTEIN–

PSYCHO #3
('Frankenstein Book II: Chapter One')

PSYCHO #4
('Freaks of Fear')

PSYCHO #5
('The Sewer-Tomb of Le Suub')

PSYCHO #6
('The Phantom of the Opera')

NIGHTMARE #13
('Frankenstein 1973')

SCREAM #6
('2073: The Death of the Monster')

SCREAM #7
('Saga of the Monster')

PSYCHO 1974 YEARBOOK
('The Brides of the Frankensteins')

*Hewetson's diary, The Comics Journal #127.

that year, which read:

> XEROX AWARD. To Skywald Publishing whose apings of CREEPY and EERIE... gave no new meanings what-so-ever to the word 'imitate'.

If this doesn't immediately seem like a clear-cut case of 'sour grapes', it's interesting to note that early the following year Hewetson writes: 'Warren called me up at home last night and asked me to edit the Warren line. A job offer. EERIE, CREEPY, and all that. I said no.'*

If PSYCHO #9 was 'the issue of the slither-slime man', NIGHTMARE #10 (Dec 72) goes one better as *'The Mad-Emotional, Throat-Choking Fat One...'* Under a good Ken Kelly cover — illustrating the poor **'Princess of Earth'** — this issue features arguably Hewetson's best story, **'The Funeral Barge'**, in which he lets his morbid imagination and alliterative style free fall. Illustrated by Xirinius, it tells the tale of a fugitive aboard a mysterious barge on the Thames that, with its zombie crewmen, transports rotten corpses down river to

> a castle of Hell that rose like some macabre growing thing... grew out of the water... grew and breathed... and as it yawned a black hole in its gut slowly widened to welcome its crawling, seething, sickening, horribly heaving food which floated upon this bizarre barge now aimed like an archaic arrow at the disgusting squalid stomach of that great carnivorous castle...

The fugitive is winched off-board with a pile of the corpses

THE HORROR-MOOD

that are being delivered to feed the vampires inhabiting the castle vaults. The fugitive tries to fight them off, but 'I fell beneath them, limp, my mind long dead… whoever was left carried me away…' When we next see our hero, he is standing, blank-faced at the helm of the barge:

> The lightless barge seemed merely to drift knowingly in the direction of the slow-moving river… I stood with the rudder-wheel in my hands… It did not turn or seem to move… neither did I…

Ed Fedory and Dela Rosa's '**Black Communion**' — the story of a monastery in the Pyrénées in which Satan raises the long dead inquisitor Carlos Cardova to wreak vengeance on the holy men — is also very good… But Hewetson's and Cintron's '**1 and 1 Equals Three**', which tells of the birth of Andrew Sartyros, the son of Edward and Mina, the Human Gargoyles, is better still. Hearing of the birth, Satan tries to claim parentage of the gargoyle child, in some blasphemous inversion of the Immaculate Conception, to which Edward responds: 'Lunatic deity! Filth Incarnate!' The resulting explosion of his clash with Satan makes it clear that the battle is far from over — the Devil will forever try to claim his child, never letting the Human Gargoyles have peace. There is also the problem of how such creatures (even as part of a freakshow set-up — to which they belong for a while) can survive and fit in with society at large… The series goes on to explore these dilemmas in sometimes touching detail, but never at the expense of an exciting punch-up with one or more of Satan's minions!

The Horror-Mood now having established the Skywald magazines as something unpleasantly different from the norm, 1973 was Hewetson and Co's most successful year in creative terms, if not in popularity. The issues of NIGHTMARE, PSYCHO, and later SCREAM during this period are the most gruesome and intense horror comics in Skywald's — or for that matter any other publisher's — history. It is important to note that the prevailing 'philosophy' behind the Horror-Mood phase brought a real sense of coherence to the magazines, a sense of being taken into another world altogether, a world that might have been evidence of the insanity of the collective unconscious. In realising this, it no longer seems necessary to provide a blow-by-blow account of the progression of the Skywalds — in horror comic terms they had nowhere left to progress; they were *there*, tapping

> **SKYWALD SERIES'**
> **THE SAGA OF THE HUMAN GARGOYLES**
>
> PSYCHO #8
> ('A Gargoyle — A Man')
>
> NIGHTMARE #10
> ('1 and 1 Equals 3')
>
> NIGHTMARE #13
> ('**Only the Strong Shall Survive**')
>
> NIGHTMARE #14
> ('**…and They did Battle with the Thing from Underneath**')
>
> NIGHTMARE #15
> ('**Once upon a time in Alabama: A Horror**' …in which the Gargoyles move south in a parable about racism)
>
> NIGHTMARE #19
> ('**The Human Gargoyles vs. the United States of America**' …during a period of civil unrest Edward Sartyros is imprisoned for destroying a valuable State artefact)
>
> PSYCHO #20
> ('**The Freaks**' …Sartyros meets journalists who look exactly like Hewetson and Cintron before attempting a jailbreak)
>
> NIGHTMARE #20
> ('**I, Gargoyle**' …Sartyros' autobiography goes on sale and Edward is released from prison in a media blitz)
>
> NB. Both NIGHTMARE #16 and #20 announced '**The Human Gargoyles vs the Human Dead**', but only the prologue appeared — in NIGHTMARE #23 (the final issue).

GHASTLY TERROR!

*No idle supposition; King regularly read the Horror-Mood mags — see note on page 166.

†A tale heavily based on 'Zombies Revenge', an ADVENTURES INTO THE UNKNOWN strip reprinted in SHOCK Vol 2 #2 (May 70).

> SKYWALD SERIES'
> —THE HEAP—
>
> PSYCHO #2
> (origin...)
>
> PSYCHO #3
> ('The Horror-Master')
>
> PSYCHO #4
> ('Night of Evil')
>
> PSYCHO #5
> ('The Cavern of Doom')
>
> PSYCHO #6
> ('Dark Victory')
>
> PSYCHO #7
> ('A Spawn of Satan', NB first Hewetson)
>
> PSYCHO ANNUAL 1972
> ('What Hath Hell Wrought')
>
> PSYCHO #10
> ('Even A Heap Can Die')
>
> PSYCHO #11
> ('A Ship of Fiends')
>
> PSYCHO #12
> ('And the World Shall Shudder')
>
> PSYCHO #13
> ('When Dies a Lunatic... So Dies a Heap')

directly into the Necronomicon, so to speak. And it was all down to Archaic Al...

Over the following months it becomes increasingly unimportant which stories featured in which issue of which magazine (though in keeping with the rest of the book this will be noted) because it was all a manifestation of the Horror-Mood; something all-pervading, bigger than its constituent parts. Put together end to end, the Skywalds form some sort of Black Book of Fate...

A lycanthrope is tortured by faceless inquisitors. Upon escaping we realise he is a malfunctioning, delusional android! (**'The Suicide Werewolf'** by Hewetson/Marcos, PSYCHO #10, Jan 73)... A perverse relationship develops between torture freaks Morris and Melinda, who play a game of *The Pit and the Pendulum* (**'The Legend of the Man-Macabre'** by Hewetson/Villanova, same issue)... A vampire dies screaming in an abandoned theatre (**'Tightrope to Nowhere'** by Hewetson/Xirinius, same issue)... An abomination lurks down a sewer (**'It'**, a Hewetson text story; same issue — inspiring Stephen King to write a big novel on the same theme with the same title*)... A lunatic mistakes the ghost train at the funfair for the lair of subterranean monsters! (**'The Wetness in the Pit'** by Hewetson/Marcos, NIGHTMARE #11, Feb 73; great cover on this theme by 'Jad' who went on to work for the Marvel monster mags)... Ghoulish prepubescent vampires hold a cannibal feast at the local school (**'Corridors of Caricature'** by Hewetson/Jesus Duran — making his first Skywald appearance, same issue)... A future-earth infested by Lovecraftian cannibal Shoggoths (**'Where are the Inhabitants of Earth?'** by Hewetson/Zesar; same issue)... An octapoidal monstrosity is left to rot in its dungeon when its 'daddy', a mad-scientist, dies (**'And it Whispered, And it Wept, And it did Shudder, And it did Die...'** by Hewetson/Rosa, PSYCHO #11, Mar 73)... Fanatical witch-hunters burn a pregnant woman and then her just-born child (**'Make Mephisto's Child Burn'** by Fedory/Rosa, same issue)... A crass comedian is forced to tell jokes to an audience of freaks until his mind snaps (**'Don't Die up there, Stanley'** by Hewetson/Suso, a very talented Spanish artist making his début here, same issue)... A voodoo ritual raises a murdered man from the swamp in which his brother buried him (**'The Thing in Horror-Swamp! — Being the Origin tale of Darkkos Mansion'**† by Hewetson/Marcos, PSYCHO #11)... An old hotel is demolished unearthing masses of dead bodies (**'A Bag of Fleas'** by Hewetson/José Gual, another tal-

160

THE HORROR-MOOD

left Blood fights blood in 'The Vampyre', NIGHTMARE #16

top right Sonia Greene — not Lovecraft's missus for sure! 'The Vampire Out of Hell', NIGHTMARE #17

above The face of the Horror-Mood. Cover: PSYCHO #17.

ented Spaniard appearing for the first time, same issue)... A man becomes insane when abused by weird little aliens and thrust before the throne of Hypnos, god of sleep (**'Nightmare in the House of Poe'** by Hewetson/Sostres, NIGHTMARE #12, Apr 73; on the theme of Poe, in this issue Hewetson offers his first Poe adaptation, illustrated by Xirinius, **'The Premature Burial'**)... A man escapes from a harsh, Arkansas prison in the swamps only to find he never really got out because he was dead all along! (**'I am Dead: I am Buried!'** by Hewetson/Villanova, another story which uses the reader's point of view to great effect; same issue)... A freak-boy turns on his tormentors when he becomes a werewolf (**'Monster, Monster, On the Wall'**, the first in this series by débuting Augustine Funnell and Pablo Marcos, same issue)... A man crashes his car and is ab-

161

GHASTLY TERROR!

*A PSYCHO WINTER SPECIAL was also planned, but never appeared.

†Another Hewetson pseudonym?

ducted by Satanists who only seem to imprison him for a few hours, but he discovers he has been missing for a year ('**The Event in the Night**' by Hewetson/Marcos, THE 1973 NIGHTMARE WINTER SPECIAL*)... Lovely Annabel Lee (the heroine of Poe's famous poem) marries Anton, a pistol-whipped lunatic who tortures her in a pit of foul, venomous creatures. She returns from the grave unshaken in her love for Anton ('**Beware it... Fear it... It Screams!**' by Hewetson/Borrell — who appeared previously in PSYCHO #11 — this truly frightening story is portrayed on the Ken Kelly cover; same issue)... Mutant children cannibalise their parents on a spaceship on an interstellar journey ('**The Night of the Mutant-Eaters**' by Hewetson/Fujitake; same issue)... A daemonic apparition appears behind a spaceman standing over the body of a dead girl (Jeff Jones' cover for PSYCHO #13, May 73 — originally to have appeared on the aborted SPACE ODYSSEY #1)... Sinister little dolls are really diminutive vampires; their wooden master is the real doll! ('**The Mad-Doll Man**' by Hewetson/Gual; same issue — the '*Asylum Issue!*')... Humanoid alien-ants invade wonderland in Alice's dream — or nightmare ('**The Weird Way It Was**' by Hewetson and a very below par Marcos; also PSYCHO #13)... The Heap goes insane in the New York subway after mutilating farm animals. (Hewetson's idea of fun! Illustrated by Villanova; same issue)... The reader is dragged into Hell, an asylum for lunatic dead things. ('**Welcome to my Asylum**' by Hewetson/Villanova; same issue)...

Meanwhile, back cover announcements for the first issue of SCREAM begin to appear...

A shrouded dead thing rises from its midwinter crypt in a swirl of snow — this is Vicente Segrelles truly frightening cover of NIGHTMARE #13 (Jun 73) '*the Corpse Issue*'... A man stuffs his nagging wife alive, and leaves her to suffocate, in a jar of spiders ('**Die Little Spider!**' by Stuart Williams†/Rubio, another Spanish artist, with a unique, 'scratchy' grotesque style; same issue)... A montage of deranged Cthuloid images ('**The Mad, Nightmare World of HP Lovecraft**' by Hewetson/Rosa; same issue)... A flying demonic head with tentacles is unearthed after a deal is made with Satan ('**Only the Wretched Die Young**', writer-artist Ricardo Villamonte's Horror-Mood début; same issue)... Two lovers are reunited after death in a blas-

The Horror-Mood in its prime at the end of 1973. Cover: NIGHTMARE #16.

THE HORROR-MOOD

phemous marriage ('**The Corpse**' by Howie Anderson/Cueto; same issue)... Humanoid Gargoyles are acquitted of crimes after battling a Satanic tentacle (part three of the continuing saga by Hewetson/Cintron; same issue)... Half-rotted away with sores, starved into insanity and chained in a dungeon with a crumbling skeleton, a man is slowly devoured by rats (this is the gross, but superbly executed cover of PSYCHO #13 by Segrelles, illustrating '**The 13 Dead Things**' — a story which didn't actually appear until PSYCHO #15)... A man accused of vampirism feeds a meal made of bloodsucking leaches to his dinner guest ('**And the Corrupt Shall Dine**' by Fedory/Rubio, NIGHTMARE #14, Aug 73)... A man from the future witnesses the destruction of the Earth whilst trapped in the mind of a turn-of-the-century lunatic ('**Diary of an Absolute Lunatic**' by Hewetson/Rosa; same issue)...

August 1973 also saw the first issue of SCREAM, sporting another horribly effective Segrelles cover... Dead things assemble in a remote castle to each tell their tale of how and why they died a horrible, damning death (part one of '**The Tales of Nosferatu**' by Hewetson/Zesar)... A weird artist's paintings come to life in a Satanic old house ('**The Paintings of Jay Crumb**' — Hewetson's in-joke after meeting R. Crumb through Jay Lynch — illustrated by Dela Rosa; same issue)... An old cripple degenerates into a trail of sentient slime ('**I, Slime**' by Hewetson/Gual; same issue)... A psychotic horror film fanatic carries out his perverse desires dressed as his favourite screen monsters ('**The Classic Creeps**' by Hewetson/Cueto, PSYCHO #14, Sep 73 — this is thematically similar to CREEPY #13's '**Scream Test**')... Hewetson and Zesar track down a manuscript written centuries ago by a decrepit old woman who discovers a weird subterranean world of zombies guarded by blood-thirsty Shoggoths — *'Prepare, the year they will come up to the Earth is 1973'* ('**This Grotesque Green Earth**', NIGHTMARE #15, Oct 73)... Sweet and innocent 'Black Chick' Anne Jackson becomes possessed by Black Anne, Queen of the Salem Witches and wife of Satan ('**Lady Satan**' part one by Hewetson/Villamonte in SCREAM #2, Oct 73)... Three Men In Black-like ghouls haunt a midnight graveyard. The fiends turn out to be members of the local authorities providing grisly meals for themselves ('**Ghouls Walk Among Us**' by Funnell/Sostres, PSYCHO #15, Nov 73)... A mutiny at sea aboard a plague ship in which the captain takes root like a living tree! ('**The Roots of all Evil**' by Howie Anderson/Borrell,

SKYWALD SERIES'
—SHOGGOTHS—
NIGHTMARE #9
('The Skull Forest of Old Earth')
NIGHTMARE #11
('Where are the Inhabitants of Earth?')
NIGHTMARE #15
('This Grotesque Green Earth')
SCREAM #1
('This Archaic Breeding Ground')
NIGHTMARE #19
('The Vault')
NIGHTMARE #20
('The Scream and the Nightmare')
PSYCHO #20
('The Dead and the Super-Dead')

—LADY SATAN—
SCREAM #2
(Origin...)
SCREAM #3
('What is Evil and What is not?')
SCREAM #4
('Satan Wants a Child')
PSYCHO #19
(The Son of Lord Lucifer')

GHASTLY TERROR!

*Hewetson's diary, *The Comics Journal* #127.

SKYWALD SERIES'
MONSTER, MONSTER

NIGHTMARE #12
('Monster, Monster, On the Wall')

PSYCHO #13
('Monster, Monster, In the Grave')

PSYCHO #16
('Monster, Monster, Rise from the Crypt')

PSYCHO #17
('Monster, Monster, Heed Death's Call')

PSYCHO #18
('Monster, Monster, Watch Them Die')

PSYCHO #19
('And in this Land… a Monster')

–LOVE WITCH–

PSYCHO #3
(**The Love Witch**')

NIGHTMARE #6
(**The Battle of the Living Dead**')

–OUT OF CHAOS–

PSYCHO #4
('A New Beginning, Part One')

PSYCHO #5
('A New Beginning, Part Two')

NIGHTMARE #16, Dec 73)… A man sacrifices his haemophiliac son to destroy a child-killing vampire ('**The Vampyre**' by Fedory/Marcos; same issue)…

And so it goes throughout the entire year, a seemingly endless catalogue of atrocities and abominations, all delivered in the inimitable Horror-Mood style.

On such a horrifically creative high it's difficult to understand why the Horror-Mood line existed for only one more short year before ceasing publication, but at the end of 1973 the rot had already begun to set in. Hewetson was lamenting the lack of home-grown material — with all the best North American artists and writers working elsewhere for fees much higher than Skywald could afford to pay. 'I want a stable bullpen!' states the irate Archaic One, 'House artists, writers, living around New York and commuting for conferences and one on one character development.'* He was looking for an extension of the creative intimacy he enjoyed with Human Gargoyle artist Maelo Cintron, and writer Ed Fedory, but Skywald's relative impecunity had made it necessary to strike a deal with the Selecciones Illustradas studio in Barcelona, some of whose 'idiosyncratic stylists' left much to be desired in Hewetson's eyes… Certainly the very best of the studio's artists — Esteban Maroto, José Ortiz, José Bea — never worked for Skywald, reserving their remarkable talents for Marvel, and chiefly, Warren. The irony was that even Skywald's *local* contributors sounded foreign: Maelo Cintron, Pablo Marcos, Ricardo Villamonte, causing Hewetson to comment: 'This company is going to look like its magazines are packaged overseas and drop-shipped into the States, which is antithetical to every precept of American magazine packaging!'* The situation was worsened by the 1973 news-stand invasion of horror comics in the shape of Marvel's monster magazine line (produced, ironically, by Sol Brodsky), which Hewetson believed ruined Skywald by 'flooding the market'.

(Although this is undeniably the case, wasn't that what Hewetson had planned himself with the creation of TOMB OF HORROR, WEIRD TALES OF THE MACABRE and TALES IN THE TRADITION OF EDGAR A. POE — a series of proposed Skywald titles which, had they ever appeared, would have done just as good a job of 'flooding the market' as the Marvels?)

One good thing hat happened in the Selecciones deal was the automatic world-wide syndication of the Horror-Mood magazines (though personally, I've never been able

THE HORROR-MOOD

Horror-Mood family portrait in NIGHTMARE #22, the Tomb of Horror issue — a fitting epitaph. (Hewetson has the voodoo doll; the corpse is identified as Herschel Waldman.)

to understand the American bias against 'foreign' art in the first place) which meant that the Skywalds would be syndicated internationally for years to come...

Lest the impression be given that Skywald's final year in publishing was one of incessant doom, gloom and sharply declining creativity, it must be said that this is not the case at all. Certainly the first several issues of the Horror-Mood comics with 1974 coverdates were as good as anything gone before — and Hewetson continued in the sme vein regarding special features on current movies (like *Dracula AD 1972*, *Vault of Horror*, *Theatre of Blood*, *The Omega Man*, *Frogs* and many others), articles on classic horror tales, reviews of selected horror novels, and a Gargoyle Egg competition (in which the lucky winner would receive a genuine 'gargoyle egg' — actually one of 10 weighty pebbles found expressly for the purpose of a competition on a Hewetson/Fedory outing to the beach). All of which was intended to make the Skywalds 'reader-friendly' in the EC tradition. One particularly interesting example of this, and a real coup for Skywald, is Hewetson's thoughtful 'Exclusive interview with Christopher Lee' in NIGHTMARE #17 (Feb 74), in which the questions asked are far more pertinent than the usual horror

SKYWALD SERIES'
–DRACULA–

PSYCHO ANNUAL 1972
('The Myth of Dracula')

NIGHTMARE #15
('Dracula did not Die!')

NIGHTMARE #19
('Castle of the Vampire Dead')

PSYCHO #19
('Hell is on Earth')

NIGHTMARE 1974 YEARBOOK
('The God of the Dead')

GHASTLY TERROR!

*Hewetson again?

†Hewetson's diary for Nov 30, 1973 reads: 'A fellow by the name of Stephen King, evidently a would-be horror writer did a piece in *Writer's Digest* about the horror market. He was very kind to Skywald... What an astute guy! I should drop him a line and offer him work as a scriptwriter. He's probably a starving young writer if he's trying to break into the horror market!' *The Comics Journal* #127.

fanzine questions, and Lee's answers are as serious and considered as ever. Along with good, disturbing tales like '**The Inquisition**' (by Joe Dentyn* and Lombardia), in which two reporters make their own news by torturing and killing an old woman in order to sell papers, and '**The Vampire Out of Hell**' (Edward Farthing*/Ricardo Villamonte) in which one Sonia Greene, a vain beauty (not Lovecraft's wife of the same name then!) becomes the captive queen of a race of monstrous vampires deep in an African jungle, NIGHTMARE #17 makes for a particularly good issue.

So too the 17th issue of PSYCHO (Mar 74) with its unbelievably repellent cover by Fabá, first-rate artwork from Callodo ('**The Narrative of Skut**'), Borrell ('**The Crime in Satan's Crypt**') and an odd scripting début by Jane — wife of underground cartoonist Jay — Lynch ('**The Lunatic Class of '64**'). Also of interest is the quote on the back-cover taken from a review in *Writer's Digest* magazine, which says about the Horror-Moods: '...the most vital — constantly moving ahead, breaking new ground, using consistently innovative stories...'

And who was it displaying such great taste? None other than Stephen King.†

SCREAM #4 (Feb 74) features a good werewolf cover by Villanova, illustrating the gory '**Blood Hunt for the Cannibal Werewolf**' by Fedory and Villamonte. Equally compel-

*Who are the victims? Panels from 'The Saga of the Victims' in SCREAM #6 (**left**) and SCREAM #8 (**right**).*

THE HORROR-MOOD

ling, but for different reasons, is Hewetson and Sostres' **'The Skull of the Ghoul'**, in which the skull of Dracula exerts its malefic influence over a girl stranded in a lonely castle. Particularly good is the fourth story in the Nosferatu series by Hewetson and Zesar (**'When the Dusk Falls... So Does Death'**), which relates the career of a lycanthrope whose head is shattered when he transforms having been forced to wear an iron mask. *'...and those evil things that gathered in the sight of Nosferatu let up a yell and a laugh that Satan could hear in Hell... to see the wretched sight of the poor fool with the shattered head...'* This series was accompanied in following issues of SCREAM by The Saga of the Victims, a rather sadistic magnum opus for Hewetson (illustrated by Suso) in which two girls are subjected to ceaseless tortures, indignities and monstrosities as they 'learn the true meaning of horror!' Other series which continued sporadically (such as The Human Gargoyles), flitted about (Lady Satan and Monster, Monster), petered out altogether (The Heap), or never really got off the ground (Autobiography of a Vampire), were accompanied by Hewetson's continuing policy of adapting classics, such as the ambitious re-telling of Gaston Leroux' **'The Phantom of the Opera'** (SCREAM #3). Hewetson was particularly fond of continuing the tales of Edgar Allan Poe, producing fine versions of **'Bernice'** (with Villamonte), **'The Oblong Box'** (Nava), **'Ligeia'** (Duran), **'The Masque of the Red Death'** (Villamonte), and **'MS. Found in a Bottle'** (Font).

Also continued were stories featuring Shoggoths, culminating in NIGHTMARE #20's **'The Scream and the Nightmare'** (Hewetson/Cardona), at the end of which is announced the *'Skywald crusade to end the Shoggoth threat... an expedition to the centre of the Earth'* — an expedition which Horror-Mood readers could join merely by obtaining the necessary Shoggoth Crusade Certificate, available from Skywald for a measly 15 cents!

Meanwhile the 'Tomb of Horror' concept, in which writers and artists themselves were depicted in the strips as story narrators, was tried tentatively in NIGHTMARE #18

Titles advertised as forthcoming... The 'flood' came from an unsuspected direction — aborted Skywald prjoects.

SKYWALD SERIES'
AUTOBIOGRAPHY OF A VAMPIRE

NIGHTMARE #17
('Chapter One')

SCREAM #5
('Chapter Two')

NIGHTMARE #19
('Chapter Three')

TALES OUT OF HELL

NIGHTMARE #19
('The Kingdom of the Dead')

SCREAM #10
('The Evil of Rasputin')

SCREAM #11
('Jesuis le Marquis de Sade')

THE SAGA OF THE VICTIMS

SCREAM #6
('What is Horror? No — Who is Horror?')

SCREAM #8
('I am... Torment!')

SCREAM #9
('I am Treachery: I am Horror-Incarnate')

GHASTLY TERROR!

*TOMB OF HORROR was scheduled to appear in the Spring of 1975 as a new Horror-Mood title unto itself, but never did.

†Hewetson's diary, *The Comics Journal* #127.

('**The Seven Weird Tales of the Man-Macabre**'; Apr 74) and then fully fledged in NIGHTMARE #22 (Oct 74) — the 'Tomb of Horror Special Edition'.* Right until the end, Hewetson was willing to experiment in this way, keeping things fresh and exciting, even inventing a new character to suit the style of oriental artist Chull Sanho Kim: '**The Fiend of Chang-sha!**' (PSYCHO #21, Oct 74). But with the final few issues being Yearbooks and Specials containing in the main reprints — something Skywald had always avoided previously under Archaic Al's editorship — it was obvious that the bubble had burst. It's sad to read Hewetson's diary entry for March 25, 1975 and the notice he reluctantly composed to all Horror-Mood contributors. 'Today is the day', he writes...

> I sent everybody this letter: ...Today the Skywald Publishing corporation announces the cancellation of NIGHTMARE, PSYCHO, and SCREAM magazines. This is due to the exorbitant production increases, rising printing and distribution costs, and a glutted magazine market. I hope Skywald has been as rewarding for you as it has been for me... The Publishers and I wish you the very best of luck and good fortune in all your endeavours. We hope you will be successful... That's all folks.
> — (Archaic) Alan Hewetson, Editorial Director.†

SKYWALD SERIES'
THE TALES OF NOSFERATU

SCREAM #1
('Where Lunatics Live')

SCREAM #2
('The Name is Sinner Kane, and the name means Evil')

SCREAM #3
('The Tale of Another')

SCREAM #4
('When the Dusk falls... So does Death')

SCREAM #6
('And the Gutters Ran With Blood')

SCREAM #7
('Satan's Third Reich')

SCREAM #8
('My Prison in Hell')

SCREAM #9
('Who Killed the Shark?')

NB. 'The Slither-Slime Man' from PSYCHO #9 appears in a sequel story ('The Slither-Slime Man Rises Again') SCREAM #8.

Hewetson also writes of 'a time of editorial freedom, and consequently literary and artistic accomplishment' in that same letter. This is a statement that cannot be played down. The Horror-Mood mags were without a doubt the most artistically expressive (and the least self-censoring) comics since the Comics Code came into effect in 1954, throwing artistic caution to the wind and not even caring to be tied down by the sort of specific editorial policy which had defined the ECs. Instead, the Skywalds were out on a limb in the true sense, venturing into the dark regions of the mind deemed off-limits 20 years previously; taking over the work that the weirder of the precode Horrors (like WEIRD MYSTERIES, WORLDS OF FEAR, VOODOO, MYSTERIOUS ADVENTURES) had been running before they were *made to stop*.

Such was their success that, while over 20 years have passed, nothing has come along to supersede the Skywald Horror-Mood magazines. The current horror comic scene (such that it is) can't even furnish a pale imitation.

BRONZE AGE SILVER BULLETS!

MARVEL COMICS, the self-proclaimed 'House of Ideas', who brought forth such popular modern icons as Spider-Man, The Mighty Thor, Iron Man, Captain America and The Fantastic Four*, had started the whole comic collecting craze with superhero titles that were exciting, mind-blowing and full of cosmic insights.

But as we have already seen, the horror comics had not been entirely forgotten, and had returned in various guises and formats to haunt the news-stands: b&w magazines, led by Warren's CREEPY and EERIE, Fifties reprint specialists Eerie Publications, and Skywald's increasingly ghoulish NIGHTMARE and PSYCHO, as well as new, regular size, colour horror comics from DC, Dell and Charlton. Realising that Warren's success had caused a turn in the tide, it was only a matter of time before the industry's biggest name caught on. After a decade of suppression, at last the Comics Code authority was beginning to relax its stringent hold over the creativity of comic book writers and artists. The first tentative steps from Marvel (and DC) created an inroad that returned horror to being an integral part of the comics industry. Comic historians have self-consciously labelled this period the Bronze Age of comics — a slightly tarnished successor to the Silver Age (which was named for its revival of Golden Age superheroes, and the values they represented). The Bronze Age saw the mainstream's exhumation of comic

*Which, during the classic Stan Lee/Jack Kirby period, really was 'The World's Greatest Comic Magazine!' and the brightest star in the shining Silver Age constellation of 1960s superheroes.

Dr Strange — the dark cloud of mysticism behind Marvel's Silver Age lining.

169

GHASTLY TERROR!

top This blood-sucking freak gets the Comic Code's seal of approval! Morbius in SPIDER-MAN #101.

above Blade the Vampire Slayer — Stoker as written by Ernest Tidyman! Cover: TOMB OF DRACULA #10.

stories designed to provoke emotions of fear and revulsion, and inspire moods of dark insight.

Marvel comics had published hundreds of horror comics in the early Fifties under Chief Editor Stan Lee, via the company's previous byline, Atlas. This tradition had never truly died, as witnessed by the plethora of 'giant monster' stories Lee produced in the early Sixties, just before the Marvel Age of comics began with the first issues of THE AMAZING SPIDER-MAN and THE FANTASTIC FOUR. In fact, even amidst this unprecedented upsurge of exciting new superheroes, there was always a hint of the mystical, the dark side, the malevolent. And not just in the guise of various super-villains and their monstrous cohorts; one of the earliest additions to Marvel's growing roster of super-characters was Dr Strange, Master of the Black Arts, a strip which appeared in STRANGE TALES. Written by Lee and drawn by Steve Ditko, it featured a host of demonic beings and spectral other-worldly entities...

However, it still came as a surprise to some when Marvel began to de-emphasise the knockabout — albeit cosmic! — style of some of their superheroes in favour of darker-toned fare, leading to the creation of two interesting, but still rather mild, horror comics: THE TOWER OF SHADOWS, in Sep 69 (which features an excellently-rendered Jim Steranko — he of Nick Fury fame — ghost story: **'At the Stroke of Midnight'**) and, in Oct 69, THE CHAMBER OF DARKNESS.

In the meantime, Marvel's highest profile comic, SPI-

BRONZE AGE SILVER BULLETS!

DER-MAN, was beginning to take on the dark tone which would eventually lead to the death of Peter Parker's girlfriend, Gwen Stacey (I still can't believe it really happened!) and the creation of Marvel's first vampire character, Morbius. But these events were preceded by the three 'drug' issues of SPIDER-MAN (May, Jun, Jul, 71) which helped pave the way. These issues concern the effects of drugs on Peter Parker's roommate Harry Osborn (son of the Green Goblin) and his subsequent hospitalisation. The anti-drugs message, though not 'preachy' in tone, is obvious. As its author, Lee explains:

> As usual, we sent the book to the Comic Code office, and... amazingly they said they had to reject it.*

The Code absolutely prohibited any mention of drugs (as stated in its 1954 'manifesto'; see Appendix II) but this was 1971 — things had changed, even though the Code hadn't. Lee took a gamble and issued SPIDER-MAN #96, #97 and #98 without the Code's stamp of approval. It was a gamble that paid off due to the support and backing of anti-drugs campaigners and educationalists who thought the story's message was an important one. As a result, the Comics Code — who now looked not just outdated, but also quite foolish — decided to re-evaluate their judgement. A move which led to nine revisions of the Code in 1971. Regarding horror comics, the Code now said:

> Vampires, Ghouls and werewolves shall be permitted to be used when handled in the classic tradition such as Frankenstein, Dracula and other high calibre literary works written by Edgar Allan Poe, Saki, Conan Doyle and other respected authors whose works are read in schools throughout the world.

Marvel wasted no time after this announcement introducing Morbius, the living vampire (he's a 'living' vampire because he's not one of the 'undead' supernatural variety, you see) in the pages of SPIDER-MAN #101 and #102 (Oct 71 and Nov 71, respectively)... Scientist Michael Morbius

Marvel instil some cosmic relevance: the Silver Surfer makes an appreareance in TOMB OF DRACULA #50.

*Stan Lee quoted in *Marvel: Five Decades of the World's Greatest Comics* by Les Daniels, Virgin 1991.

171

GHASTLY TERROR!

*There were also guest appearances by other 'Marvel superstars' — the werewolf and Dr Strange are OK, but the Silver Surfer, I ask you!

attempts to cure his rare blood disease with a treatment derived from vampire bats and — well, you can guess the rest. In the following months the success of Morbius opened the floodgates to a mass of continuing horror characters, some of them original creations, like Morbius, and some of them Marvel's idiosyncratic — some would say irritating — versions of classic tales. The foremost of them was THE TOMB OF DRACULA #1 (Apr 72). Remarkable for its atmosphere and sense of consistency, due in no small part to the fact that every issue was moodily drawn by the excellent Gene Colan, DRACULA is the most artistically and commercially successful of all Marvel's horror books. Featuring a cast of continuing characters (the descendants of those in Stoker's novel) the magazine ran for 70 issues. Along the way we were introduced to Lilith, Daughter of Dracula, and Blade the Vampire-Slayer, a black Shaft-type Dude with Attitude who would go on to appear in many other Marvel horror series, as well as featuring in several of the b&w titles (more on these later).*

Next up was WEREWOLF BY NIGHT, a variation on the teenage werewolf theme, in which Jack Russell (!) is transformed into a wolfman every full moon due to a curse passed down the family via an ancient grimoire known as The Darkhold. The Werewolf first appeared in Marvel's 'try-out'

left Conway and Ploog's FRANKENSTEIN — Good!

right Moench and Mayerik's FRANKENSTEIN — Bad!

mag, MARVEL SPOTLIGHT (#2, Feb 72), where he stayed for two more issues before ascending to his own title. WEREWOLF BY NIGHT #1 appeared in Sep 72, continuing without a blip from the story-line in SPOTLIGHT which was illustrated by Mike Ploog.

In many ways WEREWOLF is a more interesting comic than DRACULA, the character of Jack Russell being a vulnerable, sympathetic victim of the wolf-curse. Throughout its 43 issue run, the comic had various artists, including Tom Sutton (whose sewer-setting in WEREWOLF #9 and #10 echoes his work for Skywald), Gil Kane, Werner Roth, and a returning Mike Ploog in #13–16). But its longest-running illustrator was Don Perlin, at first not a popular choice until he was teamed with scripter Doug Moench, who with #32 and #33 (Moon Knight) and #34–#37 (with the haunted house plot inspired by Richard Matheson's creepy novel, *Hell House*) pulled off some first-rate entertainment.

Marvel's third addition to this roster of classic monsters was rather late in coming, but when it did arrive it was certainly worth the wait! THE MONSTER OF FRANKENSTEIN #1 appeared in Jan 73, and for six issues was a labour of love for author Gerry Conway (who adapted Mary Shelley's original tale brilliantly in the first three issues, before moving on to his own plots) and Mike Ploog (who turned out some of his very best work here). Issue #6, with its great original story '**The Last of the Frankensteins**' — a real chiller featuring the emaciated, concentration camp-like denizens of a pit beneath Frankenstein's castle — was the height of the series. After this, the creative team dissolved and the increasingly aimless plot went nowhere fast. As one fan sarcastically stated in the letters section:

> Okay guys: Ha, ha. Good Joke. Now when are you going to release the *real* FRANKENSTEIN #13?

After this, where was there left to go? The series was cancelled with #18 (Sep 75).

In the meantime the vacant slot in MARVEL SPOTLIGHT had been filled with The Ghost Rider, a series which capitalised on the then-current interest in Hell's Angels and all things Satanic. SPOTLIGHT #5 (Aug 72) told the tale of the

top A Jack Russell howling at the moon. Cover: MARVEL SPOTLIGHT #4.

above Doug Moench and Don Perlin's excursion into Hell House. Cover: WEREWOLF BY NIGHT #34.

GHASTLY TERROR!

top left Daddy's little boy, whether he likes it or not. Cover: MARVEL SPOTLIGHT #13.

above Soul Brother! Voodoo rites in STRANGE TALES #169.

right Satan's emissary on Earth, the hot-headed Johnny Blaze aka Ghost Rider.

aptly-named stunt cyclist Johnny Blaze who, on making a deal with Satan, gets tricked by the Evil One (surprise!) into becoming his demonic emissary on Earth. Seemingly inspired by Skywald's Hell-Rider, The Ghost Rider appeared in a further six issues of SPOTLIGHT before 'Satan's emissary' gave way to 'Satan's son'!

SPOTLIGHT #12 (Oct 73) featured the first episode of the adventures of one Daimon Hellstrom, 'The Son of Satan', sired by the Devil on a mortal woman and therefore at odds with human society *and* the hordes of Hell. In fact, Daimon swears to oust his infernal father and take the title of King of Hell himself! Despite the hokeyness, the first few episodes of **'The Son of Satan'**, illustrated atypically by Hulk artist Herbe Trimpe, are riveting in their depiction of the underworld with all its demonic hosts and chain-gangs of suffering, doomed sinners.

Twenty years on from the all-powerful Comics Code, mainstream comics had once again returned to the Evil One

and the torments of the damned — great stuff! Nice touches in '**The Son of Satan**' include the appearance of the horned god of the Templars, Baphomet, in #15, while #18 and #19 feature a demonic possession story influenced by *The Exorcist*, illustrated by the ever-dependable Gene Colan.

Finishing in SPOTLIGHT #24, Daimon went on to further exploits in his own title, THE SON OF SATAN (#1, Dec 75), which for some strange reason deteriorated rather quickly, running for only eight issues before cancellation. Still in its prime, THE SON OF SATAN had been a favourite of sorts, eliciting the kind of controversial mail which publishers dream about. Self-proclaimed witches and Satanists crawled out of the woodwork to contribute their twopenneth worth of views, some of them even endorsed by bona-fide membership of Anton LaVey's Church of Satan!

In the meantime, The Ghost Rider had debuted in his own title of the same name in Sep 73, and though it's difficult to understand the appeal, he kept up a head of steam for a further 10 years — finishing in Jun 83 at #81.

Marvel's obligatory swamp monster, The Man-Thing, had debuted in the hodgepodge b&w mag, SAVAGE TALES #1 (May 71) as a Gray Morrow–illustrated back-up to Conan the Barbarian. In ADVENTURE INTO FEAR #10 (Oct 72),* The Man-Thing found a home for a further nine issues until, he too, was given his own title in Jan 74. A strange variation on other swamp-monsters, The Man-Thing was an almost mindless empath who responded only to emotions — particularly the emotion of fear which resulted in those fearful of him to burn at his touch. No, it doesn't make much sense. And neither did the series as it progressed under the self-indulgent authorship of Steve

*Previously a 'giant monster' reprint title by the name of FEAR for issues #1–#9.

The Exorcist had a lot to answer for... Son of Satan in MARVEL SPOTLIGHT #19.

GHASTLY TERROR!

Happy days are here again! Marvel cracks the Code.

this page and next *Montage of covers from Marvel's reprint comics.*

Gerber, who seemed to use it as an outlet for his own emotional troubles. (Gerber is also the creator of Howard the Duck.)

When Man-Thing got chucked out of FEAR, in came Morbius. This may be getting repetitive, folks, but once again, the series progressed well for a few Paul Gulacy–illustrated episodes, but then the rot began to set in. Increasingly inappropriate (and inane) settings led to plot fragmentation and resulting confusion about future direction. And things weren't helped by the poor choice of Frank Robbins as artist on the series. (All in all, Morbius fared much better in the b&w magazine format.)

These were the major Marvel 'horror-heroes' to appear in the regular colour comics. A round-up of the rest gives us: The Living Mummy (in SUPERNATURAL THRILLERS)... Brother Voodoo, a fairly interesting Haitian Houngan with two souls — one good, one evil (in STRANGE TALES)... A couple of variations on the werewolf theme: Tigra the werewoman in MARVEL CHILLERS and the Man-Wolf in CREATURES ON THE LOOSE... Finally, a character from the 'giant monster' days, Colossus, had his own entertaining, short-lived series in ASTONISHING TALES (before the killer cyborg Deathlok took over)...

In response to a positive readership reception, Marvel also kept up with the anthology titles. The relaxation of the Comics Code meant that a huge store of material could be drawn upon. The 'giant monster' reprints which had been doing well in FEAR, were continued in MONSTERS ON THE PROWL, CREATURES ON THE LOOSE, WHERE CREATURES

ROAM and, in the longest-running of the lot (38 issues), WHERE MONSTERS DWELL. But now Marvel could also dip into the precode Atlas material, and this began to appear from Nov 72 onwards in CHAMBER OF CHILLS (25 issues); VAULT OF EVIL (23 issues); CRYPT OF SHADOWS (21 issues); BEWARE! (8 issues), which from #9 onwards became TOMB OF DARKNESS (a further 15 issues); UNCANNY TALES (12 issues); WEIRD WONDER TALES (22 issues); DEAD OF NIGHT (11 issues); JOURNEY INTO MYSTERY (19 issues); all of these reprinting previously 'banned' precode horror material!

Marvel kept up the assault on the horror-eager public, saturating the market with their line of b&w 'Marvel Monster Mags'. Débuting early in 1973 came DRACULA LIVES, a title featuring tales representing various stages of the ever-popular Dracula's (un-) life. Running 13 issues, the seemingly limited subject matter of vampires also gave birth to VAMPIRE TALES (May 73) which ran for 11 issues, most featuring a much more successfully presented Morbius the Living Vampire — as well as Satana,

GHASTLY TERROR!

top and above Marvel's independently minded zombie, Simon Garth, in TALES OF THE ZOMBIE — the best title in Marvel's monster group.

right The Living Vampire really lives it up in the b&w format! VAMPIRE TALES #2.

the Devil's daughter (sister of Daimon Hellstrom, of course). Satana was illustrated on a couple of occasions by megatalent Esteban Maroto, whose work, though a common sight in the Seventies' Warren magazines, looks startlingly inspired here amongst lesser talents and sparser lay-outs. Padded with particularly horrific Atlas reprints (which were still deemed too gruesome for the Code-approved titles), the line continued with MONSTERS UNLEASHED (who thought *that* title up?) which in #2 (Nov 73) gave birth to another modern Frankenstein series that was no more creatively or commercially successful than the colour version had proven to be. Sporadic appearances from the Man-Thing and text stories featuring the Werewolf were OK, but later issues featured the Hulk's foe, The Wendigo and the execrable Tigra, the were-woman.

Much more interesting was TALES OF THE ZOMBIE (#1, Aug 73), which ran for 10 issues, most of them featuring the 'living zombie' character who appeared back in the Fifties in MENACE #5 (see chapter: *Into the Abyss...!*). The Haitian Voodoo setting, relatively authentic in tone, made this series about the exploits of wandering zombie, Simon Garth, seem a cut above the rest. Later issues also featured Brother Voodoo, another of Marvel's more worthwhile horror-heroes.

The final magazine in the line, and a bit of a latecomer, was THE HAUNT OF HORROR (#1, May 74). The title had

been used a year previously for a two-issue prose-fiction digest — perhaps the only publication of its type Marvel ever published. The comic-magazine version, featuring *The Exorcist*-inspired character, Gabriel the Devil-Slayer (a renegade Catholic priest!) was interesting enough, but it came too late towards Marvel's brief flirtation with the b&w horror format to last more than five issues. In fact, Gabriel made his final appearance in the 11th issue of MONSTERS UNLEASHED (the last one; Apr 75).

The 50-odd issues of Marvel's monster mags all appeared in a space of less than two years. Despite initial over-seeing from Sol Brodsky (back from his publishing venture with Herschel Waldman; see chapter: *The Horror-Mood*) and a host of the industry's top writers and artists — including Marv Wolfman, Gerry Conway, Steve Gerber, Doug Moench, Don McGregor, Roy Thomas, Pablo Marcos, Neal Adams, Boris Vallejo, Tom Sutton, Rich Buckler, Alfonso Font, Vincente Alcazar, John Buscema, Mike Ploog, Dick Giordano and a host of others — this was a format that didn't seem to work out for Marvel somehow. A fact underlined by poor sales on subsequent ventures into the field: the inane LEGION OF MONSTERS (Sep 75) which attempted to throw all the main horror-heroes together in one magazine, monster mash-style, lasted for only *one* issue. So too did try-outs in the company's 'one-shot special' title, MARVEL PREVIEW — for Blade, the Vampire-Slayer (#3), Satana (#7) and again for the Legion of Monsters (#8), though ironically all three of these horror issues of PREVIEW were pretty good!

Other Marvel horrors appeared sporadically. Issue #12 of PREVIEW featured 'The Haunt of Horror' with Lilith, Daughter of Dracula, and her dad himself reappeared briefly in a six-issue b&w version of TOMB OF DRACULA (Nov 79–Sep 80).

The 1980s were lean times for Marvel's horror characters, but 1990 saw the return

top DRACULA LIVES, part of Marvel's b&w horror magazine line.

right Maroto's chick from Hell. Satana in VAMPIRE TALES #3.

GHASTLY TERROR!

top left Legion of monsters indeed! Marvel overkills the genre. Cover: MARVEL PREVIEW #8.

top right Yet more *Exorcist*-inspired mumbo-jumbo in HAUNT OF HORROR #3.

above Nice cover, shame about the content. Marvel revive the Horror-heroes one more time in MIDNIGHT SONS UNLIMITED #5.

of Ghost Rider (this time in the guise of Danny Ketch) as rendered by Javier Saltares and later by the excellent Mark Texeira. Morbius also returned in his own comic in Sep 92, giving birth to the Marvel 'Midnight Sons' — another take on the piss-poor ('scuse me) LEGION OF MONSTERS, in which the horror-heroes would team up and play at superheroes. Bad idea. Why should monsters want to save the world with the problems *they've* got?! This concept gave rise to other titles like NIGHTSTALKERS (another supernatural team), DARKHOLD and MIDNIGHT SONS UNLIMITED — via which there would be nonsensical multi-part stories and endless, endless, irritating crossovers between titles. Needless to say, all this pointless contrivance ruined both THE GHOST RIDER and MORBIUS, and along with the aforementioned titles, they were inevitably cancelled. Still, Marvel seem as unfazed as ever! As I write (Apr 98), the first few issues of new outings for MAN-THING and WEREWOLF BY NIGHT are appearing — to predictably lukewarm critical and commercial reactions...

180

BRONZE AGE SILVER BULLETS!

THE 10 BEST NON-SERIES BRONZE AGE 'MONSTER MAG' TALES...

In addition to featuring continuing series like Dracula, Morbius and The Zombie, the b&w Marvel horror comics also carried some good short tales in the Warren/Skywald tradition, often created by the same artists and writers...

1. **'The Drifting Snow'** by Tony Isabella and Esteban Maroto in VAMPIRE TALES #4 — An exciting and beautifully executed adaptation of August Derleth's famous vampire story. Probably the best thing to appear in one of Marvel's b&w mags.

2. **'The Demon of Slaughter Mansion'** by Don McGregor and Juan Boix in MONSTERS UNLEASHED #5 — *Exorcist/Hell House*-inspired tale of possession.

3. **'Skulls in the Stars'** by Roy Thomas and Ralph Reese in MONSTERS UNLEASHED #1 — Very accurate adaptation of Robert E. Howard's *Solomon Kane* story with superb illustrations by Reese.

4. **'Jilimbi's Word'** by Doug Moench and Enrique Badia in TALES OF THE ZOMBIE #3 — Voodoo curse story, with hideously detailed rotting zombies!

5. **'Lifeboat'** by Gerry Conway and Jesus Blasco in MONSTERS UNLEASHED #2 — Escape from a sinking ship into a lifeboat. But what caused the ship to sink in the first place...?

6. **'The Swamp-Walkers'** by Larry Leiber and Win Mortimer in THE HAUNT OF HORROR #3 — The swamp gives up its dead in this zombie revenge tale.

7. **'The Scrimshaw Serpent'** by Doug Moench and Alfonso Font in MONSTERS UNLEASHED #6 — Sea-serpent tale based on the myth of the siren.

8. **'The Cold and Uncaring Moon'** by Steve Skeates and George Tuska in MONSTERS UNLEASHED #3 — Werewolf tale told from the point of view of the werewolf...

9. **'The Praying Mantis Principle'** by Don McGregor and Rich Buckler in VAMPIRE TALES #2 — Sherlock Holmes pastiche with vampires!

10. **'The Man Who Cried Werewolf'** by Gerry Conway and Pablo Marcos in MONSTERS UNLEASHED #1 — Another adaptation, based on Robert Bloch's short story. Pablo Marcos of Horror-Mood 'fame' turns in one of his best artwork jobs.

Brief mention must be made of a few adaptations of stories by Robert E. Howard, Harlan Ellison and John Jakes appearing in Marvel's otherwise all-reprint anthology title CHAMBER OF CHILLS. The Roy Thomas-adapted Howard stories, **'The Horror from the Mound'** (CHAMBER #2) and **'The Thing on the Roof'** (CHAMBER #3) both illustrated by Frank Brunner, are particularly good.

Weird Tales-style adaptations also appear in TOWER OF SHADOWS: Lovecraft's **'Terrible Old Man'**, illustrated by Barry Smith (#3), and **'Pickman's Model'** illustrated by Berni Wrightson (#9). Lovecraft, Bloch, Sturgeon and HG Wells adaptations appear in SUPERNATURAL THRILLERS before The Living Mummy became a regular feature, so too early issues of JOURNEY INTO MYSTERY, which featured R.E. Howard's **'Dig Me No Grave'** (#1) and Robert Bloch's *'Yours Truly, Jack the Ripper'* (#2).

GHASTLY TERROR!

UNDERGROUND CURRENTS

WHILST THE MAINSTREAM was producing a veritable renaissance of horror comics in the late Sixties/early Seventies, there was an even darker trickle emerging from the Underground comix scene. Though occasionally crossing currents with higher profile publishers — in the guise of Richard Corben at Warren and Larry Todd at Skywald — for the most part Underground horror comix were a separate tributary altogether, picking up where the precode horrors produced by EC, Gillmor, Story *et al* had left off (and sharing a penchant for violent and sordid imagery with Eerie Publications).

Having a background in early Sixties satire magazines — like Harvey Kurtzman's HELP! and the burgeoning hippie culture's Underground press — the comix really began with Robert Crumb's ZAP!, which by early 1968 had introduced the horrific surrealism of S. Clay Wilson's Checkered De-

left Rory Hayes unveils his personal BOGEYMAN to a bewildered audience. Cover: BOGEYMAN #1.

right Demons and horrors... what a trip! 'Hog-Riding Fools', ZAP! #2.

Primal shudders in Spain's INSECT FEAR #2.

mon and Spain's* violent fantasies.

Seeing that there was genuine artistic mileage and a sense of 'statement' in this type of comix, the more comic-literate (as opposed to political/satirist) artists began to produce a gaggle of idiosyncratic and psychotic horror comix calculated to specifically offend the likes of Dr Fredric Wertham, who was remembered with much venom... The terminally strange Rory Hayes came up with BOGEYMAN, two issues appearing in 1969 and another early in 1970. Though more in the vein of ZAP! (and featuring Crumb, Wilson and Kim Deitch, along with Hayes) these were the first true Underground horror comix with a feel to them separate from the 'usual' left wing politico stuff.

Shortly afterwards there appeared, firstly, INSECT FEAR Spain's three issue tribute to the precode era, featuring works by the usual suspects (plus another ex-Warrenite, Roger Brand, who in #3 gives us the superb '**She Crawls on Her Belly like a Reptile**') and then without doubt the definitive Underground horror comic: SKULL.

Appearing in Mar 70, SKULL #1 features work by Greg Irons and Jack Jaxon. As of issue #2 (Sep 70) the book began to be published by Ron Turner's renowned Last Gasp,

*Real name: Manuel Rodriguez.

183

GHASTLY TERROR!

left Other creepy-crawlies more than welcome. 'She Crawls On Her Belly Like a Reptile', INSECT FEAR #3.

right The old master Lovecraft smiles down on these psychotic disciples. 'The Hand of Kaä', SKULL #5.

next page, left 'Rats in the Wall', SKULL #5.

next page, right 100% Horrid! Covers: SKULL #2 and #3.

*...who signed himself 'Gore' in those days.

and from here it went from strength to strength. Issues #3–#6 are exemplary and constitute almost faultless excursions into the darkest regions of horror comic book territory…

SKULL #3, which features a truly revolting cannibal cover by Spain, as well as Rich Corben's* mutant romance '**Horrible Harvey's House**' and Jaxon's Conan satire ('**Testicles the Tantologist**'), presents *the* single most tasteless story ever to appear in the comicbook format: Greg Irons' '**Cleanup Crew**'. This tells the heart-warming story of Sydney Tort, a cleaner-up of road wrecks who takes parts of mutilated carcasses and choice bits of mushed offal home at nights and fucks his slobbish, obese wife in a pile of the stuff, while snacking down on some delicate bits and pieces. In true EC 'poetic justice' style, seminal spillage brings a pile of this shuddersome hulk to life one fateful night… And you can guess the rest. This sick comedy must have been a (ahem) seminal influence on notorious *Nekromantik* film director, Jörg Buttgereit…

SKULL #4 and #5 (May and Aug 72) present the very best HP Lovecraft adaptations/variations to ever appear in any sort of comic. Issue #4 has Jaxon's '**The Hound**', an exemplary piece of work which is bettered only by Corben's

184

UNDERGROUND CURRENTS

'**Rats in the Wall**' in #5, still perhaps his most effective work for 'alternative' comix. Also great are Charles Dallas' '**Hairy Claw of Tolen**', Spain's '**The Hand of Kaä**' and Herb Arnold's '**Pickman's Model**'. Larry Todd produces a minutely detailed version of '**The Shadow Out of Time**' to his credit.

Whilst these two issues would be hard to top at any level, SKULL #6 (Nov 72) presents Tom Veitch's book-length '**A Gothic Tale**' illustrated in two parts by first, Irons, and then Corben. With Lovecraftian overtones and sly, black humour this makes for superbly disturbing reading.

Apart from the more sci-fi oriented SLOW DEATH (#1–#8, Apr 70–Mar 77; later issues were concerned with ecological issues), other Undergrounds similar to SKULL and featuring the same group of creators are:

UP FROM THE DEEP (one-shot; May 71) from Rip-Off Press — this is a rather rare item, and also one of the first Undergrounds to feature colour: Jaxon's astral opus '**The Light in the Distance**' and an odd fantasy piece from Corben which looks like it's called '**C: Dopey**'. There's also another superb piece of Lovecraftiana, again by Jaxon, '**The Black Saint and the Sinner Lady**'.* All in all, one of the scarcer and more unusual horror Undergrounds.

FANTAGOR is an all-Corben affair which ran from Dec 71–Nov 72; four issues in total. '**The Devil in the Well**' by 'Starr Armitage & Herb

*Named after a Charles Mingus LP.

GHASTLY TERROR!

top Going too far? 'Horrible Harvey's House', SKULL #3

above PSYCHOTIC ADVENTURES ILLUSTRATED... or what! Cover for issue #1.

*HEAVY METAL also ran colour reprints of Corben's **'Beast of Wolfton'** and **'Rowlf'** in its heyday.

Arnold' (Corben pseudonyms) is the highlight of the series, despite #3 and #4 being in colour. Perhaps of even more interest is Corben's GRIMWIT (two issues, June–Sep 73) which featured in #1 the classic werewolf tale '**The Beast of Wolfton**', a sexy medieval epic similar in some ways to Corben's better known one-shot ROWLF, where the lycanthropic transformation is reversed from wolf to man... GRIMWIT #2 features the first appearance (in colour, too) of Corben's famous Den, later extended and serialised to critical acclaim in the early issues of HEAVY METAL,* before becoming one of the most reprinted graphic novels of all time. Even better is the guesting Jack Jaxon with his grisly tale of Toltec sacrifice, '**Death Rattle**' — this itself the title of another Corben-initiated project from Kitchen Sink which ran for three issues (Jun 72–Jun 73), also utilising the talents of Tim Boxell, Mike Vosburg and Tom Veitch. Both FANTAGOR and GRIMWIT showcase some of Corben's most striking cover work.

More Lovecraftian shenanigans appear in the oft-reprinted TALES OF THE LEATHER NUN (one-shot; Sep 73) the ecclesiastical lady in question being a 'host' type character first appearing in SKULL. This is a collection of seedy, sinful tales with two standout macabre stories by Jaxon and Brand.

Even more deranged is Charles Dallas' self-explanatory PSYCHOTIC ADVENTURES (three issues; 72, Oct 73 and Jun 74) which features some of the darkest and most evil imagery in the horror comix. Dallas' tales, such as '**The Dreamer**' and '**The Book of Zee**' (both in #1) have an oneiric obsessiveness about them which is both disturbing and naïvely absurd at the same time — resulting in a kind of awkward beauty difficult to convey in words. Truly strange stuff.

UNDERGROUND CURRENTS

Also pushing the limits of acceptability are two comix which cash in on the Manson family murders. The first is THRILLING MURDER COMICS (one-shot; 71); the second, and more notorious, being the frequently reprinted LEGION OF CHARLIES (one-shot; Fall 71), a book-length meditation on the Tate-LaBianca slayings and the Mai Lai massacre in Vietnam, by Tom Veitch and Greg Irons. It's difficult to see how comix could go further than these jet-black satires, which in my opinion have yet to be bettered in terms of sheer visceral impact.

Though Underground comix continued for several more years with titles like DR WIRTHAM'S [sic] COMICS, THE BARN OF FEAR (!) and BRAIN FANTASY, they had in fact already reached the apex (or nadir) with tales like '**Cleanup Crew**' and '**Legion of Charlies**' and the works of Dallas, Brand and Jaxon — not to mention the continued hardcore perversity of S. Clay Wilson, Crumb and Spain in ZAP!

Just around the corner lay inroads for some of these creators into more mainstream ventures, as the divide between Underground comix and square ol' comics began to narrow with the advent of the Direct Market system — thanks to the increasing popularity of comic collecting as a 'serious' hobby, and the burgeoning proliferation of speciality stores which dealt in this type of merchandise exclusively.

Due to the 'adult' nature of the Undergrounds, 'Head Shops' in the Seventies received their stock directly from the publishers, rather than through regular news-stand distributors. This was a set-up that had also begun to work

left Are you sure? 'Cleanup Crew', SKULL #3.

right 'The Hound', one of the best Lovecraft adaptations to appear in comic form. From SKULL #4.

187

GHASTLY TERROR!

left Corben and Co. rise UP FROM THE DEEP.

right Simon Deitch evokes Cthulhu in SKULL #4.

well for the new comic stores and in turn led to a 'direct' system becoming popular, resulting in the type of stores we have today, such as Forbidden Planet.

At the time, this was a revolutionary idea which had tremendous creative repercussions, opening the way for new, inventive publishers who could utilise the freedom given to the Undergrounds in a new context. One of the first of this new breed of publishers was Pacific Comics, who gave horror veteran Bruce Jones the green light to produce the type of horror comic he had always wanted to see. The result was TWISTED TALES, a standard comic book format production, but with 'full-spectrum' colour, and printed on heavier duty 'Baxter' paper. In comparison to the usual Marvel and DC comics of the day, this seemed like unadulterated

luxury.

The first issue of TWISTED TALES, with all the stories scripted by Jones — teamed with top-talents like Corben, Alfredo Alcala and Tim Conrad — appeared in Nov 82 to a generally good reception. The magazine represented a crude, but effective, combination of EC and Underground comix, combining the aesthetics of the former with the creative freedom of the latter. The standout tale in #1 is '**Trick or Treat**', illustrated by Conrad, which tells with a chilling, underplayed atmosphere, the story of a group of dead kids who each year must relive the consequences of a terrifying Halloween prank they played on their unfortunate friend, Skeeter.

The highlight of #2 is the superb Berni Wrightson cover, but there is also good interior work from Mike Ploog and Ken Steacy. Corben covers appear on #1, #3 and #5, while

above Corben's classic 'The Beast of Wolfton' in GRIMWIT #1.

below Strike Deep O Merciful Zomboid Shaft... Wraparound cover for the tasteless (and obscure) D.O.A. COMICS #1.

GHASTLY TERROR!

#4, #6 and #7 have superb cover paintings by the talented British artist, John Bolton. Bolton also illustrates the blackly comic '**Holly's Hobbies**' (#7), a brief piece about a deranged old lady who keeps a collection of severed heads on her mantelpiece! However, by this point Jones' EC-esque formula was getting a bit stale, the best and most controversial tale of the series having appeared back in #5 — '**Banjo Lessons**', illustrated by Bill Wray.

Although Jones made the mistake of apologising for this tale in advance in a rather po-faced editorial (thereby unnecessarily building expectations), it still comes across as a powerful statement in the EC 'Shock Suspense' vein. Briefly, the story concerns a court case surrounding a group of hunters who became trapped in their cabin for weeks in the midst of a fierce snowstorm. This is recounted through the deluded eyes of a survivor who believes that in order to live they had to kill and eat their black hunting hound ('coon dog') Banjo. But this displaced memory is a product of extreme trauma: in actual fact, Banjo was a black man, their cook and bottle washer… A general *dog's* body. When the deluded narrator breaks down and admits this shocking fact

left *Distinctly out of tune. 'Banjo Lessons' in TWISTED TALES #5.*

right *Another one for Wrightson's collection. Cover: TWISTED TALES #2.*

UNDERGROUND CURRENTS

— combined with the suggestion that he had had homosexual feelings towards Banjo — the entire cannibal feast is unveiled in all its squalid glory as he finally remembers what really happened. '**Banjo Lessons**' is a dark, distasteful tale of racial tension and gender stereotyping that would never have been allowed in the pages of the comics mainstream without the pioneering efforts of the Undergrounds which preceded it. Despite kicking up a good deal of letters page controversy, '**Banjo Lessons**' still passed without undue censure, proving that horror comics with serious taboo-breaking themes could now be mass-distributed... At least in theory...

TWISTED TALES ran for only 10 issues, disappearing in Dec 84. The final issue was published by Eclipse, as by this point, like so many of the independent publishers catering to the direct market, Pacific had gone under. Eclipse followed the relative success of Bruce Jones' format with the

For once a real terror tale — 'The Revenant' from TALES OF TERROR #8.

GHASTLY TERROR!

below, top to bottom The main course... Covers from TABOO #1, #2 and #9.

right Tracing the Victorian Underworld. 'From Hell', TABOO #5.

13-issue TALES OF TERROR (Aug 85–Jul 87), a magazine about as original and innovative as its oh-so-imaginative title! Still, there were some nice John Bolton covers, some sterling interior work by the great Gray Morrow (#4) and a few good stories by the likes of Bill Wray and David Lloyd. One standout tale, equally as disturbing, but much more realistically visceral than '**Banjo Lessons**', was '**The Revenant**' (#8) by Scott Hampton, a dreadfully harrowing and bloody tale of a haunting centred around a brutal rape in a turn-of-the-century apartment block. Without a doubt one of the most shocking horror comic stories of the modern era.

While all this had been going on, a tremendous fuss had been made of the teaming of writer Alan Moore and artist Steve Bissette on DC's SWAMP THING, both of whom came from a background in Underground/alternative comix. In my opinion, the importance of the Swamp Thing character itself has been blown out of proportion, but in the context of *moods*, *themes* and *ideas* which Moore and Bissette expressed through this Code-approved, mainstream format, it is safe to say that the whole scenario of 'comix vs. comics' was blown apart and totally redefined. Just as importantly, it gave the likes of Moore and Bissette the recognition and capital to realise the type of 'dream projects' that would never have been possible in the Underground scene, and never would have passed the drawing board at Marvel. While Moore went on to create the DC-sponsored WATCHMEN and other projects which paved the way for Nineties adult comics — such as Grant Morrison's THE INVISIBLES and

UNDERGROUND CURRENTS

Garth Ennis' PREACHER — Bissette mined even deeper and came up with the avant-garde, ground-breaking TABOO, where, rather fittingly, Moore would also find his truest expression...

Despite the existence of a few other graphic novel-size horror comics which came out around the same time — such as FLY IN MY EYE from Arcane — Steve Bissette's TABOO is without a doubt *the* single most important and innovative modern horror comic anthology, taking in a staggering variety of artistic and thematic styles and presenting them in a cohesive, cutting edge format with a minute attention to detail. Initially suggested by Dave Sim of CEREBUS fame in an effort to extend his Aardvaark One imprint, TABOO #1 eventually appeared under Bissette's own aegis in Nov 88, in a joint publishing effort between himself, his wife Nancy O'Connor, and John Totleben, who had worked with him on SWAMP THING; thus was born Spiderbaby Grafix & Publications, complete with its distinctive Underground-style logo.

Under a disturbing cannibalistic cover rendered by Bissette himself, the first 112-page edition of this remarkable anthology kicks off with a story by — who else but that arch-taboo breaker incarnate — S. Clay Wilson: a two-page piece of horrible nonsense entitled 'The Kitty-Killer Kids'. This is followed by Alan Moore's game show themed '**Come on Down**', a disturbing meditation on post-media age alienation illustrated by Bill Wray. Other highlights include the bizarre '**Tooth Decay**' by Tom Sniegoski and Mike Hoffman;

top Stark is the word... 'Love in the Afternoon', TABOO #3.

centre A yummy 'Late Night Snack' from Chester Brown. TABOO #1.

above Those difficult teenage years. Charles Burns in TABOO #1.

GHASTLY TERROR!

left Tim Lucas' vital 'Throat Sprockets' from TABOO #3.

right Joe Coleman dissects a disturbed mind in 'A Good Christian', TABOO #7.

Charles Burns' '**Contagious**', an early take on his disturbing 'teenage plague' theme, developed to such stunning effect latterly in BLACK HOLE; '**A Late Night Snack**', an evil cartoon by YUMMY FUR's Chester Brown... And best of all, the first episode of Tim Lucas and Mike Hoffman's '**Throat Sprockets**', a modern vampire *noir* which plunges into the world of the sick fetish porn movie of the title, delineating the obsessive hold it has over the story's increasingly psychotic narrator. This is excellent stuff, as good as — and even better in some ways — than Taboo's most famous serial '**From Hell**' (beginning in TABOO #2). Lucas went on to develop these initial ideas into a *Throat Sprockets* novel,* which is highly recommended.

Selling over 15,000 copies from a 16,000 print run,† the first TABOO was an amazing success on every level. And in case there was any doubts where Bissette's heart and roots lay, the whole opus was dedicated to '**Cleanup Crew**' man Greg Irons (1947–1984) without whom...

There was no opportunity for Bissette to bask in the glow of success. Even before TABOO #2 went to print in Aug 89 there had been a multitude of problems,‡ mostly resulting from the inclusion of some truly hideous drawings by S. Clay Wilson which printer after printer refused to touch. This led to the departure of Nancy O'Connor from the project, who argued against the necessity of including the offending pieces. But Bissette stuck to his guns and the book finally

*Published in the UK by 4th Estate, 1996.

†See 'A Chronology', TABOO #9.

‡For details see 'TABOO is Taboo' by Bissette in TABOO #9.

194

Underground Currents

left FAUST's lonely vigil — not many comics like this anymore.

below Banned and vilified — Glenn Danzig strives to make his voice heard with VEROTIKA, but who's listening? Prelude to snuff-rape in 'A Taste of Cherry', from VEROTIKA #4.

appeared at the end of 1989 complete with the 'S. Clay Wilson Black Pages' which were stamped with the warning: CAUTION — AVOID EYE CONTACT! However, this prohibitive tactic didn't go far enough and copies were seized and destroyed by customs officers in Canada and the UK. This was repeated in 1990 with TABOO #4, where New Zealand customs also joined the fray, and by #6 (92) Canada's and the UK's boycott became official, thus crippling sales (even though some copies did, of course, slip through). All this turmoil was exacerbated by poorer distribution from #5 (91) onwards, when Spiderbaby teamed up with Kevin Eastman's short-lived Tundra Publishing. The two final issues (#8 and #9; both 95) were released via Kitchen Sink, without Alan Moore's '**From Hell**', or even more tellingly, the usual Bissette editorial minutiae.

Though TABOO's seven year history has been grossly overshadowed by two prevailing issues — Bissette's censorship battle, by turns stimulating and maddening, but ultimately exhausting to Bissette himself; and Alan Moore and Eddie Campbell's absolutely riveting, classic Jack the Ripper novel '**From Hell**' — the project had a great deal more to offer to hungry horror comic fans and students of Apocalypse Culture alike. Brilliant work by: Cara Sherman Tereno, with '**Life with the Vampire**', a kind of AIDS version of an Anne Rice novel (#2)... Rolf Stark, with his Nazi atrocity story, '**Love in the Afternoon**' (#3)... filmmaker Alexandro Jodorowsky and Moebius' '**Eye of the Cat**', and S. Clay Wilson with the strangely beautiful '**Retinal Worm**' (#4)... Tom Marnick and Dennis Ellefson, with '**39th and Norton**' — grisly speculations on the famous Black Dahlia murder case (#5)... Joe Coleman, disturbed and therefore truly disturbing, with his self-tortured '**A Good Christian**' (#7)... Veteran Jack Butterworth and Greg Capullo's Dennis Etchison-esque

GHASTLY TERROR!

'**All She Does is Eat**' (#8)... David Thorp and Adrian Potts' Sadean '**Afterlife**' (#9)... And hovering above all these, casting bizarre shadows over the proceedings were series to rival '**From Hell**', such as '**Sweeney Todd**'... Jeff Nicholson's truly weird '**Through the Habitrails**'... Alan Moore, once again, teaming up with Melinda Gebbie on '**Lost Girls**'... And the aforementioned sporadic appearances of Tim Lucas' '**Throat Sprockets**'. Mention must also go to the terminally deranged Rick Grimes for his series of primitive, monstrous cartoons which are either inspired works of art, or mindless, badly-drawn comic-cuts — take your pick!

Under some truly inspired cover paintings by Totleben (#2), JK Potter ('**Especial**'), Cru Zen (#6), Coleman (#7), *et al*, TABOO presented a coherent, cutting edge of graphic horror which took the visionary ethos of the Underground horror comix to new heights of creativity — and new depths of censorship. Bissette's bold and highly intelligent project was probably the last we'll see of its kind this century, and maybe well into the new millennium. Though there have been a few worthy horror comic projects since, such as Fantaco's splattery GORESHRIEK (10 issues in two volumes; late Eighties–early Nineties) and a few worthwhile mini-series such as Tim Vigil's blood-soaked soap opera FAUST, from Rebel Studios (89–present), most of the subsequent horror titles have been pointless regurgitations in the Clive Barker/HELLRAISER vein, with perhaps only the odd story appearing in Verotik's (for the most part admittedly braindead) anthology series VEROTIKA, having any real clout.* Especially redundant, after showing early promise, are the fun-filled but vacuous Chaos! Comics like EVIL ERNIE and LADY DEATH, which become more appropriated by the comic scene's spandex-worshipping fan-boy culture with every new mini-series.

The type of horror comic which emerged in the dark, obscure days of SKULL and which developed nastily over the years to produce TABOO seems nowhere to be seen. True horror comics have gone back deep underground, flowing against the currents created by a self-sanitised comics industry afraid of the twin shadows of censorship and poor sales figures. But the sluggish Underground currents trickle on still, just waiting for a new generation of iconoclasts to plumb its forbidden depths.

*One story, published in VEROTIKA #4 (1995) entitled 'A Taste of Cherry' and graphically depicting the rape and murder of a teenage girl, led to Verotik being boycotted by all major distributors for a period of a year-and-a-half. Verotik is owned and creatively managed by rock star, Glenn Danzig.

AFTERWORD

AS I POINTED OUT in the opening chapter, *Ghastly Terror!* is more an enthused appreciation of horror comics than an attempt to provide a definitive history. Also, the book has an almost 100% American bias due to the fact that (as in the case of comic books in general) this is the country that has produced by far the most horror comics, with easily the greatest distribution in the English-speaking world. So much so that, with few exceptions, the horror comics produced in Europe (including the UK) have been for the most part reprints of American magazines like CREEPY (of which there has been a long-running Spanish edition and a short-lived UK edition) and the Skywald magazines, which as I've previously pointed out have been syndicated world-wide.

Some other interesting horror comics, which I haven't been able to cover, are Spain's HEMBRAS PELIGROSAS and Italy's SATANIK, KRIMINAL and DYLAN DOG — and there are a lot of Mexican and South American horror comics I'd like to get hold of… Some of these being particularly sadistic and 'offensive', so I've been led to understand.

The UK has produced very little home-grown horror comic product, despite a healthy culture of weeklies up to the mid-Eighties, with titles like SMASH!, LION and WIZARD and 'girls comics' like MISTY having strips sometimes utilising supernatural themes. More recognisable horror comics have come in the form of American reprints, some of which date back to the precode era and at the time caused a similar stir in Britain as they did in the US.* Titles such as BLACK MAGIC and TALES FROM THE CRYPT, cheap b&w reprints which only ran for a few numbers, feature a hodgepodge of material from disparate American sources until they were stamped out. Along the same lines were the later Miller reprints, publishers based in Hackney who issued rather tame, expurgated editions in the early Sixties featuring material from Atlas, Ajax, Ace and

*See Martin Barker's seminal study *A Haunt of Fears*, Pluto Press, 1984.

'For the BEST COMICS and the largest selection ask for MILLER COMICS.' UK reprints of US material, 1962. Cover: MYSTIC #17.

GHASTLY TERROR!

*Portman via Marvel.
Covers: JOURNEY INTO NIGHTMARE #3 and DEMON! #2.*

*Seeing as Skywald titles were being distributed in the UK at this time, one can only assume that Top Sellers were permitted to produce their own editions as long as they had different covers. Crafty Top Sellers got around this by having 'different' covers which at first glance looked exactly like the originals!

others with titles like MYSTIC, SPELLBOUND and VOODOO. These comics were eventually stopped, along with Miller-versions of Stanley titles like GHOUL TALES in the early-Seventies. Similarly formatted were the Alan Class comics, such as SINISTER TALES, CREEPY WORLDS and SECRETS OF THE UNKNOWN — though these only occasionally featured horror material and are probably better known to British fans for reprinting a lot of pre-superhero Marvel fantasy strips, including most of the 'giant monster' stories drawn by Jack Kirby.

In the mid-Seventies, Top Sellers of London had a three-issue run each of NIGHTMARE and PSYCHO, with curious cover paintings that were poor imitations of the *original* Skywald covers.*

Gillmor and Stanley material reared its ugly face once more circa 1979 with Portman Distribution's versions of STARK TERROR, GHOUL TALES, etc. These titles ran for only three or four issues before Portman moved onto the equally short-running series of Marvel monster reprints in CASTLE OF HORROR, TALES OF TERROR and DEMON!, all with stories from Marvel's b&w horror magazines featuring the likes of Morbius and Simon Garth.

One original weekly title came in the guise of SCREAM (15 issues; 1984) from IPC, complete with a grim hooded host with the unlikely name of Ghastly McNasty (who says us Brits can't beat the Yanks at their own game?). This one comic at least showcased all-original material, with some good stuff by José Ortiz and Steve Parkhouse and one or two precode style moments, such as a story about a ghastly dentist. Blood everywhere!

I'm aware that this short survey is grossly inadequate — it's more by way of an acknowledgement of the existence of this material which, in the final analysis, I decided to leave out of the main body of the text due to its relatively peripheral nature. I'm sure there must be many more horror comics such as these — and the aforementioned Mexican and European products — that deserve greater coverage.

Perhaps this present book will encourage somebody to undertake the necessary research...

APPENDIX I

A-Z OF PRECODE HORROR COMIC PUBLISHERS

ACE

The first horror comic that famous paperback publishers Ace issued was the one-shot CHALLENGE OF THE UNKNOWN (cover-dated Sep 50, but idiosyncratically numbered #6 in the usual bewildering Fifties manner). This was followed by the quartet of long-running titles:

>THE BEYOND #1–#30, Nov 50–Jan 55
>WEB OF MYSTERY #1–#29 (the last two issues were Code approved), Feb 51–Apr 55
>BAFFLING MYSTERIES #5–#26 (the last two issues were Code approved), Nov 51–May 55
>THE HAND OF FATE #8–#25, Dec 51–Mar 55

The Ace titles have a mystical atmosphere about them, with many stories concerning spiritualism, demonology and evil fate (as the

GHASTLY TERROR!

latter comic title suggests). One excellent tale, **'The Keeper of the Flames'** (THE BEYOND #3, Mar 51) relates a dark ritual involving candle flames representing human lives, and one man who sells his soul to Death himself in order to delay his wife's demise as her candle burns low... The last two pages of this story appear to be illustrated by an uncredited Steve Ditko.* The Ace magazines also feature plenty of werewolf and vampire stories, reflecting the usual Fifties comic book concerns about revenge, sublimated sexual desires and neurotic angst. Would-be collectors could do much worse than to begin their precode horror excavations here.

ACG

The American Comics Group. As mentioned earlier, ACG's ADVENTURES INTO THE UNKNOWN is a seminal horror comic, though by many standards rather tame. However, their SKELETON HAND is a little rougher, you'll be pleased to hear.

ADVENTURES INTO THE UNKNOWN #1–#64, Fall 48–Feb 55 (with a further 112 Code-approved issues)
FORBIDDEN WORLDS #1–#34, Jul 51–Nov 54 (with a further 110 Code-approved issues)
OUT OF THE NIGHT #1–#17, Feb 52–Nov 54
SKELETON HAND #1–#6, Sep 52–Aug 53

Plus a one-shot:

*Is this Ditko's first published work, circa January 1951...?

APPENDIX I

THE CLUTCHING HAND (#1) Jul 54
Some excellent stories about vampirism and werewolves, as well as multifarious tales of ghosts and family curses — one of which, '**Zombie Revenge**', seems to have influenced the young Al Hewetson (see chapter: *The Horror-Mood*).

AJAX-FARRELL

Founded by Robert W. Farrell who employed the legendary Jerry Iger* as Art Director, the name Ajax wasn't incorporated until near the end of their run of horror comics (July–Aug 54). Ajax-Farrell produced four excellent precode horror titles:

VOODOO #1–#19, May 52–Feb 55 (plus a giant-size VOODOO ANNUAL in 52)

HAUNTED THRILLS #1–#18, Jun 52–Dec 54

STRANGE FANTASY #2, #2–#14, Aug 52–Nov 54 (yes, there were two issue #2's!)

FANTASTIC FEARS #7, #8, #3–#11, May 53–Feb 55 (confusingly enough #1 and #2 were numbered #7 and #8, so there are two issues numbered #7, and two issues numbered #8, though obviously it's easy to work out which are which by the cover-dates. Just to confuse matters further, the last two issues of FANTASTIC FEARS are retitled FANTASTIC COMICS [#10 and #11].)

For my money the Ajax titles are some of the best, most 'whacked out' of all horror com-

*See note on page 121.

GHASTLY TERROR!

ics, as can be deduced by the frequency with which I've drawn from them in the chapter *Into The Abyss...!* — almost as much, in fact, as EC and Atlas. Speaking of which...

ATLAS

Later to become Marvel, this company needs no introduction. But what a roster of horror comics!

AMAZING MYSTERIES #32, #33, May 49–Jul 49
MARVEL TALES #93–#131, Aug 49–Feb 55 (with a further 27 Code-approved issues)
CAPTAIN AMERICA'S WEIRD TALES #74, #75, Oct 49–Feb 50
SUSPENSE #1–#49, Dec 49–Apr 53
JOURNEY INTO UNKNOWN WORLDS #36–#38; #4–#33, Jun 52–Feb 5 (with a further 25 Code-approved issues)
ADVENTURES INTO TERROR #43, #44; #3–#31, Nov 50–May 54
VENUS #12–#19, Feb 51–Apr 52
MYSTIC #1–#36, Mar 51–Mar 55 (with a further 24 Code-approved issues)
ASTONISHING #3–#37, Apr 51–Feb 55 (with a further 25 Code-approved issues)
STRANGE TALES #1–#34, Jun 51–Feb 55 (with a further 133 Code-approved issues)
ADVENTURES INTO WEIRD WORLDS #1–#10, Jan 52–Jun 54
MYSTERY TALES #1–#26, Mar 52–Feb

APPENDIX I

55 (with a further 26 Code-approved issues)
SPELLBOUND #1–#23, Mar 52–Jun 54
JOURNEY INTO MYSTERY #1–#22, Jun 52–Feb 55 (with a further 102 Code-approved issues)
UNCANNY TALES #1–#28, Jun 52–Jan 55 (with a further 27 Code-approved issues)
MENACE #1–#11, Mar 53–May 54
MEN'S ADVENTURES #21–#26, Mar 53–Mar 54

As a general guide, the comics which finished in mid-54 can be considered to be the most *extreme* in the Atlas output... They were the first to go under pressure from the Code. However, all Atlas books contain some milder fantasies and science fiction tales, and this is the direction they went in with the titles that continued under Code approval. It's relatively easy to collect Atlas horror comics, as they tend not to be as scarce as a lot of the other titles, plus Marvel reprinted much of this material in the early Seventies (see chapter: *Bronze Age Silver Bullets!*).

AVON

As we've said before, Avon published the *first* proper horror comic, and went on to produce a modest amount of reasonable gruesome material. Some of the early issues of EERIE feature artwork from Joe Kubert and Wally Wood.

EERIE COMICS #1, Jan 47
EERIE #1–#17, May 51–Sep 54
WITCHCRAFT #1–#6, Mar 52–Mar 53

203

GHASTLY TERROR!

Plus these one-shots:
 CITY OF THE LIVING DEAD (1952)
 THE DEAD WHO WALK (1952)
 DIARY OF HORROR (1952)
 PHANTOM WITCH DOCTOR (1952)
 NIGHT OF MYSTERY (1953)
 SECRET DIARY OF EERIE ADVEN-
 TURES (1953; this is a sort of 'EERIE
 annual')

CHARLTON

The best Charlton title is the grisly and *extreme* THE THING!, THIS MAGAZINE IS HAUNTED and SUSPENSE were acquired from Fawcett when they ceased publishing mid-53.

 THE THING! #1–#17, Feb 52–Nov 54
 STRANGE SUSPENSE STORIES #10–#23, Apr 53–Feb 55 (#10, #15 entitled LAWBREAKERS SUSPENSE STORIES, and #23 entitled THIS IS SUSPENSE)
 THIS MAGAZINE IS HAUNTED #15–#21, Mar 54–Nov 54

Excellent early Steve Ditko artwork features in later issues of THE THING! and THIS MAGAZINE IS HAUNTED.

COMIC MEDIA

No chance of surviving the Code's purge with these two titles, both carrying the offending words in their masthead.

 HORRIFIC #1–#14, Sep 52–Dec 54
 (#14 is retitled TERRIFIC)
 WEIRD TERROR #1–#13, Sep 52–Sep 54

Comic Media's rather meagre output is very

204

APPENDIX I

interesting, gruesome fare. Most issues featured artwork by stalwart Don Heck and oddball extraordinaire, Rudy Palais. Recommended.

DC

Yes, even the publishers of BATMAN and SUPERMAN jumped on the horror train to Hell... Well, not quite, as in fact their brand of horror was relatively tame, emphasising mysterious atmospheres and mystical forces. But good stuff for all that, with stories about cursed chessboards ('**The Devil's Chessboard**', HOUSE OF MYSTERY #12) *Monkey's Paw*-like cursed idols ('**Wishes of Doom**', HOUSE OF MYSTERY #10) and even haunted stamp collections ('**Stamps of Doom**', #23)!

HOUSE OF MYSTERY #1–#35, Dec 51–Feb 55 (continued for years with Code approval until once more becoming a horror mag in the late-Sixties)
SENSATION COMICS/MYSTERY #107–#116, Dec 51–Aug 53

EC

THE CRYPT OF TERROR #17–#19, Apr 50–Sep 50 (which then becomes...)
TALES FROM THE CRYPT #20–#46, Oct 50–Mar 55
THE HAUNT OF FEAR #15–#17, #4–#28*, May 50–Dec 54
TALES OF TERROR ANNUAL #1–#3, 1951–53
THE VAULT OF HORROR #12–#40, Apr 50–Jan 55

See also *Scapegoats* chapter.

*Weird numbering like this happened a lot in precode days. One theory from George Suarez (editor, TALES TOO TERRIBLE TO TELL) is that it was to convince the <u>inundated</u> news-stand dealer he was handling an established title, as opposed to another new comic that perhaps wouldn't stay the course. All Standard titles began with issue #5.

205

GHASTLY TERROR!

FAWCETT

Superb longer tales featuring some of the most bizarre titles ever: '**Metamorphosis of the Gkmlooooms**' (WORLD OF FEAR #3), '**Wall of Flesh**' (HAUNTED #12), '**Aieeeeee! The Teeth!**' (STRANGE SUSPENSE #2)... Psychotic stuff, indeed. This is what precode horror is all about!

> THIS MAGAZINE IS HAUNTED #1–#14, Oct 51–Dec 53
> WORLDS OF FEAR #1–#9, Nov 51–Jun 53 (#1 entitled WORLDS BEYOND)
> BEWARE! TERROR TALES #1–#8, May 52–Jul 53
> STRANGE STORIES FROM ANOTHER WORLD #1–#5, Jun 52–Feb 53 (#1 entitled UNKNOWN WORLDS)
> STRANGE SUSPENSE STORIES #1–#5, Jun 52–Feb 53

FICTION HOUSE

Generally rather pedestrian stuff, but some very nice covers.

> GHOST COMICS #1–#11, No specific dates: 1951–54
> THE MONSTER #1 and #2, No specific dates: 1953

GILLMOR

Famous for their ultra-grisly Bernard Bailey covers and the mind-bogglingly bizarre Basil Wolverton strips, which truly seem to be the product of a dangerously disturbed mind. For example, '**The Brain-Bats of Venus**' (MISTER MYSTERY #7), '**Swamp Monster**' (WEIRD MYSTERIES #5), '**Nightmare World**' (WEIRD

APPENDIX I

TALES OF THE FUTURE #4). Hallucinations, torture, cannibalism, decapitation, mutants, sewers, rats, you name it, the Gillmor books have got it!

MISTER MYSTERY #1–#19, Sep 51–Oct 54
WEIRD CHILLS #1–#3, Jul 54–Nov 54
WEIRD TALES OF THE FUTURE #1–#8, Mar 52–Jul 53
WEIRD MYSTERIES #1–#12, Oct 52–Sep 54

HARVEY

A real front-runner of Fifties' horror with some top-class work from the likes of Bob Powell, Howard Nostrand and Rudy Palais.

WITCHES TALES #1–#28, Jan 51–Dec 54
CHAMBER OF CHILLS #21–#24, #5–#26, Jun 51–Dec 54
TOMB OF TERROR #1–#18, Jun 51–Dec 54 (last two issues entitled THRILLS OF TOMORROW)
BLACK CAT MYSTERY #30–#53, Aug 51–Dec 54

PL

WEIRD ADVENTURES #1–#3, May 51–Oct 51

Issue #3 of the above features a 'Dr Strange' prototype, Dr Destiny.

PRIZE

Jack Kirby fans take note! The King's spooky tales in BLACK MAGIC provide a superb contrast to his more famous Marvel work. Though

GHASTLY TERROR!

not gory and violent like so many precode horrors, they are insidiously frightening, full of menacing atmosphere. Early issues also featured Steve Ditko.

BLACK MAGIC Vol 1 #1–#33, Oct 50–Dec 54 (continued for many years as a lukewarm Code-approved title)

QUALITY

WEB OF EVIL #1–#21, Nov 52–Dec 54
Featuring some great and rare horror work from Plastic Man creator, Jack Cole — such as '**The Monster in the Mist**' (#4).

STANDARD

THE UNSEEN #5–#15, Jun 52–Jul 54
OUT OF THE SHADOWS #5–#14, Jul 52–Aug 54

ADVENTURES INTO DARKNESS #5–#14*, Aug 52–Jun 54
Again, some bizarre, off-the-wall stuff here, and some absolutely superb covers, especially OUT OF THE SHADOWS #8, by Jack Katz.

STAR

Despite the titles, do these really qualify as horror comics, full as they are of crime and jungle reprints…? Never mind! Just look out for the amazing LB Cole pre-psychedelic covers (which are jaw-droppingly good) for titles like SPOOK, GHOSTLY WEIRD STORIES and STARTLING TERROR TALES. Their title changes and odd numbering, however, confuses even the best of us!

BLUE BOLT WEIRD TALES #111–#119, Nov 51–Jun 53

*See note on page 205.

GHOSTLY WEIRD STORIES #120–#124, Sep 53–Sep 54
SPOOK #22–#29, Jan 53–Jul 54
STARTLING TERROR TALES #10–#14, #4–#11, May 52–Sep 54

STERLING

THE TORMENTED #1 and #2, Jul 54–Sep 54

A very scarce, seldomly seen, short-lived latecomer to the precode horror scene.

ST. JOHN

STRANGE TERRORS #1–#7, Jun 52–Mar 53
WEIRD HORRORS #1–#16, Jun 52–Feb 55

Actually, with this last title it's a more complicated story than it would appear (again!). Starting from #10 the title was changed to NIGHTMARE. Then, from #14 it became AMAZING GHOST STORIES... Just to complicate matters further, St. John published the final issue (#3) of Ziff-Davis' NIGHTMARE (see below). Who said horror comic collecting was easy?

STORY

Superb! Superb! Absolutely beyond the pale in terms of evil images and senseless violence, with some striking skeletal covers by Hy Fleishman and countless EC 'swipes' which go much further than their models. Gory, grotesque stories about vampires, walking corpses, skeletons, red hot pokers, broken glass bottle tortures, ad nauseum. De-

GHASTLY TERROR!

finitive stuff.

MYSTERIOUS ADVENTURES #1–#23, Mar 51–Dec 54 (plus two more Code-approved issues)

FIGHT AGAINST CRIME: HORROR AND TERROR #1–#23, May 51–Sep 54 (the *most* horrific of all crime comics)

DARK MYSTERIES #1–#22, Jun 51–Mar 55 (plus two Code-approved issues)

SUPERIOR

Badly printed in Canada (?!) this is the only negative thing that can be said about these barmy (nay, deranged) Superior Comics.

JOURNEY INTO FEAR #1–#21, May 51–Sep 54

STRANGE MYSTERIES #1–#21, Sep 51–Jan 55

MYSTERIES WEIRD AND STRANGE #1–#11, May 53–Jan 55

TOBY

What can you say about the THE PURPLE CLAW? Nothing good, except that it was the only continuing precode horror series...

TALES OF HORROR #1–#13, Jun 52–Oct 54

THE PURPLE CLAW #1–#3, Jan 53–May 53

TROJAN

BEWARE! #13–#16, #5–#14, Jan 53–Mar 53 (hence two #13's and two #14's exist)

BEWARE! is an excellent precode title con-

210

taining some really gory, grisly material and including artwork by 'Mad' Myron Fass.

YOUTHFUL

Some more mind-boggling title-changes here... CAPTAIN SCIENCE became FANTASTIC (#8 and #9, Feb–Apr 52) which then became BEWARE (no relation to either the Fawcett or Trojan titles of the same name) for a further three issues (#10–#12), until finally becoming CHILLING TALES (#13–#17, Oct 53) featuring excellent and truly bizarre covers by WEIRD TALES veteran Matt Fox. That's right — all one mag with several title changes.

ZIFF-DAVIS

Famous pulp publishers Ziff-Davis just dabbled with a few horror comics, most of which have distinctive 'pulp-style' painted covers.

WEIRD ADVENTURES #10, Jul 51
WEIRD THRILLERS #1–#5, Sep 51–Nov 52
NIGHTMARE #1 and #2, Summer–Fall 52
EERIE ADVENTURES #1, Winter 53

GHASTLY TERROR!

APPENDIX II

COMICS MAGAZINE ASSOCIATION OF AMERICA COMICS CODE, 1954

CODE FOR EDITORIAL MATTER

General Standards Part A

1. Crimes shall never be presented In such a way as to create sympathy for the criminal, to promote distrust of the forces of law and justice, or to inspire others with a desire to imitate criminals.
2. No comics shall explicitly present the unique details and methods of a crime.
3. Policemen, judges, government officials and respected institutions shall never be presented in such a way as to create disrespect for established authority.
4. If crime is depicted it shall be as a sordid and unpleasant activity.
5. Criminals shall not be presented so as to be rendered glamorous or to occupy a position which creates a desire for emulation.
6. In every instance good shall triumph over evil and the criminal shall be punished for his misdeeds.
7. Scenes of excessive violence shall be prohibited. Scenes of brutal torture, excessive and unnecessary knife and gun play, physical agony, gory and gruesome crime shall be eliminated.
8. No unique or unusual methods of concealing weapons shall be shown.
9. Instances of law enforcement officers dying as a result of a criminal's activities should be discouraged.
10. The crime of kidnapping shall never be portrayed in any detail, nor shall any profit accrue to the abductor or kidnapper. The criminal or the kidnapper must be punished in every case.
11. The letters of the word "crime" on a comics magazine cover shall never be appreciably greater in dimension than the other words contained in the title. The word "crime" shall never appear alone on a cover.
12. Restraint in the use of the word "crime" in titles or sub-titles shall be exercised.

General Standards Part B

1. No comic magazine shall use the word horror of terror in its title.
2. All scenes of horror, excessive bloodshed, gory or gruesome crimes, depravity, lust, sadism, masochism shall not be permitted.
3. All lurid, unsavory, gruesome illustrations shall be eliminated.
4. Inclusion of stories dealing with evil shall be used or shall he published only where the intent is to Illustrate a moral issue and in no case shall evil be presented alluringly nor so as to injure the sensibilities of the reader.
5. Scenes dealing with, or instruments associated with walking dead, torture, vampires and vampirism, ghouls, cannibalism and werewolfism are prohibited.

General Standards Part C

All elements or techniques not specifically mentioned herein, but which are contrary to the spirit and intent of the Code, and are considered violations of good taste or decency, shall be prohibited.

DIALOGUE

1. Profanity, obscenity, smut, vulgarity, or words or symbols which have

acquired undesirable meanings are forbidden.
2. Special precautions to avoid references to physical afflictions or deformities shall be taken.
3. Although slang and colloquialisms are acceptable, excessive use should be discouraged and wherever possible good grammar shall he employed.

RELIGION

Ridicule or attack on any religious or racial group is never permissible.

COSTUME

1. Nudity in ally form is prohibited, as is indecent or undue exposure.
2. Suggestive and salacious illustration or suggestive posture is unacceptable.
3. All characters shall be depicted in dress reasonably acceptable to society.
4. Females shall be drawn realistically without exaggeration of ally physical qualities.

NOTE: It should be recognized that all prohibitions dealing with costume, dialogue or artwork applies as specifically to the cover of a comic magazine as they do to the contents.

MARRIAGE AND SEX

1. Divorce shall not he treated humorously nor represented as desirable.
2. Illicit sex relations are neither to be hinted at or portrayed. Violent love scenes as well as sexual abnormalities arc unacceptable.
3. Respect for parents, the moral code, and for honorable behavior shall be fostered. A sympathetic understanding of the problems of love is not a license for morbid distortion. 4) The treatment of love-romance stories shall emphasize the value of the home and the sanctity of marriage.
5. Passion or romantic interest shall never be treated in such a way as to stimulate the lower and baser emotions.
6. Seduction and rape shall never be shown or suggested.
7. Sex perversion or any inference to same is strictly forbidden.

CODE FOR ADVERTISING MATTER

These regulations are applicable to all magazines published by members of the Comics Magazine Association of America, Inc. Good taste shall be the guiding principle in the acceptance of advertising.

1. Liquor and tobacco advertising is not acceptable.
2. Advertisement of sex or sex instruction books are unacceptable.
3. The sale of picture postcards, "pin-ups," "art studies," or any other reproduction of nude or semi-nude figures is prohibited.
4. Advertising for the sale of knives, conceal able weapons, or realistic gun facsimiles is prohibited.
5. Advertising for the sale of fireworks is prohibited.
6. Advertising dealing with the sale of gambling equipment or printed matter dealing with gambling shall not be accepted.
7. Nudity with meretricious purpose and salacious postures shall not be permitted in the advertising of any product; clothed figures shall never be presented in such a way as to be offensive or contrary to good taste or morals.
8. To the best of his ability, each publisher shall ascertain that all statements made in advertisements conform to fact and avoid misrepresentation.
9. Advertisement of medical, health, or toiletry products of questionable nature are to be rejected. Advertisements for medical, health or toiletry products endorsed by the American Medical Association, or the American Dental Association, shall be deemed acceptable if they conform with all other conditions of the Advertising Code.

APPENDIX III

THE TOP 10 GREATEST HORROR COMIC TITLES EVER!

For what it's worth, in closing I thought I would disclose what I consider (controversially, no doubt) to be the top ten greatest horror comic titles ever published. These are recommended as the core items to acquire in assembling a horror comic collection...

1. NIGHTMARE — Human Gargoyles... Skywald's 'flagship' title. Expect to pay between £3–£5 for issues in decent VG/Fine condition, apart from issue #1 which might set you back £10–£15.

2. PSYCHO — The Heap... another Skywald title. Expect to pay between £3–£5 for issues in decent VG/Fine condition apart, from issue #1 which will cost you £15.

3. CREEPY — Warren's premiere 'first and best' horror mag. Issues #1–#100 only recommended. Expect to pay around £20–£25 for issue #1; £10 for issues #2–#10; £7 for #11–#19: £5 for #20, on... Higher grade issues will cost about double this amount.

4. WEIRD — I'm not going to win any friends putting this lowly Eerie Publications title above the prestigious ECs, but what the Hell. Try and get as many as you can (or the other Eerie Pubs titles, as they're all basically the same!) and consider yourself well-pleased if you manage to get them for under £5 each.

5. THE HAUNT OF FEAR — Don't bother with the originals (unless you're mega-rich), just get the Russ Cochran facsimile reprints for around £3 each. I've chosen this one over VAULT and CRYPT because Ghastly Graham Ingel's covers just edge it.

6. VOODOO — Yes, the Ajax-Farrell title of demented proportions. Be prepared to spend up to £40 an issue for fairly tatty copies. Sorry!

7. SCREAM — A shorter-running Skywald title, and brilliantly tasteless stuff. Pay around £5 for issues #2–#11, in decent nick; £15 for issue #1.

8. WEIRD MYSTERIES — Unbelievably weird mysteries, actually... Basil Wolverton, Bernard Bailey covers. Superb! You must pay around £50 for issues #8, #9, #10 and #11... even more for #2–#7 (around £100)... #1, forget it!

9. DARK MYSTERIES — Worth the position just for the walking skeleton covers. Issues #9–#22 around £30 each. Issues #2–#8 around £50. Issue #1 around £90.

10. TABOO — The only 'modern' entrant. Some copies are scarce, but you can still get issues #8 and #9 at cover-price. Expect to pay about £15 for issues #1 and #2. £10 each should cover the others...

GHASTLY TERROR!

SELECTED MAIL ORDER SOURCES

Burgeoning UK horror comic fans are urged to contact the following mail order outfits, sources for the type of material covered in *Ghastly Terror!*:

QUICKSILVER COMICS
9 George Street
Ossett
West Yorkshire
WF5 9PB
Tel: 01924 315143
Email: quicksilvercomics@btinternet.com
(*Particularly good for Warrens and Seventies' Marvels*)

SILVER ACRE COMICS
PO Box 114
Chester
CH4 8WQ
Tel: 01244 680048
Fax: 01244 680686
(*Great for Warrens, Skywalds and other b&w magazines*)

KEN HARMAN
13 Wynton Gardens
South Norwood
London
SE25 5RS
Tel: 0181 771 8756
(*Great for precode horrors*)

Special mention must go to NEC's TALES TOO TERRIBLE TO TELL, which is highly recommended as it reprints (in 11 slim volumes) loads of brilliant precode material you would be hard-pressed to get hold of elsewhere. Copies can usually be obtained in the UK from (again, mail order only):

CONQUISTADOR
158 Kent House Road
Beckenham
Kent
BR3 1JY
Tel/Fax: 0181 659 9714

SELECTED BIBLIOGRAPHY

Barker, Martin, *A Haunt of Fears: The Strange Story of the British Horror Comics Campaign*, Pluto Press 1984
Benton, Mike, *Horror Comics*, Taylor Publishing 1991
—, *Masters of Imagination*, Taylor Publishing 1994
Butterworth, Jack, 'Warren Comics in the 70s Part 1', *Goreshriek* #6, FantaCo 1989
Daniels, Les, *Comix: A History of Comic Books in America*, Wildwood House 1973
—, *Marvel: Five Fabulous Decades of the World's Greatest Comics*, Virgin 1991
Diehl, Digby, *Tales From the Crypt: The Official Archives*, St Martin's Press 1996
Estren, Mark James, *The History of Underground Comics,* Ronin 1987
Evans, George, Interview in *The Comics Journal* #177, May 1995
Goodwin, Archie, 'The Warren Empire', *Goreshriek* #5, FantaCo 1988
Hewetson, Al, 'My Years in Horror Comics', *The Comics Journal* #127, Mar 1989
Ivie, Larry, 'EERIE — The Beginnings', *Monster Memories Yearbook* 1998
Nyberg, Amy Kiste, *Seal of Approval: The History of the Comics Code*, University Press of Mississippi 1998
Signorelli, Joe & Medenbach, Erich, 'Pre-Code Horror Top Ten' *Comicbook Marketplace* #46, Apr 1997
Suarez, George, 'Terrology' *Tales Too Terrible To Tell* #1–#11, New England Comics 1989–93

GHASTLY TERROR!

PICTURE CREDITS

All comics are reproduced as historical illustrations to the text, and grateful acknowledgement is made to the publishers, creators and artists of this work. Although every effort has been made to identify the owners of copyright material, in some cases this has not proved possible. Notification of omissions or incorrect information should be forwarded to the publishers, who will be pleased to amend any future edition of the book.

p7 © Warren Publishing Company
p8 © Popular Fiction Publishing Co.
p8 © Rogers-Terrill Publishing
p9 © Clayton Magazines, Inc.
p11 © Harvey Publications
p12 © Ajax-Farrell Comic Group
p13 © Gillmor Magazines
p14 © EC Publications, Inc/William M. Gaines, Agent, Inc.
p14 © Story Comics
p15 © Gillmor Magazines
p15 © EC Publications, Inc/William M. Gaines, Agent, Inc.
p15 © Comic Media
p16/17 © EC Publications, Inc/William M. Gaines, Agent, Inc.
p18 © Ajax-Farrell Comic Group
p19 © American Comics Group/ACG
p20/21 © EC Publications, Inc/William M. Gaines, Agent, Inc.
p22 © Ajax-Farrell Comic Group
p22 © Gillmor Magazines
p24/25 © Gillmor Magazines
p25 © Story Comics
p27 © PL Publishing Company
p27/28 © Marvel Entertainment Group, Inc.
p30 © Quality Comics Group
p32 © Ajax-Farrell Comic Group
p33 © Superior Comics
p34 © Quality Comics Group
p35 © EC Publications, Inc/William M. Gaines, Agent, Inc.
p35 © Story Comics
p36 © Gillmor Magazines
p37 © Marvel Entertainment Group, Inc.
p38 © EC Publications, Inc/William M. Gaines, Agent, Inc.
p39 © Marvel Entertainment Group, Inc.
p40 © Standard Publications
p41 © Master Comics, Inc.
p41 © Story Comics
p42 © EC Publications, Inc/William M. Gaines, Agent, Inc.
p42 © Gillmor Magazines
p44 © Ace Magazines
p44 © Marvel Entertainment Group, Inc.
p45 © Fawcett Publications
p45 © Gillmor Magazines
p47/48 © Ajax-Farrell Comic Group
p49/50 © Fawcett Publications
p51 © EC Publications, Inc/William M. Gaines, Agent, Inc.
p52 © Gillmor Magazines
p52 © Charlton Comics
p53 © EC Publications, Inc/William M. Gaines, Agent, Inc.
p53 © Harvey Publications
p53 © Gillmor Magazines
p53 © Story Comics
p53 © Comic Media
p54/55 © EC Publications, Inc/William M. Gaines, Agent, Inc.
p56 © Levy
p56 © 1996 Al Feldstein/St Martin's Press/EC Publications, Inc/ William M. Gaines, Agent, Inc.
p57 © Avon Comics Group
p58 © EC Publications, Inc/William M. Gaines, Agent, Inc.
p59 © Marvel Entertainment Group, Inc.
p60 © Ajax-Farrell Comic Group
p62-63 © unknown
p64-115 © Warren Publishing Company
p116-122 © Eerie Publications, Inc
p122 © Stanley Publications, Inc
p123 © Ajax-Farrell Comic Group
p123-126 © Eerie Publications, Inc.
p127 © DC Comics, Inc.
p128 © Major Magazines
p128 © Atlas/Seaboard Publishing
p129-150 © Skywald Publishing Corp.
p151 © EC Publications, Inc/William M. Gaines, Agent, Inc.
p152-168 © Skywald Publishing Corp.
p169-180 © Marvel Entertainment Group, Inc.
p182 © San Francisco Comicbook Co.
p182 © Apex Novelties/Last Gasp
p183/184 © The Print Mint
p184-186 © Last Gasp
p186 © Charles Dallas
p187 © Last Gasp Eco-Funnies
p188 © Rip-Off Press
p188 © Last Gasp
p189 © Rip-Off Press
p189 © J Osborne/Saving Grace
p190 © Pacific Comics
p191 © Eclipse
p192-194 © Spiderbaby Grafix Publications
p192 © Tundra/Spiderbaby Grafix Publications
p192 © Kitchen Sink
p194 © Tundra/Spiderbaby Grafix Publications
p195 © Northstar Publishers
p195 © Verotik
p197 © L Miller & Co (Hackney) Ltd.
p198 © Portman Distribution Ltd.
p199 © Ace Magazines
p199/200 © American Comics Group/ACG
p200 © Ajax-Farrell Comic Group
p201-203 © Marvel Entertainment Group, Inc.
p203/204 © Avon Comics Group
p205 © Charlton Comics
p205 © Comic Media
p206 © DC Comics, Inc.
p206 © Fawcett Publications
p207 © Fiction House
p207 © Gillmor Magazines
p208 © Harvey Publications
p208 © PL Publishing Company
p209 © Quality Comics Group
p209 © Standard Publications
p209/210 © Star Publications
p210 © Sterling Comics
p210 © St John Publishing
p211 © Story Comics
p211 © Superior Comics
p212 © Toby Press
p212 © Trojan Publishing
p212 © Youthful Magazines
p212 © Ziff-Davis Publications

GHASTLY TERROR!

INDEX

BLOCK CAPITALS = titles of comic books
Italics = titles of films and publications other than comic books
Bold = illustration
(n) = footnote

'1 and 1 Equals 3' 152, 159
'13 Dead Things, The' 152, 163
1984 106
1994 106
'2073: The Death of the Monster' 158
'24 Hours of Hell' 111
'39th and Norton' 195

Aardvaark One, imprint 193
Abellan, Adolfo 100, 102, 109
Abominable Dr Phibes, The 105
'Abominable Snowman' 68
'About Face' 45, 46
'Accursed, The' 101
'Accused Flower, The' 98
Ace 43, 56, 197, 199
ACG 55, 56, 124, 200
'Acid Test, The' **20**, 25, 26
Ackerman, Forest J 86
ACMP 60, **61**
'Act, Three!' 84
'Adam Link: Robot', *see also* Series characters: Adam Link 67
Adams, Neal 80–83, 87, 92, 110, 127, 179
Adkins, Dan 75, 79, 80, 82, 84, 133, 137
ADVENTURE INTO FEAR 175
ADVENTURES INTO DARKNESS 32, 40, 48, 208
ADVENTURES INTO TERROR 17, 20, 21, **27**, 31, 35, 38, 47, 49, 202
ADVENTURES INTO THE UNKNOWN 55, 124, 160(n), 200
ADVENTURES INTO WEIRD WORLDS 37, 38, 49, 202
'Afterlife' 196
'Ahead of the Game' 72
'Aieeeeee! The Teeth!' 206
AIRBOY COMICS **10**, 134
AIRFIGHTERS 134
Ajax, imprint, *see also* Ajax-Farrell 117, 197, 201
Ajax-Farrell, imprint, 13, 21, 26, 42, 51, 57, 117, 201, 215
Alan Class, imprint 198
Alcala, Alfredo 189
Alcazar, Vincente 105, 109, 110, 179
'All She Does is Eat' 196
AMAZING FANTASY 63
AMAZING GHOST STORIES 209
AMAZING MYSTERIES 55, 202
American Anthropologist 39
American Comics Group, *see* ACG
'Ample Sample, An' 29
'...And an End' 103
'...And Be a Bride of Chaos' 94
'And in this Land... a Monster' 164

'And it Whispered, And it Wept, And it did Shudder, And it did Die' **153**, 160
'And the Corrupt Shall Dine' 163
'And the Gutters Ran With Blood' 168
'And the World Shall Shudder' 160
'...And then there's Cicero' 131
'...And They did Battle with the Thing from Underneath' 159
Anderson, Howie, *see also* Al Hewetson 152, 154, 163
Andru, Ross 131, 133, 141, 142, 147, 154
'Ants In Her Trance' 35
Arcane, imprint 193
Archaic Al, *see* Al Hewetson 143
Armitage, Starr, *see also* Richard Corben 185
'Army of the Walking Dead' 88
Arnold, Herb, *see also* Richard Corben 185
Association of Comics Magazine Publishers, *see* ACMP
ASTONISHING 44, 176
ASTONISHING TALES 202
'Asylum of Frozen Hell, The' **141**, 151, 152
'At the Stroke of Midnight' 170
Atlas, *see also* Marvel Comics Group 11, 20, 26, 38, 41, 43, 44, 55–57, 119, 170, 177, 178, 197, 202, 203
Aureleon 92, 101
AVENGERS, THE 130
Avon, imprint, 43, 55, 57, 134, 146, 203
Ayers, Dick **118**, **119**, 120, 141

'Baby, It's Cold Inside' 49
'Backfire!' 77
Badia, Enrique 181
BAFFLING MYSTERIES 199
'Bag of Fleas, A' 160
Bailey, Bernard 57, 124, 206, 215
Baker, Matt 57
'Bald Sheba and Mountebank the Rogue' 111
Ballantine, imprint 63
'Banjo Lessons' **190**–192
Barker, Clive 196
Barker, Martin 197(n)
BARN OF FEAR, THE 187
Barr, Ken 88
'Basket, The' 45
'Battle of the Living Dead, The' 164
Bea, José M. 90, 93, 94, 96–98, 101, 111, 164
'Beast Man' 79, 82
'Beast of the Bayous' 43

'Beast of Wolfton, The' 186, **189**
'Beckoning Beyond, The' 80
'Bedtime Gory' 18
'Behold... the Cybernite' 98
'Beneath the Graves' 38
Benson, John 80
Bermajo, Luis 109
'Bernice' 167
BEWARE 211
'Beware It... Fear It... It Screams!' 152, **158**, 162
'Beware Small Evils' **134**, 137
BEWARE! 43, **176**, 177, 210
BEWARE! TERROR TALES 51, 206
BEYOND, THE 43, 44, 48, 199, 200
Bezaire, Bruce 106, 110
Bierce, Ambrose 49, 68
Binder, Eando, *see also* Earl & Otto Binder 70(n)
Binder, Earl 70
Binder, Otto 66, 67, 70, 124
Bissette, Steve 192, 193, 194, 196
BLACK CAT MYSTERY **53**, 207
Black Cat, The 48
'Black Cat, The' 108
'Black Communion' 159
Black Dahlia, The 195
'Black Death' 43
BLACK HOLE 194
BLACK MAGIC 46, 77, 82, **127**, 197, 207, 208
'Black Saint and the Sinner Lady, The' 185
Blasco, Jesus 181
BLAZING COMBAT 69
'Blind Alleys' 13
Bloch, Robert 71, 181
'Blood Hunt for the Cannibal Werewolf' 166
'Blood of the Werewolf' 80
'Blood Queen of Bayou Parish, The' 101
'Blood Revenge' **27**
'Blood Vengeance' 32
'Bloodbath' **121**
'Bloody Mary' 117, **123**
BLUE BOLT WEIRD TALES 208
'Body Snatchers, The' 38, 122
'Body-Snatcher, The' 70
BOGEYMAN **182**, 183
Boix, Juan 181
Bolan, Marc 7
Bolton, John 190, 192
'Book of Zee, The' 186
BORIS KARLOFF'S TALES OF MYSTERY 126
Borrell 162, 163, 166
'Bottoms Up' **14**, 17
Boudreau, Gerry 110

'Bowser' 109
Boxell, Tim 186
Boyette, Pat 85, 87–89, 149, 150
Bradbury, Ray 10, 50
BRAIN FANTASY 187
'Brain, The' **17**, 20
'Brain Trust' 77
'Brain-Bats of Venus, The' 49, 206
Brand, Roger 82, 84, 88, 124, 183, 186, 187
BRAVE AND THE BOLD, THE 132
Brennan, T. Casey 88, 93, 94, 101
Bride of Frankenstein, The 141
'Brides of the Frankensteins, The' 158
Bridwell, E. Nelson 71
Brocal, Jaime 91, 95, 98, 103
Brodsky, Sol 57, 129, 130, 131, 139, 140, 144, 153, 164, 179
'Broken Sparrow' 149
Brown, Chester 194
Brown, Len 145
Brunner, Frank 89, 96, 124, 181
Buckler, Rich 102, 103, 110, 136, 146, 179, 181
'Buffaloed' 108
Bulwer-Lytton, Edward 81
Burgos, Carl 117, 118, 123, 131
'Buried Pleasure' 98
Burns, Charles 194
Burroughs, Edgar Rice 81
Buscema, John 179
BUTCH CASSIDY 144
'Butcher, The' 106
'Butterfly, The' 144
Butterworth, Jack 99(n), 100(n), 103, 112(n), 195
Buttgereit, Jörg 184

'C: Dopey' 185
Call of Cthulhu, The 76
Callodo 166
Campbell, Eddie 195
Cannon, WB 39
CAPTAIN AMERICA 55. *See also* Series characters: Captain America
CAPTAIN AMERICA'S WEIRD TALES 55, 202
CAPTAIN SCIENCE 211
Capullo, Greg 195
Cardona 167
'Carrier of the Serpent, The' 93
Casadei 121
Cask of Amontillado, The 48
Casper Hauser 150
Castello, Hector 121
CASTLE OF HORROR 198
'Castle of the Vampire Dead' 165
'Castle on the Moor, The' 75
'Caterpillars, The' 97

INDEX

'Cavern of Doom, The' 147, 160
CEREBUS 193. *See also* Series characters: Cerebus
CHALLENGE OF THE UNKNOWN 199
CHAMBER OF CHILLS 11, 12, 31, 43, **176**, 177, 181, 207
CHAMBER OF DARKNESS, THE 170
Chaos! Comics , imprint 196
Charlton, imprint 24, 51, 52, 63(n), 85, 126, 169, 204
'Chef's Delight' 15
'Chess' 97
Chicago Sun-Times 98
'Child' 105
'Children of the Cold Gods' **132**
CHILLING TALES 211
CHILLING TALES OF HORROR 124
'Choir-Master, The' **11**, 12
Cintron, Maelo 154, 159, 163, 164
'Circle of Circe, The' 132
'City of Crypts' 154
'City of the Dead, The' 36
CITY OF THE LIVING DEAD 204
'Classic Creeps, The' 163
'Cleanup Crew' 184, **187**, 194
CLUTCHING HAND, THE 19, 201
'Cobra Queen' 101
Cochran, JR 97, 99
Cochran, Russ 215
Cockrum, Dave 89
'Coffin' 106
'Coffin for Captain Cutlass, A' 141
'Coffin of Dracula, The' 72, 75
Colan, Gene 57, 71, 74, 77, 79, 82, 151(n), 172, 175
'Cold and Uncaring Moon, The' 181
Cole, Jack 208
Cole, LB 208
Coleman, Joe 195, 196
Collado, Luis 151(n)
'Collector's Edition' **75**, 78, 79, 110
Colon, Ernie 85, 128, 136, 142, 149
Colossus 176
'Come on Down' 193
'Comes the Stalking Monster' 146
Comic Media, imprint 18, 38, 53, 117, 130, 204
Comicbook Marketplace 52
Comics Code 11, 51, 54, 56, 58–**60**, **62**, 64, 117, 124, 144(n), 168, 169, 171, 174, 176, 178, 192, 203, 204
Comics Journal, The 65(n), 139(n), 166(n), 168(n)
Coming Race, The 81
Connell, Richard 49
Conrad, Tim 189
'Contagious' **193**, 194
Conway, Gerry 89, 173, 179, 181
Cook, David 146
Cool Air 49, 107
Cooper, Alice 7
Copper Bowl, The 49
Corben, Richard 88, 89, 103, 105, 106, 109, 111–113, 182, 184, 185, 186, 189
Corman, Roger 27(n)

'Corpse by Computer' 149
'Corpse, The' 163
'Corridors of Caricature' 160
'Cosmos Strain, The' 149
CRACKED 124, 129
Craig, Johnny 17, 39, 40, 54, 57, 71, 75, 77, 84
Crandall, Reed 65–67, 70, 71, 75, 79, 83, 100, 103, 110, 122
Crawford, F. Marion 48
'Creation, The' 88
'Creatures of the Deep' 144
CREATURES ON THE LOOSE 176
'Creatures, The' 121
'Creeps' 111
CREEPY **7**, 10, 64–115, 116, 122, 126, 131, 140, 145, 158, 163, 169, 197, 215
CREEPY WORLDS 198
'Crime in Satan's Crypt, The' 166
CRIME MACHINE, THE 134
CRIME MYSTERIES 34
CRIME PATROL 55
CRIME SUSPENSTORIES 53
Critical Vision: Random Essays and Tracts Concerning Sex Religion Death 112
'Cross of Blood' 97
Crumb, Robert 163, 182, 183, 187
CRYPT OF SHADOWS **176**, 177
CRYPT OF TERROR, THE, *see also* TALES FROM THE CRYPT 55, 60, 205
Cueto 163
'Curse of Claws, A' 82
'Curse of the Full Moon' 68
'Curse of the Vampire!' 80
'Curse of the Yeti' 125
'Custodian of the Dead' **34**, 156
Cuti, Nicola 88, 126
'Cutting Cards' 31
'Cycle of Horror' 43
'Cyked-Out' 87

D.O.A. COMICS **189**
Dallas, Charles 185–187
'Damned Thing, The' 68
'Dance of Death' 48
'Dancer from Beyond, The' 48
Daniels, Les 171(n)
Danzig, Glenn 196(n)
'Dark Kingdom, The' 75
DARK MYSTERIES **25**, 31, 35, **41**, 50, **53**, 210, 215
'Dark Passage, The' 35
'Dark Victory' 160
DARKHOLD 180
Davis, Jack 20, 31, 54, 57, 64, 65
'Day after Doomsday' 80
DC 9, 63(n), 71, 84, 92, 94, 107, 113, 116, 126, 127, 132, 169, 188, 192, 205
'Dead and the Super-Dead, The' 163
'Dead Man's Race' 103
DEAD OF NIGHT **177**
'Dead Wait' 22

DEAD WHO WALK, THE 204
'Deadlier than the Male' 43
'Death Drum' **40**
'Death Expression' 110
'Death for a Death, A' 43, **45**
'Death Plane' 72
'Death Rattle' 186
'Death Wagon, The' 35
'Death's Dark Angel' 89
'Decapitation' 18
'Deep Ruby' 80
Deitch, Kim 183
Deitch, Simon **188**
Dell 63(n), 126, 169
'Demon in the Dungeon' 48
'Demon is a Hangman, The' 121
'Demon of Slaughter Mansion, The' 181
'Demon Sword' 80, 82
DEMON, THE 127
DEMON! **198**
'Demon's Night' **120**, 121
Dentyn, Joe, *see also* Al Hewetson 166
'Derelict' 97
Derleth, August 181
'Descent into Hell, A' 103
'Devil Birds, The' 49
Devil Doll 122
'Devil Flower' 27
'Devil in the Well, The' 185
DEVILINA 128
'Devil's Chessboard, The' 205
'Devil's Woman' 154
'Devil's Zombie, The' **119**
'Diary of an Absolute Lunatic' 163
DIARY OF HORROR 204
'Die Little Spider!' 162
Diehl, Digby 56
'Dig Me No Grave' 181
Dime Mystery 9
'Diminishing Returns' 23
DiPritta, Tony 57
'Discombobulated Hand, The' 152
Ditko, Steve 57, 63, 73, 74, 75, 76, 78–80, 83, 126, 170, 200(n), 204, 208
Dixon, Ken 87
Domingo 152, 156
Dominguez, Luis 127
'Don't Die up there, Stanley' 160
'Door, The' 33, **36**
'Doorway, The' **77**, 79
'Dorian Gray: 2000' 94
Doyle, Sir Authur Conan 171
'Dr Jekyll and Mr Hyde' 155
DR STRANGE 73. *See also* Series characters: Dr Strange
DR WIRTHAM'S [sic] COMICS 187
DRACULA 101(n), 172, 173. *See also* Series characters: Dracula
Dracula AD 1972 165
'Dracula did not Die!' 165
DRACULA LIVES 177, **179**
'Drawn and Quartered' 48
'Dreamer, The' 186
'Drifting Snow, The' 181

'Drink Deep!' 70
'Drums of Cajou, The' **40**, 41
DuBay, Bill 97–100, 102, 103, 106–108, 111
'Duel of the Monsters, The' 70
Dumas, Alexandre 87
Dunwich Horror, The 74
Duran, Jesus 160, 167
DYLAN DOG 197

East Coast, imprint 98
Eastman, Kevin 195
EC 8(n), 9, 11, 14, 16, 17, 20, 23, 26, 31, 32, 35–37, 39, 49–51, 53–64, 68, 70, 71, 75, 92, 98, 123, 126, 139, 151(n), 156, 165, 168, 182, 184, 189, 190, 202, 205, 209, 215
Eclipse, imprint 191
EDGAR ALLAN POE'S CREEPY STORIES 109
EERIE 64–115, 131, 140, 158, 169
EERIE COMICS 55, **57**, 203, 204
EERIE ADVENTURES 211
Eerie Publications, imprint 41(n), 69(n), 86, 94, 113, 116–124, 126, 169, 182, 215
EERIE TALES 62, 69
Eisner, Will 57, 113, 201(n)
Ellefson, Dennis 195
Ellis, Bret Easton 111
Ellison, Harlan 87, 181
Emissary, The 50
Englehart, Jones & Whitman 73
Englehart, Steve 101, 152
Ennis, Garth 193
Enrich 89, 92, 95, 101
'Entail, The' 88
'Especial' 196
Esposito, Mike 131, 133, 141, 142, 147, 154
Estrada, Rick 82
Etchison, Dennis 195
Evans, George 65(n), 72
'Even A Heap Can Die' 160
'Event in the Night, The' 162
Everett, Bill 40, 49, 57, 131, 141
EVIL ERNIE 196
'Evil of Rasputin, The' 167
'Excerpts from the Year Five' **101**, 109, 110
Exorcist, The 175, 179, 181
'Exterminator' 106
EXTRA **58**
'Eye of the Beholder' 71
'Eye of the Cat' 195

Fabá 166
'Face of Death, The' 49
Facts in the Case of M. Valdemar, The 35, 48
'Facts in the Case of M. Valdemar, The' **109**
'Fair Exchange' **78**, 80
FAMOUS FUNNIES 8

219

GHASTLY TERROR!

FAMOUS MONSTERS OF FILMLAND 62, 64, 86
fan clubs
 EC 58; Skywald 165; Warren 75, 98, **106**, **107**, 113
FantaCo 196
FANTAGOR 185, 186
FANTASTIC 211
FANTASTIC COMICS 201
FANTASTIC FEARS 12, 13, 43, 44, 47, 51, 201
FANTASTIC FOUR, THE 102, 130, 138, 170. *See also* Series characters: The Fantastic Four
Fantastic Voyage 137
Farrell, Robert W. 201
Farthing, Edward, *see also* Al Hewetson 166
Fass, Irving 117, 123
Fass, Myron 117, 211
'Fat Man, The' 48
FAUST **195**, 196
Fawcett, imprint 36, 43, 51, 53, 204, 206, 211
FEAR 175(n), 176
'Fed up!' 29
Fedory, Ed 95, 100, 151, 152, 159, 160, 163, 164–166
'Feed It' 125
Feldstein, Al 54, 56–58
Fernandez, Fernando 112
Fielding Eliot, George 49
'Fiend of Chang-sha!, The' 168
'Fiends from the Crypt' 44, **47**
FIGHT AGAINST CRIME: HORROR AND TERROR 52, 210
'Filthy Little House of Voodoo, The' **145**, 152, 154
Fleishman, Hy 209
'Flesh-Eaters, The' 121
'Fleshless Ones, The' **62**
FLY IN MY EYE 193
Font, Alfonso 167, 179, 181
'Footsteps of Frankenstein' 71, 84
'For the Sake of Your Children' 95
Forbidden Planet 188
FORBIDDEN WORLDS 200
'Forgive us our Debts' 100
'Foul Play' 31
Fox, Gardner 132, 136, 141
Fox, Matt 211
Fraga, Oscar **120**, 121
FRANKENSTEIN 89, **172**. *See also* Series characters: Frankenstein
'Frankenstein 1973' 158
'Frankenstein Book II: Chapter One' 158
Frazetta, Frank 65–70, 72–75, 77, 82, 83, 84, 86, 87, 89, 111, **114**, **115**, 132
'Freaks of Fear' **138**, 158
'Freaks, The' 107, 159
'Freedom's Just Another Word' 102
Friedrich, Gary 141
'Frog God' 100
Frogs 165
'From Hell' **192**, 194, 195, 196

'Frozen Beauty' 88
Fuente, R. Dela 155
Fujitake, Denis 152, 162
'Full Fathom Fright' 74
'Funeral Barge, The' **148**, 152, 158
Funnell, Augustine 151(n), 161, 163
FUNNIES ON PARADE 8

Gaines, Max 8
Gaines, William M. 8(n), 54, **56**, 57–59, 118
Garcia, Luis 91, 93, 97
'Garcon, The' 30
'Garden Party, The' 14
'Gargoyle' 68
'Gargoyle, A — A Man' 159
Garzon, Carlos 88, 143, 145, 149
Gebbie, Melinda 196
Gerber, Steve 175, 179
GHOST COMICS 206
GHOST MANOR 126
GHOST RIDER, THE 180. *See also* Series characters: The Ghost Rider
GHOST STORIES 126
'Ghost Town' 50
'Ghostly Guillotine, The' 31
GHOSTLY HAUNTS 126
GHOSTLY TALES 126
GHOSTLY WEIRD STORIES 208, 209
GHOSTS 127
GHOUL TALES 124, 198
Ghoulardi 64(n)
'Ghouls Walk Among Us' 163
Giacoia, Frank 137
Gillmor, imprint 14, 28, 51–53, 57, 120, 124, 182, 198, 206, 207
Giordano, Dick 179
Glut, Don 101
'Gnawing Fear' 77
'God of the Dead, The' 165
Gold Key 63(n)
Gonzalez, José 86, 89, 91
'Good Christian, A' **194**, 195
Goodwin, Archie 64–74, 76, 77, 79–83, 85, 86, 88, 89, 91, 94, 98, 108, 109, 110
Goodwin, Ivie 65
Gore, *see* Richard Corben 184
GORESHRIEK 70(n), 196
'Gothic Tale, A' 185
Grand Guignol, theatre 26
Grandenetti, Jerry 82, 93
'Grave Business' 37
'Grave Undertaking' 68
'Greatest Horror of Them All, The' 46
GREEN LANTERN 92
'Grim Fairy Tale, A' 49
Grimes, Rick 196
GRIMWIT 186
'Gruesome Faces of Mr Cliff, The' 132
Gual, José 93, 109, 160, 162, 163
Gulacy, Paul 176

'Hacker is Back!, The' 111. *See also* Series characters: The Hacker
'Hag of the Blood Basket, The' 137, 142, 143
'Hairy Claw of Tolen' 185
Hampton, Scott 192
HAND OF FATE, THE 43, 199
'Hand of Kaä, The' **184**, 185
Harvey, imprint 12, 44, 51–53, 56, 57, 207
Hastings, imprint 62
HAUNT OF FEAR, THE 14, 18, 20, 23, 25, 29, 31, 35–42, 45, 46, 48, 54, **55**, 205, 215
Haunt of Fears, A 197
HAUNT OF HORROR, THE 178–181
HAUNTED 126
HAUNTED THRILLS 42, 46, 60, 201
'Have You Seen the Black Rain' 154
Hayes, Rory 183
'Head of the Family, The' 31, 46, 77
'Head-Shrinkers, The' 121
'Headless Horror' 31
HEAP, THE **146**. *See also* Series characters: The Heap
Heath, Russ 98, 111
HEAVY METAL 106, 113, 150, 186
Heck, Don 130, 205
Hell House 173, 181
'Hell is on Earth' 165
HELL-RIDER **136**, 144. *See also* Series characters: Hell-Rider
HELLRAISER 196
HELP! 182
HEMBRAS PELIGROSAS 197
'Henpecked' **13**, 14
'Heritage of Horror' 82
Herndon, Larry 108
Hewetson, Al 87, 88, 93, 94, 97, 130, 136, 139(n), 140–145, 147, 151–155, 157, 159–168, 201
'Hey Creep: Play the Macabre Waltz' 152
Hoffman, Mike 193, 194
'Hog-Riding Fools' **182**
'Hollow Horror' **12**, 13
'Hop-Frog' 79
'Horrible Harvey's House' 184, **186**
'Horribly Beautiful' 46
HORRIFIC 38, 48, **53**, 204
'Horror from the Mound, The' 181
Horror hosts
 Abel 107; Cain 107; Corpse, The 51; Cousin Eerie 72, 79, **97**, 107; Crypt-Keeper, The 45, **51**, 68; Dr Death **50**, 51; Ghastly McNasty 198; Ghoul-Teacher, The 51; Grave-Digger, The 51; Grave-Keeper, The 51; Mummy, The **50**, 51; Nameless One, The 51; Old Witch, The **51**, 55, **56**, 142; Thing!, The 51; Uncle Creepy **65**, 67, **71**, 72, 79, 92, **97**, 107, 108; Vault-Keeper, The **51**; Webster, the Spider 125

'Horror Master, The' 131
Horror Stories 9
HORROR TALES 116–119, 121–123
'Horror We? How's Bayou?' **35**
'Horror-Master, The' **138**, 142, 160
Horror-Mood, *see also* Skywald Publishing Corp. 130, 153(n)
'Horus' 95
'Hot Spell!' 70
'Hound, The' 184, **187**
'House of Evil' 76
'House of Monsters' 119
HOUSE OF MYSTERY, THE 107(n), 126, **127**, 205
HOUSE OF SECRETS, THE 107(n), 126
'House of Vampires' 122, **124**
'How Green was my Alley' **14**, 15
Howard, Robert E. 181
'Howling Success' 67
'Human Gargoyles vs the Human Dead, The' 159
'Human Gargoyles vs. the United States of America' 159
'Hunchback, The' 45
'Hung Up' 152
'Hunger' **25**, 29
'Hunter and the Hunted, The' 19

'I am Dead: I am Buried!' 152, **155**, 161
'I am... Torment!' 167
'I am Treachery: I am Horror-Incarnate' 167
'I Chopped Her Head Off!' **118**, 119
'I Crawl Through Graves' **37**, 38
'I, Gargoyle' 159
'I Killed Mary' 120
'I Robot' **74**
'I, Slime' 163
'I, Werewolf' 88
Iger, Jerry 52, 201
Iger Shop, *see also* Jerry Iger 121(n)
'I'll String Along' 49
'I'm Only In It For the Money' 88, **89**
'Image of Bluebeard' 70
'In Deep' **104**, 110, 111, 112
'In the Neck of Time' 87
In the Vault 36
Ingels, Graham 54, 57, 215
'Inner Man, The' **135**, 137
'Inquisition, The' 166
INSECT FEAR **183**
'Into the Tomb' 77
INVISIBLES, THE 192
'Invitation, The' **72**, 73
IPC, imprint 198
IRON MAN 130. *See also* Series characters: Iron Man
Irons, Greg 183–185, **187**, 194
Isabella, Tony 181
'Island at the World's End' 76
'Island of Death' 49
'Isle of the Huntress' 90
'It' 160
'It!' 102
Ivie, Larry 58, 64, 65, 66(n),

INDEX

68, 70(n)
Izzo, Jean 141

Jack the Ripper 195
Jackson, Ezra 117, 118, 123
Jad 160
Jakes, John 181
James, Henry 157
Jaxon, Jack 183, 184, 186, 187
'Jenifer' **102**, 108, 110
Jenney, Bob 85
'Jeremiah Cold' 106
'Jesuis le Marquis de Sade' 167
'Jibaro Madness' 24
'Jilimbi's Word' 181
Jodorowsky, Alexandro 195
Jones, Bruce 108, 111, 112, 125, **133**, 136, 146, 152, 188, 190, 191
Jones, Jeff 82, 90, 124, 149, 150, 162
Jones, Russ 63, 64
José Toutain Publishing 86
JOURNEY INTO FEAR 33, 35, 40, 46, 210
JOURNEY INTO MYSTERY 177, 181, 203
JOURNEY INTO NIGHTMARE **198**
JOURNEY INTO UNKNOWN WORLDS 43, 44, 202
'Judge's House, The' 68
JUNGLE ACTION 92
JUNGLE ADVENTURES 144
'Jury of the Dead' **33**, 35
'Justice' 88

Kaluta, Mike 125, 127, 149
Kamen, Jack 54, 57
Kane, Gil 173
Kanigher, Bob 141, 149
Karloff, Boris 10
Katz, Jack 57, 136, 137, 208
Keep, The 94
'Keeper of the Flames, The' 200
Kefauver hearings 64. *See also* Senator Estes Kefauver
Kefauver, Senator Estes 59, **61**, 62
Kelly, Ken 89, 91, 93, 109, 113, 145, 158, 162
'Killer Lady' **18**, 21, 42
Kim, Chull Sanho 168
'King of Hades, The' **32**, 34
King, Stephen 103(n), 104, 160(n), 166(n)
'Kingdom of the Dead' 167
Kirby, Jack 46, 57, 63, 77, 119, 127, 138, 151(n), 198, 207
'Kiss and Kill' 46
Kitchen Sink 186, 195
'Kitty-Killer Kids, The' 193
Krigstein, Bernie 151(n)
KRIMINAL 197
Kubert, Joe 203
Kurtzman, Harvey 182

LADY DEATH 196
'Lady Satan' 163. *See also* Series characters: Lady Satan
'Lair of the Black Widow' 43, **44**
Last Gasp, imprint 183
'Last of Mr Mordeaux, The' 44
'Last of the Frankensteins, The' 173
'Late Night Snack, A' **193**, 194
Latimer, Dean 90
LaVey, Anton 175
LAWBREAKERS SUSPENSE STORIES **52**, 204
Lee, Christopher 165
Lee, Stan 33, 40, 41, 57, 58, 139, 151(n), 169–171(n)
'Legend of the Man-Macabre, The' 160
LEGION OF CHARLIES, THE 187
LEGION OF MONSTERS, THE 179, **180**
Leiber, Larry 181
'Lend Me a Hand' **16**, 20
Lenny, Mel 117
Leow, Flaxman, *see also* Mike Butterworth 112
Leroux, Gaston 167
'Let the Dreamer Beware' 148
Levy 55
Lewis, Budd 105, 106, 109
'Life with the Vampire' 195
'Lifeboat' 181
'Ligeia' 167
'Light in the Distance, The' 185
'Lighthouse, The' 75
Lights Out 10
'Like a Phone Booth, Long and Narrow' 94
'Limb from Limb from Death' **147**, 155
Lindall, Terence 113
LION 197
'Little Monsters, The' 43
'Little Red Riding Hood and the Werewolf' 51
Little Shop of Horrors, The 27(n)
'Living Death, The' 48
Lloyd, David 192
'Locked Door, The' 48, **49**
Lombardia 166
Lopez, Juan 88
Lord Horror 112
'Lost Girls' 196
'Love in the Afternoon' **193**, 195
'Love Story' 41
'Love Witch, The' 141, 149, 164
Lovecraft, HP 36, 44, 49, 74, 76, 85, 107, 155, 166, 181, 184
'Lower Berth' 45, 68
Lucas, Tim 194, 196
Lugosi, Bela 10
'Lunatic Class of '64, The' 166
'Lunatic Picnic' **157**
Lynch, Brendan 131
Lynch, Jane 151(n), 166
Lynch, Jay 163, 166

Macagno 122
Machen, Arthur 48

MAD 61, 129
'Mad, Nightmare World of HP Lovecraft, The' 162
'Mad-Doll Man, The' 162
'Madman, The' 46
'Maggots, The' 31
Major Magazines, imprint 124
Man and the Snake, The 49
Man in the Iron Mask, The 87
'Man Who Called Him Monster, The' **85**, 91
'Man Who Cried Werewolf, The' 181
'Man Who Stole Eternity, The' 141
'Man Whose Soul Was Spoiling, The' 112
'Man-Macabre, The' **150**
'Man-Plant from the Tomb' 125
MAN-THING 180. *See also* Series characters: Man-Thing
Maneely, Joe 41, 57
Manson, Charles 187
MANY GHOSTS OF DR GRAVES, THE 126
Marais, Raymond 84
Marcos, Pablo 89, 147, 151, 152, 155, 156, 160–162, 164, 179, 181
'Mardu's Masterpiece' 48
Margopoulos, Rich 98, 105
'Mark of Satan's Claw, The' 91
'Mark of the Beast' 131
Marnick, Tom 195
Maroto, Esteban 91, 93, 95, 97, 98, 100, 101, 103, 105, 108, 142, 164, 178, 181
Mars Attacks 57
MARVEL CHILLERS 176
Marvel Comics Group, *see also* Atlas, imprint 40, 56, 63, 73, 84, 92, 93, 101, 106, 113, 116, 117, 119, 128–130, 133, 138, 139, 141, 151(n), 153, 160, 164, 169, 170, 171–173, 175, 179, 180, 188, 198, 202, 203, 207
MARVEL MYSTERY 55
MARVEL PREVIEW 179, **180**
MARVEL SPOTLIGHT 173, **174**, 175
MARVEL TALES 43, 55, 202
Marvel: Five Decades of the World's Greatest Comic 171
'Mask Behind the Face, The' 98
'Mask of Horror, The' 46
Masque of the Red Death, The 49
'Masque of the Red Death, The' **81**, 82, 111
'Master of the Dead' 131
Mastroserio, Rocco 74, 77, 80, 85
'Mates' 108
Matheson, Richard 105, 173
'Matter of Routine, A' **76**, 79
Mayo, Gonzalo 106
'Maze, The' 108
McGregor, Don 91–93, 103, 179, 181
McNaughton, Chuck 136, 141,

142, 144
MD **58**
Medenbach, Erich 52
MENACE 26, 39, 40, 46, 178, 203
MEN'S ADVENTURES 203
Mephisto's, 'Make Child Burn' 160
'Mercenary, The' 150
'Metamorphosis of the Gkmloooms' 206
'Midnight Mess' 50
'Midnight Sail' 77
'Midnight Slasher, The' 151
MIDNIGHT SONS UNLIMITED 180
Milgrom, Al 103
Miller, imprint 197
Mingus, Charles 185(n)
Miralles 156
'Mirror Image' 49
'Mirror of Madness' 46
MISTER MYSTERY 13–**15**, 24, 25, 29, 43, 45, 49, **52**, 53, 207
MISTY 197
Moebius 195
Moench, Doug 88, 93, 97, 98, 100, 103–105, 108, 151(n), 173, 179, 181
Mones, Isidro 105
Monkey's Paw, The 205
'Monster in the Mist, The' 208
Monster Memories Yearbook 1998 (n) 66, 70
'Monster, Monster, Heed Death's Call' 164
'Monster, Monster, In the Grave' 164
'Monster, Monster, On the Wall' 161, 164
'Monster, Monster, Rise from the Crypt' 164
'Monster, Monster, Watch Them Die' 164
MONSTER OF FRANKENSTEIN, THE 173
'Monster of the Mist' 47
'Monster Rally' **68**
MONSTER, THE 206
MONSTER WORLD 64
'Monster!' 77
MONSTERS ON THE PROWL 176
MONSTERS UNLEASHED 178, 179, 181
'Monsterwork' 74
Montreal Gazette 139
Moore, Alan 110, 192, 193, 195, 196
MORBIUS 180. *See also* Series characters: Morbius, the Living Vampire
MORE FUN COMICS 9, **10**
Moren, Serg 139, 141, 145, 147
Morrison, Grant 110, 192
Morrow, Gray 65, 66, 68, 70, 72, 75–77, 83, 84, 131, 136, 175, 192
Morse, Stanley P. 124
Mortimer, Win 181
Most Dangerous Game, The 49, 90

GHASTLY TERROR!

'Mother Ghoul's Fairy Tales' 51
'Mother Mongoose's Nursery Crimes' 51
'Mountain of the Monster Gods' 84
'MS. Found in a Bottle' 167
'Muck Monster' 107
'Mummy... And an End, The' 111
'Mummy, The' 63
'Murder Pool, The' **22**, 26
'My Prison in Hell' 168
MYSTERIES WEIRD AND STRANGE 210
MYSTERIOUS ADVENTURES 14, 15, 17, 19, 31, **35**, 50, 168, 210
MYSTERY IN SPACE 132
MYSTERY TALES 202
MYSTIC 43, 49, **197**, 198, 202
'Myth of Dracula, The' 165

'Name is Sinner Kane, and the name means Evil, The' 168
'Narrative of Skut, The' 166
Nava 167
'Nazi Death Rattle' 145
Neary, Paul 97, 103, 105, 106
NEC, imprint 216
Nekromantik 184
'New Beginning, Part One, A' 164
'New Beginning, Part Two, A' 164
New Direction, EC 58
Nicholson, Jeff 196
'Night of Evil' 160
NIGHT OF MYSTERY 204
'Night of the Jackass' 106
'Night of the Mutant-Eaters, The' 162
'Nightfall' **99**, 107, 111
NIGHTMARE 113, 125, 129–165, 169, 198, 209, 211, 215
NIGHTMARE ANNUAL 1972 **144**
NIGHTMARE:TOMB OF HORROR SPECIAL EDITION 164, **165**, 167, 168(n)
NIGHTMARE WINTER SPECIAL 1973, THE 162
'Nightmare in the House of Poe' 161
'Nightmare World' 206
'Night's Loding [sic] , A' 87(n)
NIGHTSTALKERS 180
Nino, Alex 127
'No Place To Go' 34, **60**
'Nobody There' 20
Norman, Donald 82
Nostrand, Howard 57, 207
Novel of the White Powder, The 48
Novelle, OA 122

'Oblong Box, The' 167
Occurrence at Owl Creek Bridge, An 49
O'Connor, Nancy 193, 194
'Ogre's Castle' 66
Oleck, Jack 127
Omega Man, The 104, 165
'On a Stalking Moonlit Night' 103
'On the Wings of a Bird' 88

'Once upon a time in Alabama: A Horror' 159
'One for De-money' 71, 111
'One That Got Away, The' 43
O'Neill, Dennis 92
'Ones Who Stole it From You, The' 92
'Only Skin Deep' 46
'Only the Strong Shall Survive' 159
'Only the Wretched Die Young' 162
'Orgy of Blood' **129**, 131
Orlando, Joe 13, 63, 65, 67, 70, 72, 75–77, 82, 83, 122, 127
Ortiz, José 106, 109, 111, 164, 198
Ott, Fred 91, 97
Ottawa Journal 139
'Out of Chaos' 146, 147
OUT OF THE NIGHT 124, 200
OUT OF THE SHADOWS 40, 41, 43, 46, 208
'Out of Time' 75
'Overworked' 75

Pacific Comics, imprint 188, 191
Pagan, Kevin 101, 103
'Paintings of Jay Crumb, The' 163
Palais, Rudy 49, 57, 205, 207
Palmer, Tom 131
Parente, Bill 85, 88
Parker, Ron 73, 76
Parkhouse, Steve 198
Pearson, Bill 68, 70
Pellucidar 81
'People in Brass Hearses' 45
'Pepper-Lake Monster, The' **96**, 107
Perlin, Don 173
'Phantom of Pleasure Island, The' 110
'Phantom of the Opera, The' 158, 167
'Phantom of the Rock Era, The' 142
'Phantom Ship, The' 43
PHANTOM STRANGER 127
PHANTOM WITCH DOCTOR 204
'Pickman's Model' 71
'Pickman's Model' 181, 185
'Picnic, The' **24**, 29
picto-fiction, EC 61, 62
'Picture of Death, The' 96
Picture of Dorian Gray, The 49
Pit and the Pendulum, The 160
'Pit of Evil' 121
'Pit of Horror' 122
PL, imprint 32, 207
'Plague of Jewels' 146
Ploog, Mike 94, 173, 179, 189
Poe, Edgar Allan 35, 48, 67, 79, 82, 108, 109, 161, 162, 167, 171
Porges, Arthur 67
Portman Distribution 198
'Portrait of Death' 109
Potter, Greg 105, 109
Potter, JK 196
Potts, Adrian 196
Powell, Bob 13, 44, 57, 207

'Praying Mantis Principle, The' 181
PREACHER 193
'Premature Burial, The' **154**, 161
'Pressed for Time' 133
Prezio, Vic 84
primal spinal, Skywald 130(n)
'Princess of Earth' 158
Prize, imprint 46, 57, 127, 207
PRIZE COMICS 9
PSYCHO 129–165, 169, 198, 215
PSYCHO ANNUAL 1972 **144**
PSYCHO WINTER SPECIAL 162(n)
PSYCHOANALYSIS 58
PSYCHOTIC ADVENTURES ILLUSTRATED **186**
Purcell, Jack, *see also* Ernie Colon 142
PURPLE CLAW, THE 210

Quality, imprint 32, 208
'Quavering Shadows' 93
'Quest, The' **92**

'Rat-men of Paris, The' 44
'Rat-Trap' 43, **45**
'Rats Have Sharp Teeth' 36
'Rats in the Wall, The' 85, **185**
Rats in the Walls, The 44
'Raven, The' 109
Raymond, Alex 65
Rebel Studios, imprint 196
'Red Spider, The' 43
Redondo, Nestor 127
Reese, Ralph 125, 142, 144, 145, 148, 181
Reinman, Paul 132
'Relatively Axe-idental' 109
'Rendezvous' 112
'Rescue of the Morning Maid, The' 82, 85, 110
'Resurrection Man, The' 103
'Retinal Worm' 195
'Return Trip' 67
'Revenant, The' **191**, 192
'Revenge of the Beast' 68, **69**, 110
'Revolt of the Beast' 48
Reynosa 121
Ribage, imprint 34
Rice, Anne 195
Rich, Sinclair 137
Rip-Off Press, imprint 185
Robbins, Frank 176
Robbins, Trina 86
'Rock God' 87
Rodriguez, Manuel, *see also* Spain 183
Roland, Philip, *see also* Bruce Jones 136
Rolling Stones, The 151
ROOK, THE 106
'Room with a View' 73
'Roots of All Evil, The' 152, 163
Rosa, Dela 152, 154, 159, 160, 162, 163
Rosen, R. Michael 88
Roth, Werner 173

'Rottin' Deal, A' **133**, 136
Rovin, Jeff 128, 150, 151
ROWLF 186
'Royal Guest' 87
Rubio 162, 163
'Rude Awakening' 70
'Rumplestiltskin' 51
'RX Death' 48

'Saga of the Monster' 158
Saki 171
Saltares, Javier 180
Salvador, Martin 103, 109
Sanchez, Leopold 105
'Sand Castle' 151
Sanjulian 89, 90, 93, 97, 98, 100–103, 110
'Sands that Change' 83
'Satan Wants a Child' 163
SATANIK 197
'Satan's Plaything' 48
'Satan's Spectacles' **30**, 32
'Satan's Third Reich' 168
Saunders, Buddy 80
SAVAGE TALES 175
Savoy, imprint 112
'Scared to Death' 35
Scary Monsters 58
SCREAM 129–165, **158**, 198, 215
'Scream and the Nightmare, The' 163, 167
'Scream Test' 80, 163
'Scrimshaw Serpent, The' 181
'Sea Monsters, The' 122
Seaboard, imprint 128
Second Coming, The 96
SECRET DIARY OF EERIE ADVENTURES 204
SECRETS OF THE UNKNOWN 198
Seduction of the Innocent 28, 59, 62
Segrelles, Vicente 94, 150, 162, 163
Selecciones Illustradas Studio 164
SENSATION COMICS 205
Sergeant, Philip W. 133(n)
Series characters
Adam Link 67, 70; Autobiography of a Vampire 167; Batman 205
Blade, the Vampire Slayer **170**, 172, 179; Brother Voodoo 176, 178; Buck Rogers 9; Captain America 9, 169; Cerebus 111; Checkered Demon, The 182; Conan the Barbarian 175, 184; Dan Flagg 65(n); Dax the Warrior 91, 95, 97, 100, 103, 104; Deathlok 106, 176; Den 186; Dick Tracy 9; Dr Archaeus 105; Dr Destiny 207; Dr Occult 9; Dr Strange 133, **169**, 170, 207; Dracula 63, 165, 177, 181; El Cid **95**, 106; Fantastic Four, The 44, 169; Flash Gordon 9; Frankenstein 9, 141, 158, 178; Funky Phantom 106; Gabriel, the Devil-Slayer 179; Ghost Rider, The 130, 173, **174**, 175, 180; Giant Man 117; Goblin, The **94**, 106; Green Goblin, The 171; Hacker, The

INDEX

105; Hawkman 132; Heap, The 9, **10**, 130, 131, 134, 135, 142, 146, 151, 152, 160, 162, 167, 215; Hell-Rider 130; Howard the Duck 176; Hulk, The 174, 178; Human Gargoyles, The 107, **149**, 154, 159, 163, 164, 167, 215; Human Torch, The 117; Hunter 97, 105; Iron Man 169; Lady Satan 163, 167; Lilith, Daughter of Dracula 172, 179; Little Nemo in Slumberland 107; Living Mummy, The 176, 181; Love Witch 141, 149, 164; Man-Thing 130, 175, 176,178; Man-Wolf 176; Monster, Monster 164, 167; Morbius, the Living Vampire **170**, 171, 176, 177, **178**, 181, 198; Nick Fury 170; Nosferatu 167, 168; Out of Chaos 164; Plastic Man 208; Purple Claw, The 210; Red Skull, The 9; Rip Kirby 65(n); Rook, The 106; Saga of the Victims, The **166**, 167; Satana, the Devil's Daughter 177, **179**; Schreck 104; Shoggoths 160, 163, 167; Silver Surfer **171**, 172; Simon Garth, the Living Zombie 40, **178**, 198; Slither-Slime Man, The 152, 156, 168; Son of Satan, The 174, 176; Spectre, The 9, **10**; Spider-Man 73, 144(n), 169–171; Spook, The **91**, 105; Sub-Mariner 131; Superman 148, 205; Swamp Thing 127, 192, 193; Tales out of Hell 167; Tigra, the Were-Woman 176, 178; Thor 169; Vampirella **83**, 86, 97; Wendigo, The 178; Werewolf, The 178
'Seven Weird Tales of the Man-Macabre, The' 168
Severin, John 68, 70, 108, 110, 111
Severin, Marie 60
'Sewer Monsters' 44
'Sewer-Tomb of Le Suub, The' 147, 158
'Shadow of the Axe, The' 111
'Shadow Out of Time, The' 185
'She Crawls on Her Belly like a Reptile' 183, **184**
Shelley, Mary 173
Sherwood, Don 65(n)
'Ship of Fiends, A' 160
SHOCK **122**, 124, 160(n)
SHOCK SUSPENSTORIES (n) 151
Shock Theatre 64(n)
Shoggoth Threat Crusade **143**, 167. *See also* Series characters: Shoggoths
Shores, Syd 88, 124, 131, 141, 146
'Shrieking Man, The' **74**, 76, 111
Shuster, Joe 9, 77, 127
Siegel, Jerry 9, 148, 149
Signorelli, Joe 52
'Silver Thief and the Pharaoh's Daughter, The' **87**, 90
Sim, Dave 111, 193
Simon, Joe 46
SINISTER TALES 198

'Sink-Hole' 35
Sinnott, Joe 44, 57
Skeates, Steve 89, 103, 105, 108, 181
SKELETON HAND 200
'Skin and Bones Syndrome' 131
'Skin 'em Alive' 31
SKULL 183–186, 188, 196
'Skull Forest of Old Earth, The' 155, 163
'Skull in a Box' 122, **126**
'Skull of the Ghoul, The' 167
'Skull Scavenger' 39
'Skulls in the Stars' 181
Skywald Publishing Corp. 85, 86, 88, 93–95, 97, 104, 107, 113, 125, 128, 129–169, 173, 174, 181, 182, 197, 198(n), 215
'Sleep' 94
'Slime World' **139**, 144
'Slimy Mummy, The' **120**
'Slipped Mickey Click-Flip, The' 103
'Slither-Slime Man Rises Again, The' 168
'Slither-Slime Man, The' 152, 156, 168
SLOW DEATH 185
SMASH! 197
Smith, Barry 181
Smith, Clark Ashton 49
Smith, Kenneth 88
Sniegoski, Tom 193
'Snow' 110
Snow Bound' 152
'Solitude' 109
Solomon Kane 181
'Something to Remember Me By' 94
'Son of Dracula, The' 102
'Son of Lord Lucifer, The' 163
SON OF SATAN, THE 175. *See also* Series characters: The Son of Satan
Sostres, Ferran 152, 161, 163, 167
'Soul of Horror' 74, 77, 111
'Soul of the Warlock' 138
SPACE ODYSSEY 149, 162
Spain 183–185, 187
Sparling, Jack 87
'Spawn of Satan, A' 160
'Spawn of the Cat People' 66
SPELLBOUND 41, 198, 203
Spiderbaby Grafix & Publications, imprint 193, 195
SPIDER-MAN, THE AMAZING 170. *See also* Series characters: Spider-Man
'Spiders Are Revolting!' **84**, 87, 97, 111
'Spirit of the Thing, The' 76, 110
SPIRIT, THE 113
'Split Personality' 17
SPOOK 208, 209
Sproul, Robert C. 124
St. John, imprint 209
'Stake in the Game, A' 93
Stallman, Manny 73

'Stamps of Doom' 205
Standard, imprint 32, 41, 57, 205(n), 208
Stanley Publications, imprint 116, 124, 198
Star, imprint 208
Stark, Rolf 195
STARK TERROR 124, 198
STARTLING TERROR TALES 208, 209
Steacy, Ken 189
Stenstrum, Jim 98, 100, 110
Stepancich 122, **124**
Steranko, Jim 170
Sterling, imprint 209
Stevenson, Robert Louis 70
Stewart, Bob 80
Stillwell, Bill 88
'Sting of Death' **142**, 153
Stoker, Bram 68, 172
Stone, Chic 119–**121**, 123, 138, 153
'Storm, The' **28**, 33
Story, imprint 15, 31, 50–53, 182, 209
STRANGE FANTASY 22, 26, 34, 39, 48, 117, 201
STRANGE MYSTERIES 31, 44, 210
STRANGE STORIES FROM ANOTHER WORLD 206
STRANGE SUSPENSE STORIES 204, 206
STRANGE TALES 28, 33, 63, 133, **169**, 170, **174**, 176, 202
Strange Tales 9
STRANGE TERRORS 209
'Strange Undertaking, A' 36
STRANGE WORLDS 146
'Stranger in Hell, A' 93
Strnad, Jan 94, 95, 109
Stuart, Lyle 59
Sturgeon, Theodore 181
Suarez, George 205(n)
'Success Story, The' 14, 65, **66**, 110
'Sucker for a Spider, A' 43
'Suffer Little Children' 157
'Suicide Werewolf, The' **150**, 160
'Sum of its Parts, The' 100
Summers, Leo 108, 128
'Sunken Grave, The' 46
Superior, imprint 31, 35, 210
SUPERNATURAL THRILLERS 176, 181
'Susan and the Devil' 34
Suso 160, 167
SUSPENSE 55, 202, 204
Suspense 10
Sutton, Tom 82, 84, 85, 87–89, 94, 100, 102, 105, 133, 136, 137, 141, 146, 173, 179
'Swamp Devils' 122
'Swamp Girl' 43
'Swamp God' **77**, 79, 82
'Swamp Haunt' 42
'Swamp Monster' **42**, 43, 124, 206
SWAMP THING 127, 192, 193

'Swamp-Walkers, The' 181
'Swamped' **42**, 67
'Sweeney Todd' 196

TABOO **192**–196, 215
'T'aint the meat, it's the Humanity' 31
'Tale of Another, The' 168
Tales From the Crypt 56, 153
TALES FROM THE CRYPT 13, 15, **16**, 20, 26, 31, 35, 39, 43–46, 48, 50, **54**, 55, 60, 118, 197, 205, 215
TALES FROM THE CRYPT (Eerie Publications) 116
Tales From the Crypt: The Official Archives 55
TALES FROM THE TOMB 63(n), **117**–121
TALES IN THE TRADITION OF EDGAR A. POE 164
TALES OF HORROR 210
'Tales of Nosferatu, The' 163
TALES OF SUSPENSE **59**, 63
TALES OF TERROR 118, 192, 198
'Tales of Terror' 55
TALES OF TERROR ANNUAL 205
TALES OF THE LEATHER NUN 186
TALES OF THE ZOMBIE 178, 181
TALES OF VOODOO 41(n), 117, 118, 121–123, **125**
TALES TO ASTONISH **59**, 117, 130
TALES TOO TERRIBLE TO TELL 205(n), 216
'Taste of Cherry, A' **195**, 196(n)
Taycee, Jay, *see also* Johnny Craig 71, 84
'Tell-Tale Heart, The' 67
Tereno, Cara Sherman 195
'Terrible Old Man' 181
TERRIFIC 204
'Terror Beyond Time, The' 81, 82
'Terror in the Streets' 43
TERROR TALES **117**, 121, 122, **125**
Terror Tales **8**, 9
Terror, The 49
'Terror Unlimited' **48**
'Testicles the Tantologist' 184
Texeira, Mark 180
Theatre of Blood 165
'They Crawl by Night' 43, **44**
'Thing from the Grave, The' 35
'Thing from the Sea, The' 48
'Thing in Horror-Swamp!, The' 160
'Thing in the 'Glades, The' 47
'Thing in the Pit, The' 68, 110
'Thing of Darkness' 77
'Thing of Terror, A' 122
'Thing on the Roof, The' 181
'Thing That Grew, The' 47
THING!, THE 24, 25, 48, 51, 52, 204
'Third Night of Mourning, The' 98
'This Archaic Breeding Ground' 163
'This Graveyard is not Deserted' 103

'This Grotesque Green Earth' 163
THIS IS SUSPENSE 204
THIS MAGAZINE IS HAUNTED 36, 48, 50, 51, 204, 206
Thomas, Roy 179, 181
Thorp, David 196
'Thrill Kill' **100**, 110
THRILLING MURDER COMICS 187
THRILLS OF TOMORROW 207
Throat Sprockets 194
'Throat Sprockets' **194**, 196
'Through the Habitrails' 196
'Tightrope to Nowhere' 160
'Till Death' **38**, 40, 71
'Tiny Heads, The' **19**
'To Kill a God' 90
'To Laugh, Perchance to Live' 136
Toby, imprint 210
Todd, Larry 89, 146, 149, 182, 185
Todd, Sean, *see also* Tom Sutton 133, 137, 141, 142
TOMB OF DARKNESS **177**
TOMB OF DRACULA **171**, 172, 179
'Tomb of Horror', see NIGHTMARE:TOMB OF HORROR SPECIAL EDITION
TOMB OF TERROR **52**, 207
'Tomb of the Gods' 95
'Tooth Decay' 193
Top Sellers, imprint 198(n)
TORMENTED, THE 209
Torrents, Ramon 101, 128, 152, 154
Torres, Angelo 65–68, 70, 71, 74, 77, 79, 80, 83
'Torture Travelogue' 41
Toth, Alex 57, 68, 70, 71, 75, 83, 105, 110
Totleben, John 193, 196
TOWER OF SHADOWS, THE 170, 181
'Trick or Treat' 189
Trimpe, Herbe 174
Trojan, imprint 43, 51, 117, 210, 211
'Trophies of Doom' 32
'Trophy, The' **15**, 20
'Truth Behind the Myth of Dracula, The' 155
Tundra Publishing, imprint 195
'Tunnels of Horror' **140**, 152
Turn of the Screw, The 157
Turner, Ron 183
Tuska, George 73, 181
'Twisted Medicine' 108
TWISTED TALES 112, 136, 188–191
'Two of a Kind' 30

'Ugliest Man in the World, The' 46
UNCANNY TALES 203
UNCANNY TALES FROM THE GRAVE **177**
'Under the Skin' 75, 132
UNEXPECTED, THE 127
'Unholy Creation, The' 106
'Unholy Satanists, The' 147
UNKNOWN WORLDS 206

UNSEEN, THE 208
UP FROM THE DEEP 185, **188**
Upper Berth, The 48

Vallejo, Boris 89, 132, 136, **137**, 144, 148, 179
'Vampire Out of Hell, The' **161**, 166
VAMPIRE TALES 177, 181
VAMPIRELLA 86, **88**–91, 93, 94, 97, 98, 100, 101, 104, **105**, 108, 112–**114**, 131. *See also* Series characters: Vampirella
'Vampyre, The' **161**, 164
Varela, Hector 135
'Vault of a Vampire' 139
VAULT OF EVIL **177**
Vault of Horror 165
VAULT OF HORROR, THE 16, 17, 20, 22, 29, 30, 35, 36, 38, 40, 45, 46, 49, 50, **53**–55, 205, 215
'Vault, The' 163
Vaults of Yoh-Vombis, The 49
Veitch, Tom 185, 186, 187
'Vengeance' 121
'Ventriloquist's Dummy, The' 44
VENUS 202
'Verdict of Terror' 35
Verotik, imprint 196(n)
VEROTIKA 196(n)
'Vested Interest, A' 73
Vigil, Tim 196
'Village, The' **90**
Villamonte, Ricardo 162–164, 166, 167
Villanova 154, 157, 160–162, 166
'Vision of Evil' 71
Voltaire, Frank 137
VOODOO 21, 27, 31, 34, 41, 42, 48, 168, 198, 201, 215
VOODOO ANNUAL 201
'Voodoo Death' 39
'Voodoo Doll' 122
'Voodoo Dolls' 40
'Voodoo Drum' **79**
'Voodoo Horror' 49
'Voodoo!' 65
Vosburg, Mike 186
'Vow, The' 150

Waldman, Herschel 129, 140, 144, 150, 179
Waldman, Israel 144
'Wall of Flesh' 206
'Wall, The' 48
'Wanderer, The' 81, 111
WAR FURY 53
'Wardrobe of Monsters' 66, 132
Warren, imprint, *see* James Warren
Warren, Bill 87
Warren, James 62, 63, 64–116, 121, 123–126, 128, 130, 131, 133, 140, 145, 150, 151, 155, 156–158, 164, 169, 178, 181, 182, 215
WATCHMEN 192

'Way to a Man's Heart, The' **22**, 28
'We Ain't Got Nobody!' 35
WEB OF EVIL 30, 32, 34, 36, 47, 48, 156, 208
WEB OF HORROR 124, **128**, 125
WEB OF MYSTERY 199
'Webtread's Powercut' **91**
Wehrle, Joe 91
WEIRD 69(n), 116, 117, 120, 122, 123, **125**, 215
WEIRD ADVENTURES 27, 32, 207, 211
'Weird and the Undead, The' 152
WEIRD CHILLS 124, 207
'Weird Dead, The' 41
WEIRD HORRORS 209
WEIRD MYSTERIES 22, 28, 30, 33, 36, 40, 42, 43, 48, **52**, 53, 120, 168, 206, 207, 215
WEIRD MYSTERY TALES 127
WEIRD TALES 211
Weird Tales **8**, 9, 181
WEIRD TALES OF THE FUTURE **53**, 124, 206, 207
WEIRD TALES OF THE MACABRE **128**, 164
WEIRD TERROR **15**, 18, 49, 204
WEIRD THRILLERS 211
'Weird Way It Was, The' 162
WEIRD WONDER TALES 177
Weiss, Alan 88
'Welcome to my Asylum' 162
'Welcome to the Witches Coven' 93
'Well Cooked Hams' **20**, 26
Wells, HG 181
'Werewolf' 65
WEREWOLF BY NIGHT 89, 172, **173**, 180
Wertham, Dr Fredric 22, 28, 57, 59, 62, 183
Wessler, Carl 127
'Wetness in the Pit, The' 160
Whale, James 141
'What Hath Hell Wrought' 160
'What is Evil and What is not?' 163
'What is Horror? No — Who is Horror?' 167
'What Rough Beast' 95
'What the Dog Dragged In' 50
'What's Cookin'?' 31
'When Dies a Lunatic... So Dies a Heap' 160
'When the Dawn Gods War' 136
'When the Dusk Falls... So Dies Death' 152, 167, 168
'When Witches Summon' 48
'Whence Stalked the Werewolf' 145
'Where Are the Inhabitants of Earth?' 160, 163
WHERE CREATURES ROAM 176
'Where Lunatics Live' 168
WHERE MONSTERS DWELL **177**
'Where Monsters Dwell' 49
Whistler, The 10
White, Ron 84
'Who Killed the Shark?' 168

Wilde, Oscar 49
Wildey, Doug 19, 149
Williams, Stuart, *see also* Al Hewetson 162
Williamson, Al 64, 65(n), 75, 83, 111, 113, 136
Williamsune, Tony 85, 87
Wilson, F. Paul 94
Wilson, S. Clay 182, 183, 187, 193–195
'Wishes of Doom' 205
'Witch and the Werewolf, The' 119
WITCHCRAFT 43, 203
Witches & Warlocks 133(n)
WITCHES TALES 44, 46, 49, 53, 118, 207
WITCHES' TALES 119, 122, **125**
'Witches Tide' 82
WITCHING HOUR, THE 127
'Witch's Curse, The' 48
'Witch's Pit, The' 123
'Witch's Revenge' 120
Witch's Tale, The 10
'With Silver Bells and Cockle Shells' 94
'Withered Hand, The' 47
WIZARD 197
'Wolf Bait' 80
'Wolf Hunt' 91
Wolfman, Marv 89, 99, 142, 146, 154, 179
Wolverton, Basil 43, 49, 57, 124, 206, 215
Wood, Wally 57, 65(n), 75, 90, 110, 203
WORLDS BEYOND 206
WORLDS OF FEAR 43, 45, 48–50, 53, 168, 206
'Worms in the Mind' **90**
Wray, Bill 190, 192, 193
Wrightson, Berni 75, 107, 108, 125, 127, 181, 189
Writer's Digest 57, 59, 103(n), 166(n)

Xirinius 154, 155, 158, 160, 161

Yeats, WB 96
'Yeeech' 123
YELLOWJACKET 55, **56**
'You, Murderer' **151**
'Yours Truly, Jack the Ripper' 181
Youthful, imprint 211
YUMMY FUR 194

Zacherly 64(n)
ZAP! 182, 183, 187
Zen, Cru 196
Zesar 156, 160, 163, 167
Ziff-Davis, imprint 209, 211
'Zodiac Killers, The' 144
'Zombie' **39**
'Zombie Revenge' 160(n), 201
Zombie, The 181
'Zombie Vault' 121
'Zombie!' 39, 40

'Wild-Bunch, The' 144